Henri de
Toulouse-Lautrec

Norma J Carder
Sacramento, Ca
Nov. 25, 1998

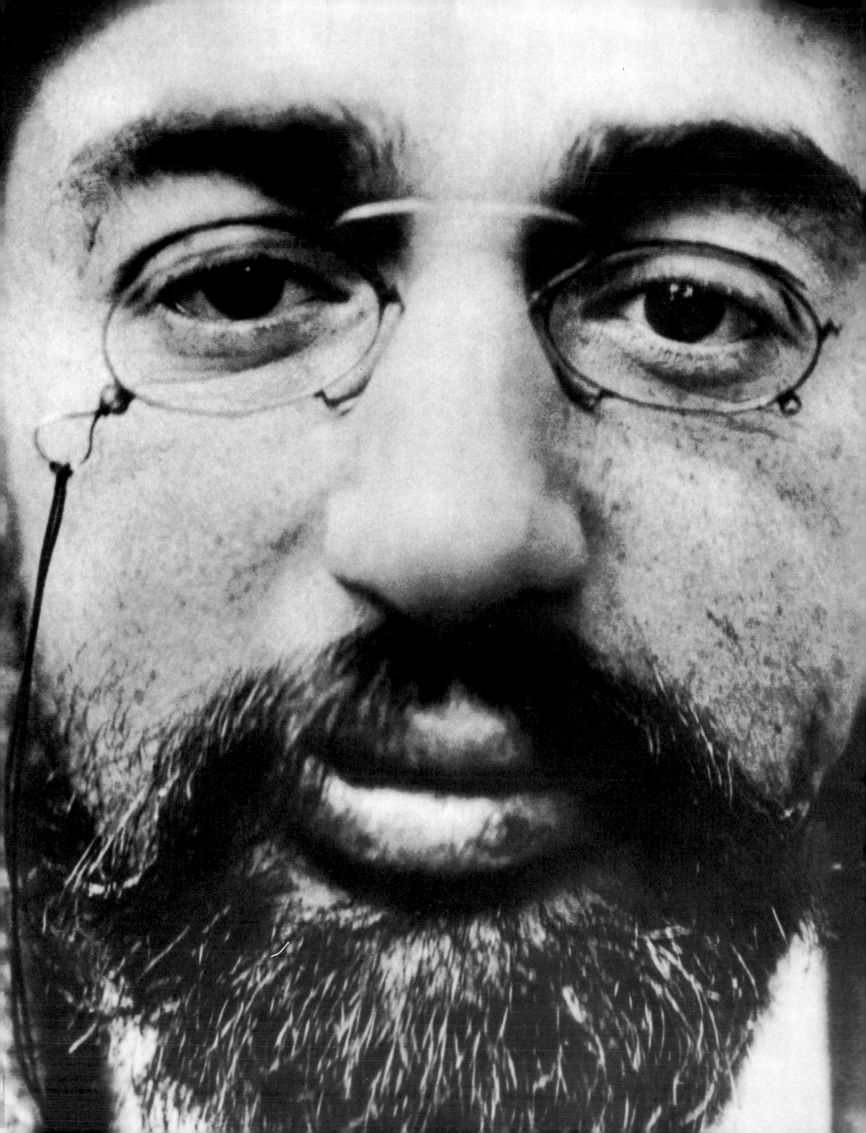

Gilles Néret

Henri de
Toulouse - Lautrec

1864–1901

Edited by
Ingo F. Walther

BARNES
&NOBLE
BOOKS
NEW YORK

ILLUSTRATION PAGE 2:
Henri de Toulouse-Lautrec, c. 1900
Photo: Thadée Natanson

© 1994 Benedikt Taschen Verlag GmbH,
Hohenzollernring 53, D-50672 Köln
English translation: Charity Scott Stokes, London
Editing and design: Ingo F. Walther, Alling
Captions and appendices: Ingo F. Walther, Alling
Cover design: Angelika Muthesius, Cologne;
Mark Thomson, London

Printed in Germany
ISBN 3-8228-9036-7
GB

Contents

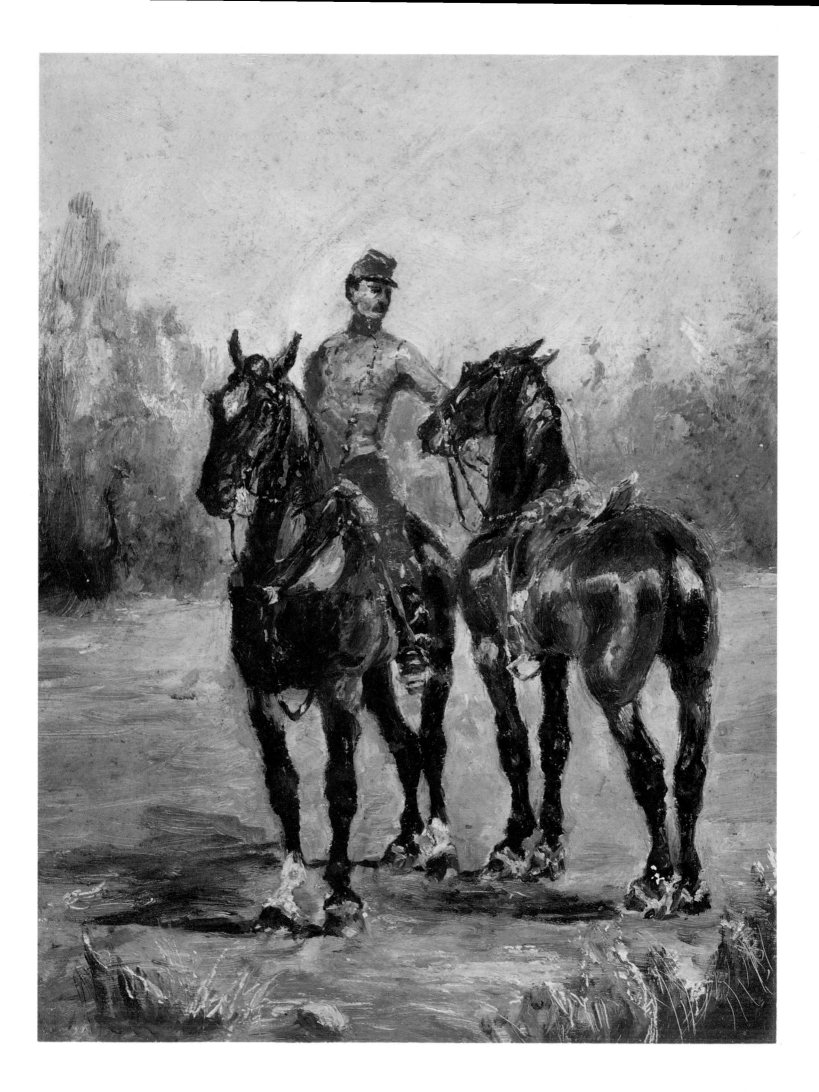

The Burden of Heredity

Henri de Toulouse-Lautrec remains an enigma in spite of his fame and his legendary diminutive stature. All too often, public awareness is restricted to the Hollywood image of a dwarf brought to life on the screen, of a famous poster artist wall-papering the Paris Boulevards of the Belle Epoque. He is seen as a forerunner of modern poster art – in itself no mean achievement.

Like his contemporary Edgar Degas (1834–1917), he is equally an innovator and a genius; he may aptly be described as the inventor of the "photographic paintbrush". With pencil and pen, Toulouse-Lautrec becomes the paparazzo *par excellence*: his renderings of the excitement and vibrating nuances of life outstrip the new techniques of photography. The film director Federico Fellini has fittingly expressed the importance of Toulouse-Lautrec in art and film history: "I always felt that Toulouse-Lautrec was a brother and a friend. Perhaps because he anticipated the viewpoint and the principles of cinematography even before the Lumière brothers made their discoveries, but also, of course, because he was attracted by the disenfranchised and rejected, by those who were regarded as sinful by respectable members of society… This aristocrat scorned sanctimony and safety and believed that the loveliest and purest flowers were to be found on rough soil and wastelands. He liked men and he loved women – the true, the hardboiled and those with wounded souls. He despised painted dolls because he hated hypocrisy and artificiality more than any other vices. He himself was simple and true, and magnificent in spite of his ugliness…"

He was criticised for these very qualities in his own time, and even today there are those who find it hard to forgive Lautrec his lack of prejudice, to forgive his openness to what is commonly regarded as vicious and evil. However, he treated his contemporaries no worse than did, for instance, Pieter Bruegel (*c.* 1525–1569) or Francisco de Goya (1746–1828).

Lautrec roved around with his photographic brush and the resulting pictures are his "Comédie humaine", in the spirit of Balzac (1799–1850). "If I were not a painter," he once said, "I would like to be a physician or a surgeon." One might add: a great reporter. This laughably diminutive prince of revelry always had his eye to the view-finder.

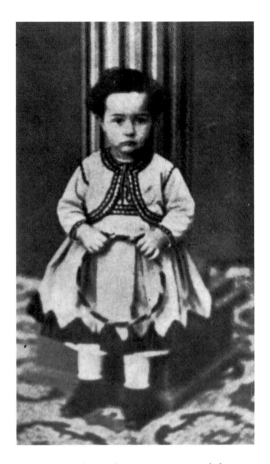

Little Henri de Toulouse-Lautrec, aged three, fondly called "Petit Bijou" (Little Jewel) by his parents and friends.

Two Horses with Soldier, 1880
Deux chevaux avec ordonnance
Oil on cardboard, 32.5 x 23.8 cm
Dortu P 75 Albi, Musée Toulouse-Lautrec

But there was nothing of the voyeur in him, nothing of the malice of a Degas, some of whose pictures might well have been snapped with a zoom lens or through a keyhole. Lautrec is never more cruel than the moment itself.

"Oh no, how horribly you've treated me, you little terror!" scribbled Yvette Guilbert (1868–1944) at the bottom of a canvas which she returned to him. She took offence at the caricatured face, whereas he saw only the black gloves, the quivering wings which he sketched several times. Lautrec quoted with mock solemnity Baudelaire's stricture – "I hate the movement which distorts the line" – only to give emphasis to his own version: "No, it is the movement that creates the line." He is alluding here to one of the essential characteristics of his own work, which also represents a vital contribution to modern painting: for him, beauty lies in movement, in vitality, in the absence of physical or moral constraint.

In order to paint more quickly he developed a technique of his own which involved thinning his paint with turpentine, so that it would be absorbed and dry better. Instead of priming canvas he tended to use coloured cardboard which needed no grounding. He was a passionate lithographer because this enabled him to make multiple reproductions of his work as a magazine might have done. Here too, he invented new techniques, for instance in his use of a toothbrush – he was never without it – to enlarge his spectrum of colours while printing. He set about choosing his colours as carefully as a photographer might select his developing agent. In the process he came upon "tricks", such as the use of gold dust to imitate the shimmering effect of electric light on the veil worn by Loïe Fuller (1862–1928) as she dances under the spotlight.

Regarding side by side the accomplished works and the preparatory drawings, one is astonished by their similarity. For all his man-about-town nonchalance, Lautrec executed his drawings with meticulous economy: the little sketch contains the final painting. Gestures, demeanour, composition – everything is there, with barely any need for experiment or revision, and rarely any trace of subsequent modification, since the final scheme of things is clear from the outset. No sketch is undertaken in vain; each one is conceived with a precise aim in mind. He is surrounded by the picturesque, and he takes full advantage of it. There is no need for him to roam to distant parts in search of the exotic and the true, as did Paul Gauguin (1848–1903) in Tahiti, or to pursue solitude and the sun in Provence, as did van Gogh (1853–1890). He made his journeys in the here and now. There could have been no straighter path, no more direct route than that disorderly vagabond life. "I have always done one and the same thing," he said. He portrays his own time, and nothing escapes his perspicacity.

Lautrec makes nothing lovelier or uglier than it is. He gives expression to what he sees, and whoever takes offence may well have good cause to do so: the empty-headed and the affluent will always feel themselves caught in the act by his remorseless drawings. His most important works, such as *Ball at the Moulin Rouge* (p. 59), *Marcelle*

Lautrec spent most of his childhood at the Château du Bosc (above), high above the Viaur valley near Albi where his grandfather, "The Black Prince", lived. He also spent time at the Hôtel du Bosc in Albi, and at the family seat at Céleyran near Narbonne.

Lautrec rarely portrayed himself and, even when he did, tended to distance himself from the subject by means of irony and dissembling caricature. *Self-portrait in front of a Mirror* (p. 9) is his only self-portrait. Even here his face is obscured by shadow and hardly discernible, while refraction denies the viewer eye-contact with the subject.
A further barrier is created by the objects looming large in the foreground of the picture. His congenital condition and the accidents of 1878 and 1879 had severely impaired his growth. Only his upper body had been able to develop normally, while his legs remained thin and brittle. In his self-portrait the painter gives the viewer no hint of his stunted growth or of his features disfigured since puberty.

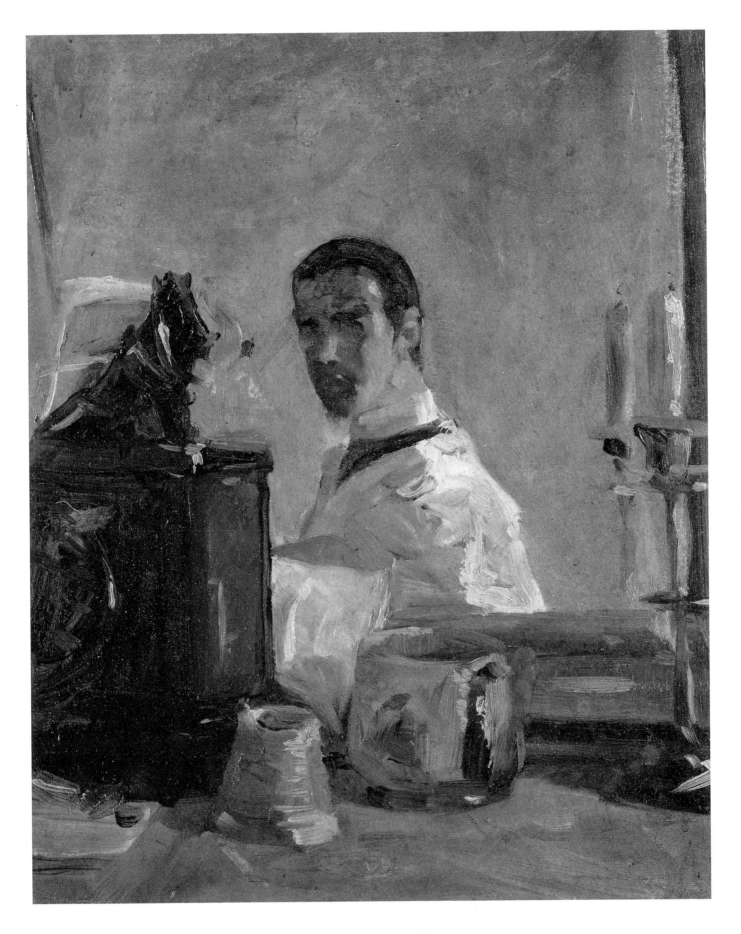

Self-portrait in front of a Mirror, *c.* 1882/83
Autoportrait devant une glace
Oil on cardboard, 40.3 x 32.4 cm
Dortu P 76. Albi, Musée Toulouse-Lautrec

Lender Dancing the Bolero in the Operetta "Chilpéric" (p. 93) or *In the Salon of the Rue des Moulins* (p. 145) have a status comparable to that of *The Night Watch* for the œuvre of Rembrandt (1606–1669), *Las Meninas* for Velázquez (1599–1660) or *Liberty Leading the People* for Delacroix (1798–1863). The painter of the red-light district kindles scandal, as did Charles Baudelaire (1821–1867) with his *Fleurs du mal*: he rejects established hierarchies. It was not thought proper to challenge the established order or to display the errors and lapses of the bourgeoisie; still less was it acceptable to display the beauty and grace of a prostitute in a brothel. Lightly, ironically, maliciously, he gives expression to the most unpalatable truths.

Lautrec's portraits may be a testimony of friendship, and yet he would not overlook even the smallest of warts. He observed of a well-known ladykiller, apparently without evil intent: "He looks like a flatfish, both his eyes are on the same side of his nose." Many were ag-

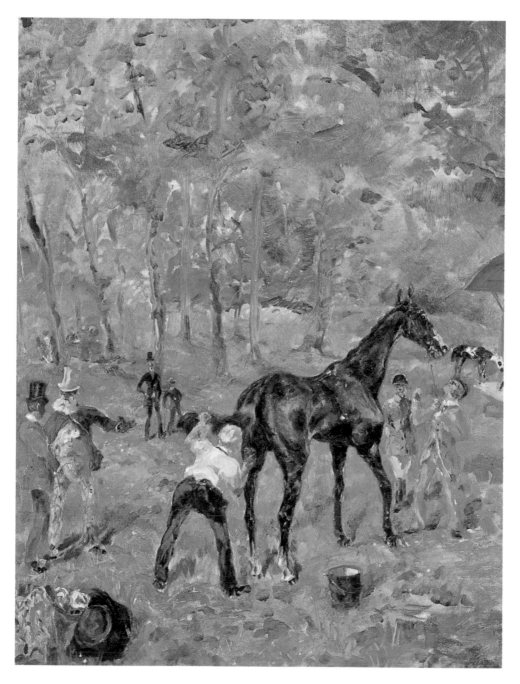

Souvenir of Auteuil (At the Races), 1881
Souvenir d'Auteuil (Aux courses d'Auteuil)
Oil on paper, 73.4 x 54.4 cm.
Dortu P 96. Private collection

At the left edge of the picture stands Lautrec's father, Count Alphonse, overseeing the grooming of a race-horse. Behind his outstretched left hand one recognises the caricatured silhouette of the painter, in the company of his tutor René Princeteau.

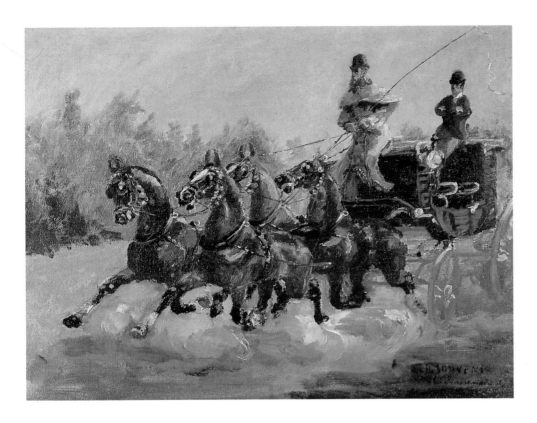

Count Alphonse de Toulouse-Lautrec Driving his
Coach and Four, 1880
Comte Alphonse de Toulouse-Lautrec
conduisant un attelage à quatre chevaux
Oil on canvas, 38.5 x 51 cm
Dortu P 94. Paris, Musée du Petit Palais

grieved by his sharp perceptions, yet beneath his piercing eye-glass
insects squirmed into unforgettable beings. Many creatures of low es-
teem, of the type familiar from picture postcards, with their vulgar
glitter, their flaccid skin and undisguised eroticism, have, thanks to
Lautrec, attained a quite different standing. Generously he bestowed
upon them his own nobility, his intelligence, his sympathy and irony.
"There is a Lautrec type of woman," says Jean-Gabriel Domergue, "a
type he discovered as he watched them living and dancing." Like the
ancient Greeks, Lautrec has his own gods and heroes, his brightly-col-
oured idols. Naturally he cannot paint without being overcome by
passion. His talent is not that of a deformed human being who sees
only ugliness, who exaggerates the ugliness of human existence, as
antagonists maintain. In his works atmosphere and climate become
tangible, the essence of his figures becomes visible as they appear and
move. "Oh! Life! Life!" calls this "moral self-destroyer" time and time
again. His short life ended at 37 – a fateful age for him as for many
another great artist, such as van Gogh, Raphael (1483–1520) and Jean-
Antoine Watteau (1684–1721).

Lautrec is neither cynical nor crude. He is open and honest, and he
retains until the end of his life his original verve, the spontaneity of a
child. "He was seen caressing the most disreputable women," writes
Thadée Natanson (1868–1951) in his recollections of Lautrec, "and
they were surprised, but moved..." Certainly Valentin the Contor-
tionist cannot be compared with Michelangelo's Adam on the Sistine
Chapel ceiling, yet with his power of suggestion, his world of matter,
of the senses and of the spirit, Lautrec created a whole universe; in the
history of painting he is as significant as the most famous of his prede-
cessors.

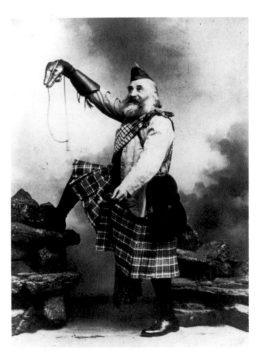

Lautrec's father: Count Alphonse-Charles-
Marie de Toulouse-Lautrec-Monfa (1838–
1913) dressed as a Scottish falconer. Henri's
father is described as a crotchety eccentric,
who was mainly interested in hunting, and
who seemed to love horses, dogs and falcons
more than people. When he realised that his
weakling son would never equal him in riding,
hunting or soldiering, he turned away in dis-
appointment. For little Henri this was a pain-
ful experience that perhaps hurt him more
than his physical ailments.

It is hard to imagine anyone of more aristocratic background, more favoured by destiny, surrounded with more loving care by his family, than Lautrec. He proudly bore his affectionate family nickname "Petit Bijou" (Little Jewel; cf. p. 7). Yet his life was to be a continuous drama, a brief tragedy which he accepted with full awareness and intellectual clarity, grandseigneur to the last, a man of the world, his appearance notwithstanding. His discretion and modesty were such that those whose company he kept did not always sense his searing bitterness. The glaring artificial light in the background of his work and of his life was nothing more than décor and embellishment; rather than illuminating the real Lautrec, it concealed him, and relegated him to the shadows.

The counts of Toulouse belonged to the forty families who, together with the royal family, created France. Up until the fourteenth century they were lords of Languedoc. There was a Count of Toulouse among the crusaders who set out for the Holy Land in 1100. Charlemagne acknowledged the first Count, forefather of Henri as of all the others, as an independent imperial vassal. Times have changed, lamented Henri's nostalgic father, Count Alphonse: "A Toulouse should go straight from the font to the saddle!" Horses and hunting had been the business of life from time immemorial, with a little wax-modelling or water colours in the evening. There was an old-established tradition of art in the family, with portraits in chalk and crayon and etchings executed by Lautrec's great-grandfather in the early nineteenth century. In his leisure hours Count Alphonse made little models of horses and hounds. "Bagging a snipe gives my sons threefold pleasure," said grandmother Gabrielle, "the pleasure of the gun, the drawing-board and the table."

Henri, the "Petit Bijou", is licensed to do as he pleases; he pulls charred wood out of the fire and proceeds to blacken the pattern on the large carpet in the salon. He is three years old when his younger brother Richard is christened in Albi cathedral. He is determined to inscribe his signature in the baptismal register. "But you cannot yet write," said one of the gentlewomen. "Well then, I'll draw an ox!" was his reply.

The vitality of the counts of Toulouse is legendary. From one generation to the next life is lived to the full, and the excesses of the men are matched by the liveliness of the women, for instance by Adélaïde of Toulouse who, in the eighteenth century, was able to say there was "no man, servant, lord, citizen or yokel around", with whom she had not dallied. But fate gives with one hand what it takes away with the other. In this family, living without regard to the law, intermarriage is the norm. Centuries of blood relationships leave their mark on the aristocracy, and Henri is not the first dwarf in his family; there was a female dwarf before him. This is the dramatic end-point of an evolutionary development described by scholars as delayed achondroplasia or as *osteogenesis imperfecta*, an insufficiency in bone formation. All authorities agree: at the moment of birth, Lautrec's biological develop-

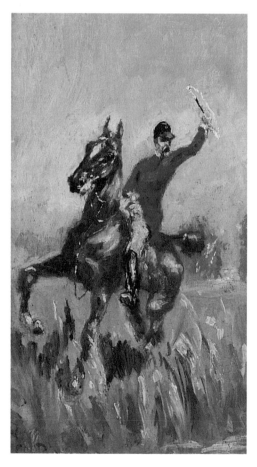

Master of the Hunt, *c.* 1882
Le maître d'équipage
Oil on wood, 23.5 x 14 cm
Dortu P 186. Private collection

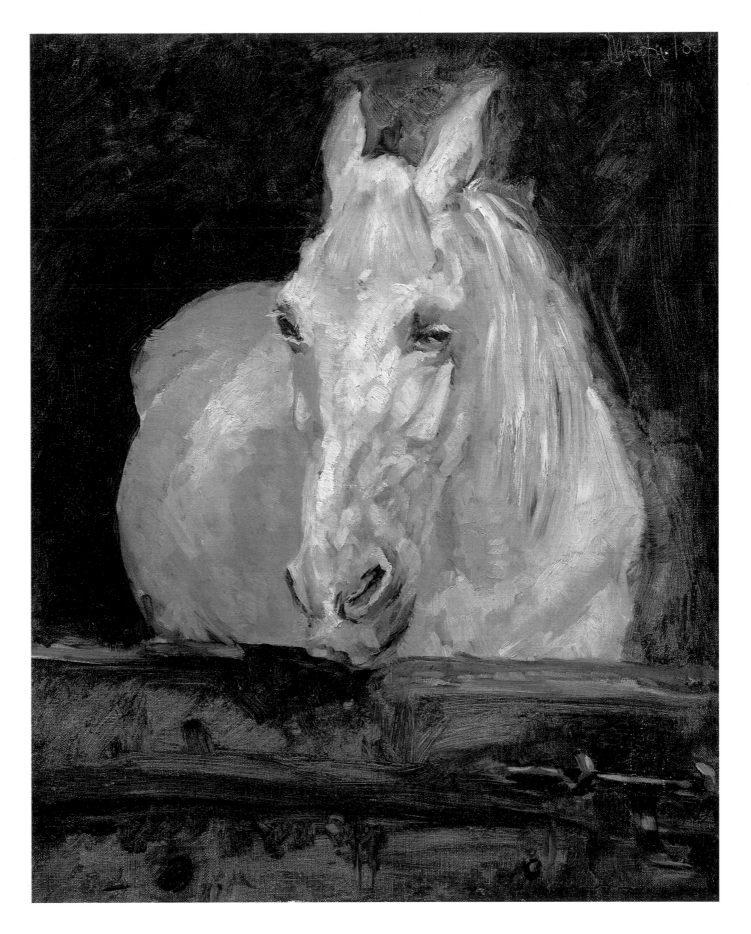

The White Horse "Gazelle", 1881
Le cheval blanc "Gazelle"
Oil on canvas, 60 x 50 cm
Dortu P 103. Private collection

ment was already determined; but so, most fortunately, was his talent, and so was his character.

On 30 May 1878 Lautrec broke his left thigh bone as he was getting up from his low chair in the salon. Not long afterwards he had a fall while he was out walking, which resulted in a fracture of the right thigh. His fate was sealed: he was to grow no more. At the age of thirteen he was not quite five feet tall, and in spite of loving care and attention he never grew more than another half-inch.

Little Henri has to watch in the mirror as his nose begins to thicken and swell, his lips protrude, his legs buckle, his feet become stumps and his strangely black and piercing eyes become short-sighted. His body, by contrast, achieves massive proportions; his sexual development is alarming, as is his libido. Women friends in the brothels which he later frequented give him the graphic nickname "tripod", or "coffee pot". His friend, the author Jules Renard (1864–1910), gives this description of him: "A midget with glasses. A little sack with two tubes into which he presses his pathetic legs. With protruding lips, and hands like the ones he paints, with splayed bony fingers and crooked curving thumbs. He often speaks of small men, as much as to say: 'But I'm not as little as that!' At first he arouses pity by being so small, but then he's very lively and very friendly, he punctuates his sentences with growls, and rolls up his lips, and drools into his beard…"

From this moment on, Lautrec never goes out of the house without his little walking-stick, cut down to match his size, with the dangerously spiked iron tip removed. He hobbles like a "lame duck" and swings his stick, often lunging at women's legs in the process. On one occasion a night-reveller in the Maxim picks up a coloured pencil that Lautrec has left on the table, and calls cruelly after him: "Sir, you have forgotten your stick!"

"One has to find ways to help oneself," admits Lautrec to his fellow student and subsequent biographer Maurice Joyant (1864–1930). He follows his own lead, finding ways to help others, loving them for all their failings and shortcomings, even when they make fun of him. This enables Lautrec to develop one of his most distinctive characteristics: his ability to enter into another person's psyche.

The two broken thigh-bones condemn him to almost total immobility, yet this strengthens and encourages his vocation. He is sent to health resorts and spas. On the Promenade des Anglais he sees the ladies of the foreign leisured classes stroll up and down, and he draws them until his hand hurts. He sits his school examinations; unsuccessful at the first attempt, he passes them in the following autumn. He writes to one of his friends: "I was quite carried away by the hectic examination fever, and this time I managed it. To that end, I neglected friends, painting and everything else that deserves attention down here, and devoted myself instead to dictionaries and textbooks. In the end the Toulouse directorate decided to accept me in spite of the follies that I expounded in reply to their questions! I recited quotations from Lucian that he never wrote, and the professor, who wanted to appear

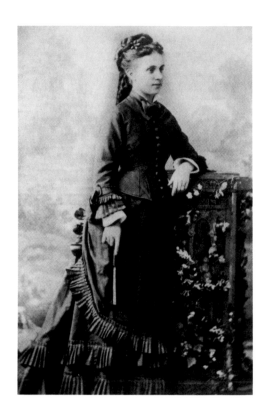

Lautrec's mother: Countess Adèle-Zoë-Marie-Marquette Tapié de Céleyran (1841–1930). Lautrec's mother came from an old family from the Aude province. The two families, Toulouse-Lautrec and Céleyran, had been inter-related since the 18th century. Adèle married her cousin, Count Alphonse-Charles-Marie de Toulouse-Lautrec-Monfa. After the birth of their second child the couple separated and, after her divorce, Adèle lived at Malromé château where the portrait (p. 15) was painted.
Throughout his life, Lautrec was very close to his caring mother, who repeatedly provided financial support, and he painted her several times (pp. 16, 17, 39) in her slightly melancholy tranquillity. The Countess was well-known for her generosity. In 1922 she gave her son's studio to his birthplace Albi, and it is now displayed in the Palais de la Berbie.

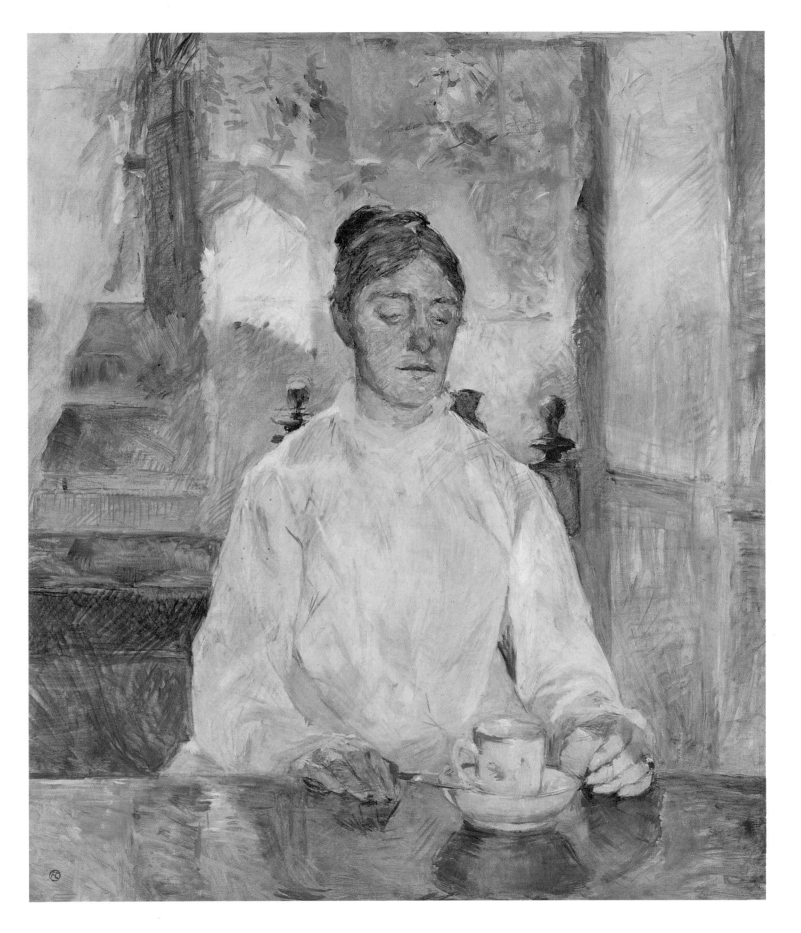

**The Artist's Mother, Countess Adèle de Toulouse-Lautrec,
at Breakfast in Malromé Château**, *c.* 1881–83
*La mère de l'artiste, comtesse Adèle de Toulouse-Lautrec,
en train de prendre son petit déjeuner au château Malromé*
Oil on canvas, 93.5 x 81 cm
Dortu P 90. Albi, Musée Toulouse-Lautrec

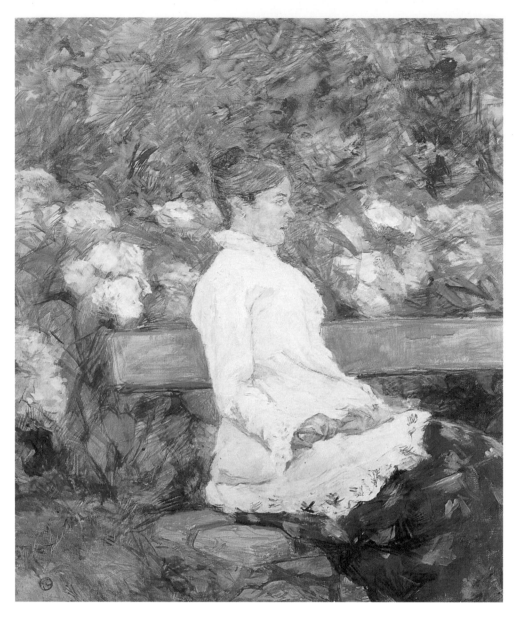

Countess Adèle de Toulouse-Lautrec in the
Garden, *c. 1881/82*
*Mme la comtesse Adèle de Toulouse-Lautrec
au jardin*
Oil on canvas, 55 x 46 cm. Dortu P 190
São Paulo, Museu de Arte de São Paulo Assis
Chateaubriand

very learned, extended the warmest welcome to me. So I've got that
behind me. You will find my writing somewhat enervated, that's be-
cause of the mental limpness that follows the exertions required for the
examinations. Let us hope that it will be better next time!"

His sketchbooks fill up. He signs his letters "Hobble-foot", adding
delightful caricatures. Since he can no longer ride on horseback, can
no longer "press the quivering flanks between his thighs", he draws
horses from every conceivable angle. The surroundings of the château
were used at the time for army manoeuvres, and he takes the oppor-
tunity to observe the soldiers and paint some live scenes on canvas. His
family's affluence assists him in this project. Three of these pictures are
destined to hang one day in museums: *Trotting Rider, Artillery-Man
Saddling a Horse* and *At the Races in Chantilly*. He might well have
applied the words of Georges Rouault (1871–1958) to himself: "For
me painting is only a means of forgetting life. A cry in the night. A
stifled sigh. A laugh that sticks in the throat."

Lautrec works without pausing for breath. Three hundred drawings
and some fifty paintings accrue during 1880. His favourite subjects are

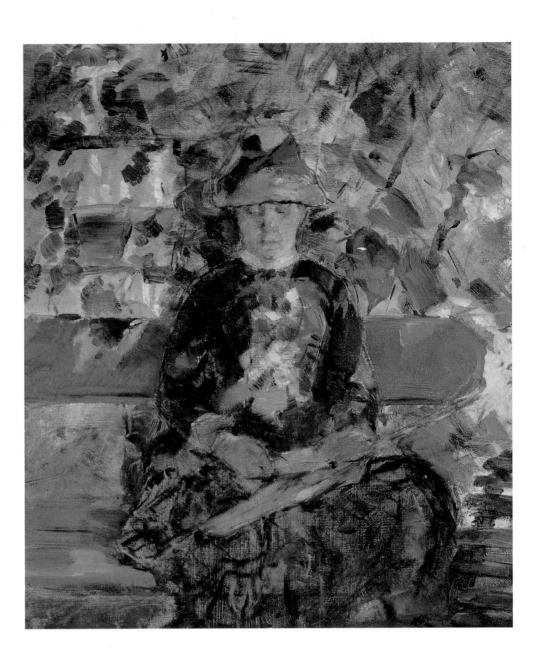

Countess Adèle de Toulouse-Lautrec, 1882
Mme la comtesse Adèle de Toulouse-Lautrec
Oil on canvas, 41.7 x 32.5 cm
Dortu P 180. Albi, Musée Toulouse-Lautrec

still horses, horse-drawn carriages, ships and dogs. Movement is of supreme importance to him, he studies every stance and posture and displays enormous skill.

"I shall make beautiful, wonderful things," he boasts to his father, who answers with cruel lack of understanding: "Yes, as a painter of meadows, fields and woods!" He says despairingly: "My room is full of trash." But he has no other choice. As unworthy scion of a renowned and powerful line, he has nothing at his disposal but the strength of others in his attempt to bring everything that moves within his grasp; and all this life reminds him of his lost universe. He already feels drawn to everything that is odd. It makes his own oddity more acceptable to him.

A constituent of the strangeness around him is the eccentricity of his father, from whom he inherited his love of costumes and disguises. Count Alphonse can carry it off, he has no inhibitions about the most bizarre behaviour. Lautrec's biographer Henri Perruchot portrays the father in humorous vein: "On a summer's day he would walk through the streets of Albi with a falcon on his wrist, stopping from time to

time to give the creature little morsels of raw meat. Since he does not wish to deprive his animals of the blessings of religion, he gives them holy water to drink. His appearance often seems surprising to those who do not know him, he loves to dress up in unusual costumes, he finds it agreeable or useful to wear the costume of a cowboy, Circassian, or Scottish Highlander or a crusader's coat of mail."

Several times Lautrec painted his father in the saddle, in the chief's costume from *The Last of the Mohicans* by James Fenimore Cooper (1789–1851), or as a Circassian with his falcon on his wrist. For his twelfth birthday he received from his father a book on falconry, with an inscription which reads strangely when one bears Lautrec's destiny in mind: "Remember, my son, that the only healthy life is the free outdoor life in daylight. Everything that is deprived of that freedom becomes crippled and soon perishes. From this little book on falconry you shall learn the true worth of country life, and when one day you experience the bitterness of life, you will find that your horse, your dog and your falcon are valuable companions, who can help you to forget a little." Twenty years later Lautrec reminded his father of these lines, when he wrote from the enclosed institution in which he was supposed to be being cured of his alcoholism: "I am shut in, and everything that is deprived of freedom perishes."

Lautrec is drawn also to the otherness of René Princeteau (1839–1914), his first tutor, and friend of the family. Princeteau was deaf and dumb from birth, but he painted wonderful horses. What a pair they must have been, the dwarf and the deaf-mute! At lightning speed Lautrec learns his tutor's technique, imitates his manner of manipulating the solid and yet light brush, influenced, remotely, by the Impressionists. The two become good friends. "The 'little one' is working hard and making enormous progress," writes Princeteau to his parents, "he imitates me like a monkey!" Henri does indeed take over his motifs, and his skill in handling them; there is a certain flexion in human figures and horses which emphasises contours and upward movement. Above all, he learns a technique of painting delicate feathered strokes with light effects from the half-shadows that play on costume, skin and hair.

Lautrec develops complete mastery in this "finely attenuated Impressionism", as noted by Emile Zola (1840–1902) in his article of 1880, "Naturalism in the Salon". Before long he surpasses his master, as is shown by the portrait that he paints of him. Princeteau feels bound to recommend most emphatically to the parents that they should send their son to one of the most famous painters in Paris, Léon Bonnat (1833–1922), who taught at the Paris Academy. Since this seems to be their little son's vocation, the family does not venture to deny the wish; moreover, painting is an occupation which a Toulouse can be seen to engage in without loss of dignity. "One thing is certain, if my legs had been a bit longer I would never have become a painter!" Henri asserts, giving life a well-deserved rebuke. His decision means that he will settle permanently in Paris.

Young Routy in Céleyran, 1882
Le jeune Routy à Céleyran
Oil on canvas, 61 x 49 cm
Dortu P 149. Albi, Musée Toulouse-Lautrec

This portrait of the young Routy, painted in the summer months of 1882, is particularly indicative of Lautrec's study of Edouard Manet and the pictures by the open-air painters exhibited at the 7th Impressionist exhibition. Routy, about the same age as Lautrec, was employed as a farmworker on the Céleyran estate. This introverted, rather mistrustful-looking young man was Lautrec's favoured model at the time, and he portrayed him in three paintings and seven sketches.

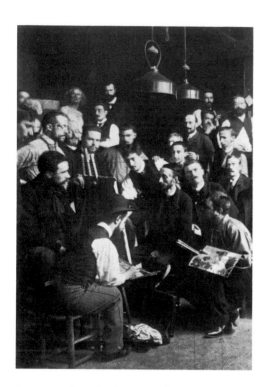

Lautrec, left in the foreground, as a student in the Paris studio of Fernand Cormon, who is sitting at the easel, c. 1885/86.

During his training in Cormon's studio, Lautrec painted several portraits of his fellow students; that of the young painter Gustave Lucien Dennery (1863–1953) is one of the most original (p. 21). This friend became more famous as Lautrec's model than as a painter. He was a genre and portrait painter and exhibited regularly at the Paris Salon between 1887 and 1946. Nothing in the casually relaxed pose or respectable bourgeois clothing indicates that the subject is a painter. Only the location – Dennery is sitting in Lautrec's studio, on the models' sofa (cf. p. 23) – establishes a connection between the subject and his profession.

Princeteau had already taken him on a journey of discovery to Paris; they had been to the theatre, and to the Cirque Fernando, where the main attraction for Lautrec was of course the dressage and the bareback women riders. He was excited too by the trapeze artists, the jugglers, and all the performers who were in control of their bodies. But the clumsiness and ridiculousness of the clowns, which reminded him of his own wretched condition, could also make him laugh, and joke at his own expense: "I'm just a half-penny-worth."

In a light open carriage he pays a call on his new teacher Bonnat, the most official of official painters. Influential recommendations or genuflections are necessary before he will deign to paint a portrait at a horrific price. He is becoming a figure of fun: "Only if you are recommended by a general, a minister or an ambassador will Monsieur Bonnat condescend to paint you, standing upright, stiff as a post, shining under the light from above, as if you were made of crystal." This man at the height of his renown, heaped with accolades, a dedicated practitioner of "good style", is exactly the opposite of the slipshod Impressionists. He is therefore just the right person to convince the family of Toulouse-Lautrec that a glorious future lies ahead of their offspring.

Contrary to Lautrec, whose art in a sense anticipates the ventures of modern photography, Bonnat derives his inspiration from the rigid and contrived photography of his time. This is evident in the portraits that he was always painting of people standing ready to go out, in their outdoor attire. It is hardly surprising that such a man understood nothing of Lautrec's budding genius. "You will certainly be curious to know what sort of encouragement Bonnat is giving me," writes Henri to his Uncle Charles. "He says to me: 'Your painting is not bad, that's all very clever, really not bad at all, but your drawing is simply appalling.' And then one has to rally all one's courage and begin again from the beginning. Those are the crumbs…"

In spite of his pronounced personal likes and dislikes, Lautrec trusts and accepts the master's directives, even though his words often seem very strange to him: "While you are busy with the model's feet, look at his head…" Lautrec takes note of Bonnat's instructions, as of those of others, and at least his understanding of the rules of composition is strengthened, and he becomes more aware of the need to recognise his own means of expression. To Bonnat's influence must be attributed the more orthodox and darker oil-painting style, with smoother surface structure, which can be seen in the portrayal of his models at this time. For instance, he paints a whole series of studies of the red-haired Carmen Gaudin (p. 25), and an important picture entitled *The Laundress* (p. 33). The *Nude Study* (p. 23) is further evidence of Lautrec's determination to follow the advice of the famous master, who owed his allegiance to the academicists and favoured the simple brush stroke, quite in the manner of Dominique Ingres (1780–1867). At this point one fact emerges quite clearly: woman is beginning to take the place of the horse in Lautrec's universe!

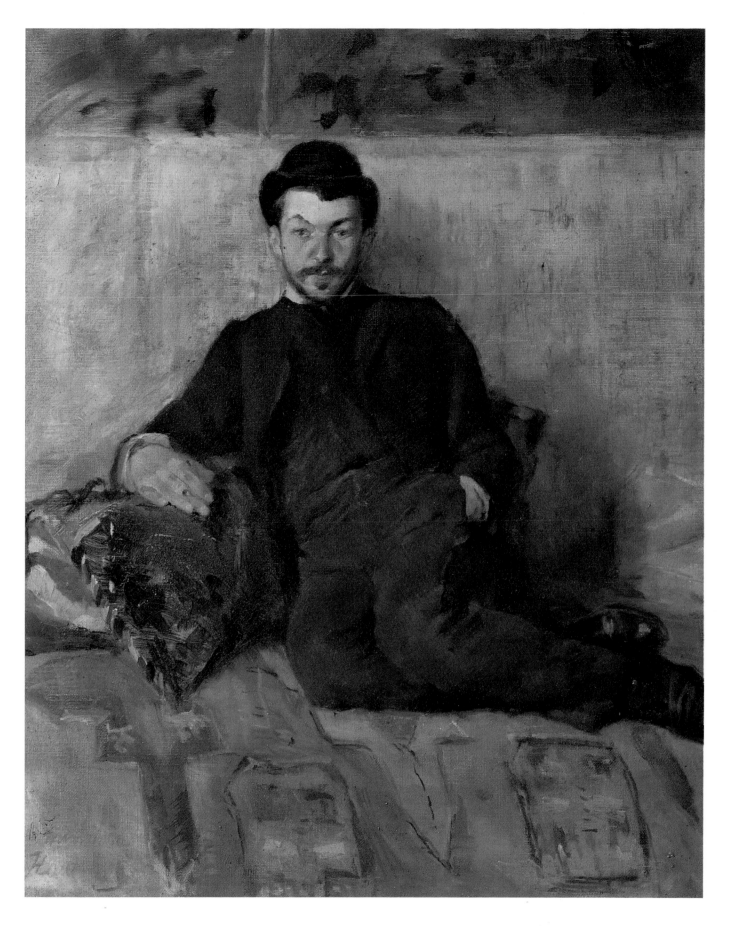

Gustave Lucien Dennery, 1883
Oil on canvas, 55 x 46 cm
Dortu P 223
Paris, Musée d'Orsay

Fat Maria, 1884
La grosse Maria ou *Vénus de Montmartre*
Oil on canvas, 80.5 x 65 cm. Dortu P 229
Wuppertal, Von-der-Heydt-Museum

Lautrec still moves uncertainly between one school and another. He cannot decide between the dark palette of painters such as his master and the Impressionists' spray of colours. His vacations in the South of France, far from Bonnat's studio, help him to lighten and extend his palette. All the time he keeps painting people, sometimes with horses, and everyone wants to be painted by him. His whole family appear in his paintings, his grandmother, his uncles, his cousins, and above all, time and time again, his mother (pp. 15–17). He sometimes pays the peasants and servants 75 centimes for a sitting, and he makes enormous progress. His best canvases are now flooded with light. His portraits of agricultural labourers, of his cousin Gabriel Tapié de Céleyran, of young Routy (p. 19) are unmistakably "modern".

The new bright colours enable him to express light, but indirectly, in a bold new manner. His draughtsmanship becomes firmer, more emphatic, the compositions become more skilful, the proportions more assured. These are no longer pictures from the Academy, but

Nude Study, 1883
Etude de nu
Oil on canvas, 55 x 46 cm. Dortu P 170
Albi, Musée Toulouse-Lautrec

they are not Impressionist either: the artist does not disperse local colour into the colours of the spectrum in the systematic manner of Claude Monet (1840–1926) or his friends. Lautrec's works are closer to those of Edouard Manet (1832–1883), or to the interiors of Gustave Courbet (1819–1877) or of Degas, as is evident in the large nudes of the period, *Fat Maria* (p. 22) and *Nude Study* (p. 23). These portraits have something in common, in their conception and execution: attention is drawn to the feelings which emanate from them, often feelings of sadness or disappointment, which are to become a leitmotif of Lautrec's work. Of course the family does not know that for *Fat Maria* the artist persuaded a prostitute to sit for him. One can sense the sympathy that he felt for this fading creature, whose physical decline in a sense echoes his own physical wretchedness.

His mother, his "sainted lady mother", as he liked to call her, represented for him love in its purest form. She was the only person in the world from whom he accepted pity, and he painted no fewer than five

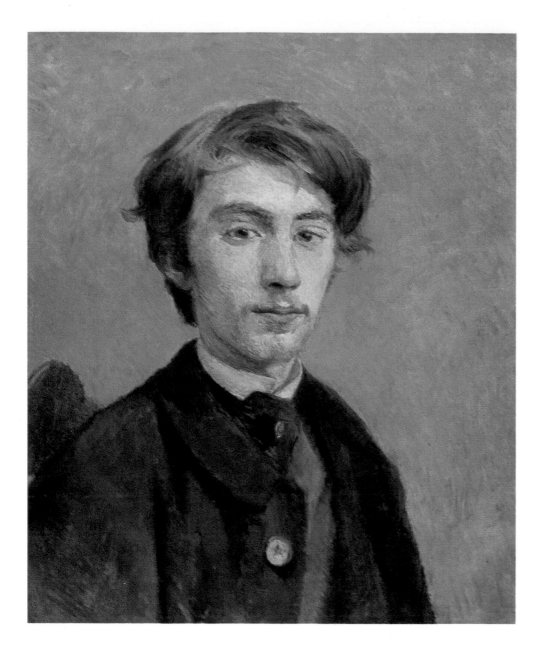

Emile Bernard, 1886
Oil on canvas, 54.5 x 43.5 cm
Dortu P 258. London, Tate Gallery

portraits of her, in rapid succession, as if he wanted to show how swiftly his art was progressing. The first portrait is in subdued colours, putting the figure in the foreground, with muted light effects. The second portrait shows her profile against a dark background. One senses the withdrawal of the Countess, as if behind a tissue of filigree, loving and disappointed by life. In the third portrait she is seen sitting in the garden at Céleyran, with a book in her hands and a parasol on her knee (p. 17). The brush stroke and cross-hatching suggest the influence of Paul Cézanne (1839–1906) and the Impressionists. Her gaze is lowered, and there is more resignation than before. In the next portrait of her, at breakfast at Malromé (p. 15), the gaze is again lowered, this time towards a china cup, and the scene is bathed in gentle light that would give her the appearance of tranquillity, but for the subtle detail of her taut lips, which contradict the seeming peace and contentment. This is the centre of Lautrec's universe, to be abandoned no more. The last portrait, which shows the Countess sitting on a seat in the garden (p. 16), exploits all the magic nuances of a palette which has

Carmen Gaudin, 1885
Oil on canvas, 52.8 x 41 cm
Dortu P 243
Williamstown (MA), Sterling and Francine
Clark Art Institute

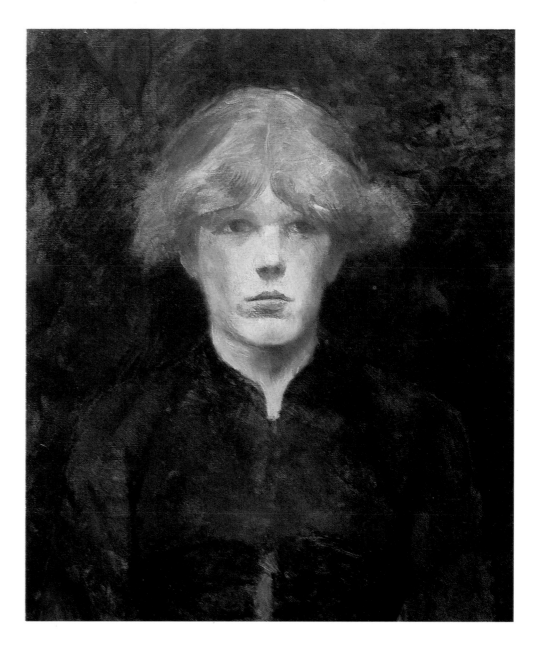

Carmen Gaudin, 1885
Oil on wood, 23.8 x 14.9 cm
Dortu P 244
Washington (DC),
National Gallery of Art,
Ailsa Mellon-Bruce Collection

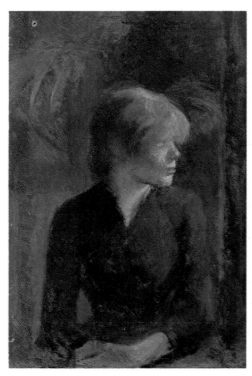

reached its final lightness. The effect of this picture is even more devastating. One senses the growing bitterness of this woman, who accepts each blow in silence, from the infidelities of her husband to the ailments of her child. It is only with this picture that one can grasp the significance of Henri's mother for him. She is for him the absolute woman, who first believed in him, who reached out to him with an inner understanding which at times seemed to surpass the humanly possible, and who closed her eyes to all his eccentric whims and excesses.

Lautrec is now twenty years old, and Montmartre is his field of action. Bonnat has closed his studio, and Fernand Cormon (1845–1924) has succeeded him. Cormon was an enthusiastic admirer of palaeolithic artefacts. His reputation is founded on archaeological and anatomical precision, which results in his being known amongst his many students as "Father Ball-and-Socket". His most famous picture, entitled *Cain* (Paris, Musée d'Orsay) was one of the great Salon triumphs of 1880. The Stone Age is his domain, his reserve. He adorns

Quadrille of the Louis XIII Chair, 1886
Le quadrille de la chaise Louis XIII à
l'Elysée-Montmartre
Ink and pencil on paper, 50 x 32 cm
Dortu D 2973
Albi, Musée Toulouse-Lautrec

The strange title of the drawing (right) and the
painting (p. 27) needs explaining, as they are
clearly not set in the Elysée-Montmartre but
in Aristide Bruant's newly-opened Mirliton
next door. In 1885, Rodolphe Salis moved the
Chat Noir, a cabaret in which Bruant himself
appeared, from 84 Boulevard Rochechouart to
the Rue de Laval. Salis, his artistes and cus-
tomers turned the move into a jolly pro-
cession with music and costumes and, while
Salis believed he had left nothing behind, he
had nevertheless forgotten a Louis XIII chair.
Bruant, the new proprietor of the premises, re-
fused to relinquish the chair. Instead he hung
it on the ceiling and made it the butt of one of
his famous satirical songs.
Lautrec has captured the movement of the per-
formers, dancing couples and audience in
numerous sketches. The conductor Louis Du-
four and the guardian of public morals, Coute-
lat du Roché appear twice each. Roché was
known by the nick-name "Père la pudeur"
(Father Prude), and it was his duty to inspect
the cabarets and see that the bounds of
decency were not overstepped. Lautrec has
immortalised himself at the right-hand edge of
the picture (in the middle and below, on the
chair).

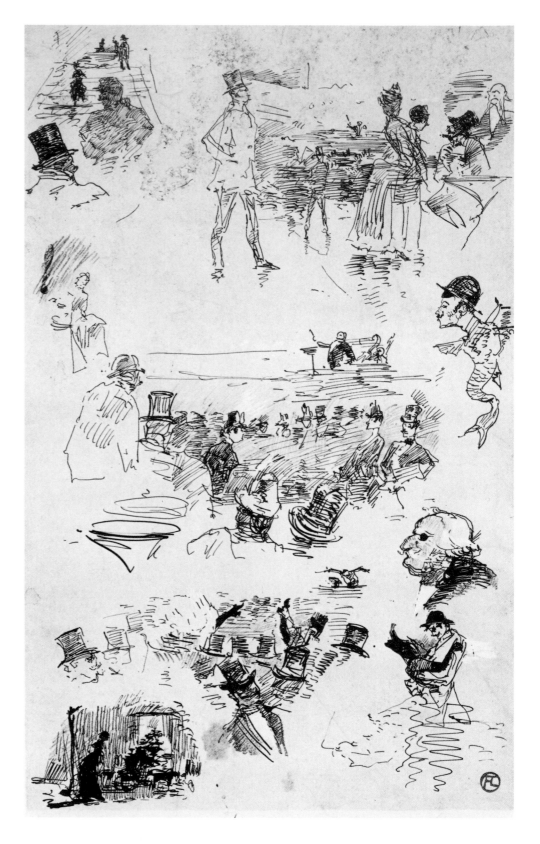

the pretty girls who sit for him with animal skins, and transforms street
lads into bear-hunters. In Hollywood he would have made a career for
himself in décor and costumes.

Whereas Bonnat was unsuccessful in awakening kindred spirits
among his students, Cormon by contrast was well regarded and popu-
lar. As a teacher he indulged in all sorts of nonsense, and was always
ready for a joke. Lautrec considers that his lenience goes too far, and
even misses Bonnat's severity at times. He writes to his Uncle Charles:

"Cormon's correctives are more focused than Bonnat's. He looks at everything he is shown, and does everything he can to encourage us. You will be surprised, but I don't like it!" And he adds: "I'd like to tell you a little about what I'm doing, but it's so strange, so 'beyond the pale'. Papa would certainly call me an outsider…"

Count Alphonse was indeed uneasy about what his son was doing, and about the direction his art was taking, which was less and less in accord with the perceived honour of the family. He therefore urged his son to adopt a pseudonym. In order to be left in peace, Lautrec signed his paintings from that time on as "Tréclau", an anagram on his name. However unfavourably disposed his father may have been, among his fellow-students Lautrec's popularity was growing. "Lautrec has the gift of making people like him", notes his contemporary François Gauzi (1861–1933), "all the other students like him, and he never takes advantage of people to make fun of them behind their backs. In his drawings he makes fun of himself and of those right next to him."

Henri dreamt of finding "a woman with a lover even uglier than

Quadrille of the Louis XIII Chair, 1886
Le quadrille de la chaise Louis XIII à l'Elysée-Montmartre
Oil on canvas, 46 x 55.5 cm
Dortu P 261. Private collection

In the right foreground Roché, the guardian of morals, is to be seen. To the right, behind him, stand the two painters Louis Anquetin and François Gauzi; behind them, the conductor Dufour. Bruant, with his famous wide-brimmed hat, observes the dancers La Goulue and Grille d'Egoût. Bruant personally commissioned this painting from Lautrec and it hung in the Mirliton. He used a second grisaille version for the cover illustration of the 29 December 1896 edition of his magazine *Le Mirliton.*

myself!" Someone pointed out to him that old Cormon, who was far from being a handsome man, had no less than three mistresses. Montmartre is a garden full of nymphs who are not in the least shy; people dance, and drink in the arbours. His friend Louis Anquetin (1861–1932), whose art he admires as much as his muscles, does not even count his conquests any more. Women! Lautrec sits in the corner, gazing after them. Which one of them will be truly fond of him, and will not be embarrassed or recoil from the sight of him?

He sits dreaming till daybreak, till another of his friends, Lucas, senses the suffering in his soul, and remembers a young model to whom he has been of assistance several times. He resolves to throw Marie Charlet into Lautrec's arms. She could have been the heroine of a harlot's novel, having run away from home, from the drunkard father who abused her after his drinking bouts. This 17-year-old "pavement artist" with the body of a Greek stripling has seen everything there is to see; moreover, she is a nymphomaniac.

With her Lautrec, wishing as always to escape pity, discovers fetishism. The painter's malformed body fills her with ecstasy. This precocious young person discovers in his monstrous shape just what she wants. With her dwarf lover she experiences new delights, lovingly she calls him her "clothes-hanger" and recounts everywhere all the details of her splendid nights with the little man. Certainly it is through this adventure that Lautrec discovers the existence of voluptuous pleasure as an alternative to love. All barriers are broken down, and he devotes himself just as wildly to pleasure as to art and hard work. La Butte, the nightlife district of Montmartre, turns out to be "a little world full of wonders", peopled with the strangest beings. This is Lautrec's rightful place, here he is in good company, no longer the odd one out. Here he finds a certain balance, and inner peace.

Gradually Lautrec's exertions begin to bear fruit. His talent is acknowledged by his teachers as well as by his friends. Even Bonnat puts in a good word for Lautrec, and his evident progress leads Cormon to involve him in his own new project: the illustration of the works of Victor Hugo (1802–1885).

With his friends from the studio he goes the rounds of the cafés in Montmartre, and he finds a new friend, alcohol. "I've a craving like the parson's cat," he says, and he laps up the alcohol that "unfolds a peacock's fan" in his mouth. At home in the family château the bishop had spoken prophetic words to him: "My son, yours is one of the most beautiful vocations, but also one of the most dangerous."

Although Henri's path takes him further and further away from the restricted world of the family, he returns each summer to his mother. She has bought the Malromé property not far from Bordeaux, with some fifty hectares of wood and grasslands. This is the best environment for Lautrec's work. Not for landscape painting, which seems to him just as pointless as still life – as a painter he is no more interested in landscape than he is in little flowers – but for rural scenes and above all for portraits. He is interested most of all in people, although his manner of painting them may preserve a certain dispassionate remoteness. He cares not a jot for bourgeois conventions and family ties. It is enough for him to paint what he sees, without further involvement. In Malromé he is a summer guest. It is in Montmartre that he will meet the people who are really going to count for him, the ones who are marked and scarred by life.

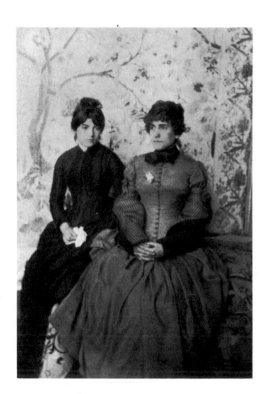

Photograph of Jeanne Wenz (left) and Marie-Clémentine Valade (right), who later, as Suzanne Valadon (1867–1938), became a well-known painter. Jeanne Wenz was the companion of painter Frédéric Wenz who studied with Lautrec at Cormon's studio. Suzanne first worked as a laundress, before joining the Molier travelling circus as a trapeze artist. When she fell from the trapeze at fifteen, she had to work as a model – for, among others, Renoir, Lautrec and the Italian Impressionist Federico Zandomeneghi (1841–1917), who resided in Paris. She became something of a celebrity among the Montmartre bohemians. In 1883 she gave birth to a son who later became a famous painter under the name of Maurice Utrillo (1883–1955). The story goes that she set her heart on marrying Lautrec and even threatened suicide should he refuse. When he discovered her intention he separated from her and never saw her again.

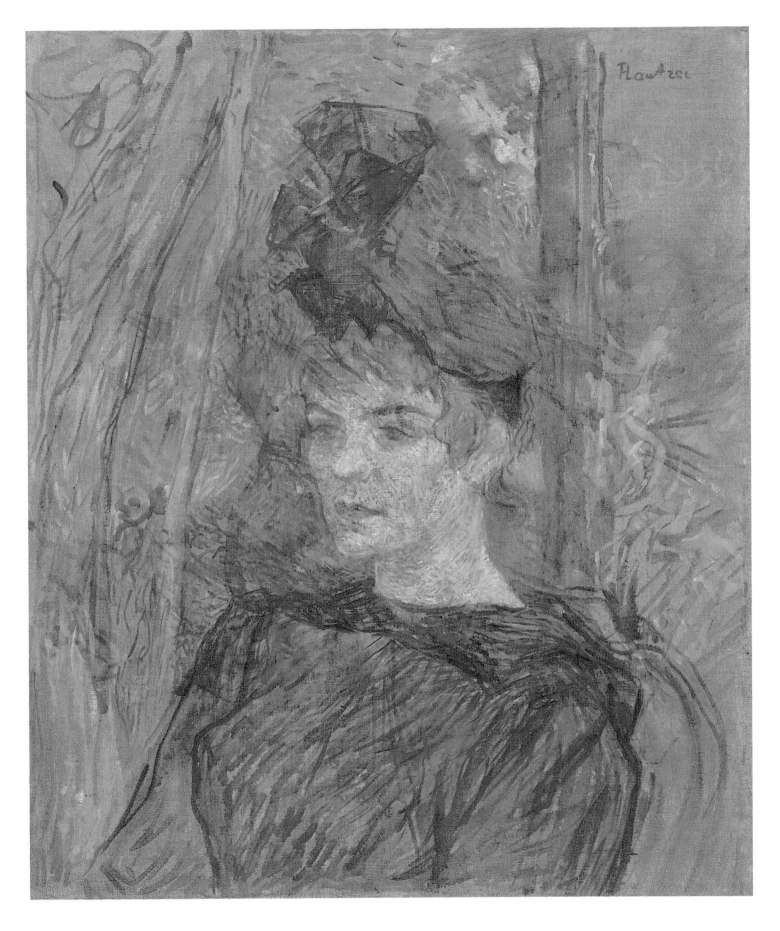

Suzanne Valadon, *c.* 1886/87
Oil on canvas, 54.5 x 45 cm
Dortu P 250
Copenhagen, Ny Carlsberg Glyptotek

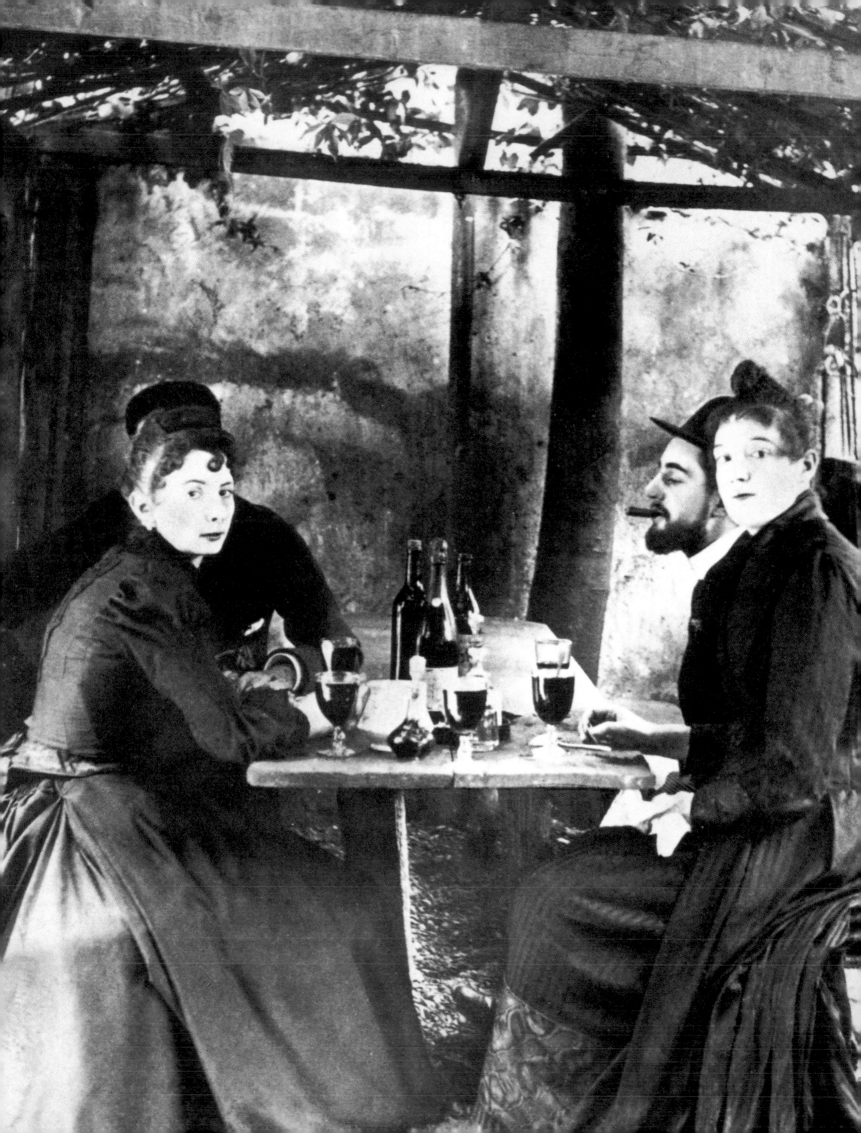

Painting Life

It is time for Lautrec to cut the umbilical cord and prove his independence. He feels the need to put some distance between himself and his preferred model, Countess Adèle, his "sainted lady mother". From this time on he prefers to surround himself with a circle of companions and kindred spirits, and the arguments he presents to his family are diplomatic rather than convincing: "I have been obliged to act against my own inclinations; you know as well as I do that it is against my will that I lead the life of a bohemian. It is a great trial to me, I have to throw overboard so many of my sentimental attachments in order to reach the state that has to be..."

At the same time he turns away from the official art that has been presented to him as the rightful goal. He has in any case had little recourse to this academic and pompier art, since he scorns the prescribed subjects from the scriptures, from mythology and history. If he had his way people would "leave the Greeks in the Pantheon and firemen's helmets to David". His close friend François Gauzi, who sat for him several times – most notably for *The Day of First Communion* (p. 34), in which he appears in a black overcoat pushing a pram – wrote a book of memoirs entitled *Lautrec and his Time*. In this book he records from the viewpoint of a contemporary and trusted friend the distinctive development of his fellow student, who was destined to become one of the most important modern painters. Since Gauzi is himself a painter, his judgement is particularly significant. He says that for Cormon the subject of Lautrec was taboo: he viewed him as a strange pupil, prominent but peripheral, exceptionally gifted as a caricaturist, but one for whom great art would remain a foreign field, a kind of madman who liked to indulge his fantasies. Lautrec, for his part, supported the theories of the Impressionists and showed the greatest appreciation of their revolutionary work, and of the freedom with which they cheerfully arrogated the right to dismantle all the rules that had operated until that time. "Truth in art" was a notion that matched his own ideas to perfection. It was high time to stop mixing colours; rather, one should achieve the right tone by applying paint properly, and keeping its freshness. It was time to put an end to chiaroscuro and replace it with light. Black should be banished entirely, and so should bitumen and bistre and earth col-

Louis Anquetin:
Portrait of Henri de Toulouse-Lautrec, 1889
Charcoal on paper, 61.5 x 39 cm
Albi, Musée Toulouse-Lautrec

Lautrec sitting beside La Goulue, drinking wine in a leafy arbour of the Moulin de la Galette, c. 1887.

PAINTING LIFE 1886–1891 31

The Laundress, 1888
La blanchisseuse
Charcoal on paper, 65 x 50 cm
Dortu D 3028
Albi, Musée Toulouse-Lautrec

The Laundress, 1886
La blanchisseuse
Oil on canvas, 93 x 75 cm
Dortu P 346
France, private collection

The model for this laundress, leaning forward
and resting on her hands, was in all prob-
ability the red-haired Carmen Gaudin, a fa-
vourite model of Lautrec's from 1885 on-
wards (cf. p. 25). He espied her on the street
through a restaurant window, while dining
with his friend Henri Rachou, and was de-
lighted by the girl's simple, unspoilt ex-
pression. He persuaded Carmen to sit for him
and painted a number of portraits, one of
which he exhibited at the 1888 Brussels exhibi-
tion of "Les XX". What interested him most
in this working-class girl was her worn-out
body and her expression of dull rawness, un-
falsified by any kind of education. For him
she represented the populace, carrying life's
burden on her shoulders, tired, yet strong.

ours, all of which were not colours at all. Artists should stop using
tricks, should stop touching things up in the studio, should not leave
anything out or make any additions, should not paint their pictures
anywhere but in full view of nature... Bravo! Lautrec applauded
these theories. It just happened that they could not be put into prac-
tice with regard to his own current projects. As far as he personally
was concerned, a rule was only any good if it fitted in with what he
wanted to do at the time. Since no rules were important to him, they
were easily jettisoned.

There was one idea which appealed to Lautrec hugely: he liked the
idea of beating the Academy painters on their own ground, in the
Salon, not because of the financial rewards available to anyone who
gained access to the Salon, but because of the opportunities to make
fun of them. "Pshaw, the members of the jury! They've no idea what's
going on, it will be easy to hoodwink them. I shan't bother about them
in the slightest... I shall paint a still life." In his studio he discovers a
little black frame with gold border and a suitable canvas, and he des-
patches the concierge: "Alexandre, run along to the dairy and buy a
wonderful Camembert, but hurry, I need it at once!" Gauzi records
the surprise he felt when he visited Lautrec in order to view the pro-
spective Salon piece: "I was dumbfounded: I had been expecting a
revolutionary picture, a super-Lautrec, a painting that would make the
jury cry out in rage, a Camembert glowing with all the colours of the
rainbow. But no! This was a real yellow ochre Camembert, with only
a hint of lemon yellow and Veronese green; a dutifully painted Cam-
embert, very realistic, with its soft texture, and the whole thing lying
on a plate between a glass and a knife, which didn't even have a blue
handle, for instance, but a black one, ebony black. 'Have you been out
buying black paint and yellow ochre?' 'Of course, it's a picture for the
Salon!'"

Lautrec had aimed to arouse the admiration of the jury with his
painting in academic style, but his scorn rebounded on him when the
picture was rejected. Lautrec was furious that his plot had failed. It is,
by the way, a great pity that this still life has disappeared, since it is
probably the only one that he ever painted, preoccupied as he was with
people.

Ever a good loser, he visited the Salon, a true battlefield on which
phalanxes of painters pushed their way to the fore. The great Ernest
Meissonier (1815–1891) reigns supreme, while Henri Gervex (1852–
1929) condescendingly greets the snobs, Giovanni Boldini (1842–
1931), Emile-Auguste Carolus-Duran (1837–1917) and the fashion-
able portrait painters who all parade in silk and velvet for the fleeting
moment of glory. There too is the famous actress Sarah Bernhardt
(1844–1923), whom Lautrec is soon to portray in the role of Phèdre.
She is surrounded by a bodyguard, to protect her against the stormy
admiration of the crowd. One can imagine what Lautrec thought of
this world, yet he accepted his own place in it in later years.

The Salon at the time was plastered with nudes, giving it the air of a

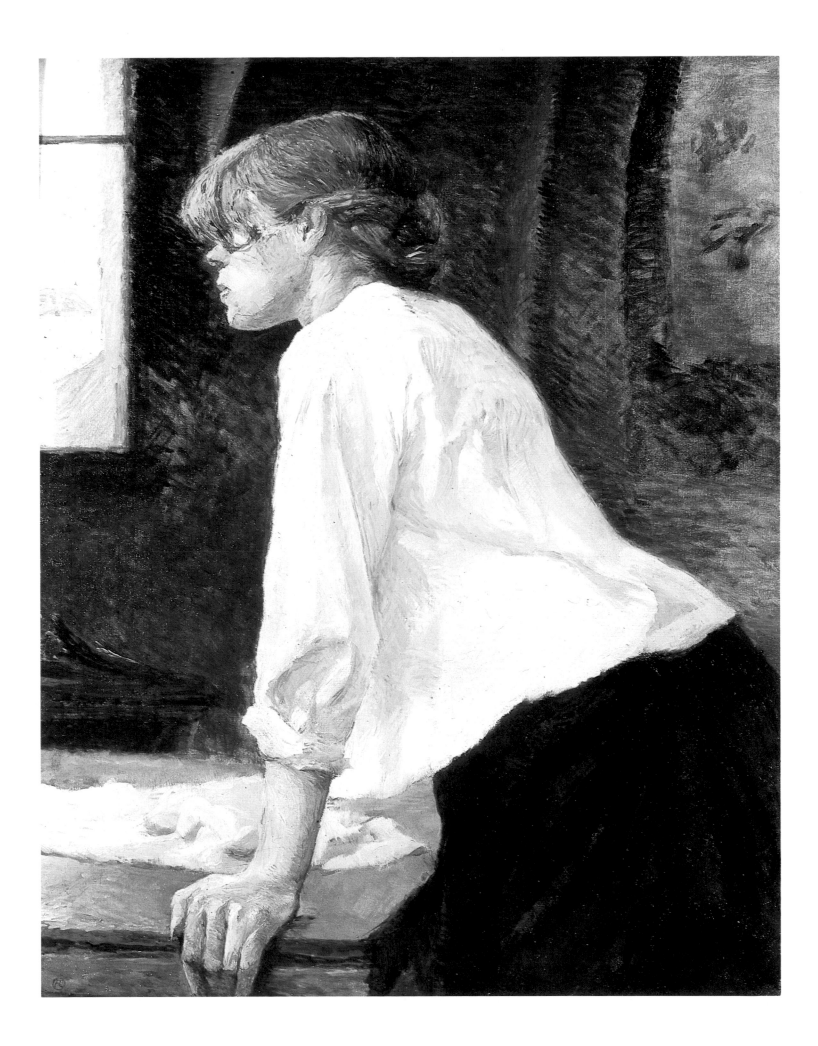

The Day of First Communion, 1888
Un jour de première communion
Charcoal and oil on cardboard, 65 x 36 cm
Dortu P 298. Toulouse, Musée des Augustins

The Omnibus Company Trace-Horse, 1888
Le côtier de la Compagnie des omnibus
Charcoal, ink and oil on cardboard,
80 x 51 cm. Dortu P 300
Paris, private collection

harem. The paintings are highly erotic, but their titles are tailored to the occasion: *Birth of Venus, Susannah Bathing* and *Truth Rising from the Well.* They are declared respectable, ennobled by their historical and cultural allusions. These hordes of dryads, nymphs, odalisks and Oriental maidens, sprung from the brushes of the Academy painters, can be made exciting, piquant or frankly voluptuous at will – indeed it is expected of them – and their brilliance enhances the status of the highly respected gentlemen who buy them, and often contributes to the worldly wealth of the artists who created them. These artists have medals and commissions heaped upon them, for they know precisely how to calculate the requisite drapery and modesty required of a vestal virgin. They know just how much flesh a female Christian martyr must show in order to waken the lion's appetite and the potential purchaser's desire. Whether they are called bacchante, goddess or holy martyr, these creatures can display the full beauties of their bodies, for they are saturated with history.

Lily Grenier, 1888
Oil on canvas, 55.5 x 46.5 cm
Dortu P 302
New York, The Museum of Modern Art,
The William S. Paley Collection

Lily Grenier in a kimono, c. 1880.

The painters of the Academy are respectable people, no doubt about it, and the system works perfectly. Each one of them has his own speciality: William-Adolphe Bouguereau (1825–1905) chooses ambiguous biblical scenes, Jean-Léon Gérôme (1824–1904) chooses scenes from classical antiquity, and Cormon surprisingly favours the Stone Age. Not until the Impressionists, those layabouts with their forerunner Courbet and their leader Manet, does anyone venture to paint the girls of the populace, the all-too-realistic Olympias, the faded prostitutes from the street corner, who look as if they have just put their clothes on, as if they have been taken by surprise, as if they are waiting for a lover or a client. This display of realism is shocking, it is felt to be an intrusion on private life. The girls' clients are also the Salon's clients, perhaps ministers or generals. Intolerable!

This moral discrimination corresponds approximately to the distinction between the words "nude" and "naked", between the artist's nude and a figure stark-naked. As far back as Plato's "Symposium" we

Lautrec as choirboy at the "Courrier Français" fancy dress ball, 1889. To the right of him, René and Lily Grenier (cf. p.35).

Lautrec, sitting on the floor in the foreground, with his friends Claudon and Nussez, dressed in oriental costumes, c. 1884.

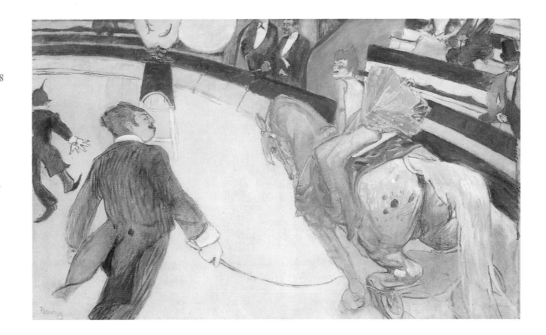

Bareback Rider at the Cirque Fernando, *c.* 1887/88
Au Cirque Fernando: Ecuyère
Oil on canvas, 103.2 x 161.3 cm
Dortu P 312
Chicago (IL), The Art Institute of Chicago

The Fernando Circus had its pitch on the
Boulevard Rochechouart. In 1894 it was rede-
signed as a theatre. Included among its regular
guests were Lautrec, and also Degas, Renoir
and Seurat, who decorated the rooms with
their paintings. Seurat's famous last painting
The Circus (1891; Paris, Musée d'Orsay) also
features a bareback rider from the Fernando.
Since Lautrec's painting was exhibited in the
foyer of the Moulin Rouge from October
1889, it is likely that it inspired Seurat's com-
position.

may read of the two types of the goddess of love, the divine and the
vulgar. Pierre-Auguste Renoir (1841–1919) explained the difference in
this way: "The naked woman arises from the sea or from her bed; she
is called Venus or Nini, one cannot improve on that."

If he wanted to be acknowledged and respected as a perfect
Academy painter Lautrec would have done better to paint a Venus
rather than a Camembert, but given his temperament she would cer-
tainly have turned into a Nini beneath his brush. "Mars and Venus,
what a joke," he said one day to Gauzi, "look at this…", and he
delves among his drawings and pulls out one which shows an artil-
leryman pulling on his trousers. That is how he imagines Mars.
Choosing such unlikely characterisations is his way of demonstrating
his independence. Notwithstanding the fact that no more is heard of
his Mars and Venus, Lautrec would have liked to exhibit his works.
Since his mockery of the Salon is not soon forgotten, he turns to the
Rue Volney, where an exhibition of works of art is mounted every
year, usually works by amateur painters from respected families.
Without any difficulty he becomes a member of this circle, and in
1890 he submits his *Portrait of Hélène Vary* (Bremen, Kunsthalle),
which is accepted. Lautrec is satisfied; as a newcomer he could expect
nothing more.

In this portrait Lautrec gives Hélène Vary, a young neighbour
whom he had known as a child, a certain shy beauty, dignity, and
clarity of feature. Certainly he did not deliberately make her uglier
than she was, as he is so often said to have done; on the contrary, he
pays his respects to her pleasing profile. Evidence of this is provided
by his obliging friend Gauzi, who at the painter's request took a
photograph of her afterwards in the same pose as in the painting. A
comparison of the two shows that Lautrec did not in any way deform
or distort his subject; rather, his canvas bestows more life and more
intensity than the best photograph is able to do.

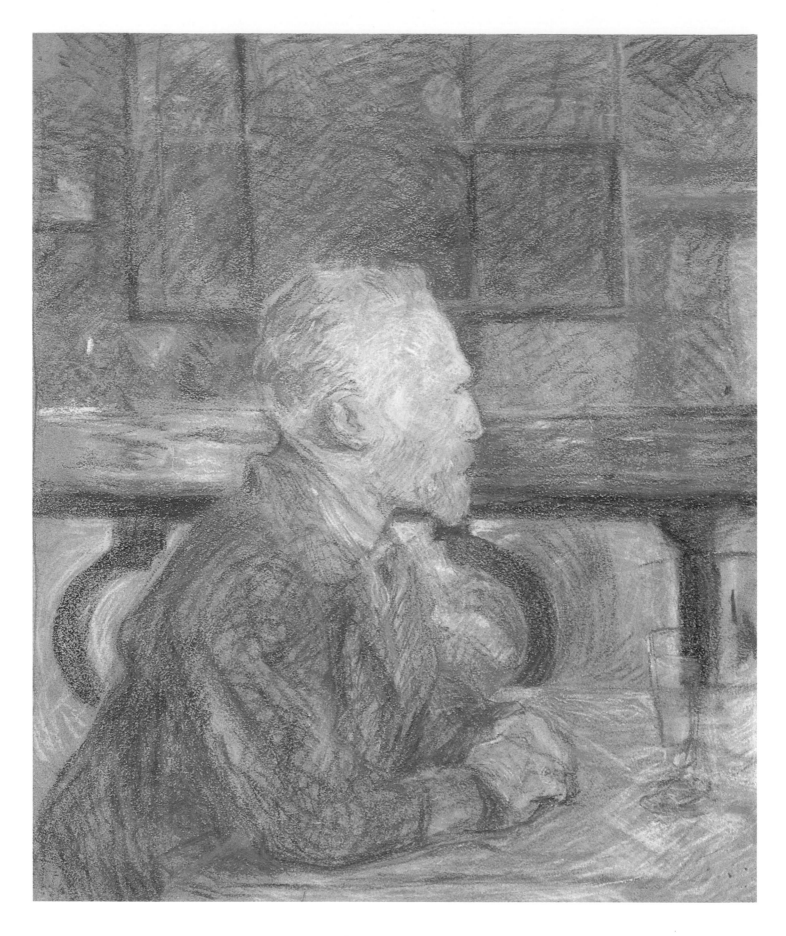

Vincent van Gogh, 1887
Pastel on cardboard, 54 x 45 cm
Dortu P 278
Amsterdam, Rijksmuseum Vincent van Gogh,
Vincent van Gogh Foundation

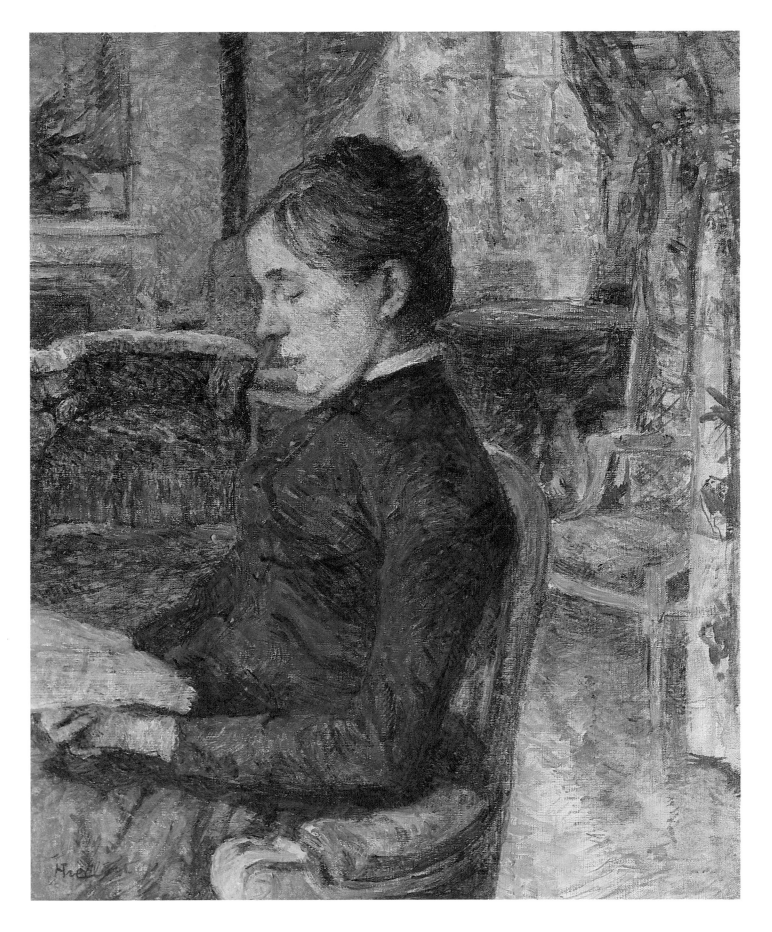

**Countess Adèle de Toulouse-Lautrec in the Salon
of Malromé Château,** 1887
*La comtesse Adèle de Toulouse-Lautrec
dans le salon du château Malromé*
Oil on canvas, 54 x 45 cm
Dortu P 277. Albi, Musée Toulouse-Lautrec

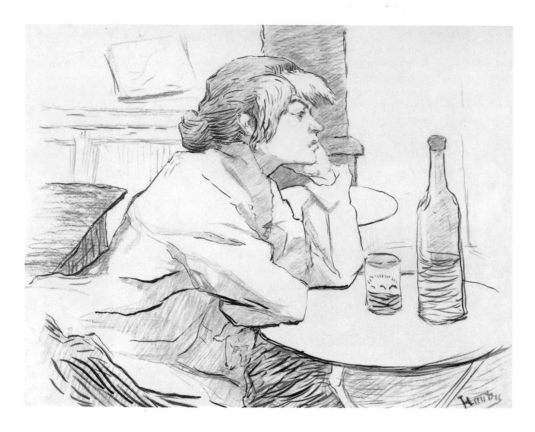

Hangover: The Drinker (Suzanne Valadon),
c. 1887/88
Gueule de bois: La buveuse
Black ink, pen, brush and chalk on paper,
49.3 x 63.2 cm. Dortu D 3092
Albi, Musée Toulouse-Lautrec

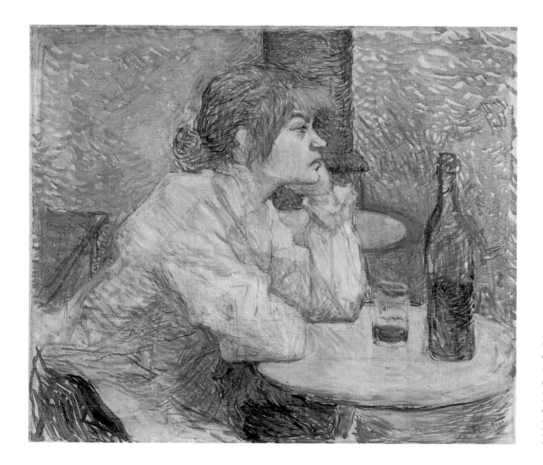

Hangover: The Drinker (Suzanne Valadon),
c. 1887/88
Gueule de bois: La buveuse
Oil and chalk on canvas, 47.1 x 55.5 cm
Dortu P 340
Cambridge (MA), The Fogg Art Museum,
Harvard University, Bequest of Collection of
Maurice Wertheim Class of 1906

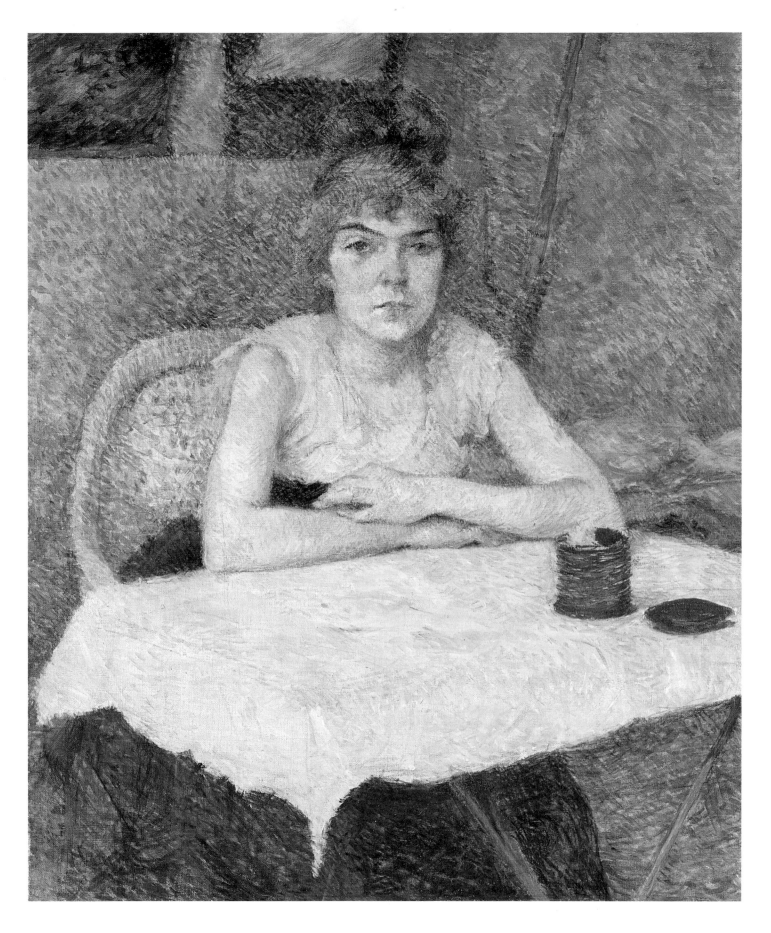

Rice Powder (Suzanne Valadon?), *c. 1887/88*
Poudre de riz (Suzanne Valadon?)
Oil on canvas, 56 x 46 cm
Dortu P 348
Amsterdam, Rijksmuseum Vincent van Gogh,
Vincent van Gogh Foundation

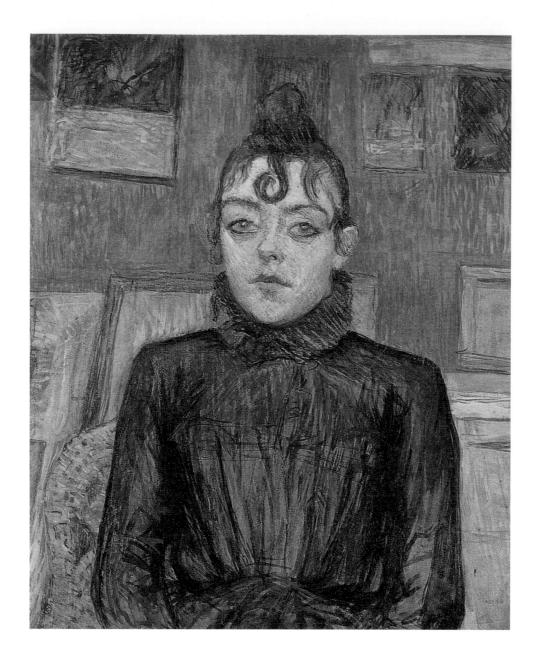

Girl with Lovelock, 1889
Fille l'accroche-cœur
Oil on cardboard, 68 x 55 cm
Dortu P 336. Private collection

The truth is that Lautrec is so preoccupied with working on his new style at this point that he is not much troubled by the rare opportunity to exhibit his work. He has achieved perfect success in integrating in his own painting the lessons learnt from Impressionism, and in his own way he does paint as an Impressionist for a time. This may be observed in the portrait of his fellow artist van Gogh, executed in pastel, which represents his new style, and the type of psychological study characteristically found in his painting.

The two very different painters probably got to know each other in February 1886, at the time when van Gogh had left Holland and Antwerp in order to settle with his brother Theo in Paris; he became a student with Cormon, whose studio was becoming a veritable meeting point for talented young artists. Both young men were known to be outsiders, and seemed destined to get on well with one another. Lautrec introduced van Gogh to his friends from the studio, Charles Laval (1862–1894), Eugène Boch (1855–1941), Gauzi, Anquetin and Emile Bernard (1868–1941).

**Red-haired Girl in Monsieur Forest's Garden
(Carmen Gaudin)**, 1889
Femme rousse assise au jardin de M. Forest
Oil on canvas, 64.6 x 53.7 cm
Dortu P 343. Private collection

The model has frequently been incorrectly
identified as Rosa. She is in fact Carmen
Gaudin, who regularly modelled for Lautrec
from 1885 to 1889 (cf. pp. 25 and 33). She is
sitting in a garden or small park-like area
below Montmartre's cemetery, at the corner
where the Rue Forest (to which Monsieur
Forest doubtless owed his name) and Rue
Caulaincourt meet on the Boulevard Clichy.
The owner of this half-wild, half-cultivated
garden was Père Forest, an enthusiastic archer.
Three times a week the neighbourhood's ar-
chers met here to enjoy their sporting hobby.
The garden, which was screened from city
noise and infrequently visited, was open to
the public. Thus Lautrec, whose studio was
nearby, often came here to paint in the open
air (cf. p. 61).

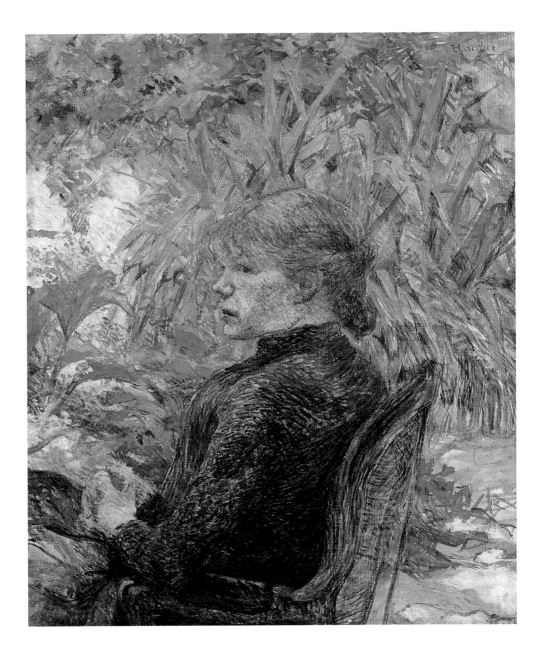

Cormon's studio was a fervid melting-pot which generated some of
the most important post-Impressionist developments, notably what
came to be known later as the cloisonné style. The term is drawn from
enamel work, and describes the laying of small fillets of metal to form
compartments in which the coloured pieces of enamel remain separ-
ated from one another, like stained glass set in metal. The young artists
imitated this technique, as did Gauguin, who was not one of Cormon's
students but was shown the technique by Bernard. They achieved the
effect they wanted by painting coloured areas separated from one an-
other by dark contour lines. These works are reminiscent also of
Japanese woodcuts with their stylised form and marked contours, and
the resulting schematisation and simplification give an added intensity
of expression. The total absence of shadow, the diagonal composition,
the astonishing effect of trimmed photograph or film clip, and certain
decorative elements – all characteristic of Lautrec's figurative universe
in his later years – can be traced back to this early cloisonnism and
Japonisme.

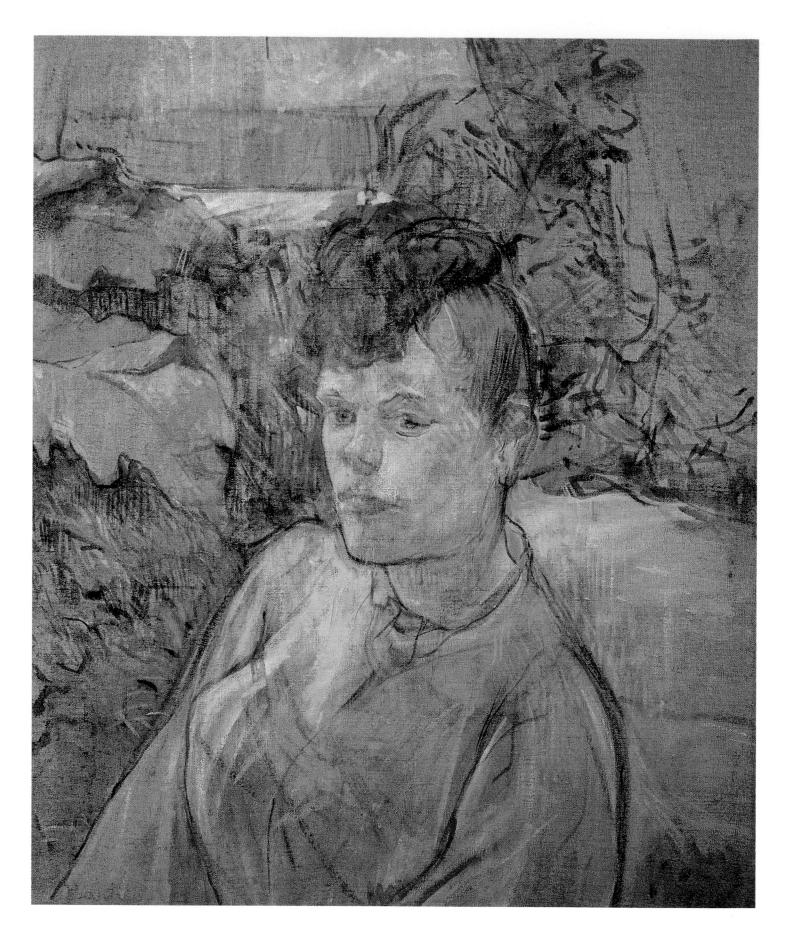

Woman in Monsieur Forest's Garden, 1889
Femme en buste dans le jardin de M. Forest
Oil on canvas, 55 x 46 cm
Dortu P 344
New York, The Metropolitan Museum of Art

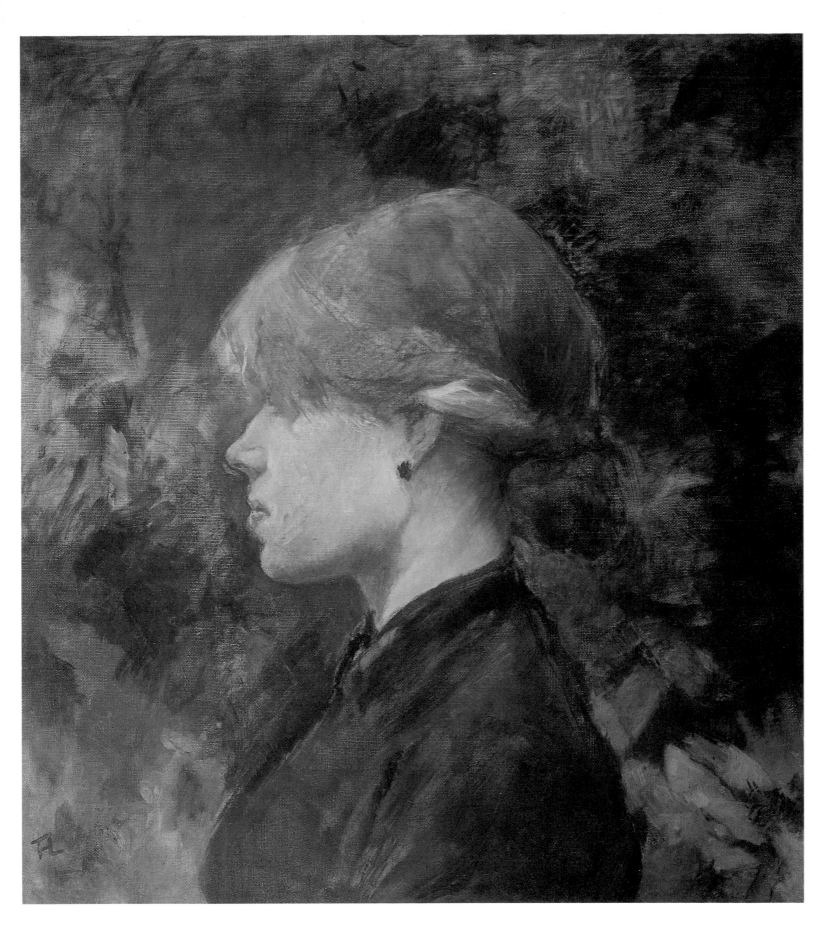

Young Woman with Red Hair, 1889
Jeune femme aux cheveux roux (La rousse)
Oil on canvas, 55.5 x 50 cm
Dortu P 353
Zurich, E. G. Bührle Trust Collection

Monsieur Henri Fourcade (study), 1889
Charcoal on paper, 39 x 28 cm
Dortu D 3094
Albi, Musée Toulouse-Lautrec

It is striking that Lautrec chose to portray the banker Henri Fourcade at a Paris ball of all places (p. 47), where it is not immediately obvious what the subject's position in public life was. For Lautrec, to paint the banker behind his desk would have meant to show only what was already known about the man: namely that he was a banker. By contrast, the man portrayed at the Opera ball, who is standing significantly forward from the other people in the picture, stimulates the attention, interest and imagination of the viewer.
The two figures in the background, a seamstress and the man with top hat, whom one can recognise as Lautrec's cousin, Gabriel Tapié de Céleyran (cf. p. 93), from his characteristic features, hardly distract from the vivid features of the banker. In the absence of detailed presentation of clothes or hands, concentration is focused on the marked characterisation of the facial expression. The unstable stance of the banker makes the picture seem like a spontaneous record of the moment, and the subject is given a lively presence.

"Lautrec thought of the Japanese as brothers just his size," writes Gauzi in a kindly note. Alongside them his stature would have seemed normal. All his life he dreamt of going to the land of the geishas and the bonsai. He had miraculous visions of it, derived from the woodcuts of Katsushika Hokusai (1760–1849), but he never found anyone to accompany him, so the journey was never made.

Lautrec is in his Impressionist phase when, at the age of 23, he portrays his 34-year-old friend Vincent (p. 38), using pastels and hatching. But in contrast to the Impressionists, Lautrec shows himself a master in his grasp of the psychology of his subject. The power and the passion of van Gogh are inscribed in the figure as he sits, like a beast of prey, ready to jump. In painting his friend in profile Lautrec not only proffers an unknown side of the artist (for most of the portraits and self-portraits of van Gogh show a full-face view), he also allows a glimpse into the depths of this "phenomenon" and his psyche.

While van Gogh is painting a pair of well-worn shoes from the flea market (Amsterdam, Rijksmuseum Vincent van Gogh) – the last painting in sombre colours, before he turns to a bright palette – Lautrec is putting the finishing touches to his picture *Rice Powder* (p. 41). This painting of a woman with her make-up, finished in 1888, was purchased by Theo van Gogh (1857–1891) for his private collection.

The portrait *Countess Adèle de Toulouse-Lautrec in the Salon of Malromé Château* (p. 39) was executed in the same year, also in the Impressionist manner, under the influence of Monet and Camille Pissarro (1830–1903); but it is already apparent that Lautrec is no blind follower of Impressionism. The composition still shows the fine interplay of line and curve, but much more to the point is the way in which the silhouette of the Countess stands out against the background and dominates it, instead of merging with it in uniformity of light effect, in the manner favoured by the Impressionists. The figure of the Countess is in the foreground in a psychological sense as well, and it is her expression, her human presence that is actually portrayed here.

The influence of van Gogh on Lautrec's developing style as a painter during this epoch, and in the years that followed, was greater than has commonly been acknowledged. It is evident in numerous pictures, above all in the 1889 portrait of *Justine Dieuhl in the Garden of "Père" Forest* (p. 60). Characteristic of Lautrec's manner of painting at this time are the long, broad brush strokes with paint scarcely thinned at all, influenced to a certain degree by van Gogh canvases such as *The Italian Woman* (Paris, Musée d'Orsay) or *Portrait of Père Tanguy* (Paris, Musée Rodin), both painted in 1887. There were mutual correspondences and influences between these two great painters. It is equally clear that van Gogh's *Marguerite Gachet at the Piano* (Basle, Kunstmuseum) was in turn influenced by Lautrec's *Mademoiselle Marie Dihau at the Piano* (p. 65). Van Gogh greatly respected Lautrec's work, and he even persuaded his brother to buy some of his paintings, but the two artists were too dissimilar in temperament and motivation to remain close companions.

Monsieur Henri Fourcade at the Opera Ball, 1889
Monsieur Henri Fourcade au bal de l'Opéra
Oil on cardboard, 77 x 62 cm. Dortu P 331
São Paulo, Museu de Arte de São Paulo Assis Chateaubriand

Ball in the Moulin de la Galette.

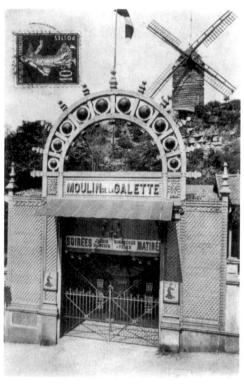

The Moulin de la Galette was a large barn on the hill of Montmartre, on the Rue Lépic, surrounded by a green wooden fence. It comprised two windmills, one of which served as a dance hall, while the other ground lily bulbs for a perfume factory. The dance hall was redeveloped by the miller family Debray, who fitted a podium for the orchestra. They also baked the famous cookies that gave the venue its name (galette = flat, round pastry cake). From 3 p.m. to midnight every Sunday, the families of Montmartre, the workers, students and artists, met to dance either here or in the adjacent garden, which was lit by lanterns in the evenings. The entrance fee was 25 centimes and the men were charged an extra 20 centimes for every dance.

Lautrec marked out his territory much as an animal might. New motifs match his new style: models from Montmartre, scenes from cabaret or circus, intimate scenes, a variety of portraits. His version of Impressionism becomes more distinctive. He schematises the landscapes that serve as background for his figures. Landscape has the same function as the ambience of a Salon. "Nothing out there exists," he explained one day to Joyant. "Landscape is nothing and never should be anything but an extra, an accessory. Landscape should only be used to make a person's character more visible." This formula is indicative of Lautrec's whole approach.

The liberating step forward is achieved with the first undisputed masterpiece: *Bareback Rider at the Cirque Fernando* of c. 1887/88 (p. 37). Circus motifs appear frequently in paintings of the time. In 1879 Degas had chosen this subject for his *Miss Lala in the Cirque Fernando* (London, National Gallery). Georges Seurat (1859–1891) and Pierre Bonnard (1867–1947) take up the theme a little later. Lautrec's painting is his first attempt to include several people at once in a composition. It is innovatory in its choice of colours as in its organisation of space, with a diagonal line dividing the scene into two halves. The centre of the picture remains empty, which goes against the conventional practice of putting the most important motif in the middle. There are several motifs, and they are all accorded equal importance. The galloping horse seems to take off from the surface of the picture with its strong sense of physical power and movement. A counterbalance is provided by the lightness of the bareback rider, and this impression of lightness is strengthened by the pleated tulle of her costume that flies out behind her like butterfly wings. Asymmetrically placed at the opposite side of the picture is Monsieur Loyal, cracking his whip. His posture and mass provide an echo to the dynamics of gesture and movement. Then there is the clown with splayed limbs on the far left, emphasising the apparent arbitrariness of the composition, and the members of the public sitting outside the ring, some with their heads cut off by the upper edge of the picture. This compositional ploy

is borrowed directly from the Japanese; it had already fascinated Degas. Everything is exaggerated, from the foreshortened lines of the horse to the twisted silhouette of the clown, and yet it all works like a well-oiled machine. As a composition it is equally remote from the Academy and from the Impressionists. It is a kind of manifesto that declares Lautrec's mastery of his art as well as his strong personality; at about this time he finally leaves Cormon's studio.

Lautrec had learnt technique from Bonnat and Cormon. His style had been enriched by the Impressionists and the Japanese. From painters such as Manet, van Gogh and Degas he had borrowed a theme, or a brilliant effect. From now on he can be himself. "He wears my clothes, cut down to fit his size," says the sharp-tongued Degas maliciously, and without just cause. Cézanne, questioned on the subject of Degas, answers in his unruffled way: "I prefer Lautrec."

Of all his contemporaries, Degas undoubtedly has the greatest influence on Lautrec; both were interested in the same motifs, and sub-

Ball at the Moulin de la Galette, 1889
Bal du Moulin de la Galette
Oil on canvas, 88.5 x 101.3 cm
Dortu P 335
Chicago (IL), The Art Institute of Chicago

Lautrec often visited the Moulin de la Galette and painted a number of pictures there. The venue was popular both with the poorer sections of Montmartre and with the artists and bohemians. Markedly erotic and therefore offensive to respectable society were the evening dances, which brought out the police – visible in the right-hand background of the picture. In the right foreground is the picture's original owner, the landscape painter and friend of Lautrec, Joseph Albert (c. 1865–1928).

The Actor Henry Samary of the Comédie-
Française, 1889
Monsieur Henry Samary de la Comédie-
Française
Oil on cardboard, 75 x 52 cm
Dortu P 330. Paris, Musée d'Orsay

Henry Samary (1864–1902) was a young actor
from the Comédie-Française, where his fa-
mous sister, Jeanne Samary, also appeared; she
was painted several times by Renoir. The
lightly caricatured Samary was playing the
role of Raoul de Vaubert in the comedy
"Mademoiselle de la Seiglière" by Jules San-
deau (1811–1883) at the time the portrait was
painted. The young actor enjoyed great suc-
cess in this role. The costume and the affected
pose on stage, as well as the slightly ironic
overdrawing, are in themselves a comment on
the profession of the actor.

ject to the same influences. It is possible that Degas' condescending attitude towards Lautrec, whom he actually admires, should be at- tributed to rivalry, manifesting itself in a certain aggressiveness of the older man towards the younger. There could be a trace of rivalry, for instance, in Lautrec's picture *After the Meal* (p. 66), which recalls Degas' *Absinthe* (Paris, Musée d'Orsay). In Degas' picture the com- positional element – clearly showing Japanese influence – is more important than the content. Lautrec, by contrast, is not content to show a couple sitting at a tavern table, rather he reveals to us their characters and the situation in which they find themselves, which he has grasped in its entirety. The man, Lautrec's friend Maurice Guibert (1856–1913), is slumped on his chair, a hopeless drinker inert after a drinking about, while his companion, a quarrelsome person with red hair, has turned her back on him and is giving vent to her bad temper. It is noteworthy that this Megaera may well be modelled on Suzanne Valadon (1867–1938), mother of Maurice Utrillo (1883–1955), herself a talented painter. She was soon to play an important role in Lautrec's emotional life. The radical transformation of the palette is also remark- able, the predominance of aggressive shades of red, of darkly meaning- ful colours, and of forceful brush movements which roughly outline the figures, giving eloquent expression to their abasement and decay. "With Lautrec," notes Matthias Arnold, "content demands matching form. The only real comparison in the history of French art, which is focused almost entirely on harmony and decorative decorum, is with some of the caricatures and paintings of Honoré Daumier. After Lau- trec – and to a certain extent under his influence – only the young Picasso and Käthe Kollwitz achieved such powerful statements of so- cial criticism."

A second important composition, the *Ball at the Moulin de la Ga- lette* of 1889 (p. 49), marks a further development in Lautrec's work. The organisation of space is much tighter, and the element of caricature has vanished. The contrast between the compositional planes is less startling: the dancers form the background, and attention is focused on the main figures in the foreground, three women and a man with bowler-hat. They are sitting, or leaning, on a bench, the back of which forms a diagonal line at an angle to the diagonal lines of the floor- boards, and this sleight of composition gives the picture spatial depth and a dynamic feeling. Tension is created by opposites, by the op- position of vertical and horizontal lines determining both foreground and background, and also by the contrast between the profile view of the main characters and the silhouettes of the dancers. The picture displays a distinctive manner of composition which Lautrec mastered in his youth, and which he will use again, setting clear-contoured figures in the forefront, who thus stand out against the crowd sug- gested rather than depicted in the background. This is also one of the first pictures in which Lautrec employs another original technique, applying a thin layer of fairly liquid paint with large brush strokes. He takes this so far that at some points the canvas shows through, creating

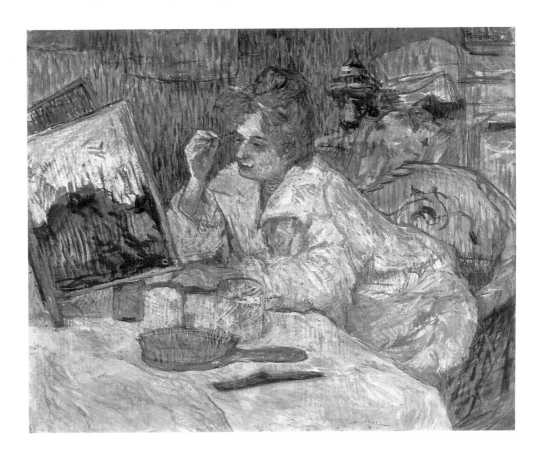

Woman at her Toilette, 1889
Femme à sa toilette
Oil on cardboard, 45 x 54 cm
Dortu P 347
Switzerland, private collection

**Woman in Evening Dress at the Door of a Theatre
Box,** c. 1889/90
*Femme en toilette de bal à l'entrée d'une loge
de théâtre*
Oil on canvas, 81 x 51.5 cm
Dortu P 523
Albi, Musée Toulouse-Lautrec

Even though the whole figure of a woman
dominates the picture, Lautrec resists painting
her face. He characterises the woman solely by
her stance, dress and hair style. The view from
the box is indicated by a mirror on the left side
of the picture. The woman is on the point of
leaving the box, and is leaving behind a man in
dark evening dress, who is only schematically
recognisable in the mirror. He is facing the
viewer, but remains featureless. Lautrec has
here succeeded in catching the unique atmos-
phere of theatres and their corridors, where
people meet in passing and disappear into hid-
den séparées, or meet for fleeting moments
only to disappear into the crowd again.

a sense of transparency which reinforces the impression of brightness,
luminosity and space.

All his life Lautrec was interested most of all in portraits. One of his
very first works was a portrait of his father on horseback, and one of
his last a significant portrait of his friend Paul Viaud as admiral (p. 185).
Throughout his development as a painter he never forgot what for him
was the first encounter with the ideal, the drawing by Jean-Louis Fo-
rain (1852–1931) of his father, Count Alphonse. This drawing was a
"miracle", a source of wonder that the years could not dim. What he
admired most about it was that one could tell from the bearing of the
figure, hardly more than a silhouette, who it was, and the similarity
was not restricted to the face: the figure was alive.

Portraiture presented him with the following aesthetic challenge:
how was it possible to reconcile the clear line of the draughtsman with
the painter's new concern to dissolve line in such a way that the draw-
ing can be forgotten? Lautrec has recourse to his gift for caricature and
tries to find a solution by concentrating entirely on expression. Com-
paring photographs of his models with his sketches of them, one is
astonished by his almost Expressionist exaggeration. His real aim is to
extend the frontiers of painting into life itself, to bear witness to an
insuppressible vitality by means of vibrating nuances of colour and
the nervous energy of the brush. "Life! Oh, life!"

This is the starting-point of all the characteristic full-figure portraits
that follow, the portraits of Henry Samary (p. 51), Louis Pascal (p. 73),
Céleyran (p. 89), Joyant (p. 186), Gauzi, the Dihaus, and others – in-
cluding his female acquaintances. His friends knew that when he was

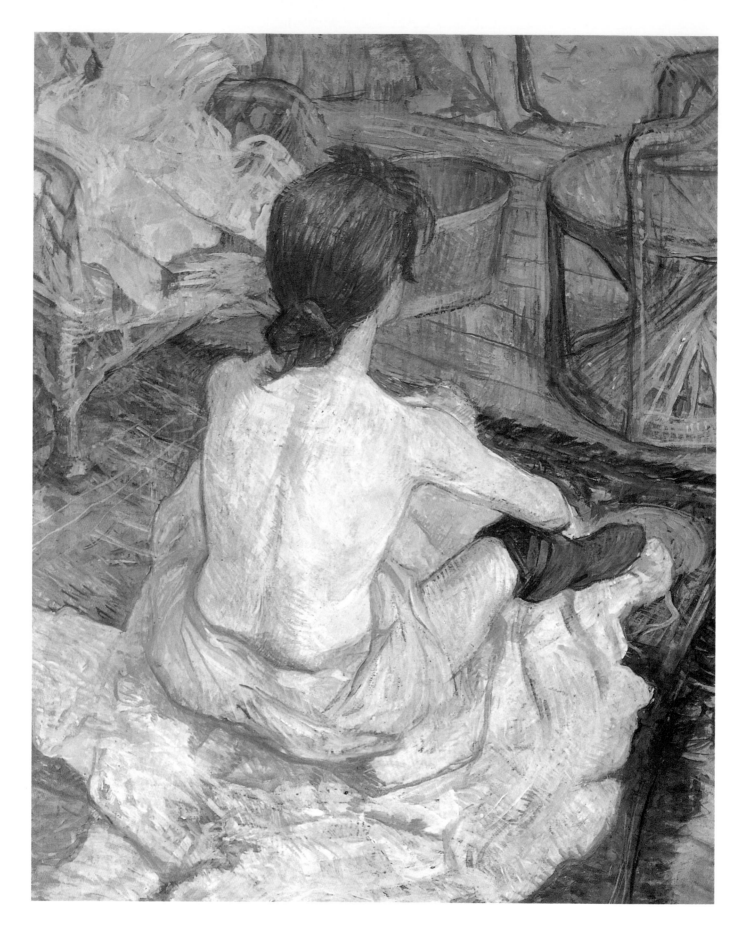

The Toilette, 1889
La toilette (La rousse)
Oil on cardboard, 67 x 54 cm
Dortu P 610
Paris, Musée d'Orsay

looking for models he was only interested in ones that he could make into "honest whores". He always tries to capture the silhouette, the distinctive bearing, the naturalness of the model rather than the conventional pose. Two paintings deserve especial attention because they illustrate to perfection Lautrec's notion of the portrait, based on his admiration of Forain's drawing of his father: they are *The Day of First Communion* (p. 34 left) and *The Omnibus Company Trace-Horse* (p. 34 right). Both pictures belong to a series of four illustrations undertaken for the article "Summer in Paris" by Emile Michelet which was to appear in the magazine *Paris illustré* on 7 July 1888. The technique is reminiscent of lithograph colouring and shading, and the restricted range of thinned, quickly applied colours is accounted for by the fact that the pictures were painted for black-and-white magazine reproduction. On the platform at the back of the omnibus, Lautrec's own silhouette is clearly recognisable, with his tall hat and chequered trousers. The man pushing the pram on the occasion of the first communion is the faithful Gauzi, who as model had to rest his hands on the back of a chair since no pram was at hand. Even in his artisans's Sunday best, with trousers too short and feet too large, there is no mistaking Gauzi.

Until Lautrec cuts the umbilical cord he lives dutifully with his mother and returns every evening to the Faubourg Saint-Honoré. His first successes permit him to break free, with the consent of the family, who give him an allowance. At first he lodges with friends, the Greniers, who live at no. 19, Rue Fontaine. The three young people stay together for two years. René Grenier, a fellow-student of Cormon, is a few years older than Lautrec. He comes from a very wealthy family and has an annual income of more than ten thousand gold francs. He had served as a non-commissioned cavalry officer, and decided on art as a pastime when he was discharged. He enjoys the bohemian life amongst his artist friends, he has a sunny disposition, and above all he is not jealous.

Grenier's wife Lily is a shapely young woman, very much to the taste of her time, as she is well aware. She often misbehaves, and does stupid things which amuse her husband, but he is too well-brought-up to let her see it. With her flaming red hair, sharp little fang-like teeth, milk-white complexion and tiny freckles, Lily was very attractive, and she gathered a host of admirers round her who were ever-hopeful, thanks to her flattering words. Lautrec hoped for nothing; he knew that dwarves were not to Lily's taste. He made do with being an amusing friend. Lily loved dressing up, and he too delighted in travesty.

"The Greniers were very hospitable. After meals people had a good time dressing up, often masquerading in groups, and there was a special charm in being photographed in this guise. Lautrec dressed up as an Apache, a Japanese, a choir boy, or a Spanish dancer fanning herself. Lily liked having her photograph taken, but she could never spare the time to sit for Lautrec to paint her portrait, which he would dearly have liked. The fact was, she didn't trust the Impressionist painter's

Lautrec c. 1890–1895. Photo: Paul Sescau.

PAGE 56/57:
Lautrec in his studio at 7 Rue Tourlaque, during work on *Ball at the Moulin Rouge*, 1890 (cf. p. 59). Left next to the easel stands the painting *Woman in Evening Dress at the Door of a Theatre Box* (p. 52). Photo: Maurice Joyant.

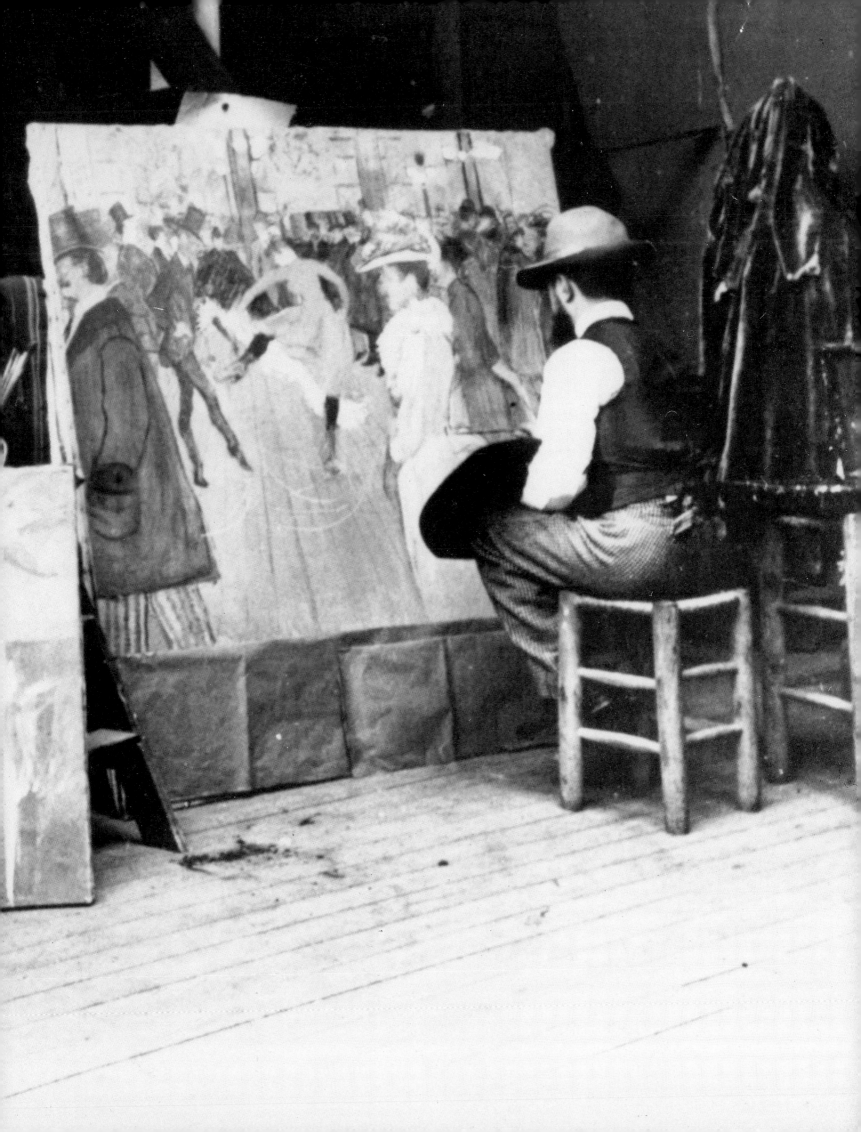

Star dancer at the Moulin Rouge: Etoile Filante.

cruel brush; she was afraid of having to see her complexion fading on the canvas, furrowed with yellow, green or purple lines…"

This description by Gauzi is of two-fold importance: it shows the atmosphere in which Lautrec's new life was unfolding, and, through the figure of Lily, it marks the beginning of a new phase of intimacy with a previously unknown kind of creature. Lily, who could have been a Rubens model, had already taken off her clothes and washed herself in the bath for Degas. Since running away from her little village at the age of 16, she had on several occasions offered her splendid body as artist's model. Her relationship with Lautrec is a special one. This big girl, who loves life and is generous with her body, is simple, but also proud and domineering; yet towards Lautrec she shows an almost maternal tenderness. Of course Lautrec is in love with her, as everybody else is, but what draws him to her particularly is the warmth that goes with her femininity. He likes it when she takes his hand like a child's, to cross the street with him. She proves to be his best and most perceptive woman friend, and even manages to console him in moments of dejection. When they go out together, Lautrec is proud to be seen at her side: there is a part of her that belongs to him, perhaps the best part. Although she may not have sat for him, there are three portraits of her: one shows her in a Japanese kimono (p. 35), another is a three-quarter view, and one portrays her from the front, with her face turning slightly to the right. The portraits revere her, and honour her. One senses that Lautrec was devoted to her at this time.

There are very different types of woman in Lautrec's female gallery, with whom he had more or less lasting relationships. They tend to remain anonymous, known only by their first name, or by their portraits, which are rich in psychological, humorous human perceptions.

The Moulin Rouge in Place Blanche, c. 1890.

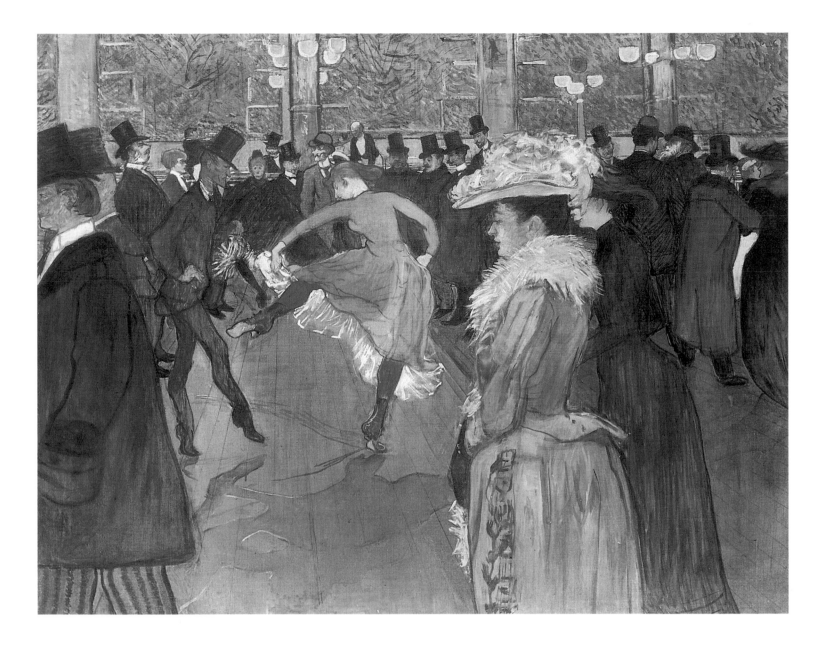

Hélène Vary and Marie Charlet are important in this series – to which Augusta, Gabrielle, daughter of the city policeman, dumb Berthe, Justine Dieuhl, Honorine P., the ladylike woman with the glove, also successively belong. Most of them are red-heads, for Lautrec had a passion for red hair. Between 1888 and 1891 he painted them all obsessively.

Then there is Carmen Gaudin, for a time Lautrec's favourite model. She is a simple working girl, meek and gentle, but also red-haired. The faithful Gauzi tells us more about her. They are on their way to dine at Boivin's when they encounter a young girl, dressed in working clothes, but with copper-coloured hair that makes Lautrec stop in his tracks and call out enthusiastically: "She's marvellous! What an equine face! It would be fantastic to have her as a model. You must ask her." "Nothing simpler," replies his friend, and runs after the young girl, followed by Lautrec who runs as fast as his short legs will let him. When the girl hears the painter's polite enquiry she hesitates: she has never posed as model. But in the end she agrees. Lautrec thought of her as an "honest whore". To his great surprise, and perhaps disap-

Ball at the Moulin Rouge, 1889/90
Moulin Rouge (Dressage des nouvelles par Valentin le Désossé)
Oil on canvas, 115 x 150cm. Dortu P 361
Philadelphia, Philadelphia Museum of Art

The Moulin Rouge dance hall was opened by Charles Zidler on 5 October 1889, at 90 Boulevard de Clichy, and was the meeting place of Paris society, artists and demi-monde. The red windmill at the entrance, installed by the designer Adolphe Willette, was a mock-up; its back consisted of various booths and a wooden elephant that could be turned into a stage. The venue was lit up as bright as day and decorated with mirrors, galleries and gas-lights. In the middle was a large dance floor surrounded by a promenade, tables, and a garden. Lautrec had a table reserved for him from the very first day, and his sketches and paintings constituted the house chronicle. They made a significant contribution to the fame of the Moulin Rouge and were exhibited from time to time in a small gallery in the foyer.

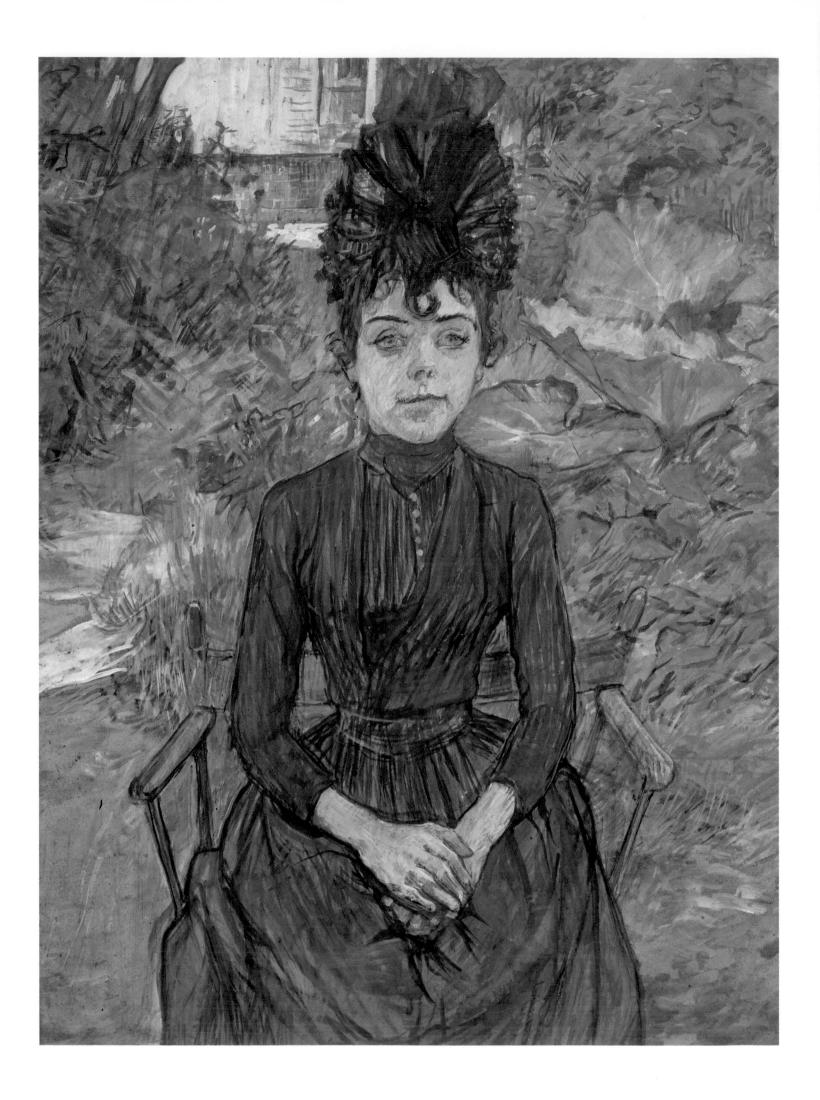

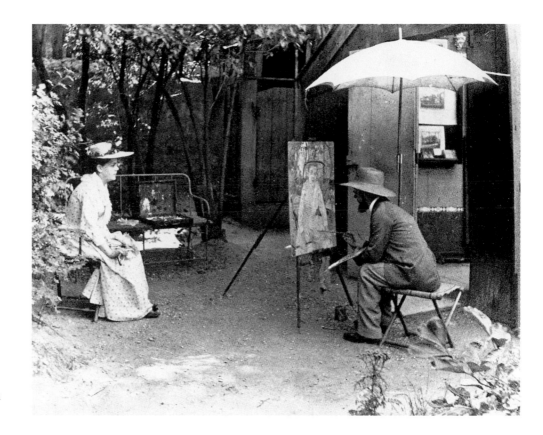

Lautrec in Père Forest's garden, at work on a portrait of Berthe la Sourde, *c.* 1890. The portrait of Justine Dieuhl (p.60) was also painted in the open air. "Only the figure exists for me," said Lautrec, "the landscape is merely an accessory."

Justine Dieuhl in the Garden of "Père" Forest, 1889
Justine Dieuhl au jardin du "Père" Forest
Oil on cardboard, 74 x 58 cm. Dortu P 394
Paris, Musée d'Orsay

The painting was originally owned by the Japanese Prince Matsukata, and was only returned to the French in 1959 in the wake of the Peace Treaty between France and Japan.

pointment, she turns out to be meek and not very strong. Sometimes she arrives at the studio covered in bruises; her official lover beats her black and blue. For all her shyness she gradually becomes part of Lautrec's universe, and he makes her into his *Laundress* (p.33), a subject he "borrowed" from Degas.

In order to perfect his technique and develop his style still further, Lautrec sets himself the task of painting several practice pictures each week. He calls them his "quota". *The Laundress* is probably one such task, and by no means a bad one. The difference between this and Degas' pictures of laundresses is clear. Whereas Degas is interested above all in complicated contrasting effects of light and dark, and in the women's angular movements with the flat-iron or the heavy laundry baskets, Lautrec shows us a woman pausing for a moment in her work, whose body imprints on our awareness the physical exhaustion that has long dwelt in her, as has her melancholy. It is not necessary for him to paint her features in any detail, but what wild beauty there is in her colourful hair. What a gift red hair is, at least in Lautrec's eyes! "To be honest," adds Gauzi for the record, "Carmen's hair was dyed copper-red, but Lautrec had nothing against artifice."

Some time later Gauzi needed a model himself, and he asked Lautrec: "Is she still posing for you?" "No, she came to see me after a gap of six months, to ask whether I needed her again. But now she's got brown hair! You'll understand that I've lost all interest in her."

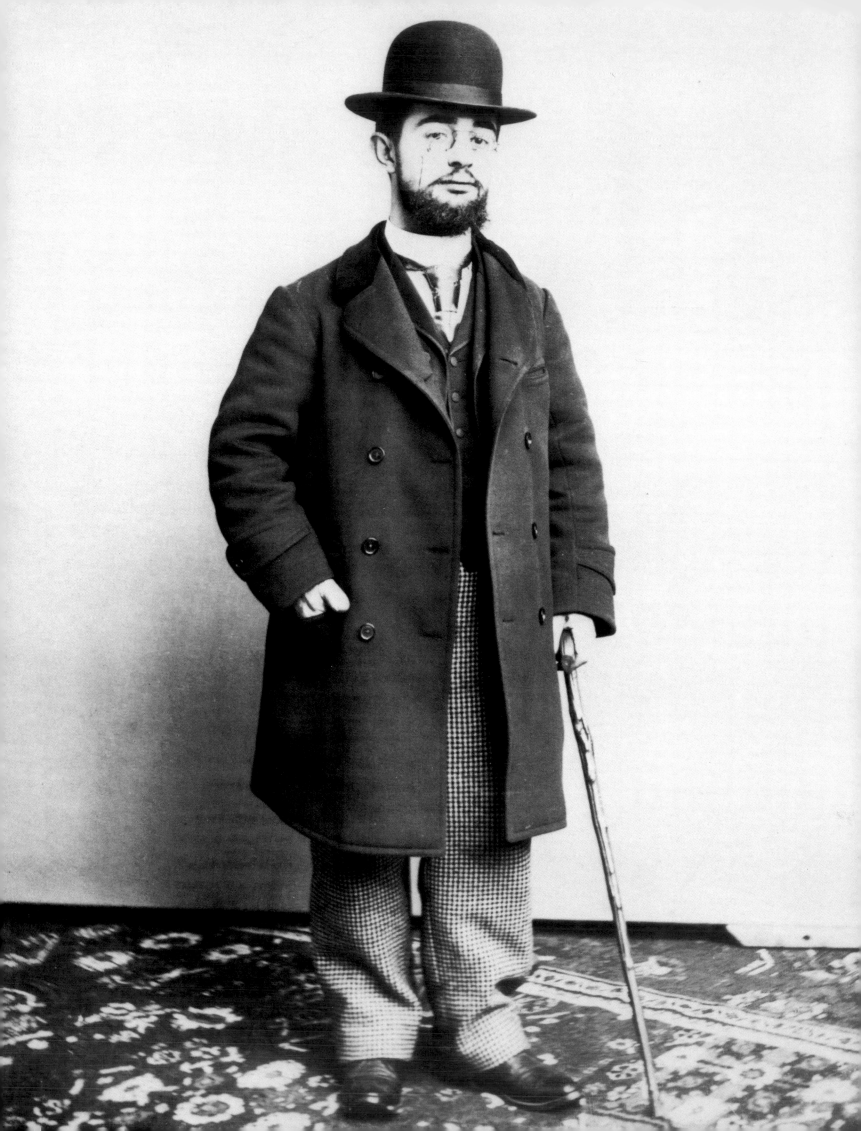

The Artist Conducts the Orchestra 1891–1898

In the time of Louis XIV poets were already singing the praises of the hill of Montmartre, on which thirty windmills showed which way the wind was blowing. The Italian poet Torquato Tasso (1544–1595) visited Paris in the retinue of Cardinal Luigi d'Este, and remembered the windmills "that turned as swiftly as the Parisians' heads". There were vineyards there too, which belonged to the Benedictines, but the wine was sour and did not keep well so that it was only served locally in garden taverns frequented by the city's drinkers, who went there to get drunk on the cheap, making out that they were there for the good fresh country air. Montmartre was above all the place for the populace, including rogues and villains, and gentlemen lodged their mistresses in its pleasant little houses.

Dancing became more and more popular in the taverns, some of which became public dance halls; the most famous was the Elysée Montmartre. The quadrille was danced to music by Jacques Offenbach (1819–1880), and then there was the wicked can-can, which in the 1890s was Montmartre's chief attraction. The pleasures of the people took on a new look, with a new kind of prostitution to match, which Baudelaire describes in such terms that one thinks immediately of the later works of Lautrec:

"Splendidly attired women, who take fashion to such a pitch that they lose all grace and actually destroy their prime purpose, brush the ground with their train and with the lace fringe of their shawl; they come and go, sauntering backwards and forwards, and open their eyes wide in amazement as animals do; they give the impression of seeing nothing, but in fact they scrutinise everything very carefully. Bathed in infernal light, or against the background of northern lights in red, orange, sulphur yellow, pink (the colour of ecstasy for the libertine) and sometimes purple – against this magic Bengal fire of a background, the protean picture of depraved beauty is revealed: majestical or casual; slender, even skinny, or Cyclopian; tiny and effervescent, or heavy and monumental. This is beauty untamed by civilisation, the beauty of evil, all ties with spirituality severed, and yet marked at times by an exhaustion bordering on melancholy." (Baudelaire: *The Painter of Modern Life*, Chapter XII: *Women and Girls*)

Lautrec is one of those who created the new Montmartre – just as

Charles Laval:
Portrait of Henri de Toulouse-Lautrec, 1883
Oil on canvas, 46 x 38 cm
Albi, Musée Toulouse-Lautrec

Lautrec in the year 1892, at the age of 32, when most of the paintings and lithographs on the following pages were executed.

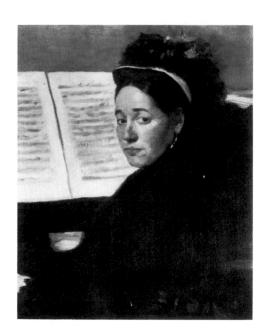

Edgar Degas:
Mademoiselle Marie Dihau at the Piano,
1869–1872
Mademoiselle Marie Dihau au piano
Oil on canvas, 45 x 32.5 cm
Paris, Musée d'Orsay

Twenty years before sitting for Lautrec, Marie Dihau had served as model for Degas, also at the piano.

Mademoiselle Marie Dihau at the Piano, 1890
Mademoiselle Marie Dihau au piano
Oil on cardboard, 68 x 48.5 cm
Dortu P 358. Albi, Musée Toulouse-Lautrec

Marie Dihau, a sister of Désiré (p. 67), was a successful singer at the Paris Opera in the 1870s. Later she gave piano and singing lessons. The portrait recalls Vincent van Gogh's *Marguerite Gachet at the Piano* (Basle, Kunstmuseum), painted in June 1890 in Auvers. Maybe van Gogh saw Lautrec's painting during his visit to Paris in May 1890. "Lautrec's picture, the portrait of a music-maker, is really remarkable. It deeply affected me," he later wrote to his brother Theo. Marie Dihau gave all the paintings that Lautrec painted of her and other members of her family to the city of Albi in exchange for a life pension.

Jean-Paul Sartre (1905–1980) half a century later was one of those who made Saint-German-des-Près into an artists' quarter. When Lautrec set up his studio on the corner of Rue Tourlaque and Rue Caulaincourt, this was the beginning of the end of the locality's rural character. Bars, cafés, music halls and cabarets sprang up, and became not only the centre of nocturnal pleasures but also the meeting-point of the bohemian world.

Lautrec's setting up of his studio in Montmartre can be seen as the moment of his true entry into society, and life. Since the fracture of his legs in early youth, there had been no such decisive experience – and this one was of his own choosing. It is as if he had decided from this moment on to make his life into one continuous dramatic spectacle. He threw himself into the world of dance and games of chance to the point of total exhaustion. It was his way, the artist's way, to call the tune.

At last he could lead his own life, and merrily watch it consume itself with the help of large measures of alcohol; he was a passionate participant in the pleasure-seeking night-life on the magic hill. His drinking companions were writers, painters, actors, dancers and prostitutes, always at his side on his feverish nocturnal rounds. He watched them like a lepidopterist, but he reached out towards them too, like Narcissus bending down to the water to catch his own reflection. While van Gogh was concerned more to excite pity, or to sublimate it, for Lautrec it was a matter of recognising his own identity. If he had not become a painter, he would have liked to be a physician or a surgeon, and there was indeed something in him of the surgeon operating upon himself, or of the physician observing the progress of his own incurable malady.

Just as the name Renoir is inseparable from the Moulin de la Galette, so the name Lautrec is inseparable from the Moulin Rouge. In his book on Montmartre Philippe Jullian points out the differences: "Fifteen years separate Renoir's masterpieces from Lautrec's. The district is the same, yet what a difference! The clientèle in the Moulin de la Galette and the clientèle in the Moulin Rouge represent pleasure and vice respectively. Around 1890 the great era of purchasable vice begins. Not only the brothels here at home must be provided for, but also those abroad, and the Parisian girl was very much in demand. The white slave trade began at this time, and the Moulin Rouge, ostensibly a dance hall, was market and stock exchange for girls."

In this entertainment world, rival establishments mushroomed and a hierarchy developed. In order to move upwards, an ambitious girl had to move from the Moulin de la Galette, where people had a good time, to the Moulin Rouge, where fame was won. But only in Elysée-Montmartre did anyone really learn to dance. The rivalry between the organisers of dance events and shows of all sorts was intense. When the popularity of his Elysée-Montmartre declined disturbingly following the opening of the Moulin Rouge, and his dancers departed one

After the Meal, 1891
A la Mie
Oil and gouache on cardboard, 53.5 x 68 cm
Dortu P 386
Boston (MA), Museum of Fine Arts

The painting, cynical and disillusioned, shows an aged couple with a hangover after a meal, perhaps based on a photograph by Paul Sescau, which shows Lautrec's friend and frequent companion, Maurice Guibert, at the side of a young Montmartre model (p.67). Guibert was an amateur painter and worked as a representative for the champagne company Moët et Chandon. He was in reality a kindly, jovial man, by no means as evil-tempered as is shown here. The painting is highly reminiscent of Edgar Degas' *Absinthe* of 1876 (Paris, Musée d'Orsay), and was exhibited at the Salon des Indépendants in March 1891.

after another, Déprez reacted quickly. He launched a counter-offensive, and in 1892 he opened the Casino de Paris.

Sitting with his wine glass, Lautrec observed animate life in the Moulin Rouge, Elysée-Montmartre and Folies Bergère. His pencil recorded the form of a body or a head, captured in flight a provocative woman's gesture, the rousing curve of a buttock, the mottled red face of a drunkard. All he perceived was profoundly human, to the point of brutality and animal reality. He observed and drew, drew rapidly and drank. A sketch, a glass… His gaze was neither cruel nor affectionate, it was impartial and relentless as the world itself. Nothing escaped his eye, no detail of the ritual dance and the erotic ceremony which the can-can had become. Lautrec was well-known everywhere in Montmartre, just like the local heroines: Grille d'Egoût, Môme Fromage, Rayon d'Or, Miss Rigoletto, Nini Pattes-en-l'Air (cf. p.76) and their partner Valentin the Contortionist, who was called "the Snake" because of his contortions, and in real life was an honest bar proprietor (p.100).

Monsieur Désiré Dihau, Bassoonist at the Opera,
1890
Monsieur Désiré Dihau, basson de l'Opéra
Oil on cardboard, 56.2 x 45 cm
Dortu P 379. Albi, Musée Toulouse-Lautrec

Lautrec was a good friend of the Dihau fam-
ily, who came from Lille, and often visited
them in their flat in the Rue Frochot, where
he also sometimes met Degas. Désiré, por-
trayed here, was a brother of Marie Dihau
(p.65), and was also portrayed by Degas in his
Orchestra at the Opera (*c.* 1870; Paris, Musée
d'Orsay).

The painter Maurice Guibert, a friend of Lau-
trec, with a model, 1891.
Photo: Paul Sescau.

In Montmartre Lautrec found his "promised land". Several times a
week he visited the Elysée-Montmartre or Moulin Rouge with his
friends Joyant, Guibert, Anquetin and Lucien Métivet, and never tired
of watching the skirts whirl to the intoxicating rhythms of the music,
with an occasional glimpse of naked skin. "Père la Pudeur" (Father
Prude), photographer by day and guardian of morals by night, upheld
the laws of decency. Should a young lady, having forgotten her
knickers, delightfully reveal too much as she threw her leg over her
head, she was ordered out of the ball-room and might only return fully
dressed. The Moulin Rouge was no brothel, but as soon as the watch-
ful guardian of public morals had disappeared the girls loosened their
ribbons to show more of their lace petticoats, drew down their black
net stockings and displayed their pretty garters, and whatever else
might have a price put on it. They tempted their prospective customers
with free samples of the enticing wares on offer. As they danced they
competed to see who could throw her leg highest, and everyone was
delighted when an outstretched toe knocked top-hat or bowler to the

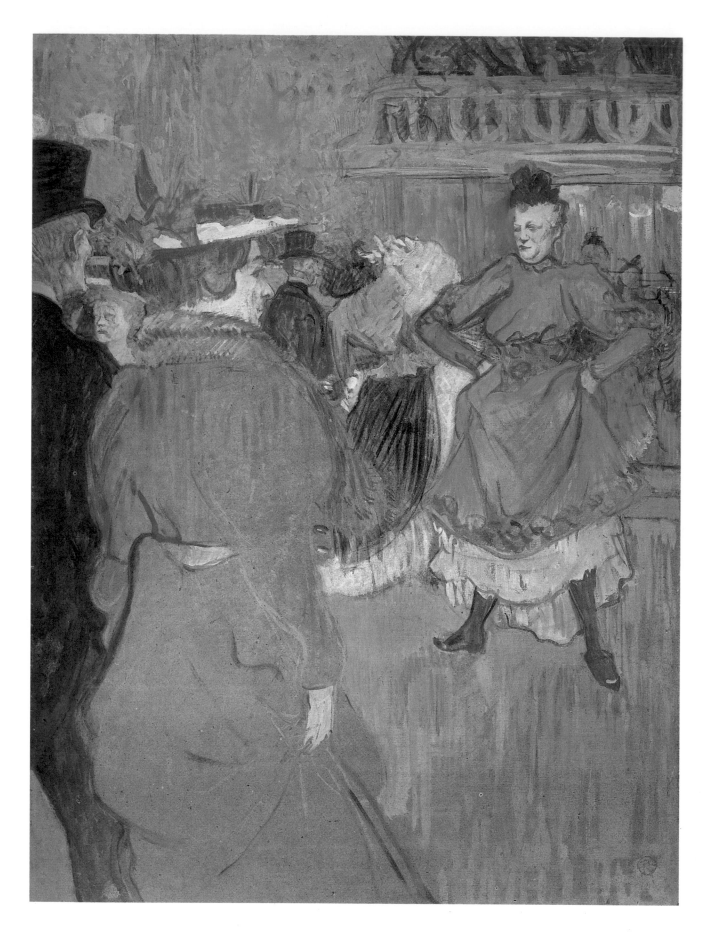

At the Moulin Rouge: Start of the Quadrille, 1892
Au Moulin Rouge: Le départ du quadrille
Oil and gouache on cardboard, 80 x 60.5 cm
Dortu P 424
Washington (DC), National Gallery of Art

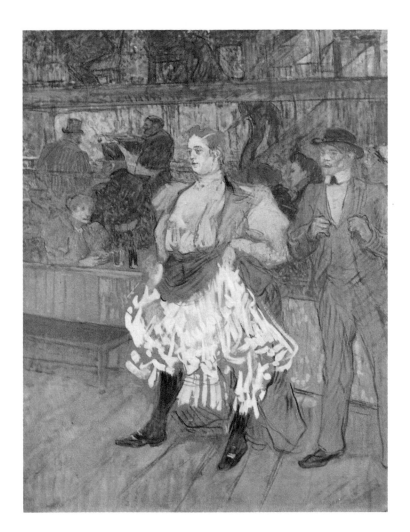

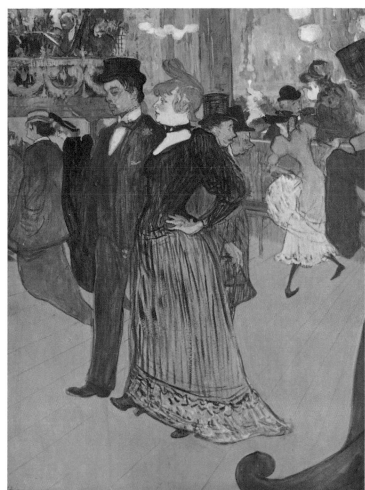

ground. Amidst peals of laughter the little mischief-maker turned round, elegantly flung her skirt over her head and stuck out her bottom by way of an apology.

As the hours passed, the Moulin Rouge became the place of bacchanal and revelry that its visitors, especially the foreigners, adored. An English reporter described it in this way: "Far into the night the scene is indescribable. Drink rouses the slumbering passions of the dancers, there is no need to restrain one's passions in this place. People play at hobby-horse, women are carried on men's shoulders right across the room, everyone cries out for drink. A man in torero costume with a woman on his shoulders rides past me… The woman has her arms around his neck, his coarse face is not dimmed by the slightest trace of sleeping intelligence. Then the floor is cleared for the final quadrille, the most extraordinary dance imaginable in this bizarre atmosphere. But the peculiarities of the quadrille result in an unforgettable spectacle: the ceremonious yet lascivious grace and ease of these women, the craving of the crowd packed round the dance floor, greedy for something unseemly, the keen excitement of everyone involved, that passes back and forth from one to another."

The illuminated Moulin Rouge shone out over the boulevard like an enormous brothel lantern. Jules Chéret (1836–1932) painted the poster for the opening, but the director Charles Zidler commissioned a poster from Lautrec for the 1891 season. The season saw the début of a young

At the Moulin Rouge, 1892
Au Moulin Rouge
Oil on cardboard, 80 x 60 cm
Dortu P 421. Whereabouts unknown

At the Moulin Rouge or The Promenade.
La Goulue and Jane Avril in the Background,
c. 1891/92
Au Moulin Rouge ou *La promenade*
(La Goulue et Jane Avril au fond)
Oil on cardboard, 80 x 65 cm
Dortu P 399. Private collection

PAGE 70/71:
Ball in the Moulin Rouge, *c.* 1890.

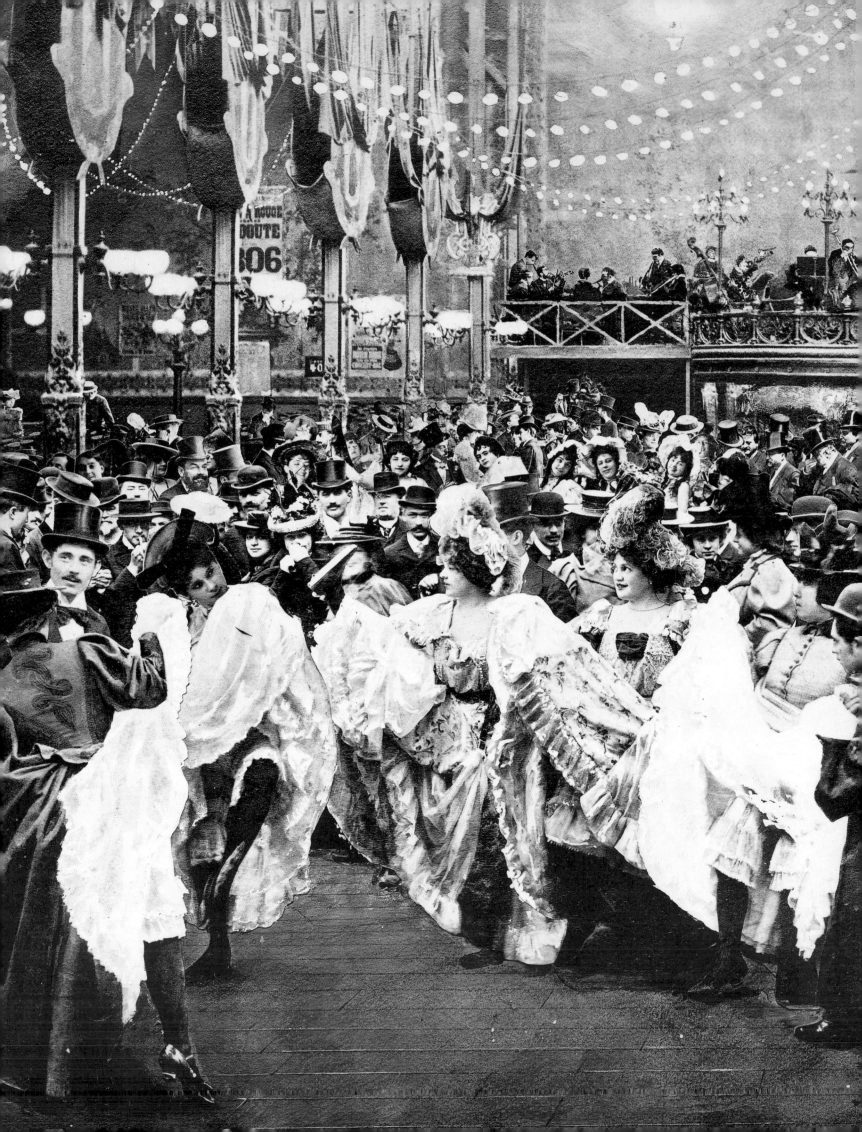

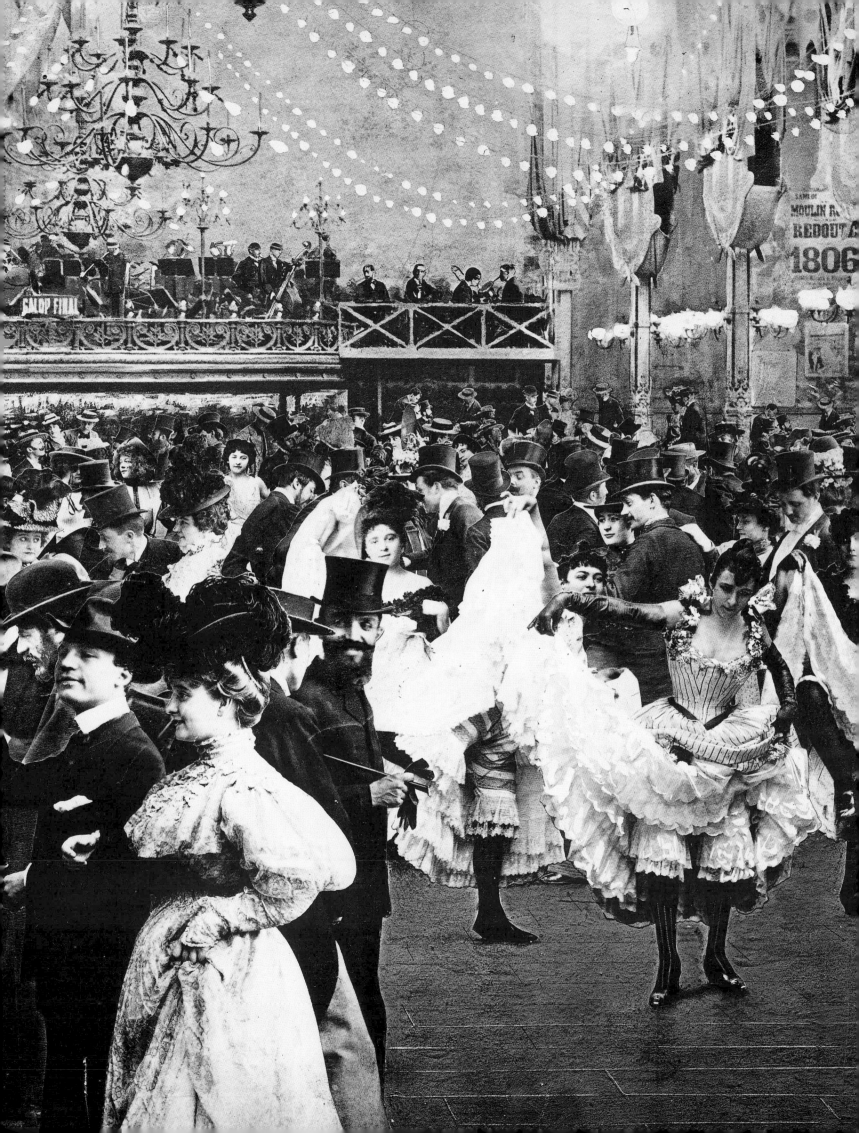

Monsieur Louis Pascal, Seen from the Back, 1891
Monsieur Louis Pascal vu de dos
Oil on cardboard, 65 x 40.5 cm. Dortu P 466
São Paulo, Museu de Arte de São Paulo Assis
Chateaubriand

Louis Pascal, son of the Prefect of the Gironde, was Lautrec's second cousin, and had been a fellow pupil at the Lycée Fontane in Paris. Lautrec valued his company, as well as that of his mistress, Moute. Pascal later worked as an insurance broker; when he and his family got into financial difficulties in the summer of 1892 they were supported by the Lautrecs.

Monsieur Louis Pascal, 1891
Oil on cardboard, 81 x 54 cm
Dortu P 467
Albi, Musée Toulouse-Lautrec

dancer whom he had hired from the rival Elysée-Montmartre establishment – La Goulue ("The Glutton"), a pretty girl of twenty whose real name was Louise Weber (1870–1929). At his first attempt Lautrec found the key to successful modern poster advertising: boldness and simplification. In a single night the large-scale poster was pasted up on walls and pillars throughout the whole of Paris (p. 101). It was during this period, too, that Lautrec made his first ventures into graphic art. Up to that time he had done a number of drawings intended as magazine illustrations, from which prints were subsequently made. Now, however, he turned to original lithography, and it became apparent that this technique was eminently suited to his artistic personality. He was to produce 360 lithographs, of which thirty were posters (pp. 129, 131). The technique allowed him to realise a dream: to achieve simplicity of line, to use even colours without shading. The uniformly grey-green silhouette of Valentin the Contortionist in the foreground creates a sense of magic, while La Goulue, whose right leg is hidden by Valentin's profile, is cleverly placed in the middle of the composition. A sense of depth is created by the lines of the floor, a strategy that Lautrec often employs. Finally, at the top of the poster there are the famous capitals, three times over: "MOULIN ROUGE".

In this first poster Lautrec uses the cloisonné technique inspired by Japanese art, which he had already used in *Cirque Fernando* (p. 37). His manner of levelling depth, of indicating the foreground with just a few strokes, of making people stand out as silhouettes against a lighter background, fulfils all the demands of the modern poster, which must stand out powerfully even from a distance. Economy and simplification are taken to the extreme, they are the true strength of Lautrec's posters and point the way forwards to modern poster art. They are probably the qualities that have made the Moulin Rouge poster one of the most popular in the history of art.

Between 1890 and 1896 the Moulin Rouge inspired Lautrec to no less than thirty paintings, which give us a better picture of the famous dance hall, its atmosphere and its clientèle, than any photo-reportage could have achieved. The proprietor Zidler was favourably disposed towards Lautrec, particularly after his poster brought such fame. He allowed him to display his pictures in the long corridor leading from the entrance to the ball-room.

La Goulue's success was as dazzling as it was short. Five years after being the model for the poster she was putting herself on show in a fairground booth, for which her friend Lautrec painted two decorative advertising placards. Her misfortune was that she drank too much and became too fat. Later she had to work as a maidservant in a brothel, then she sold sweets at the entrance to the Moulin Rouge, and she ended her days as an obese tramp, dying in 1929. The fate of the two booth placards, *Dancing at the Moulin Rouge* (p. 90) and *Moorish Dance* (p. 91), was for a time uncertain; La Goulue had passed them on to her creditors. A greedy dealer then cut them into several pieces to get a better price. French museums succeeded in re-purchasing the

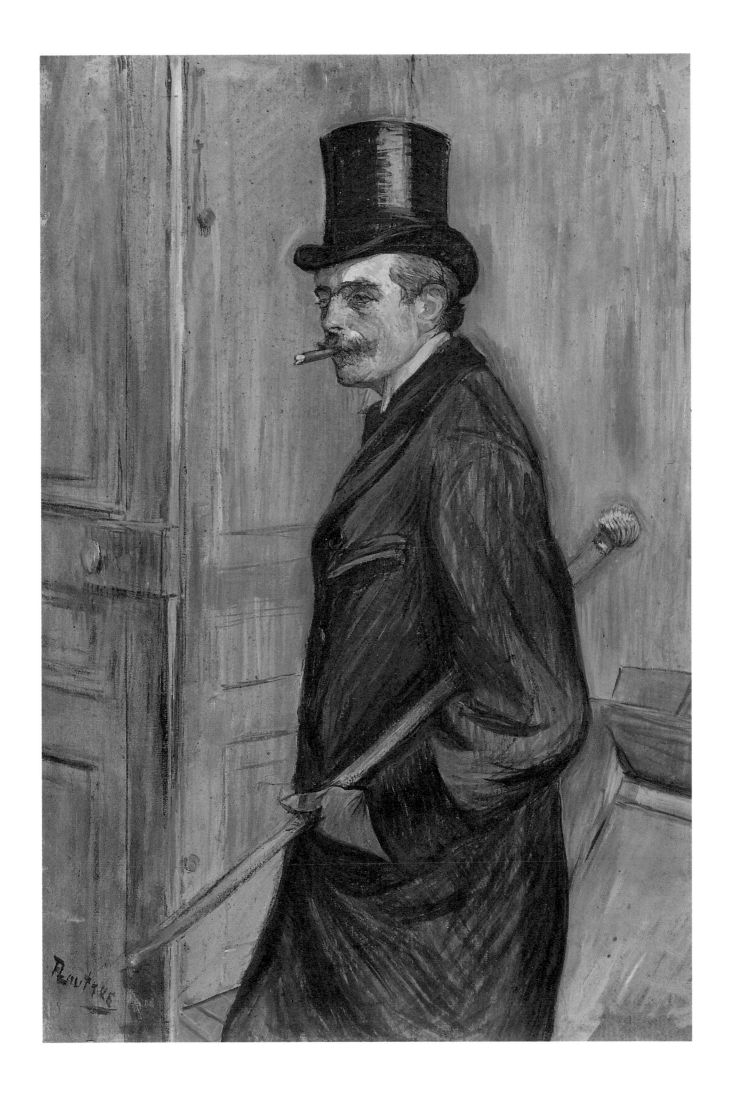

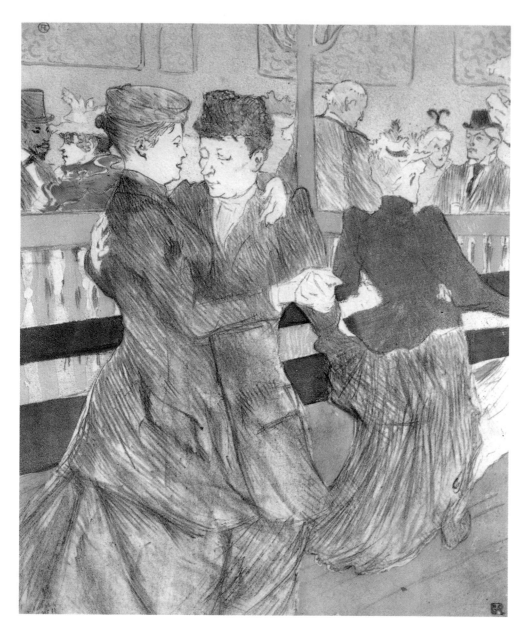

At the Moulin Rouge: Two Women Waltzing, 1897
Au Moulin Rouge: Les deux valseuses
Colour lithograph, 51 x 35.5 cm
Adhémar 258, Wittrock 181, Adriani 208
Private collection

The lithograph (p.74) was executed five years after the painting of the same name (p.75). Both works show the nude dancer and artist, Cha-U-Kao (middle; cf. pp.118–120), dancing with a girlfriend, with Jane Avril to their right. In the right background we see Lautrec's friends and fellow painters, François Gauzi and the Englishman Charles Conder (1868–1909), who also studied with Cormon.

pieces and putting them back together again. Their disappearance would have been an irreparable loss, since they represent a kind of résumé of Lautrec's Moulin Rouge work, a decisive phase in his life and in his œuvre. The same characters appear again and again, the composition becomes more skilfully assured, details become finer and finer. Lautrec shows us, with enormous suggestive force, a universe that he himself knew well and loved. We must not, however, look to him for moral edification!

There are good grounds to suppose that in this ambience of dissolute excess Lautrec saw reflected, above all else, himself; that in the ever more apparent decay of the fading actors in this tragi-comedy, he recognised his own blighted life. The role that he assigned himself is not only that of an observer, but also of accomplice and eye-witness reporter. Was the role of Rembrandt so very different, when contemplation of nudity and meditation on bare skin led him to paint the sagging buttocks, the varicose veins and musing face of a peasant girl who could be transformed into a queen by means of a few glass beads?

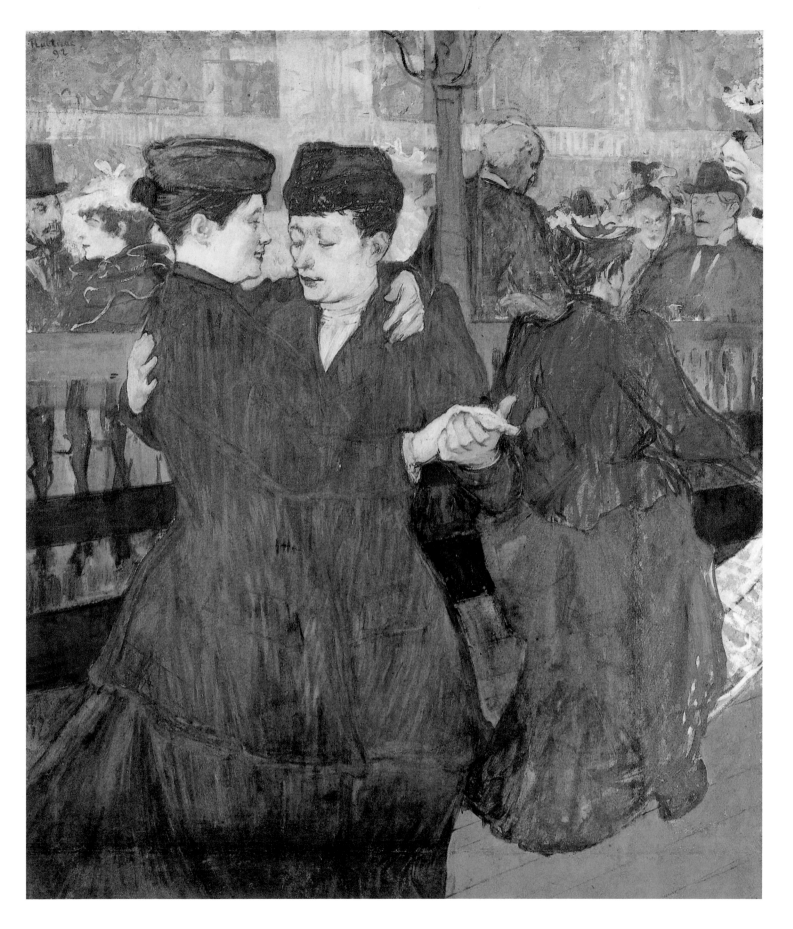

At the Moulin Rouge: Two Women Waltzing, 1892
Au Moulin Rouge: Les deux valseuses
Oil on cardboard, 93 x 80 cm
Dortu P 428
Prague, Národni Galerie

Pictures such as *At the Moulin Rouge: Two Women Waltzing* (p. 75), *At the Moulin Rouge* (p. 85), *The Clowness Cha-U-Kao at the Moulin Rouge* (pp. 118, 119), and *Marcelle Lender Dancing the Bolero in the Operetta "Chilpéric"* (p. 93) were Lautrec's most important compositions since *Ball at the Moulin de la Galette* (p. 49), and also the most

Star dancers at the Moulin Rouge. From left: Môme Fromage, Miss Rigoletto, Nini Pattes-en-l'Air and Rayon d'Or.

successful. A comparison between *At the Moulin Rouge* (p. 85) and the earlier picture demonstrates the progress he had made: in both pictures the diagonal line is emphasised, and the confluence of diagonals from floorboards and balustrade creates an illusion of space in the room; but in the later picture, without doubt one of his best paintings, Lautrec displays not only greater inventive genius, but also much more accomplished skill in applying the distinctive stylistic devices of the Japanese woodcut. The startling and suggestive harmony of the colours yellow, orange and green is an effect gained from his poster work. The main group of figures at the table – the critic Edouard Dujardin with his blond beard, the Spanish dancer La Macarona, the photographer Sescau, Guibert and, with her back to us, an unknown red-haired woman – is positioned off-centre and is balanced by the close-up view of a young woman, possibly the dancer May Milton, at the right-hand edge of the picture. Her greenish mask-like face and burnished hair are lit from below and cut off by the frame at the side in a manner which shows the direct influence of Degas' photographic technique. In the background one can see La Goulue arranging her hair in front of the mirror, and to the left is Lautrec accompanied, as so often, by his cousin Céleyran. The picture is proof of Lautrec's consummate skill as a painter and also of his masterly ability to transform an impressionistic or photographic painting into something entirely realistic, yet at the same time more gripping and compelling than reality.

Philippe Jullian gives Montmartre the name "Mount Lesbos" and says of it: "It is the metropolis of anarchists and artists, of all those who feel thwarted by the laws of society and who therefore resolve to despise them; around 1880 Montmartre became the great centre for the

At the Moulin Rouge: La Goulue and her Sister, 1892
Au "Moulin Rouge": La Goulue et sa sœur
Colour lithograph, 46 x 35 cm
Adhémar 2, Wittrock 1, Adriani 6
Private collection

The person shown to the right of La Goulue is not her sister but the dancer Môme Fromage, which roughly translates as "cheese girl". She had been a dressmaker's assistant and was a close friend of La Goulue, which is why people often referred to them as sisters.

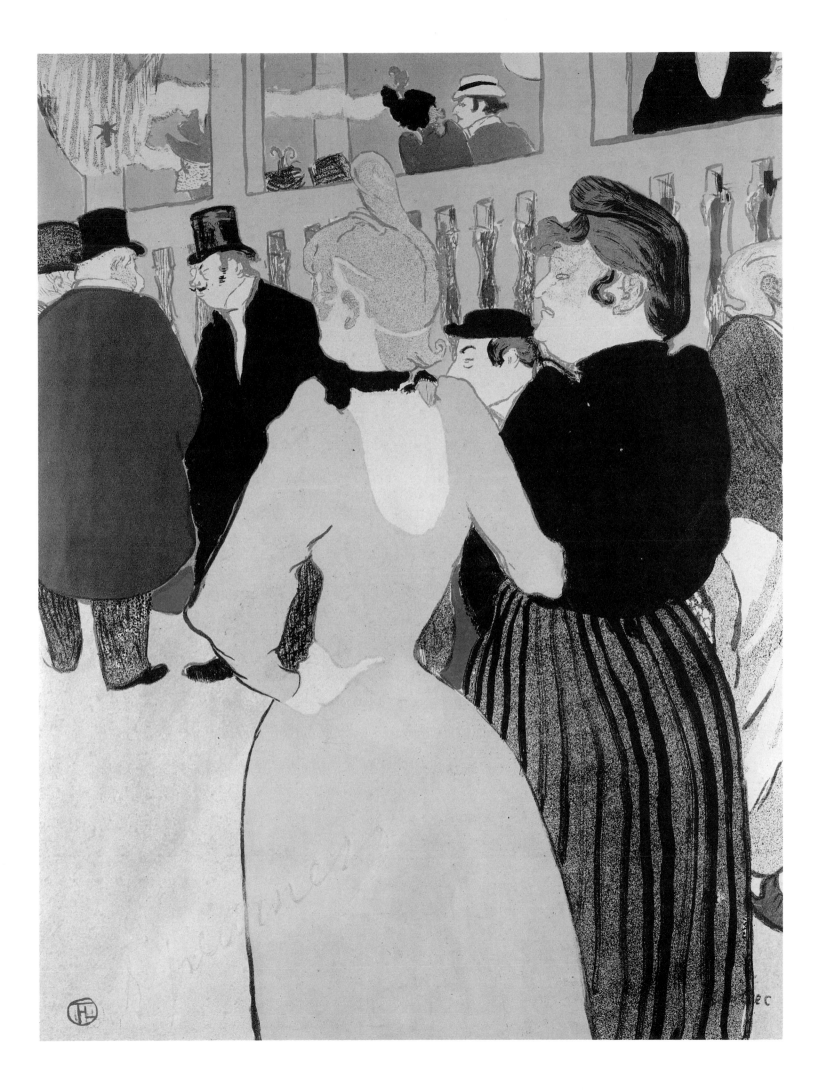

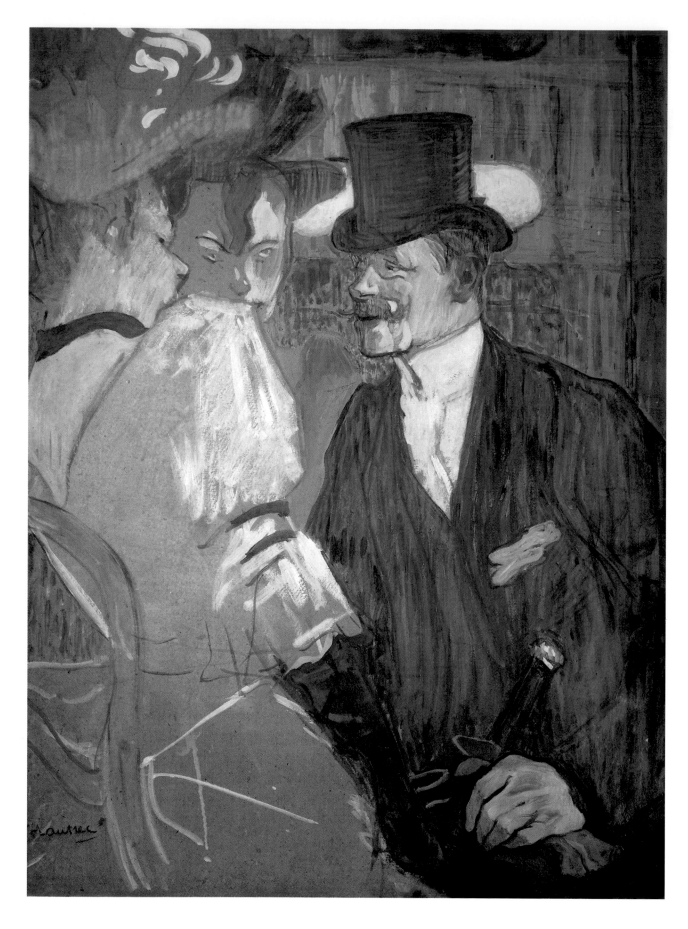

The Englishman at the Moulin Rouge, 1892
L'Anglais au Moulin Rouge
Oil and gouache on cardboard, 85.7 x 66 cm
Dortu P 425
New York, The Metropolitan Museum of Art

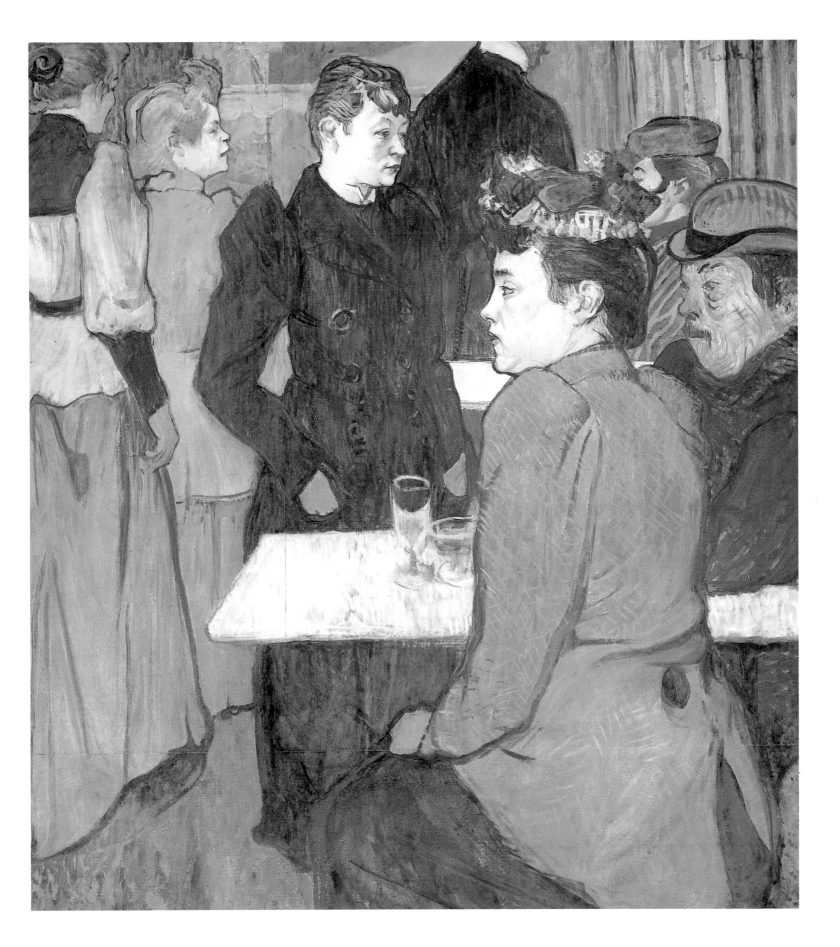

A Corner of the Moulin de la Galette, 1892
Un coin du Moulin de la Galette
Oil on cardboard, 100 x 89 cm
Dortu P 429
Washington, National Gallery of Art,
Chester Dale Collection

Paris in Lautrec's day: the Place de l'Opéra around 1895. The street is a meeting-place for the citizens of Paris, and people saunter between horse-drawn carriages and omnibuses on the broad boulevards. The first métro was not opened until 19 July 1900.

lesbians of Paris. It was no rarity to see women in men's suits, complete with cravat and hat, sitting on the café terraces. No one protested when two women waltzed together, as in Lautrec's painting, hatless, in open-necked men's shirt and waistcoat, holding each other so close that their breasts rubbed – the clearest demonstration of voluptuous desire…"

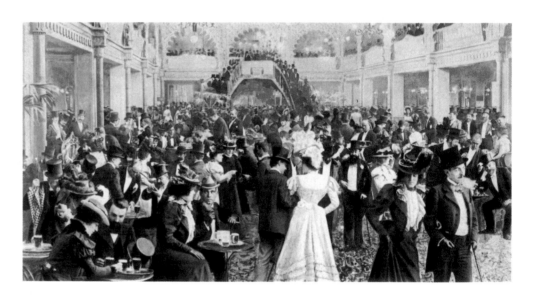

The Folies Bergère at 32 Rue Richer, was popular with pleasure-seekers from all walks of life. At first it was a circus, then a café-concert and, finally, a world-famous variety venue. Lautrec was a frequent guest there between 1894 and 1896.

Lautrec takes this female idyll as his theme both in *At the Moulin Rouge: Two Women Waltzing* and in *A Corner of the Moulin de la Galette*, in which the woman standing in the centre seems to have designs on the one in the foreground (p. 79), who has an absent and ill-tempered look reminiscent of Degas' *Absinthe* and of Manet's *Sloe Gin* (Washington, National Gallery of Art). In this latter painting Lautrec could have used his caricaturist skills to heighten the effect, but he has not done so, and this attests once again to his profound human compassion and also his ability to remain emotionally detached from his pictures. Lesbians became a familiar sight in Montmartre, and Picasso took up the theme in the autumn of 1900 when he too painted a ball scene in *Le Moulin de la Galette* (New York, The Solomon R. Guggenheim Museum), in which he showed two women embracing, sitting in the front row in the left foreground of the picture. There can be no doubting Picasso's indebtedness to Toulouse-Lautrec.

PAGE 81:
"Monsieur Toulouse paints Monsieur Lautrec-Monfa". Photomontage by Maurice Guibert, c. 1890.

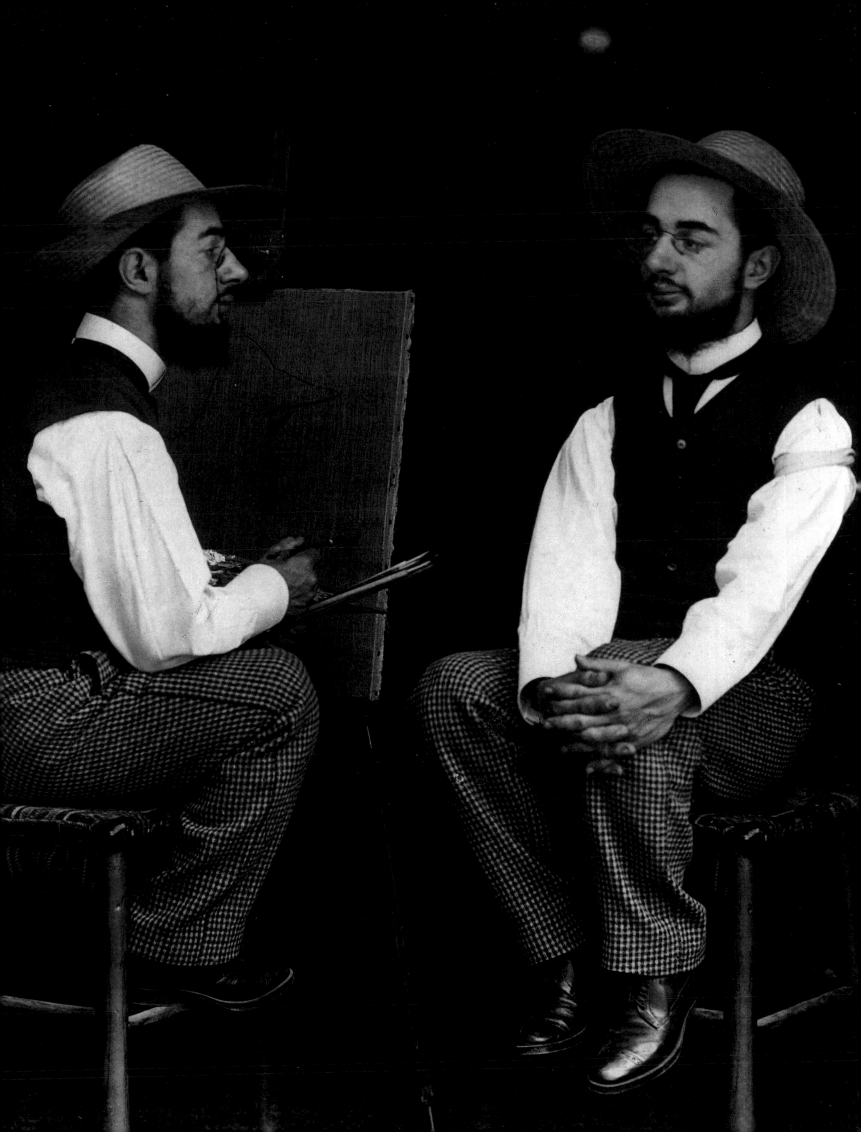

Reine de Joie (study for a poster), 1892
Charcoal on canvas, 152 x 105 cm
Dortu D 3224. Albi, Musée Toulouse-Lautrec

Reine de Joie was a novel by Viktor Joze, pseudonym of the Polish writer Victor Dobrski, friend and neighbour of Lautrec in the Rue Fontaine. The poster, designed for bookshop displays, is composed of two parts joined in the middle. It also served as model for the book jacket designed by Pierre Bonnard. The charcoal drawing (ill. above) is the design for the poster (p. 83). The inspiration for this motif probably came to Lautrec from a woodcut by the Japanese Isoda Koryusai (c. 1775).
The anti-semitically tinged novel and Lautrec's poster provoked a scandal. The scene shows Hélène Roland, heroine of the novel, at a richly-laden table, kissing the stout Olizac. Baron Rothschild, who thought he recognised himself in the figure of Baron Rosenfeld, tried in vain to have the book banned.

Reine de Joie, 1892
Lithograph in four colours (poster),
136 x 93 cm
Adhémar 5, Wittrock P 3, Adriani 5
Private collection

While the dance halls were the scene of nocturnal revelry, the intellectual centre of Montmartre was located a little way away in the Café de la Nouvelle-Athènes on the Place Pigalle. At the time of the Second Empire, the Café Guerbois in the Avenue de Clichy had been the place where young painters met, often clustered round Emile Zola. It was soon eclipsed by the new meeting-place, in which poets and painters such as Paul Verlaine (1844–1896), Manet and Degas gathered, as did the women of the demi-monde who favoured the company of artists as a means of recovering from the boredom inflicted by their wealthy lovers. Cézanne could be seen here from time to time, during his visits to Paris. He was appalled by the new generation of painters, who had quite lost touch with bohemian life: "These fellows are already dressed just like notaries!" Another frequent guest at the Café de la Nouvelle-Athènes was Suzanne Valadon, a sought-after model who was reputed to be both intelligent and sly. Degas was very interested in her, and talked to her about painting while she obliged him with the most daring poses. Under his influence she herself began to draw, and Degas was very impressed by her firm line. Renoir chose her to sit for several of his pictures, and she sat also for Puvis de Chavannes (1824–1898), who used her as model for muses and Greek striplings, and taught her how to hold a brush. People surmised that while introducing her to the mysteries of painting he may also have fathered her child, who was to become the painter Utrillo. She seems to have led a turbulent love-life, and the paternity of the child was ascribed in Montmartre in turn to a drunken singer, to the Spaniard Miguel Utrillo domiciled in the Moulin de la Galette, and to Puvis, who, however, had a watchful wife, Princess Cantacuzène, who kept a close eye on her renowned husband's models.

Suzanne, who also called herself Maria, was Lautrec's favourite model, and it did not take long for her to be persuaded to become his mistress as well. She was not in the least repelled by his physique, rather she found it just as attractive as his temperament. His deformity being no obstacle, for a time everything went well between the unprejudiced working-class girl and the aristocrat; they loved each other, and seemed made for each other. He trained her in the professional attributes distinctive of his art: the psychological approach, the refusal to gloss over things, the frequently aggressive strength of pencil and brush. Later she said of herself: "I paint people as a way of getting to know them... Don't ever persuade me to paint a woman who is looking for something nice and pretty, I would be a great disappointment to her."

She was the daughter of a plain seamstress, and after a short spell in a convent school she had earned her living in various ways. She was successively a seamstress, a nanny, a waitress in a restaurant and a greengrocer. At the age of fifteen she was a trapeze artist in an amateur circus, but a fall put an end to her acrobatic career. After this she became a model, and was much in demand because of her figure and her rather austere beauty. She was passed from one artist to another,

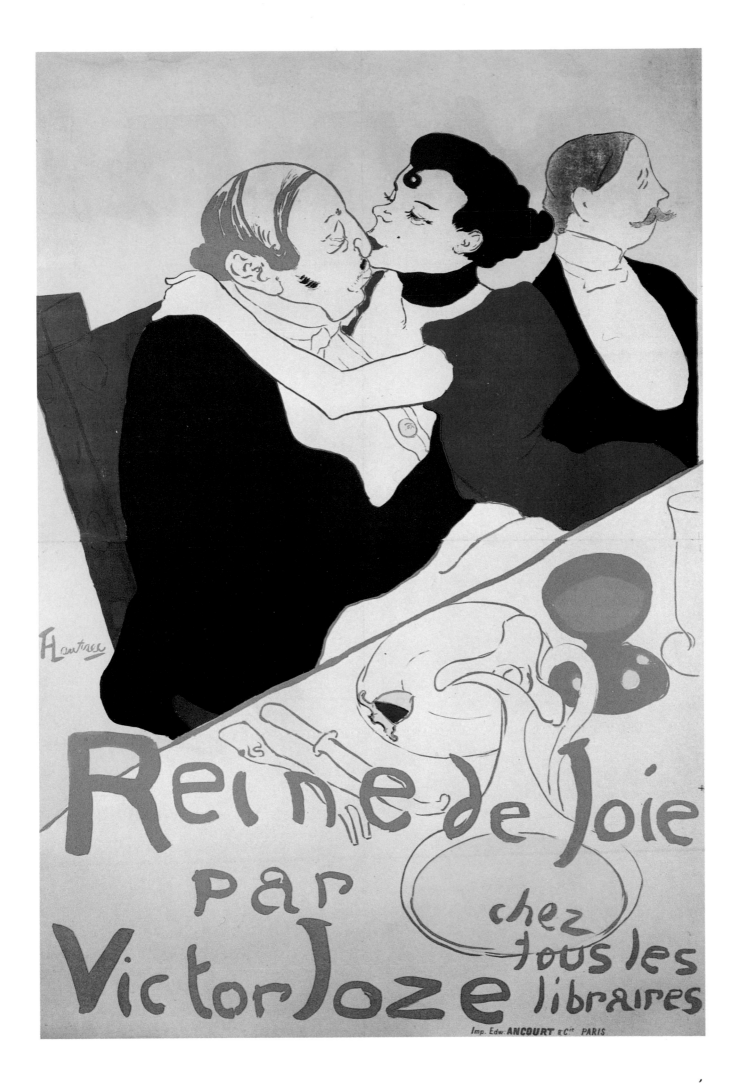

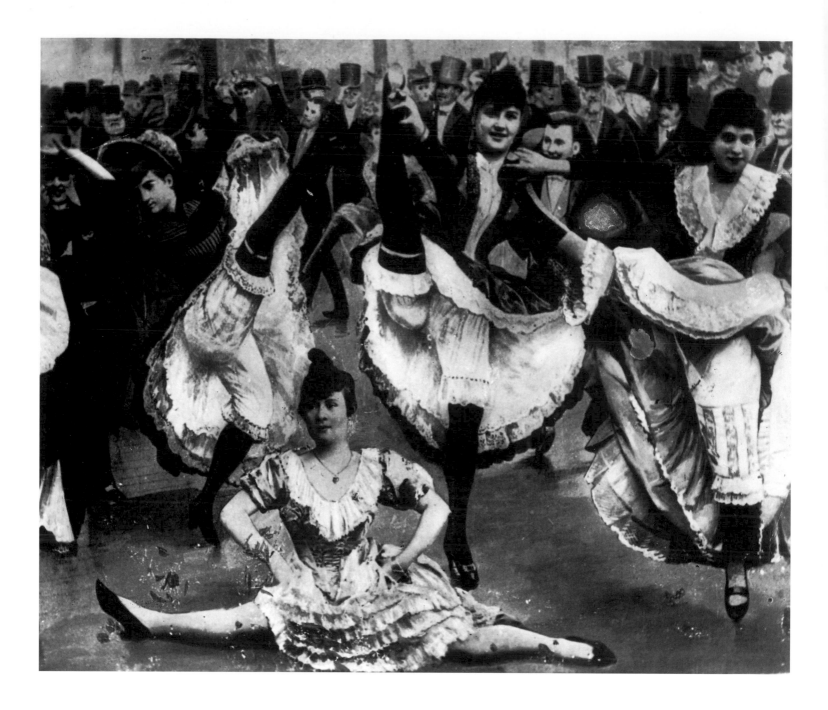

Dancing the quadrille in the Moulin Rouge, c. 1894. Doing the splits, in the middle, is La Goulue, queen of the quadrille. Behind her Nini Pattes-en-l'Air, Môme Fromage and Grille d'Egoût (left to right).

and arrived finally in Lautrec's studio, where it immediately became apparent that she was quite unlike the conventional model. Lautrec was greatly taken with her beauty, although she had brown hair. There was a great affinity between him and this totally amoral creature, imbued with physical love.

In his pictures he gave her several roles. She was the bareback rider, but also the woman combing her hair, the dancer and the laundress. She walked through the streets of Paris with a heavy laundry basket on her arm with his consent, but she was unfaithful, and sometimes she would disappear for several days. She might meet her procurer friends, or flit to some artist or other, for instance to the rascal Renoir who was delighted to paint a lascivious picture of her in *The Plait*. In this picture he portrayed with delicate brush strokes not only her big blue eyes but also her sensuous mouth, her luxuriant hair and her round tight-laced breasts. In short, he made a typical Renoir of her. Lautrec painted a

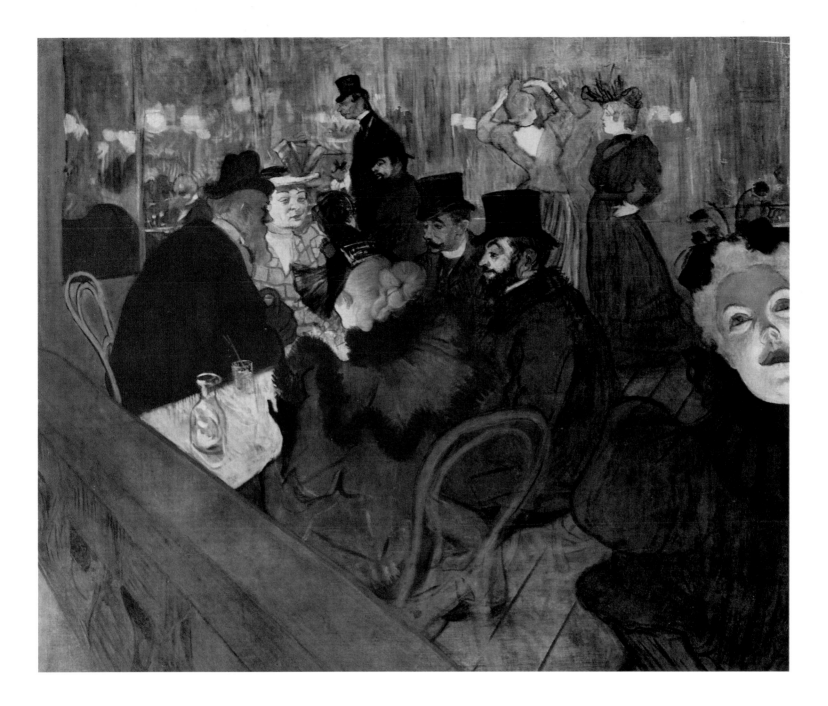

typical Lautrec. He painted her with sharp features and a sullen ex-
pression, with tautly drawn silhouette, stretching in an almost mas-
culine pose her frail shoulders and longish neck (pp. 29, 40, 41).

Their intimacy would certainly have lasted longer, had not Suzanne
taken it into her head to be married to Lautrec, and even threatened
suicide as a last resort in her efforts to achieve this end. When Lautrec
saw what she was doing he left her, and never saw her again.

"The best way of possessing a woman," said Ingres, "is still to paint
her." When a beautiful woman passed by, Lautrec would say cynically:
"I could have that one for fifty francs if I wanted to." But his friends
recognised beneath this sarcasm all his disappointment and despair.
However cruel, even obscene, his witticisms might be, the Suzanne
Valadon affair shows that the cold and calculating approach did not
come easily to him. Nevertheless, his collection of women became
larger and lovelier, and beautiful red-heads came and went in rapid

At the Moulin Rouge, *c. 1892/93*
Au Moulin Rouge
Oil on canvas, 123 x 140.5 cm
Dortu P 427. Chicago (IL), The Art Institute
of Chicago, Helen Birch Barlett Memorial
Collection

Sitting at the table from left to right: literary
and music critic Edouard Dujardin, the dancer
Georgette (La Macarona), the photographer
Paul Sescau and the painter and photographer
Maurice Guibert. In the foreground, the red-
haired Nelly C. In the background La Goulue
is tidying her hair, while to the left the physi-
cian Dr Gabriel Tapié de Céleyran with top
hat and, in front of him, Lautrec with bowler
are easily recognisable. The woman with
mask-like make-up at the right edge of the pic-
ture is probably the dancer May Milton
(cf. p. 117).

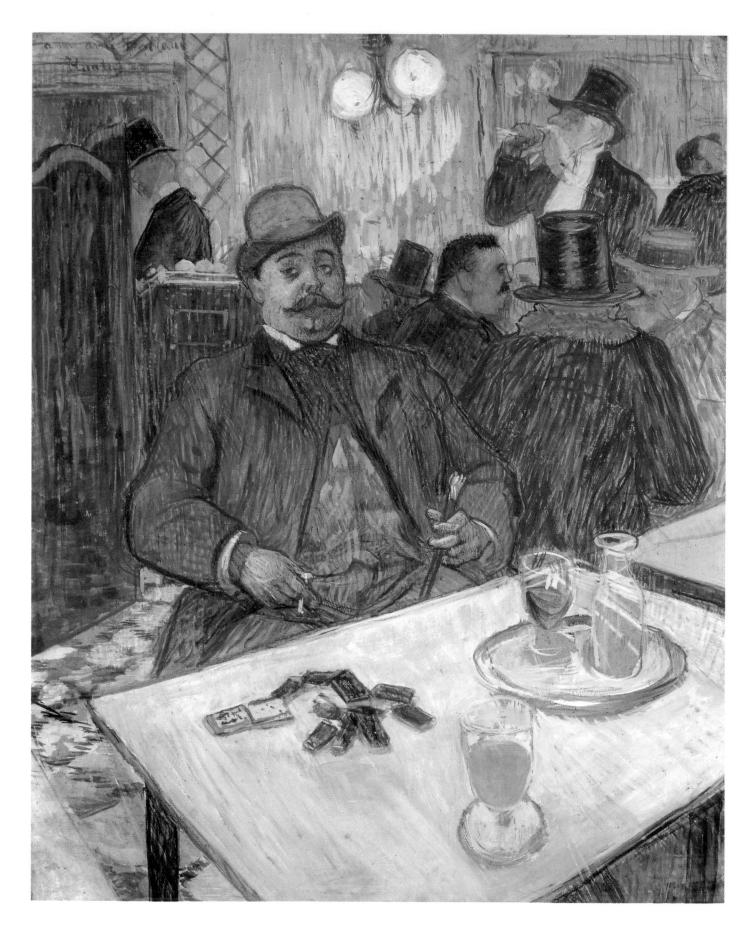

Monsieur Boileau, 1893
Oil on canvas, 80 x 65 cm
Dortu P 465
Cleveland (OH), The Cleveland Museum of Art,
Hinman B. Hurlbut Collection

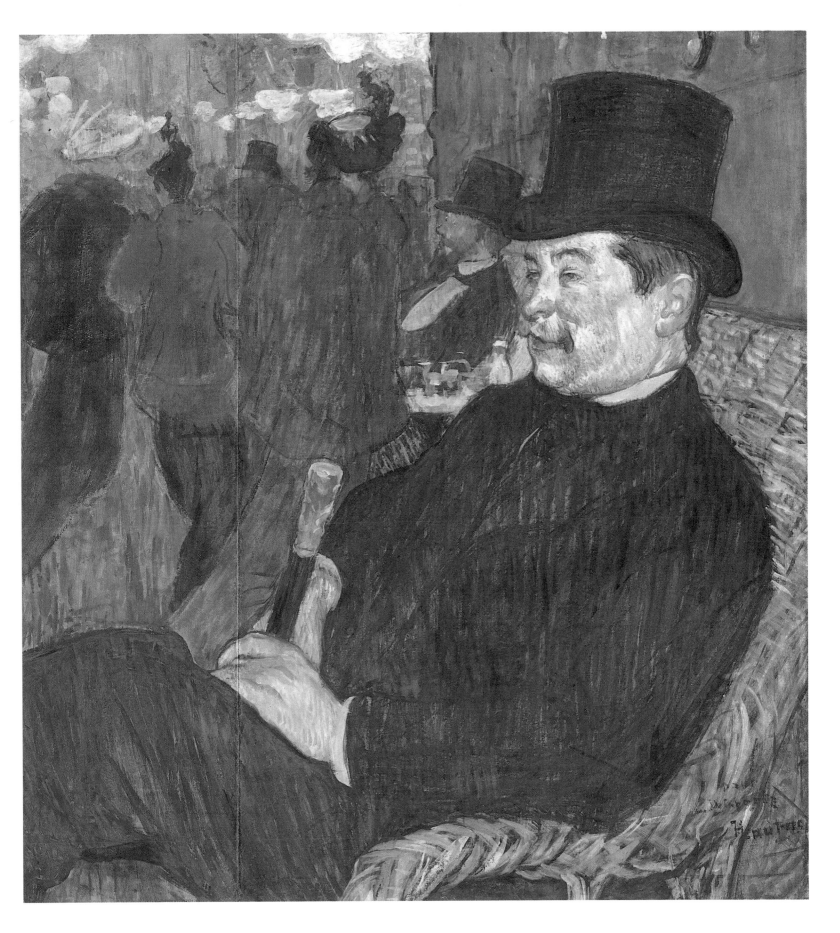

Monsieur Delaporte in the Jardin de Paris, 1893
Monsieur Delaporte au Jardin de Paris
Oil on cardboard, 76 x 70 cm
Dortu P 464
Copenhagen, Ny Carlsberg Glyptotek

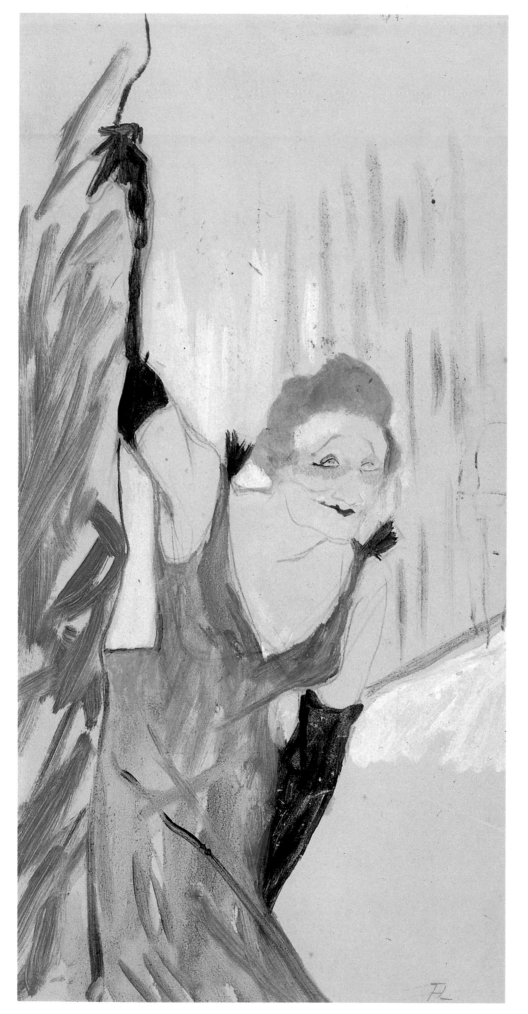

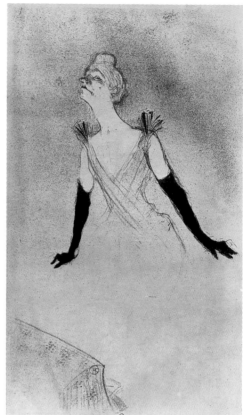

Yvette Guilbert Greeting the Audience, 1894
Yvette Guilbert salutant le public
Black-and-white lithograph, 34.2 x 20.2 cm
Adhémar 90, Wittrock 73, Adriani 77

Yvette Guilbert Greeting the Audience, 1894
Yvette Guilbert salutant le public
Oil over reproduction on photographic paper,
48 x 28 cm. Dortu P 520
Albi, Musée Toulouse-Lautrec

Yvette Guilbert (1867–1944) was a celebrated
singer and raconteuse. Before making her
career she was a model and sales assistant at
the Printemps department store. In 1889 she
appeared at the Eldorado for the first time
and, in 1890, at the Moulin Rouge. In 1895
she went on tour to America; she returned to
Paris even more famous than before. Long
black gloves were her trademark – harking
back to her old governess. Lautrec drew her
wearing her gloves, and he dedicated two li-
thograph albums to her.

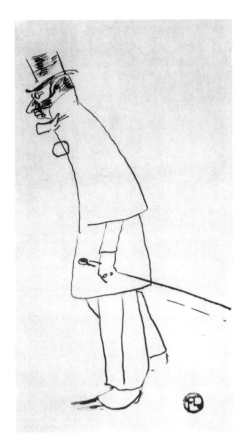

Gabriel Tapié de Céleyran, 1894
Ink on paper, 33 x 22 cm
Dortu D 3507
Albi, Musée Toulouse-Lautrec

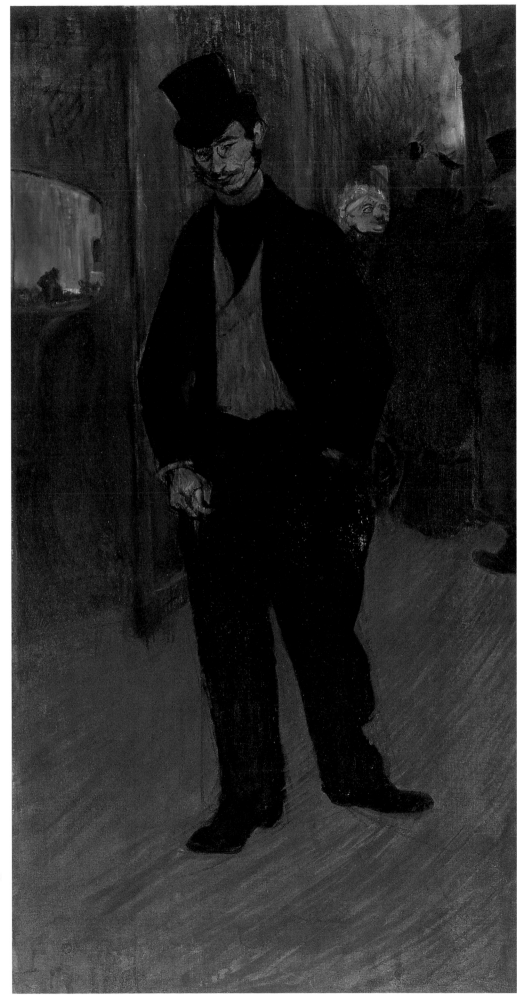

Gabriel Tapié de Céleyran in the Theatre Foyer,
c. 1893/94
Gabriel Tapié de Céleyran dans un couloir de théâtre
Oil on canvas, 110 x 56 cm
Dortu P 521
Albi, Musée Toulouse-Lautrec

Gabriel was Lautrec's cousin and probably his closest friend. He studied medicine in Paris and passed his final examinations in 1899 (cf. p. 189). After Lautrec's death he campaigned for the street in which Henri was born in Albi to be named after him. With Maurice Joyant he built up the Musée Toulouse-Lautrec in Albi, to which he donated many of the pictures in his possession.

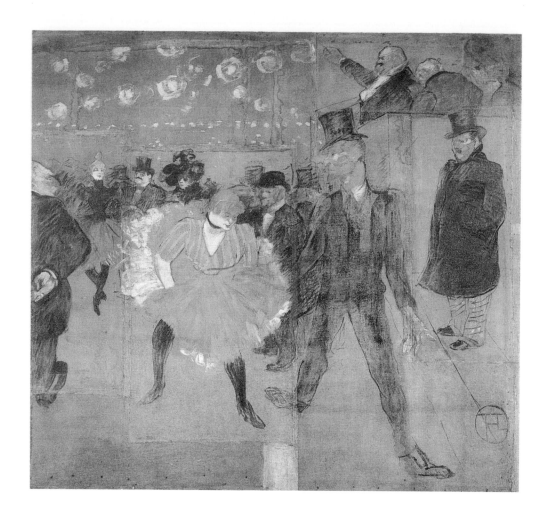

Dancing at the Moulin Rouge: La Goulue and
Valentin the Contortionist, 1895
*La danse au Moulin Rouge: La Goulue et
Valentin le Désossé*
Oil on canvas, 298 x 316cm
Dortu P 592. Paris, Musée d'Orsay

La Goulue in her naked glory at the time of
her greatest triumphs. By 1895, however,
when Lautrec's decorations for her fairground
booth were undertaken (ill. above and p. 91
bottom), she had passed her zenith.

succession in his studio. In Lautrec's eyes their great attraction, and
the crowning perfection of womanhood, was their flaming hair. All his
women were Venetian blonds or red-heads, except for the doomed
Valadon with her brown hair.

Another one arrived on the scene, a new dancer from the Moulin
Rouge, Rosa la Rouge, whom Aristide Bruant (1851–1925) had made
famous with a single music-hall song. For a time she was Lautrec's
favourite muse, but she brought trouble with her. A friend had already
warned him: "Be careful, she could leave you with something that you
cannot get rid of!" But in his pursuit of pleasure Lautrec had become
careless, and in any case he was convinced that his friend wanted the
girl for himself. He disregarded the advice, and was left with a searing
reminder. "One day," writes Gauzi, "he showed me a reproduction of
André Gill's *Madman* and said: 'Look, that's what awaits us!' Of
course he was speaking of himself, and if he included me it was just
because he took the matter so personally. Unfortunately the life that
he led made him a true prophet."

Another of Lautrec's models was the famous Casque d'Or (p. 94), a
girl from the most deprived urban background who was kept by an
anarchist wanted for murder. He was finally executed, and Jacques
Becker made a sensitive film about him with Simone Signoret playing
the part of Casque d'Or. As a model she showed exactly the quality
that was in vogue at the time, namely a kind of waif-like beauty which
Lautrec also liked. There was another beautiful woman in Lautrec's

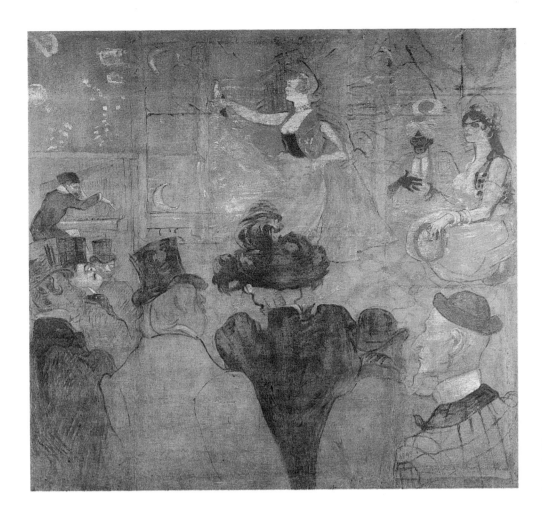

Moorish Dance ("Les Almées"), 1895
La danse mauresque (Les Almées)
Oil on canvas, 285 x 307 cm
Dortu P 591. Paris, Musée d'Orsay

kaleidoscope whom he passionately admired: Cha-U-Kao, nude dancer, acrobat and clown, who pretended to be Japanese. He painted numerous pictures of her in all kinds of costumes, instigating various special fancy-dress events at the Moulin Rouge for this purpose (pp. 118–120).

All these models posed for portraits, but they are to be found also among the background figures in his pictures. He drew them not only in the studio, but also drumming up business in music-hall seating areas and walkways; their silhouettes, illuminated by rose-tinted footlights, were always with him. They belonged to the colourful fauna of the milieu, ranging from procuress to the very young girl still fresh, but painted with layers of make-up, dressed in seemingly costly apparel, which is in reality worn and drab.

Then there are also the men who are excellent dancers, old gentlemen or young pimps, and there are the men waiting for their girls. To them Lautrec dedicated a whole series of pictures: *Monsieur Louis Pascal* (p. 73), *The Englishman at the Moulin Rouge* (p. 78), *Monsieur Boileau* (p. 86), *Monsieur Delaporte in the Jardin de Paris* (p. 87), *Gabriel Tapié de Céleyran in the Theatre Foyer* (p. 89), *Monsieur Maxime Dethomas at the Opera Ball* (p. 95) and many more, all showing the influence of Degas and Manet. The women flutter round them, and the silhouettes of these men, all occupying the foreground, take on a bas-relief quality, as if they were leaning against a painted background. All of them are Lautrec's friends, ever faithful to him.

Lautrec designed these two paintings as decorative panels for La Goulue's fairground booth. The one on the left recalls her star performances with Valentin the Contortionist at the Moulin Rouge; the one on the right announces her new fairground show. The figures in the front row of the audience are photographers Paul Sescau and Maurice Guibert, Lautrec's cousin Gabriel Tapié de Céleyran, Jane Avril, Lautrec himself, and the critic Félix Fénéon. La Goulue later had to sell the two canvases to pay her debts. A greedy dealer then cut them into several pieces to get a better price. They were later bought back and, in 1929, put together and restored by the Louvre.

La Goulue's fairground booth at the Foire du Trône in Paris, in which she performed in 1895.

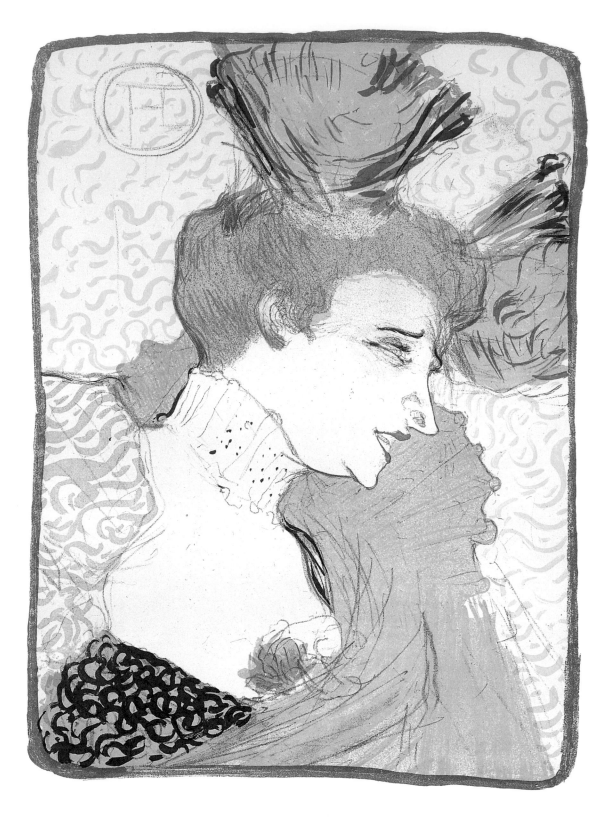

They pose for him, they are his slaves and his admirers. Together they immerse themselves in an atmosphere in which the animal is ennobled by the magic of art – and perhaps vice versa. They are fundamental ingredients of the material on which Lautrec draws in his work.

Lautrec's preferred companion on his rounds through the dance halls was his cousin, the physician Gabriel Tapié de Céleyran, whose tall, rake-thin and round-shouldered silhouette contrasts comically with that of Lautrec. They were a familiar sight in the pleasure park – as it had become – of Montmartre, where people of all sorts met and passed in the night. They strolled from one venue to another, and one

Mademoiselle Marcelle Lender (bust), 1895
Colour lithograph, 32.5 x 24.6 cm
Adhémar 131, Wittrock 99, Adriani 115
Private collection

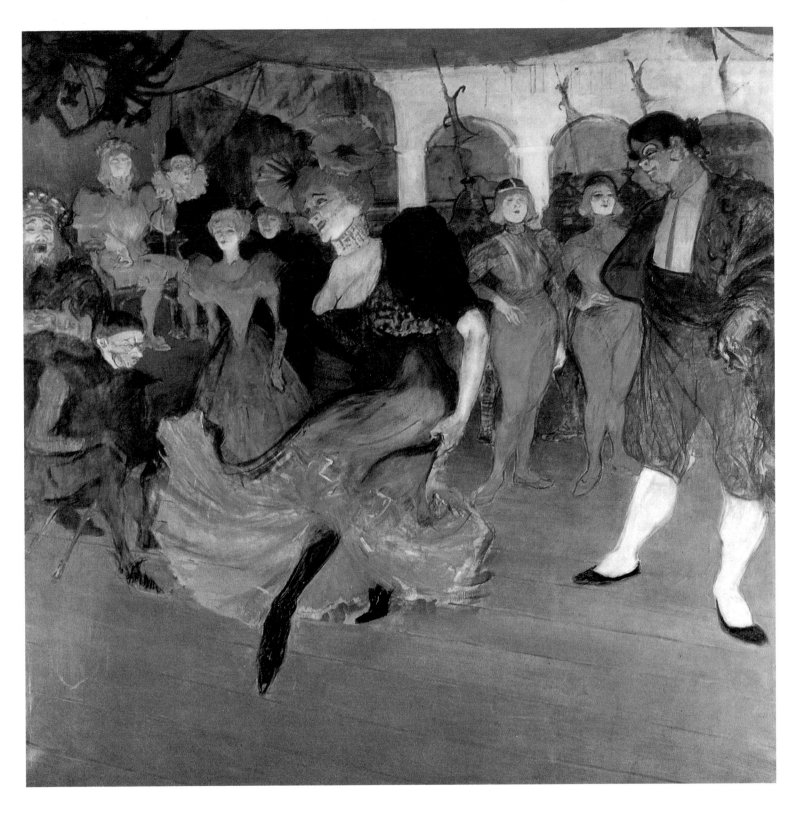

Marcelle Lender Dancing the Bolero in the Operetta "Chilpéric", 1896
Mademoiselle Marcelle Lender dansant dans "Chilpéric"
Oil on canvas, 145 x 150 cm. Dortu P 627
Washington (DC), National Gallery of Art,
Gift of Betsey Cushing Whitney

of their ports of call was the Divan Japonais, for which Lautrec had painted a poster in 1892 (p. 115). The Divan Japonais in the Rue des Martyrs had just introduced the first striptease act, and Lautrec told his friends the news: "A woman undresses on stage till she's stark naked, miming the scene 'Yvette is going to bed'. Of course the police soon step in; the whole thing is worth looking at." The friends hurried along to watch a young girl, Yvette Cavelli, in the guise of a midinette, enter her little bedroom and start taking off her clothes, slowly in order to protract the viewers' pleasure. As her last garment fell to the ground Yvette stood there quite naked... in a skin-toned silk tricot

Quadrille in the Moulin Rouge. From left: Casque d'Or, Valentin the Contortionist and Môme Fromage.

drawn tightly over her entire body. "We've been tricked!" said Gauzi to Lautrec. "So what, we just haven't seen Cavelli stark naked, but she's fabulous all the same…" Far from being banned, this type of performance was taken up by the Folies Bergère and the Casino de Paris, and one after another the bride, the courtesan and the whore were put to bed. Not for another ten years was Yvette allowed to appear without her tricot.

Evening after evening the cousins watched these performances, and the dramas that were performed in the glittering theatres. Lautrec painted and drew this world endlessly; it had inspired not only other artists, including Degas, but also poets and authors. Horror remains beautiful, Baudelaire had said, pleasure and pain are often one. Lautrec might well have echoed the poet's words in *Les fleurs du mal*: "It is one of the wonders of art, that artistically expressed horror and rhythmically articulated suffering fill the spirit with joyful serenity."

Lautrec had his personal Olympus, his unending cinematograph of divine and heroic beings – in his own eyes at least. When this fiendish little man returned home at dawn, his eyes full of pictures, his pockets full of sketches, then, untiring, he set to work.

Monsieur Maxime Dethomas at the Opera Ball, 1896
Monsieur Maxime Dethomas au bal de l'Opéra
Oil and gouache on cardboard, 67.3 x 52.7 cm
Dortu P 628
Washington (DC), National Gallery of Art, Chester Dale Collection

Maxime Dethomas (1868–1928), painter and graphic artist, was a friend of Lautrec's and one of his favoured companions on brothel-crawls. His painting was strongly influenced by Lautrec, with whom he travelled to Normandy and Holland. Dethomas was tall and chubby but, in spite of his stature, tended to be insecure. What fascinated Lautrec about his friend was his "ability to remain aloof, even in a place of entertainment".

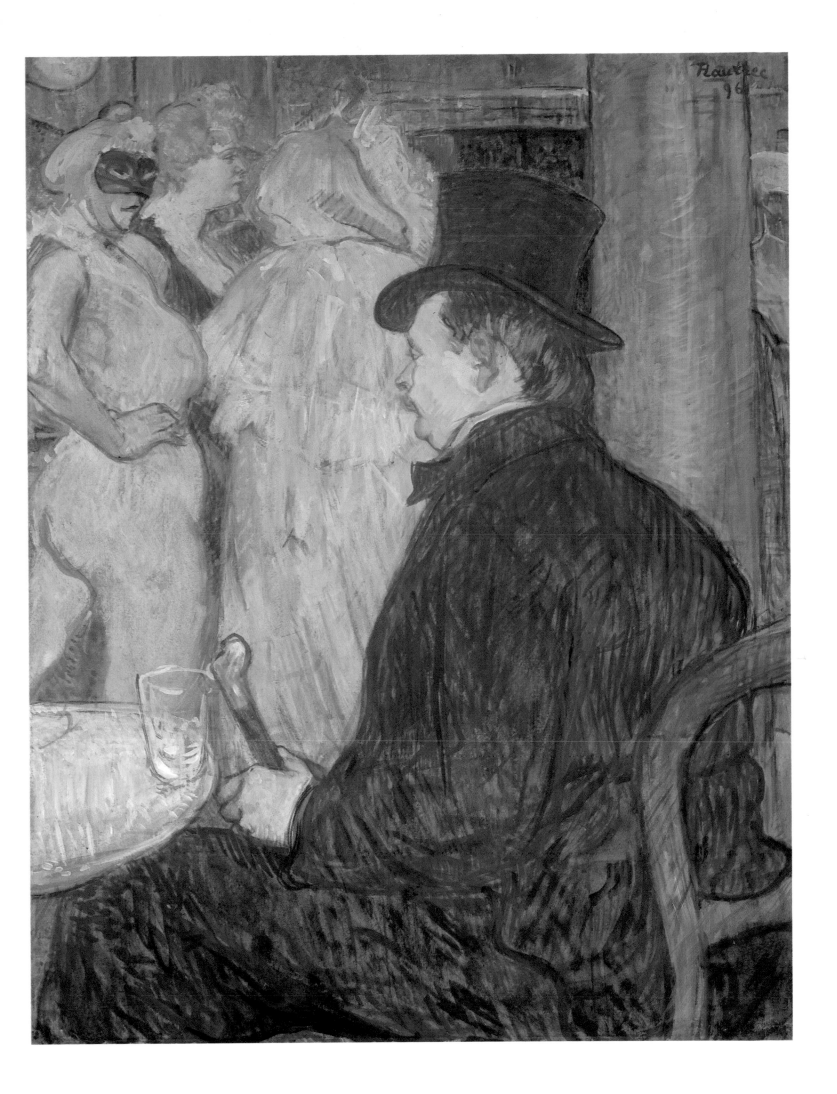

The Stars and the Paparazzo 1891–1898

By 1890 Henri de Toulouse-Lautrec was a famous painter. In spite of his appearance, or perhaps because of it, he was one of the great personalities of Paris. A poster by him could help someone along the road to fame. He was friendly with all the stars, and one of them, Jane Avril (1868–1943), said gratefully not long before her death: "I owe all my fame to Lautrec, from the moment of the first poster he designed for me…" And who would remember Yvette Guilbert today, if Lautrec had not immortalised her? Once he was famous he generously squandered his talent and his reputation for the sake of others. He helped artists whom he liked to win public favour and acclaim.

The glorious flaming hair, the spontaneity and incomparable charm of La Goulue was "discovered" in Paris at the same time as Lautrec's genius as a graphic artist, and he became one of the most sought-after poster designers. He was so fashionable, so much in evidence on walls throughout the city, that his importance as a painter was almost forgotten, a phenomenon that continues to the present day. It may be that Lautrec's modesty is to blame for this injustice. In his relations with other painters he was always timid and hesitant. In his paintings he strove less for panache and dazzling technique than for the rapidity that would allow him to capture the movements of the people he saw, with no later alteration. Meanwhile, in his studies he often experimented with his tubes of paint to see whether a lithograph would look better in colour, or black and white.

The painting technique that he had invented for his works was itself a cause of confusion. He used turpentine to thin his oils and make them dry more quickly, until they looked like water-colours. He painted on coloured cardboard, which absorbed the paint easily, and which he left exposed in places as his ground. This made his paintings look similar to his lithographs and illustrations. "A photographic technique", he might have said. It makes it difficult for the specialists working on his catalogues raisonné to categorise his paintings. Many of the masterpieces hanging in galleries and museums today in fact originally served as studies or preparatory drawings for lithographs and posters. His paintings were known only to a small number of friends, whereas the burgeoning success of his posters on the walls of Paris was celebrated in the chronicles of the time.

Aristide Bruant, 1893
Black-and-white lithograph, 26.8 x 21.5 cm
Adhémar 38, Wittrock 24, Adriani 22

Lautrec with Trémolada, one of the directors of the Moulin Rouge, in front of the first Moulin Rouge poster, designed by Jules Chéret, c. 1889. Shortly afterwards Lautrec designed his first poster for the Moulin Rouge (p. 101).

Aristide Bruant, *c.* 1885. Bruant (1851–1925) came from Sens to Paris, where he at first worked as an office boy for a lawyer. Then he was an employee of the railway and finally he worked as a conférencier in the cabarets. From the opening of his own venue, the Mirliton, in July 1885, he performed as singer of realistic chansons, occasionally coloured by anarchism and sometimes punctuated with vulgar jokes.
Bruant also published the magazine *Le Mirliton*, in which he printed illustrations and paintings by Lautrec. When he starred at the Ambassadeurs in 1892, he compelled the director to cover the whole venue with the poster designed by Lautrec (p. 99), and to display it all over Paris. By so doing Bruant contributed not inconsiderably to Lautrec's fame, and his own. Bruant was married to Mathilde Tarquini d'Or who sang at the Opéra Comique. In 1895 he retired from singing.

Ambassadeurs: Aristide Bruant, 1892
Lithograph in six colours (poster),
141 x 98 cm
Adhémar 6, Wittrock P 4, Adriani 3
Private collection

"The café-concert has the same meaning for Lautrec as Versailles for Lebrun, Saskia for Rembrandt or San Marco for Fra Angelico. He finds in it the framework of his life, the subject matter of his pictures, and his public," write P. Huisman and M. G. Dortu in their laudatory book, *Lautrec par Lautrec*. "At that time the cafés were popular with people from all walks of life, they were to be found in every part of the town and it did not cost much to get in. It was like going to the cinema today, though the lights were not turned down, except in the odd corner, and the audience did not sit passively in front of an artificial screen. People drank and ate, and joined in the refrains, and applauded or protested at every opportunity. The uneven lighting contributed to the lively atmosphere; the footlights lit up the performers in a strange way from below, and highlighted quite unexpected features…"

It is easy to imagine Lautrec's feeling of well-being in such authentic surroundings, and to understand why he was so much more interested in the performers than in the texts. Indeed the texts are very similar to one another, but they give the singers and story-tellers the opportunity to show off their talent and make an impact. Lautrec does the rest at the easel.

The "succulent pieces on display" – the writer Lorrain's phrase for the girls – aroused Lautrec's enthusiasm more than the poets and song-writers, and he was supremely interested in the popular female singers, dancers, actresses and even opera stars. Since he was not able to paint without passionate involvement, his paintings and posters, including those of starlets whom he helped to become stars, make up an impressive portrait gallery, not of forgotten ancestors but of the famous contemporaries he admired most: Aristide Bruant, Jane Avril, Yvette Guilbert, Loïe Fuller, Sarah Bernhardt, Réjane, Caudieux, Oscar Wilde, Marcelle Lender, Cha-U-Kao, May Belfort, May Milton, Chocolat, Misia Natanson, Berthe Bady – this is Paris in full bloom, a mythology in pictures of an entire epoch.

For his activities at this time Lautrec favoured the lithographic techniques which had been known for a hundred years. Alois Senefelder (1771–1834) was the first to make a lithographic print, in 1796. He had discovered that it was possible to draw with wax crayon on porous limestone, to moisten the unwaxed areas with water and then to apply a roller to the whole surface with wax printing colour which was not absorbed by the moistened areas. After printing, the colour reproduced only what had been crayoned. Théodore Géricault (1791–1824), Richard Parkes Bonington (1802–1828), Goya and Delacroix all used this technique successfully. In Lautrec's own time, Paul Gavarni (1804–1866) and Honoré Daumier (1808–1879) exploited its possibilities.

It is hard to imagine any other technique more ideally suited to Lautrec's artistic aims: oriented towards cloisonnism, and inspired by Japanese art, he used it for the first time in a circus picture of 1888. It allowed the artist to adopt what had previously been a highly unusual

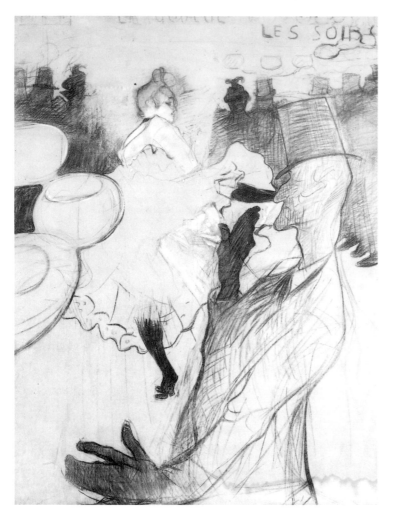

La Goulue and Valentin the Contortionist, 1891
La Goulue et Valentin le Désossé
Charcoal and oil on canvas, 154 x 118 cm
Dortu P 402. Albi, Musée Toulouse-Lautrec

La Goulue and Valentin the Contortionist at a joint performance, *c.* 1892.

compositional arrangement, whereby the scene is dramatically curtailed, cut off by the poster's outer edge. This results in an extreme levelling of pictorial depth, whereby the figures detach themselves from the background and take on greater weight. It is also possible to demarcate the different planes from one another by means of emphatic outline, and this is not only a feature of poster style, but is also one of the most important features of modern art in general, especially when shading is not used.

The chansonnier Bruant was exactly the right type to impress Lautrec, because of the brash effrontery with which he treated his audience, an audience made up of sophisticated gentlemen in smart attire and elegant sparkling women, who ventured among the people for a change and visited the cabaret in search of prurient entertainment. Lautrec despised these people just as much as Bruant did, and delighted to see Bruant expose them. It was just what he did in his own painting. It was Bruant himself who insisted that Lautrec should do a poster for him when he moved to the Ambassadeurs, the famous café on the Champs-Elysées next door to the equally famous Hôtel Crillon, mostly frequented by diplomats and other important persons. Lautrec painted a very romantic and imposing picture of him, with his cape thrown over his shoulders and his famous red scarf around his neck, very much in the style of the Japanese woodcut (p. 99).

Moulin Rouge: La Goulue, 1891
Lithograph in four colours (poster),
191 x 117 cm
Adhémar 1, Wittrock P 1, Adriani 1
Private collection

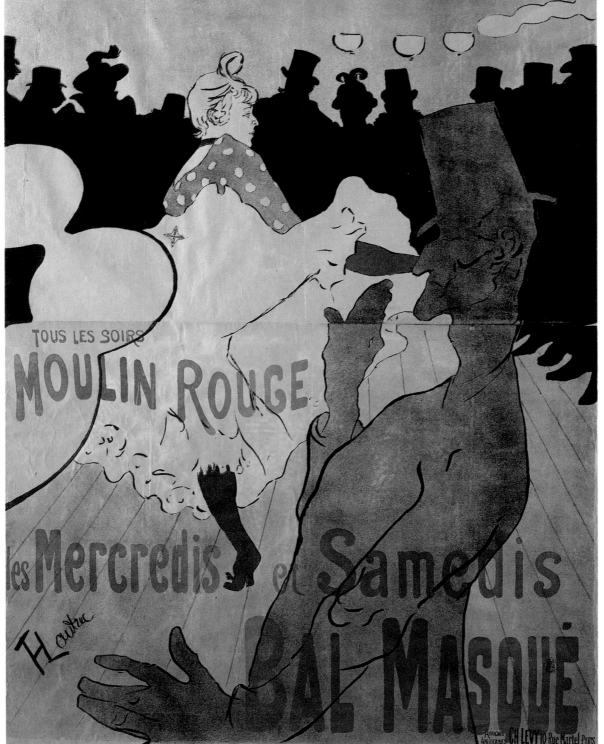

La Goulue dances the can-can. La Goulue was actually called Louise Weber (1870–1929), but was given her nickname as a result of her uncontrolled appetite (goulue = greedy). She was the most successful can-can dancer of her time and appeared at the Moulin de la Galette, the Alcazar, the Elysée-Montmartre, the Jardin de Paris, and later especially at the Moulin Rouge, frequently with Valentin the Contortionist, her partner in the quadrille. She was the most attractive and popular dancer there. La Goulue was from the Alsace and worked as a washerwoman until she was discovered. When she became too fat and the Moulin Rouge withdrew the quadrille, she opened her own show booth at the Foire du Trône, which Lautrec decorated, in 1895 (pp. 90/91). After that she worked as a flower-seller, in 1896 even as a wrestler at the Neuilly Fair, and as an animal tamer. Later she lived with a man who exhibited her as a fairground curiosity in 1925. She deteriorated ever more, survived for a time as maid in a brothel, and died lonely and impoverished in the Hôpital Lariboisière in Paris.

"The afternoon before the performance," Joyant recounts, "the posters are being mounted on the advertising boards at the entrance, and Lautrec and Bruant are looking on. When Pierre Ducarre, director of the establishment, sees them he yells: 'What pigwash! That's terrible! Take it down at once!' At which Bruant shouts back: 'You leave it there, and what's more, stick it up on the stage on both sides… and if it's not done by quarter-to-eight – eight's no good – I'll chuck in my number and disappear!' At the appointed time the poster is mounted on the stage and surrounds Bruant from all sides; the success of the chansonnier, and of his image, is overwhelming. After the performance Ducarre has to admit that he was wrong. 'Now, my friend,' says Bruant disdainfully, 'you'll stick it up all over Paris to make amends.'"

While Bruant sings the praises of Nini Peau-de-Chien, the renowned heroine and seductive whore from the Bastille district, Lautrec paints her, giving her the features of Frédéric Wenz's companion, Jeanne. Wenz was a fellow-student and friend from Cormon's studio. While Bruant portrays a streetwise woman, Lautrec paints the dreamy, questioning look of a drinker. Melodrama and caricature are replaced by a moving image of simple humanity. Never before had Lautrec been so busy. Disconsolate for many years over the lack of opportunity to show his work, he now saw it everywhere, not only in his friend Bruant's cabaret but also in the Volney artists' circle and in the Salon des Indépendants. The pictures sold well and received an excellent press. The critic Yvan Rambosson saw "great value in the contingency of the banal", Octave Maus (1856–1919) recognised in Lautrec's work "art divested of the conventional and the literary. Its rawness prompts deep reflection; it is the art of bitterness, fever and shamelessness." In May Lautrec travelled to London in the company of Pissarro. Never before had his creativity reached such a pitch.

He began to take an interest in Jane Avril. He had known her as a pale background figure in the Moulin Rouge; now she began to dance, as Joyant put it, "like an orchid in delirium". She was the exact opposite of La Goulue, for whom dance was the sensuous and impure expression of superfluity and excess. For Jane Avril, dance was spirit and form. Lautrec delighted in the unusual figures she drew with her legs, and in her pleasing, harmoniously designed costumes. She was the only dancer in the Moulin Rouge who did not wear white underclothes, but coloured silk and muslin lingerie in black, green, violet, blue or orange tones that made wonderful harmonies of colour.

This was no longer a superficial dalliance on Lautrec's part; he was bewitched. Several gallant protectors appeared, one after another, but that did not trouble the relationship. The two enjoyed friendship and mutual trust. She liked playing the part of the lady of the house for him, and all above she admired him as an artist. He painted her incessantly, enchanted by her demureness, which he found provocative. His pictures give her a disturbing, perverse magic, described by Arthur Symons as the expression of "depraved virginity". Each of Lautrec's pictures and posters captures a vital moment of her life: as she

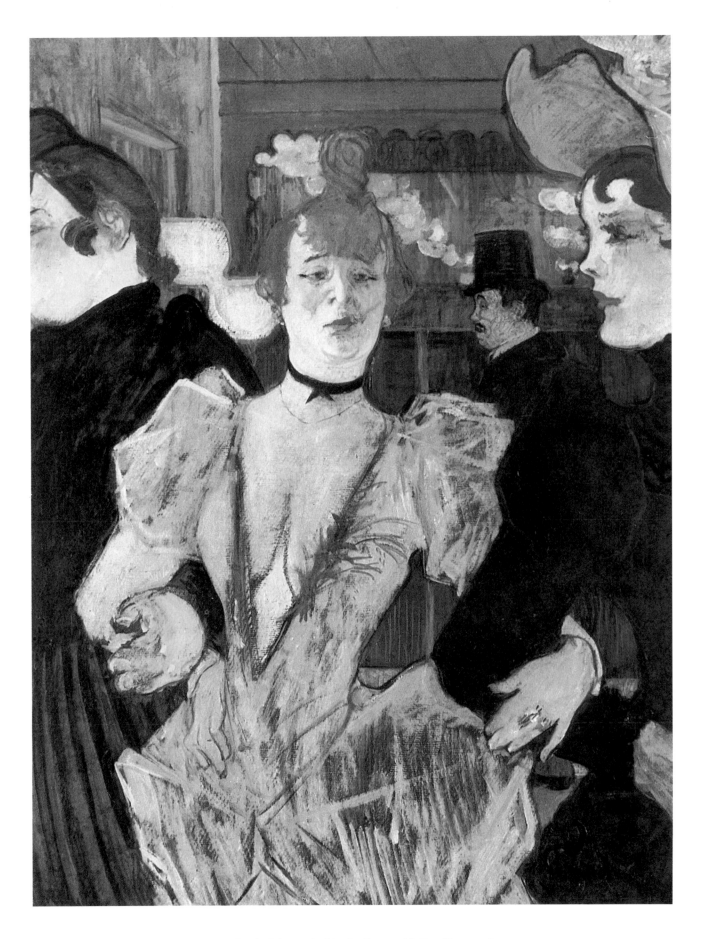

La Goulue Arriving at the Moulin Rouge with Two Women, 1892
La Goulue entrant au Moulin Rouge
Oil on cardboard, 79.4 x 59 cm
Dortu P 423
New York, The Museum of Modern Art

Jane Avril (1868–1943), dancer, singer and actress. This photograph provided Lautrec with the starting-point for a painting, upon which the famous poster (p. 105) was in turn based. Avril's father was an Italian nobleman, while her mother was from the demi-monde and died mentally deranged. At first she worked as a cashier at the Hippodrome in the Avenue de l'Alma, then as a horserider. Finally she was allowed to perform the quadrille with La Goulue at the Moulin Rouge, under the name of "Mélinite" (dynamite). That dance made her so well-known that she was able to perform in the best venues of Paris from then on. Famous were her wild dances after the manner of Kate Vaugham. Her greatest triumphs came in the years 1890–94 at the Jardin de Paris (p. 105) and at the Folies Bergère. In 1897 she danced at the Casino de Paris again, and appeared in an ice revue at the Palais de Glace before moving to the Palace Theatre in London. She still had great successes after 1900 in the French provinces and on tour in America. In 1895 she married the journalist and draughtsman, Maurice Biais, who died in 1926 leaving her penniless. She spent the last ten years of her life in an almshouse. Jane Avril was friendly with many artists and had a particularly close friendship with Lautrec, whose pictures she greatly admired. He gave her many of his works, all of which, however, she gave to her lovers over the years.

Jardin de Paris: Jane Avril, 1893
Lithograph in four colours (poster),
124 x 91.5 cm
Adhémar 12, Wittrock P 6, Adriani 11
Private collection

lifts her leg high in one of her solo dance routines (pp. 105 and 109); as she leaves the Moulin Rouge, pulling on her gloves (p. 107); thrusting her hands deep into the pockets of her loose-fitting coat (p. 106). One senses his tenderness as well as his respect for this fragile and sensitive young woman. Sometimes she seems ailing and forlorn, and people wonder whether she is a morphium addict, or they fancy her the daughter of a good English family who has somehow strayed into a troupe of good-time girls, who call her "Crazy Jane". She certainly does not belong to their world; she loves books and pictures, and she can talk. Delicate, and different from the others, she was not particularly popular among her colleagues; but for Lautrec that made an agreeable change.

In the meantime Lautrec had of course progressed. After three years of sowing wild oats and learning from his studies in the Moulin Rouge, his enthusiasm for the quadrille was fading. The can-can and its places of worship no longer inspired him to the same degree, and his last pictures on this theme demonstrate the change. The motifs are no longer the same: he may paint the quadrille in stasis, before the orchestra strike up and the dancers begin to move; or he may choose to draw attention to the psyche or mutual attachment of the women dancing with one another, rather than to their movements.

Increasingly Lautrec sought in his compositions a strict economy of means, and simplification of the motif. His work on poster design proved invaluable, and helped him to focus even more strongly on those elements in his art which were already executed with extreme rigour. The interchange between poster art and painting was of mutual benefit; both were enriched with the expressive and decorative elements that are so typical of his work.

Another star who caught *paparazzo* Lautrec's roving photographic eye was Yvette Guilbert, who made her début at the Ambassadeurs at about this time. She had started her career at the age of fifteen as a mannequin. Her first appearances as a chanteuse had been at the Moulin Rouge and the Divan Japonais; in 1890 and 1891 she performed songs by Jean Richepin, Aristide Bruant and Maurice Donnay with great success.

The mere presence of a star is enough to cause a stir. We know how the image of a filmstar becomes stylised, and associated with idiosyncrasies of costume and style. Bruant and Jane Avril were known for certain movements and gestures, and for a distinctive costume that contributed to the persona. Yvette Guilbert appeared on stage in a white silk evening gown, with black gloves reaching to the top of her arms; just such gloves as were worn by Rita Hayworth in the cult film "Gilda". Yvette Guilbert would excite the audience, drawing her gloves off with a striptease effect that drove them wild with enthusiasm, especially Lautrec, who saw only the gloves, fluttering backwards and forwards like van Gogh's ravens (p. 88).

When Lautrec was finally introduced to her by Maurice Donnay, he was very keen to do a poster for her, but she replied by letter: "Cher

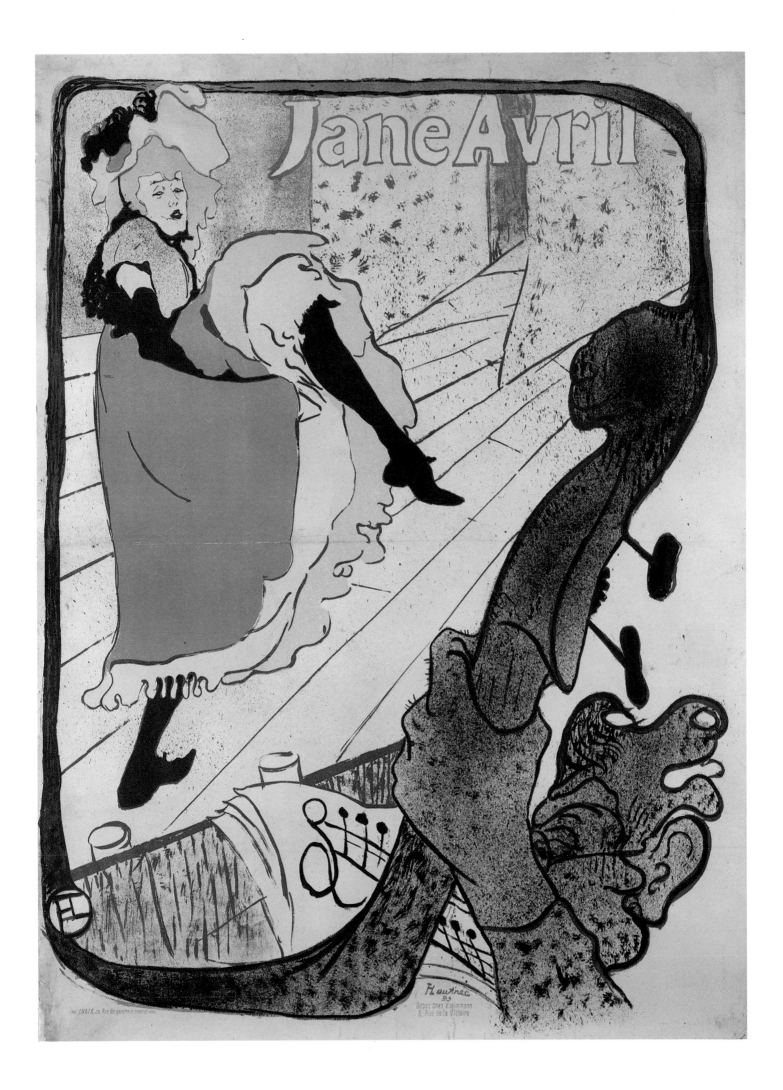

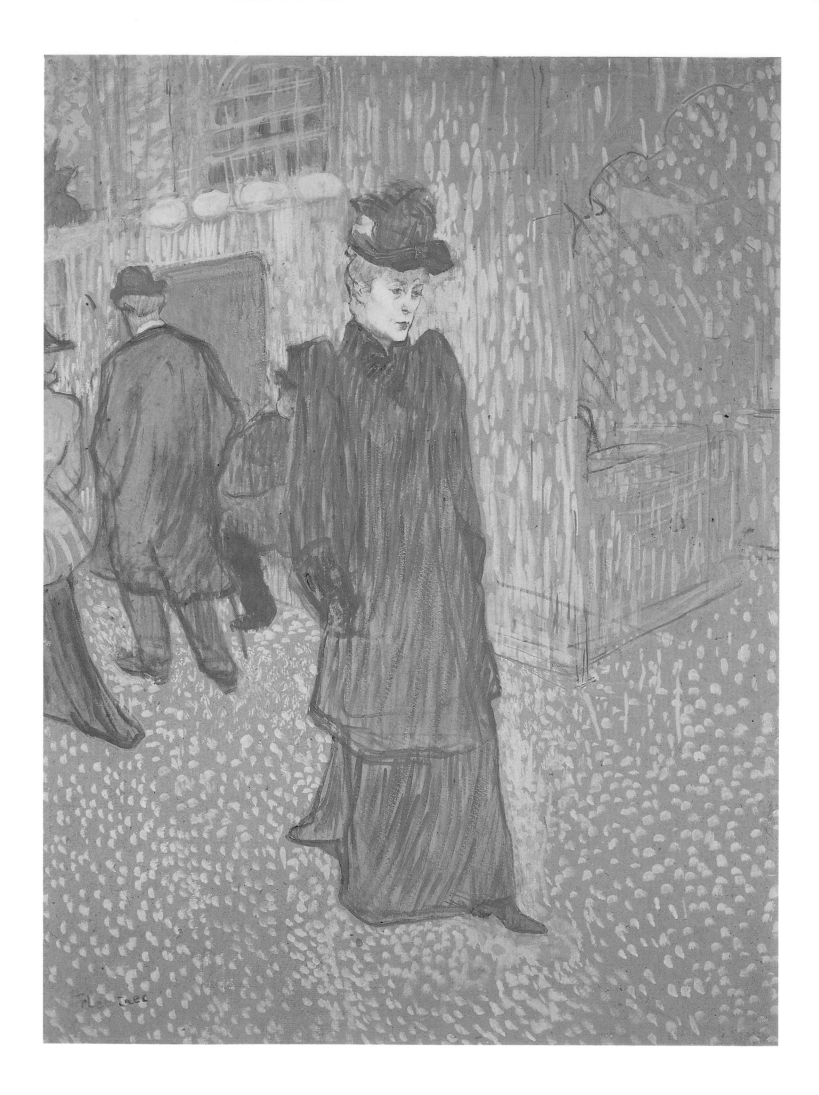

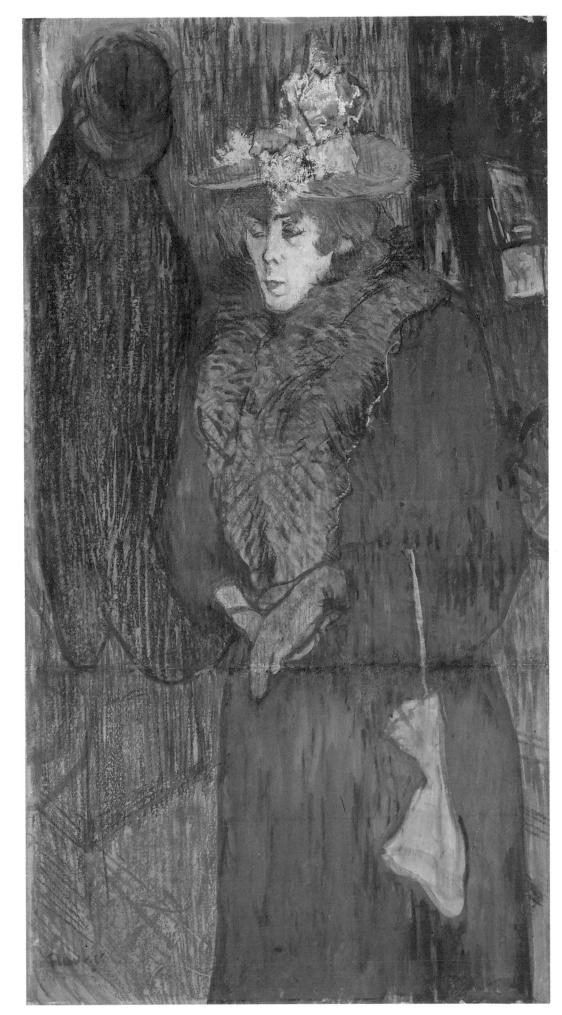

Jane Avril arriving at the Moulin Rouge,
1892
Jane Avril entrant au Moulin Rouge
Oil on cardboard, 102 x 55 cm
Dortu P 417
London, Courtauld Institute Galleries

PAGE 106:
Jane Avril leaving the Moulin Rouge, 1893
Jane Avril sortant du Moulin Rouge
Oil and gouache on cardboard
84.3 x 63.4 cm. Dortu P 414
Hartford (CT), Wadsworth Atheneum,
Bequest of George A. Gay

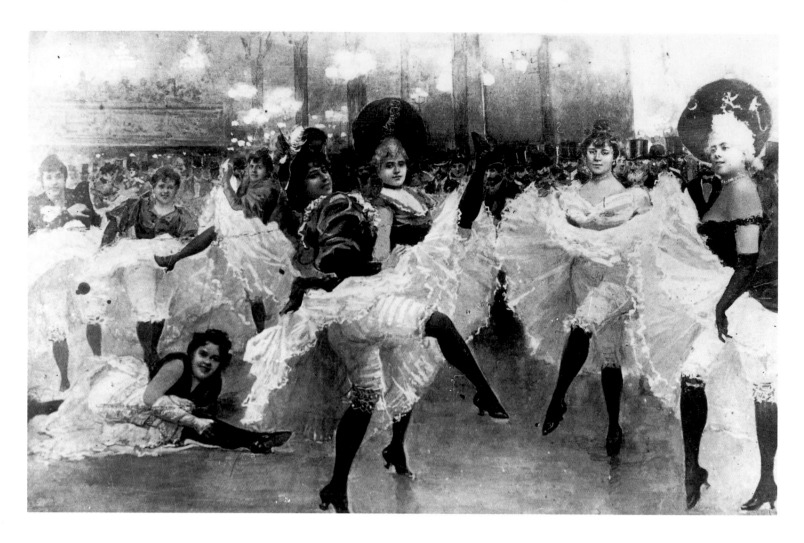

Dancing the quadrille at the Moulin Rouge.
From left: an unknown dancer, Môme Fromage, Serpolette (doing the splits), Nini Pattes-en-l'Air, La Sauterelle, Casque d'Or, La Goulue and Rayon d'Or.

Monsieur, as I said to you, my poster for next winter has already been commissioned, and is almost finished, so we will have to wait for another occasion. But for goodness sake, don't make me so horribly ugly! Just a little less ugly! Lots of people visiting me uttered a cry when they saw the coloured sketch... Not everyone sees just the artistic side of it... of course not! Many thanks and warmest good wishes. Yvette."

Lautrec's art made it possible for Yvette to forget his unfortunate appearance, and, intelligent as she was, she was less repelled by him than fascinated by his talent. She might have taken up his offer, but this was made difficult by the circle she lived in. On the occasion of her first meeting with Lautrec she was struck dumb, as she recounts in her memoirs, when she encountered the "enormous head of dark hair, the very dark face with black beard, an oily skin, a nose large enough for two faces, and a mouth that slices across the face from cheek to cheek, a terrifying obscene gash framed by bulbous purply pink lips, curving upwards. Finally my eyes meet his. How beautiful they are! Large and full of warmth, shining with fire and light. I go on looking at them, and Lautrec quickly removes his pince-nez. He knows his one magnificent feature, and he offers it to me with all his generosity. His gesture draws my attention to his comical dwarf hand, sitting broad and square on a strange, puppet's arm..." As usual, Lautrec's simplicity and charm have a rapid effect.

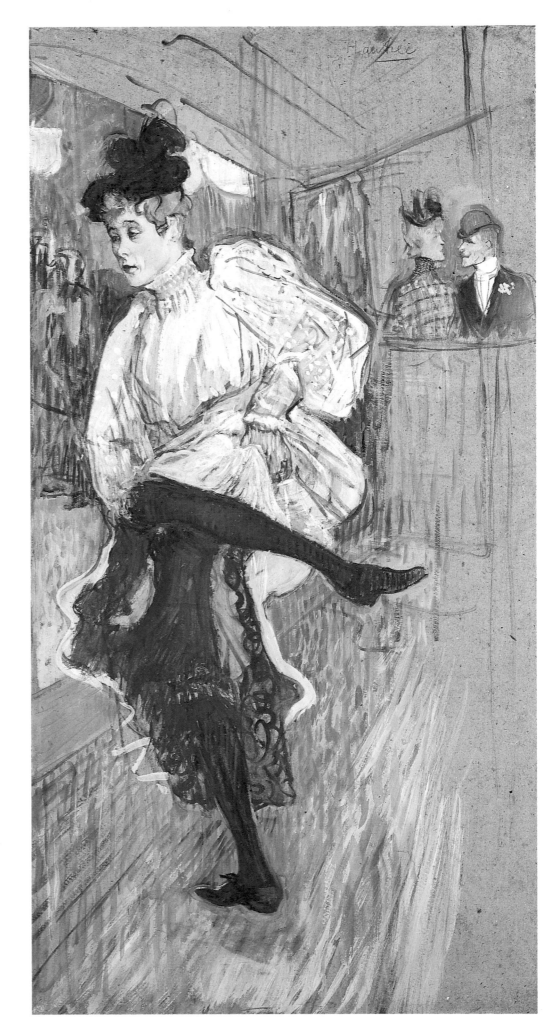

Jane Avril Dancing, 1892
Jane Avril dansant
Oil on cardboard, 85.5 x 45 cm
Dortu P 416. Paris, Musée d'Orsay

"There was an uproar in the middle of the crowd," relates Paul Leclercq, a friend of Lautrec's, "a corridor was formed and Jane Avril danced: she turned, graceful and light, a little pale, a little thin, but classy… she wove back and forth, weightless, just like a climbing plant; Lautrec shouted his applause to her."
Jane Avril was always similarly attired for her sensational performances. She wore a full-skirted dress of white muslin that was gathered in a narrow embroidered collar at the neck, and had wide sleeves. With this she wore a kind of beret on which a few feathers swayed. Trademark of her choreography was a particular pose in which her left leg was raised high and swivelled wildly back and forth.

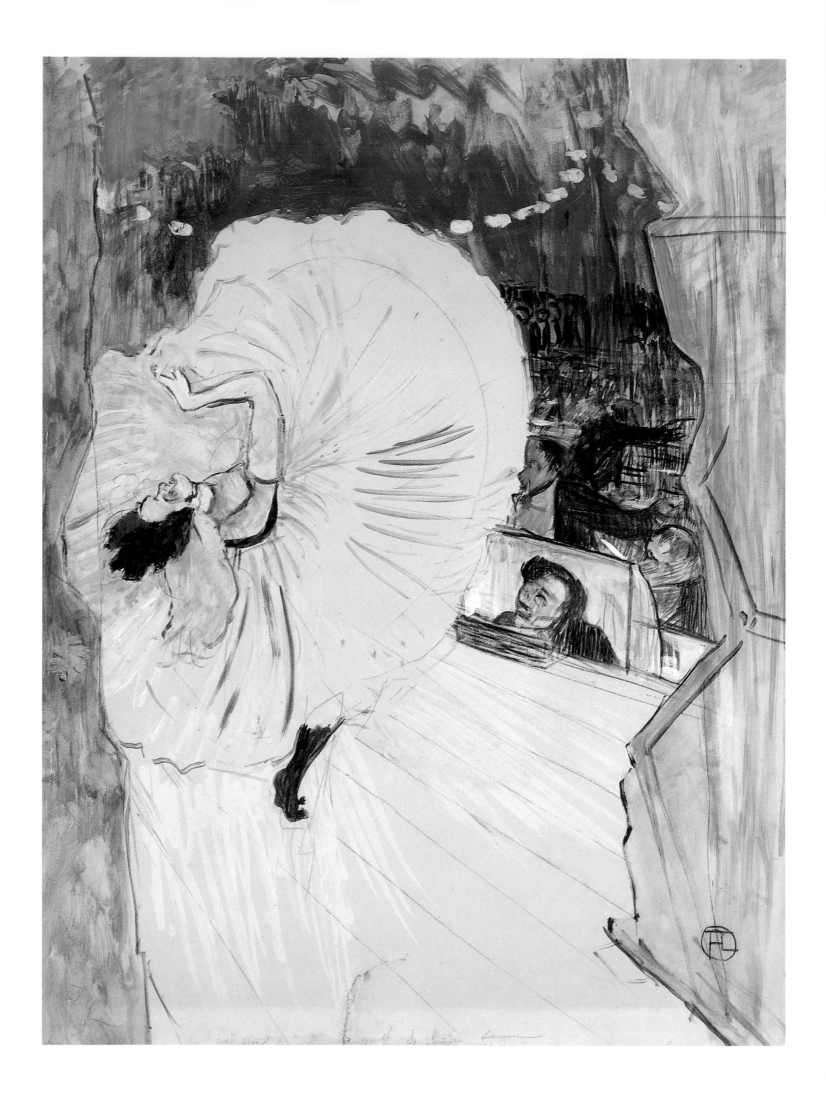

It was only after the very favourable press response to the first "Yvette Guilbert" album, which contained a series of lithographs, that the star was convinced of his talents and reconciled with "dangerous" portraitist. "Really," she said to him, "you are the genius of deformation", to which the painter made the acerbic reply: "Yes … that should be obvious!"

Their encounters were tempestuous. "Love!" he cried. "You can sing of it in every key, Yvette, but take care… Songs of yearning we could understand, and we could be amused by the rush of blood… But love, my poor little Yvette… Love does not exist!" "And the heart has nothing to do with love. How can an intelligent girl confuse the heart with business? Men, my little Yvette, who are loved by pretty girls, have only sin in mind, sin on their lips, sin in their hands… sin in their bellies… And how is it with women? They enjoy it, the sweet villains!" He showed her one of his albums and pointed to a sketch: "Look at their ugly mugs, all these beloved lovers, these Romeos and Juliets!" And he laughed and laughed, until he was overcome by emotion and the laugh became a shiver.

Lautrec bestowed immortality on other stars too, for instance on Loïe Fuller, the discovery of the 1893/94 Paris season. The highly talented American dancer knew very well how to turn chance to her advantage; the idea for her number is said to have occurred to her while she was trying on a theatre costume: "We asked the lighting man to turn on the stage lights, and the orchestra leader to play a soft melody. It was a matter of choosing which dress I was to wear." She remembered a dress that had been brought back from India for her: "My dress was so long that I was always treading on it, and I automatically lifted it up with both hands, and then lifted both arms high in the air and went on dancing round the stage like a winged spirit. Suddenly a voice called from the auditorium: 'A butterfly, a butterfly!' I turned in circles, running at the same time from one end of the stage to the other, and another voice cried: 'An orchid!'" From that time on, Fuller cultivated this type of dance at the Folies Bergère and at the Metropolitan Opera. Finally she appeared on the stage swathed in tulle veils which she unfolded and wound into incredible spirals with long sticks that extended her arm span, creating mysterious aureoles of light and shade (p. 110).

What a challenge for a painter! One can imagine how fascinated Lautrec was by this phenomenon, that could be transformed successively into clouds, a rainbow or a shower of petals. Her "Fire Dance" was likened to flowing lava: beneath her feet were red lights, shining up through a sheet of glass to make her seem unreal. At this time electric light was still used very sparingly in the theatre, but she could "sculpt" the light with her veils, scattering colour like a kaleidoscope. Since she enthused over every new discovery, she entered into correspondence with Marie Curie, who had just discovered radium, and explained to her that she worked in a real-life laboratory, impregnating fabrics with phosphorescent salts. She thus performed her own

Loïe Fuller at the Folies Bergère, 1892/93
Loïe Fuller aux Folies Bergère
Black chalk and oil on cardboard,
63.2 x 45.3 cm. Dortu P 468
Albi, Musée Toulouse-Lautrec

Loïe Fuller in her famous veil dance at the Folies Bergère, c. 1892. The American dancer, born in Illinois, performed in a costume made entirely of veils, illuminated by coloured reflecting lights. "Electric technique", was Lautrec's opinion. Fuller did not particularly like the painter although he portrayed her several times.

PAGE 110:
The Wheel (Loïe Fuller), 1893
La roue (Loïe Fuller)
Gouache on cardboard, 63 x 47.5 cm
Dortu P 483. São Paulo, Museu de Arte de São Paulo Assis Chateaubriand

PAGE 112:
Caudieux, 1893
Charcoal and oil on paper, 114 x 88 cm
Dortu P 474
Albi, Musée Toulouse-Lautrec

Caudieux, called "Homme canon", performed as a comic singer at the Petit Casino as well as at the Eldorado and the Ambassadeurs. He was famous for his agility, which was in no way impeded by his rotund belly. He reached the height of his career around 1893 when this portrait of him was painted. In the same year Lautrec also designed a poster for him (p. 129, no. 9), and portrayed him, along with other luminaries of the Paris entertainment world, in his first album of lithographs ("Café-Concert").

LEFT:
Alfred la Guigne, 1894
Oil on cardboard, 65 x 50 cm
Dortu P 516
Washington (DC), National Gallery of Art

"Alfred la Guigne" was the title of a story in the book *La Lutte pour l'Amour (The Battle for Love)* by Oscar Métenier that had appeared in 1891. However, in this scene, which is probably set in the Moulin de la Galette, Lautrec has actually portrayed his friend Gaston Bonnefoy and only later did he offer it as an illustration for Métenier's book. Lautrec's dedication in the lower right-hand corner reads: "Pour Métenir/d'après/son Alfred la Guigne/T-Lautrec".

"Radium Dance" and "Ultra-violet Dance". She positioned mirrors all round the stage, which reproduced her figure to infinity as she flitted past. Lautrec for his part was busy in the printing laboratory, impregnating paper with colours. Numerous metal sculptures were produced of Fuller as lady of the flowers; she could well claim to personify the spirit of the modern style. The Daum glassworks produced a small glass figurine of her, with blue glass shaded in green and mauve. She is taking a light, dancing step, her head is bent to resist the wind, and she is wrapped in a veil, suggestive of the body beneath. Lautrec sought to translate the original spectacle and its exciting colours into his own language, using new lithographic techniques. After the prints were made he applied water-colour paint to each sheet with a thick wad of cotton; then he strewed gold-dust irregularly over the whole surface. Each sheet is quite different from all the others, and the colour varies as did Fuller's costume under the variegated theatre lights (p. 111).

PAGE 114:
Theatre Box with Gilded Grotesque, 1894
La loge au mascaron doré
Colour lithograph, 37.2 x 32.7 cm
Adhémar 72, Wittrock 16, Adriani 69
Private collection

PAGE 115:
Divan Japonais, 1893
Lithograph in four colours (poster),
81 x 61 cm
Adhémar 11, Wittrock P 11, Adriani 8
Private collection

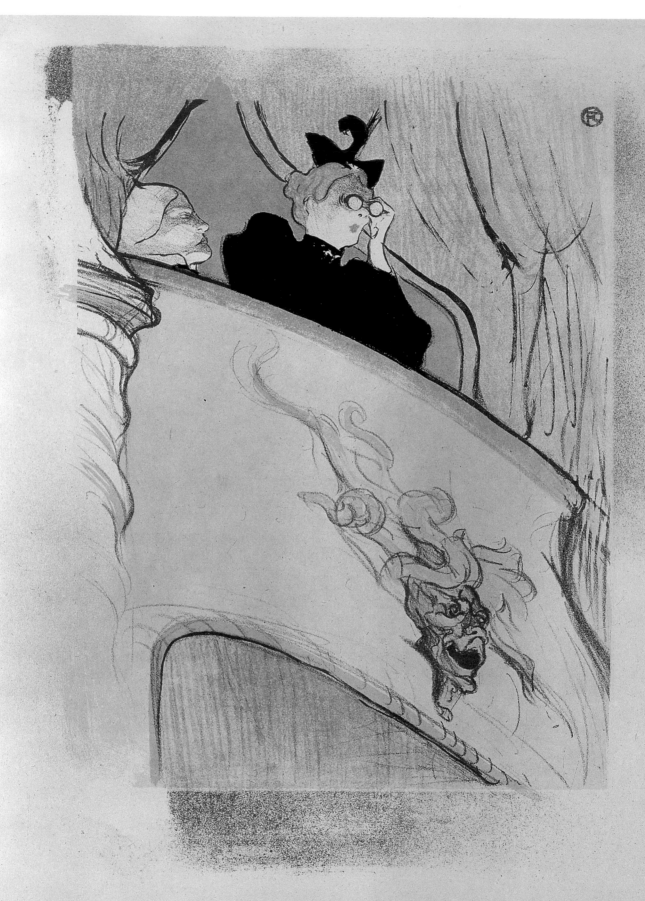

FLautrec

Une loge

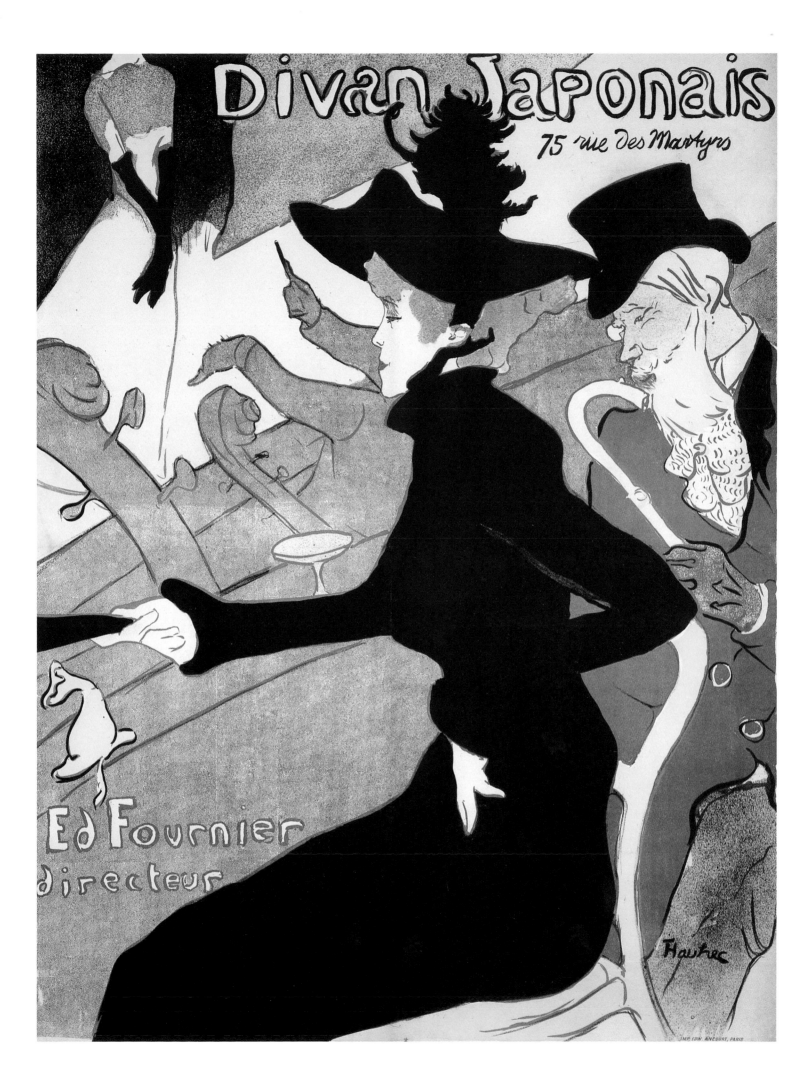

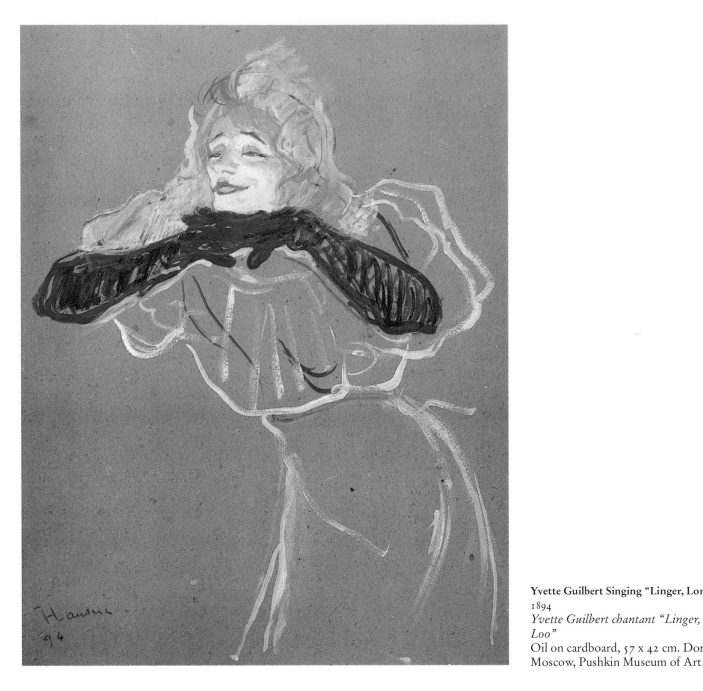

Yvette Guilbert Singing "Linger, Longer, Loo",
1894
Yvette Guilbert chantant "Linger, Longer, Loo"
Oil on cardboard, 57 x 42 cm. Dortu P 522
Moscow, Pushkin Museum of Art

May Milton, 1895
Lithograph in five colours (poster),
79.5 x 61 cm
Adhémar 149, Wittrock P 17, Adriani 134
Private collection

The English dancer and singer, May Milton, appeared in a ballet troupe in Paris, which she then left in order to take up an engagement in the Rue Fontaine. She was a close friend of Jane Avril's without, however, attaining anywhere near the same kind of success – even though Lautrec designed this poster for her. Pablo Picasso included the poster of May Milton in the background of his painting *The Blue Room*, 1901 (Washington (DC), The Phillips Collection), in which it hangs on the wall.

Lautrec's lithographs may be said to mark the culmination of a long development in his work, for which many preparatory phases were necessary. They are therefore of equal importance as his paintings. He might approach the final version of a particular work in a variety of ways: a sketch might be followed by a more detailed drawing, a study by an aquarelle, a tempera drawing or an oil painting, usually on cardboard; then he would proceed to a final version painted on canvas and often to a lithograph as well. But Lautrec's talent also enabled him to dispense with the preliminary stages, and to proceed straight away to the drawing on stone and printing, thanks to his remarkable memory for detail. He drew at such a speed and with such precision, and his eye for essentials was so keen, that some of his most successful lithographs were done in this way.

In the 1890s Lautrec was a regular customer of the Paris printers Chaix and Verneau, Ancourt and Stern. He felt quite at home on their

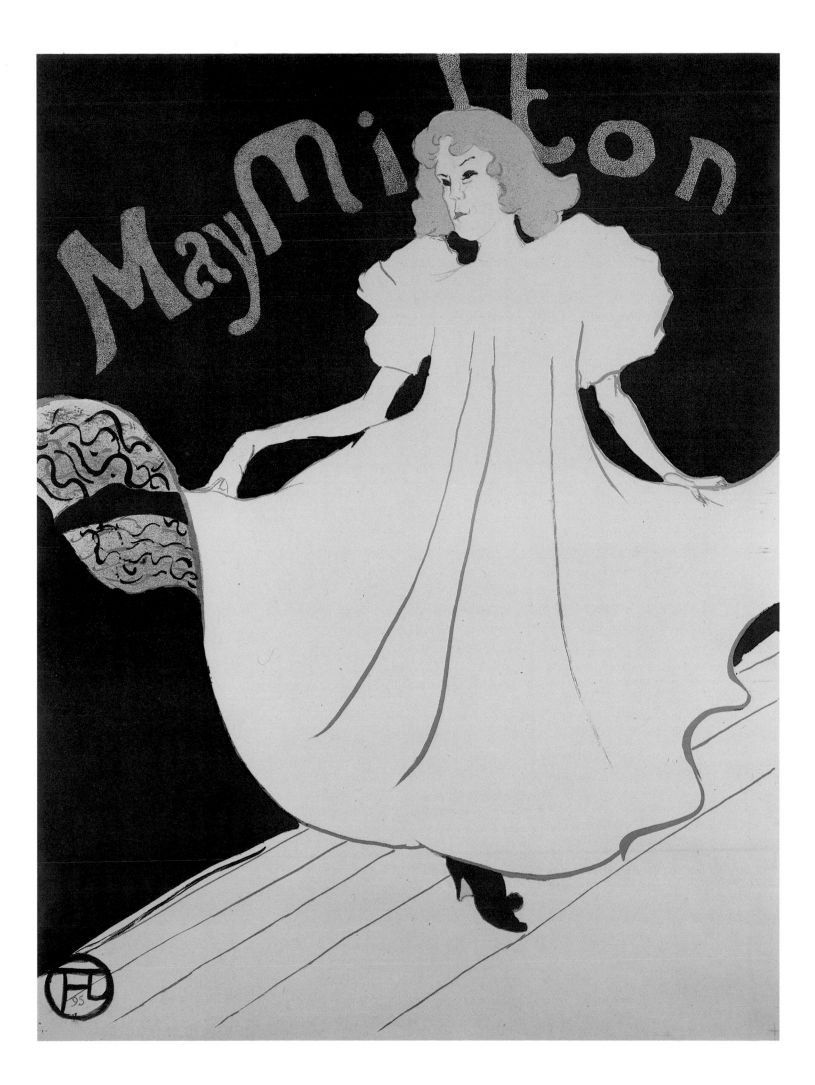

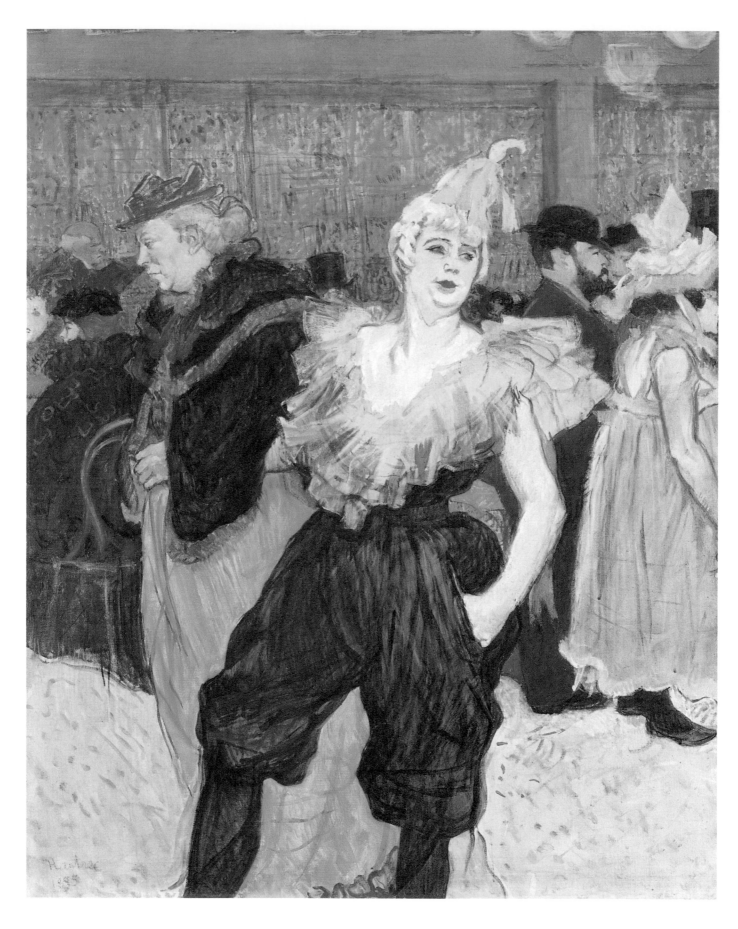

The Clownesse Cha-U-Kao at the Moulin Rouge, 1895
La clownesse Cha-U-Kao au "Moulin Rouge"
Oil on canvas, 75 x 55 cm
Dortu P 583
Winterthur, Oscar Reinhart Collection

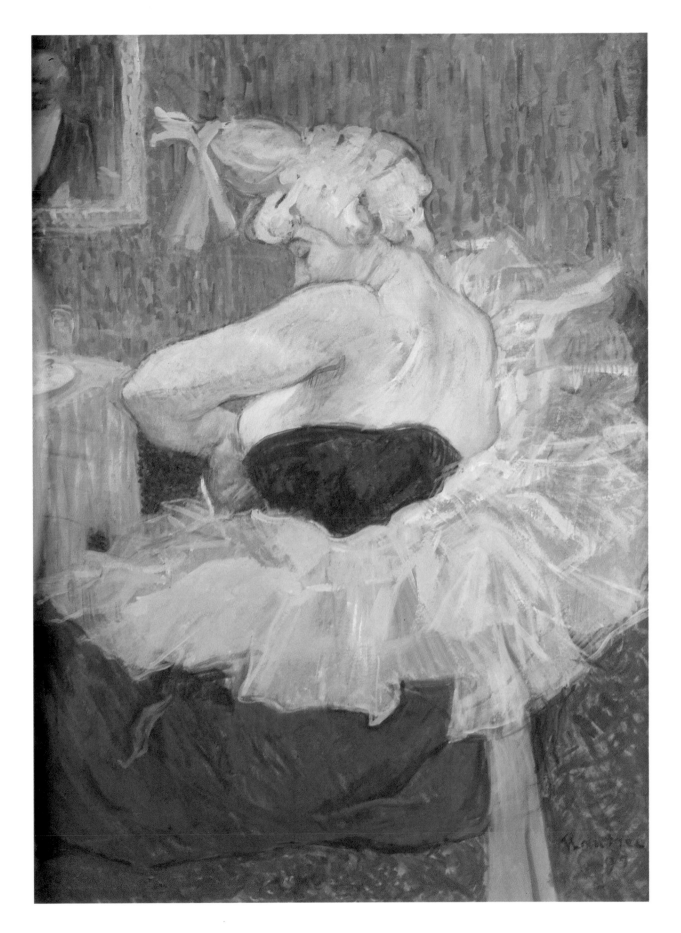

The Clownesse Cha-U-Kao at the Moulin Rouge, 1895
La clownesse Cha-U-Kao au Moulin Rouge
Oil on cardboard, 64 x 49 cm
Dortu P 581
Paris, Musée d'Orsay

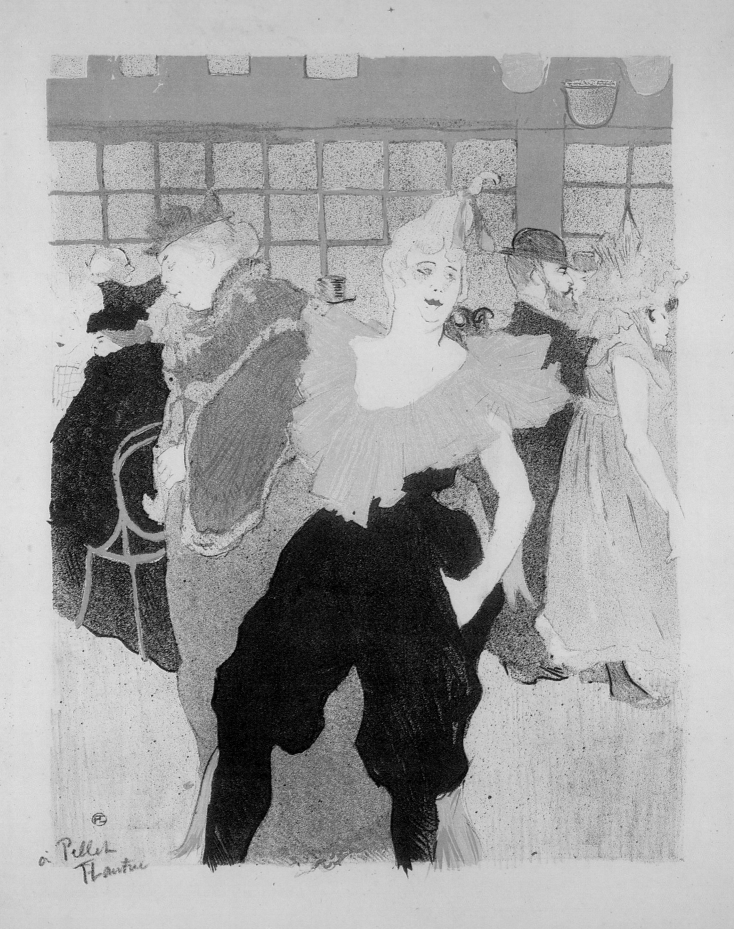

premises, and experimented with different colours on paper of various shades. He followed his innovatory techniques through to completion, pulled the first proofs from the litho stone himself, supervised the whole print-run and put the finishing touches to each print.

Undoubtedly he was obsessive about details of technique and of his chosen motifs. He was quite willing to see the Merovingian operetta "Chilpéric" by Florimond Hervé (1825–1892) more than twenty times, with Marcelle Lender (1863–1927) playing the lead. The friends who accompanied him protested vehemently that he already knew the whole piece off by heart, but he was so fascinated by Lender's décolleté, her back and her costume that he wanted to make further studies: "I go there in order to see Lender's back; have a very good look at it, you will never see anything more beautiful." He made six lithographs of Lender (p. 92) and painted the ambitious *Marcelle Lender Dancing the Bolero in the Operetta "Chilpéric"* (p. 93). This picture is clearly preceded by protracted studies and reflection. On this occasion, realism yields pride of place to the artificial element. This time there is no perspective suggested by floorboards, but an accurate recreation of the stage set. With consummate skill, he presents the scene against which the dancer's movements can best be observed. Again Lautrec uses beams of light shining up from below, which give a mask-like and yet highly individualised and characteristic appearance to the faces.

Sic transit gloria mundi! So passes away earthly glory. The fame of Lautrec's idols, from La Goulue to Loïe Fuller, was meteoric: it rose and fell. There were others who never achieved comparable fame in spite of his talent and his brilliant posters, but there were two whom he took it into his head to "launch" – the English dancer May Milton, inseparable friend of Jane Avril, and the Irish singer May Belfort. Both had some talent, but there were very personal reasons for Lautrec's interest in them. Miss May Belfort was promoted in the programme as an English operetta singer, but her singing was considered poor. This bleating sheep in baby dress, with curls falling to her shoulders, cascades of lace at her wrists and a little bonnet tied under her chin, came on stage with a kitten in her arms, which she cradled as she declaimed a lament in lisping childish tones. "I have taken her by the hand," said Lautrec. What attraction can there have been?

For him she had the charm of a sickly child. But her pure and childish appearance should not blind anyone to her taste for the exotic, and even for the dubious and sordid. Snakes, toads, crabs and scorpions were her favourite creatures. Joyant called her "Frog", while Lautrec called her "Orchid" and pressed garlic-flavoured kisses upon her. This naughty child stretched out her limbs like a cat to the artist's fantasy, and he painted five quick portraits of her, printed several lithographs and finally did a poster for her, a dream in red that shone out from the walls of Paris (p. 131, no. 18). The poster was matched by one in blue, designed at the same time for May Milton (p. 117). Despite his greatest endeavours, artistic and otherwise, the public was not convinced of the talent of May Belfort, and she disappeared from Paris and from Lau-

Cha-U-Kao: Nude dancer, clown, contortionist and lesbian. Her artist's name is taken from the words "Chahut-Chaos", meaning noise and chaos. It was also the name of a frenetic dance, popular at the Moulin Rouge where she performed.

The Clownesse Cha-U-Kao at the Moulin Rouge, 1897
La clownesse Cha-U-Kao au Moulin Rouge
Colour lithograph, 41 x 32 cm
Adhémar 231, Wittrock 178, Adriani 203
Private collection

Marcelle Lender (1863–1927) was a variety artist who first appeared at the Théâtre Montmartre at the age of 16. She undertook an American tour with the actor Coquelin, and her greatest successes were celebrated in the revues at the Théâtre des Variétés and with the operetta "Chilpéric", in which she both sang and danced.

Seated Woman, 1897
Femme assise
Oil on cardboard, 63 x 48 cm
Dortu P 652. Munich, Bayerische
Staatsgemäldesammlungen, Neue Pinakothek

The features suggest that this is a portrait of the actress and dancer Marcelle Lender (cf. pp. 92, 93 and photograph above). She is easily recognisable because of her narrow, long snub-nose with its light upward curve, and the lips which become very thin at the outer edges. Her features recur in Lautrec's pictures again and again. She came to fame in February 1895 with her sensational success in the operetta "Chilpéric" by Florimond Hervé. Lautrec discovered her in the Théâtre des Variétés and he sat enthralled at her feet during more than twenty performances.

trec's life at the same time. He completed a few more drawings of her, and the lithographs, and then he forgot her, but not without ensuring that she would be remembered to this day.

May Milton, beloved friend of Jane Avril, held the trump cards in Lautrec's view: a wild shock of hair and a freckled face. Others had no such favourable memories of her, but commented rather on less advantageous features such as her yellowish teeth and oily complexion. She came to Paris with a troupe of English girls and soon found favour with Jane Avril, who insisted that "Miss" be included in every invitation to dinner. This led Lautrec to call her "Miss Aussi" ("Also"). He painted her twice – once in stage costume for the blue poster, and once in outdoor dress. In spite of her well-wishers, May Milton only danced for one winter, since she did not find favour with the general public. She owes her only true fame to Lautrec.

There is no doubt that Lautrec's interest in "Miss Aussi", as in Jane Avril, was aroused by the fascination that every sexual deviation, but above all lesbianism, exerted on him. During the Moulin Rouge phase the female clown Cha-U-Kao, of whom he painted several masterly portraits, had already become an archetypal figure for him. She personified the double role-reversal of a woman performer in what was traditionally a man's profession, and of a woman who loved other women. She appears in the picture *At the Moulin Rouge: Two Women Waltzing* (p.75), which almost seems an intrusion on privacy. Cha-U-Kao is shown in a very personal, almost secret, moment, as if Lautrec wanted to say: "Look, I will show you what a lesbian is, what a prostitute is – namely, above all, a woman".

How great, by contrast, was the natural beauty of Misia, the good spirit of the "Revue Blanche" circle, and wife of its editor Thadée Natanson. Here the intellectual level was decidedly more sophisticated. The journal brought together many literary stars: Stéphane Mallarmé (1842–1898), André Gide (1869–1951), Pierre Louis (1870–1925), Octave Mirbeau (1848–1917), Charles Maurice Donnay (1859–1945), Maurice Maeterlinck (1862–1949), Paul Valéry (1871–1945) and many others. There were long discussions which proved enriching for Lautrec, and were in marked contrast to life at the Moulin Rouge. Montmartre and its inhabitants still interested him, but he was equally drawn to the intellectual and artistic élite; he appreciated their fine taste and intelligence, and they awakened memories of his background and family traditions.

Misia was the star at the centre of these "Revue Blanche" discussions. Everyone admired her, and she took pleasure in her role as goddess and muse. She was in part responsible for discovering Henrik Ibsen (1828–1906), and she contributed to Aurélien-Marie Lugné-Poe's success at the Théâtre de l'Œuvre. It was for Lugné-Poe, who was at once theatre director and actor, that Lautrec created the set for *Ubu Roi* by Alfred Jarry (1873–1907), working collaboratively with the designers Paul Sérusier (1864–1927) and Paul Ranson (1861–1909). He also designed the programmes for *Salome* by Oscar Wilde (1856–

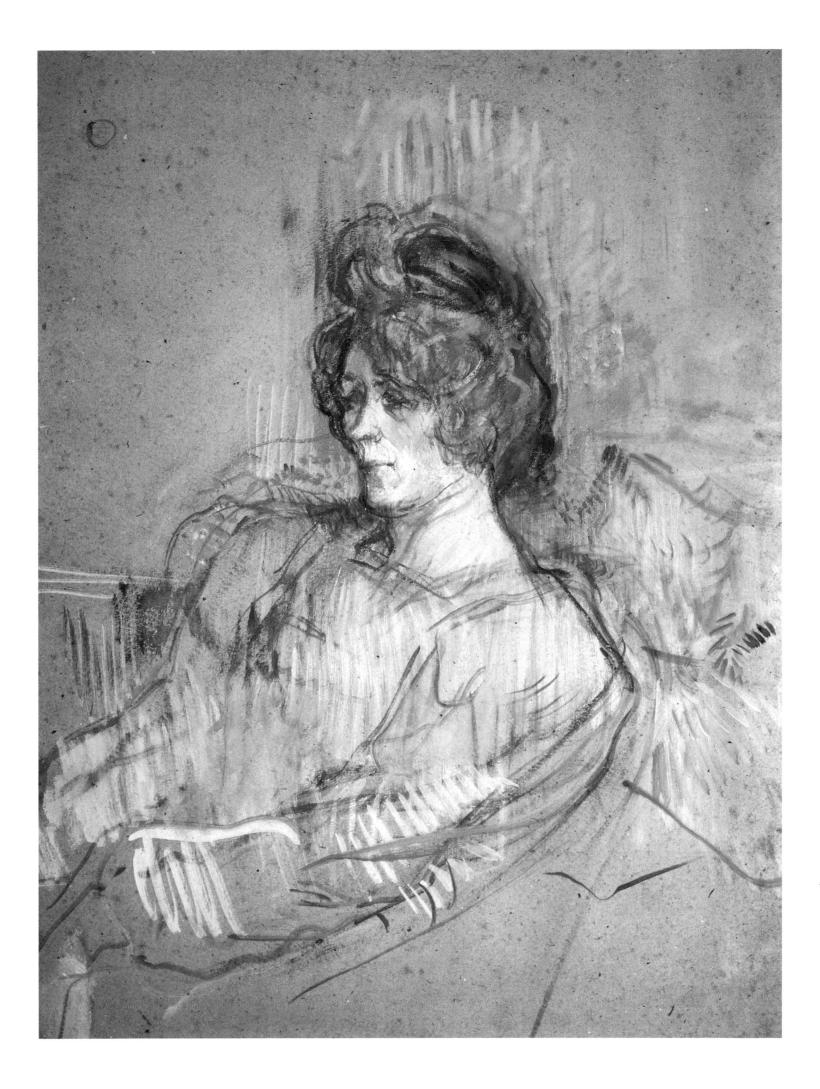

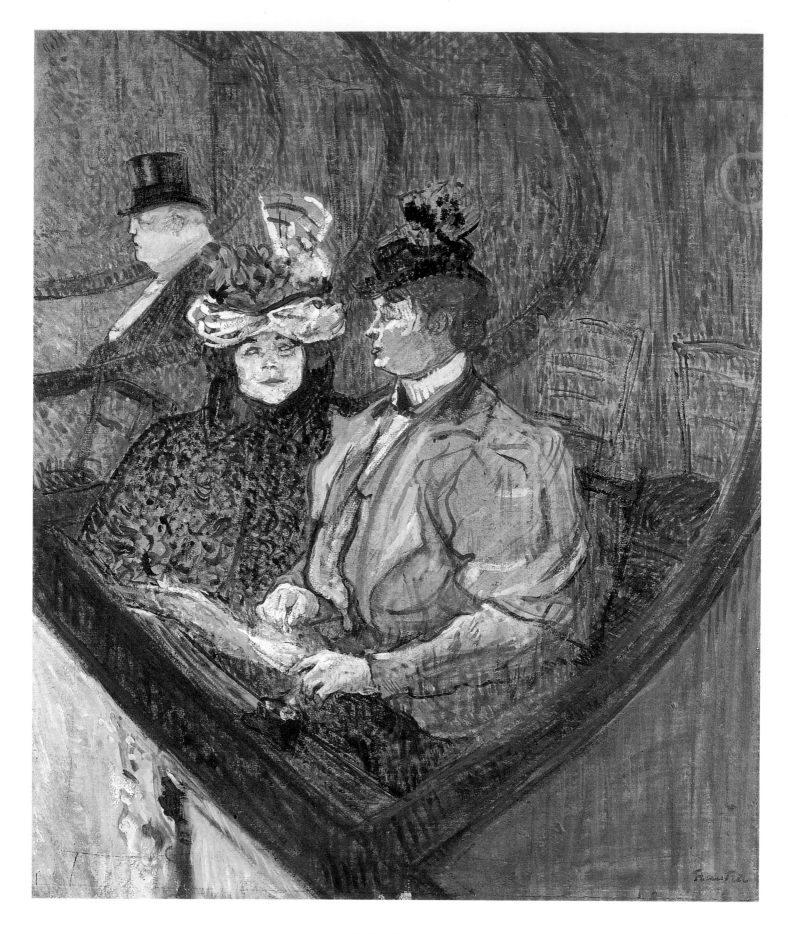

The Grand Box, 1896
La grande loge
Oil and gouache on cardboard, 55.5 x 47.5 cm
Dortu P 651. Private collection

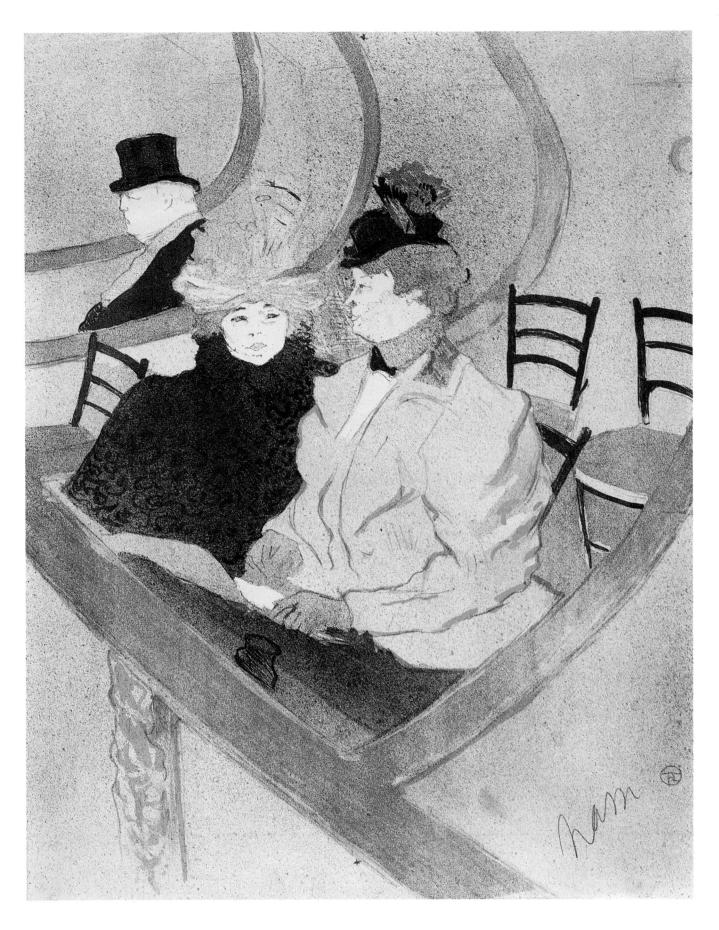

The Grand Box, 1897
La grande loge
Colour lithograph, 51.5 x 40 cm
Adhémar 229, Wittrock 177, Adriani 202
Private collection

Jane Avril, *c.* 1900.

1900) and for *The Leper Girl* by Henri Bataille (1872–1922), in which
Berthe Bady played the leading part. He painted an unusually conven-
tional portrait of the actress, without his customary inspiration, per-
haps because she was not red-haired. He made two lithographs of
Lugné-Poe in his major roles.

Misia was an accomplished pianist, and performed pieces by Gabriel
Fauré (1845–1924) and Claude Debussy (1862–1918) particularly well.
She considered that Lautrec's work had a rightful place among the art
forms which her husband brought together in his journal. He had no
hesitation about including in one and the same issue of the "Revue
Blanche" poems and reflections by Mallarmé, the nimble patter of
Tristan Bernard (1866–1947), Lautrec's masterly black-and-white il-
lustrations together with others by Félix Vallotton (1865–1925), and
inflammatory anarchist articles by Félix Fénéon (1861–1944), and by
the devilishly passionate socialist Léon Blum (1872–1950). "Here art
is treated both playfully and religiously, it is regarded both from the

Jane Avril, 1899
Lithograph in four colours (poster),
56 x 34 cm
Adhémar 323, Wittrock P 29, Adriani 354
Private collection

The appliqué snake on the singer's dress not
only reflects Lautrec's study of the vocabulary
of Art Nouveau, but also adorns the singer's
silhouette with a clarity that highlights her
bodily grace.

1899

JANE
Avril

H. Stern, Paris.

viewpoint of popular culture or from the perspective of a small élite. All are miraculously open to everything, ready to try anything, listen to anything, look at anything. Their openness and good will are disarming; the sting is taken out of snobbish criticism and speculations about the lack of direction. Lautrec's work is a mirror of this life of industrious leisure and smiling fervour" (P. Huisman and M.G. Dortu in *Lautrec par Lautrec*).

Misia revealed a secret about her relationship with Lautrec: "He is a skilful and sensitive practitioner of a sport which I find quite delightful. The rules are as follows: I sit down on the ground in the garden, lean against a tree and bury myself in the joys of a good book. Lautrec crouches in front of me with a paintbrush and tickles the tips of my outstretched feet with the hairs of the brush… This exercise, in which he may use his fingers too at the appropriate moment, can last for hours. I feel exquisite pleasure, and he makes as if he was drawing imaginary landscapes on the soles of my feet…" No such erotic subtlety would have been possible with La Goulue or Nini Pattes-en-l'Air! Lautrec drew numerous sketches of Misia before completing a poster for the "Revue Blanche", in which she was represented as *a grande dame*, with fur jacket and muff, a bunch of violets and a large hat adorned with black feathers (p. 131, no. 23). Misia was no exception in considering that her little playmate had damaged her lovely face: "Lautrec, why do you always make women so ugly?" "Because that is how they are," he replied.

Lautrec was increasingly prone to utter abrupt insults of this sort, which might be ascribed to misogyny but also to an exalted love of women. Such remarks tended to be viewed not as the product of real malice, but rather as a consequence of his continual excesses, of the strain placed on his nerves by his nocturnal life, of his extravagant lifestyle and his permanent lack of sleep. He was drinking far too much. As Thadée Natanson noted: "The tip of his beard never had time to dry out." He was seldom drunk, but constantly, more perniciously, under the influence of alcohol. The whiff of a cocktail was enough for the magic influence to grip him. His understanding and indulgent friends took pains to forget his offensive remarks as soon as they were made, but there were some women who never forgave his insults.

Sometimes Lautrec painted as he spoke. Oscar Wilde refused to sit for him, but Lautrec portrayed from memory the arrogant enervated face with heavy chin and mouth of an ageing temptress, as if he wanted to insult him. Yet beneath the brush strokes one senses that Lautrec was fascinated by the sagging cheeks, pale skin and small contemptuous eyes, set deep in the plump unhealthy face. There was less revenge than sympathy for the writer whom the painter James Abbott McNeill Whistler (1834–1903) once described as "the artist who may not be". Certainly the "monsters" Wilde and Lautrec had little in common.

The revelatory force of alcohol is felt not only by Lautrec, but by others too. To intoxicate the delicate plant of art and literature, to make

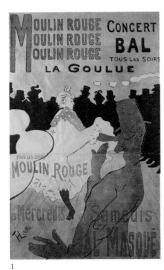

1

2

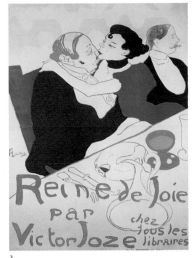

3

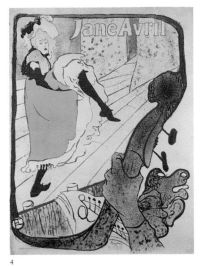

4

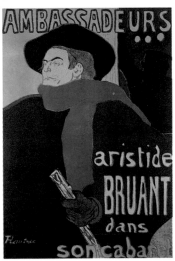

5

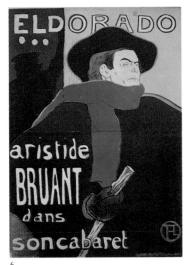

6

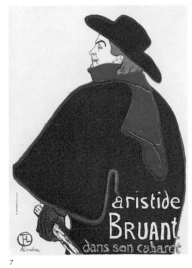

7

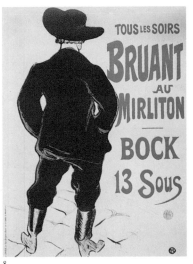

8

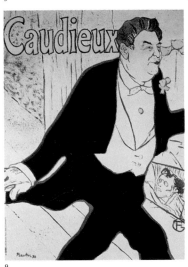

9

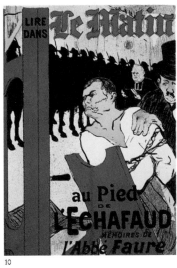

10

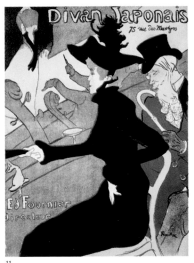

11

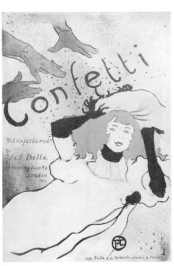

12

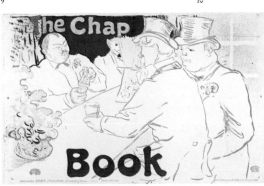

13

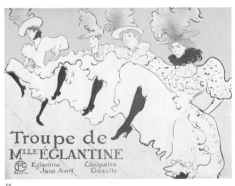

14

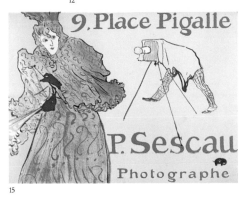

15

the awe-inspiring lose their awesomeness, to destroy dignity, to tear the mask from the face – all this appealed very much to Lautrec, and so he took the opportunity to appoint himself as barman when Natanson invited three hundred guests to his house in the Bois de Boulogne. Lautrec had his head shaved for the occasion, his beard reduced to sideboards; he wore a short white jacket and a waistcoat made from an American flag. He spent the whole night shaking cocktails, inventing one explosive mixture after another, each increasingly likely to knock out the worshipful company on the spot. The next day he boasted that during that memorable night he had filled more than two thousand glasses. His killer drinks with such attractive names as "Love-Awakener" and "Prairie Oyster" were highly laced, and in order to stimulate the guests' thirst he served a *flambé* dish of sardines in gin or port on a silver platter. Naturally the guests fell like flies. Fénéon was hot in pursuit of Mallarmé, bent on persuading him to down some of this devil's brew, but the latter vehemently refused "to quaff the irksome cup". The bald head of Edouard Vuillard (1868–1940) turned turkey-red. Bonnard opened one eye and thought he was facing a canvas; Lugné-Poe believed he was on stage. Lautrec exulted behind the bar, sober on this one occasion, and beheld with sparkling eyes through his spectacles the battle-field, his work. At dawn he fled joyfully, the deed was done. The next morning Romain Coolus (1868–1952) sent him a quatrain: "They envy you your profile Greek, that suits you in your barman's role, no fop or dandy to be sure, Toulouse-Lautrec most rare and droll!"

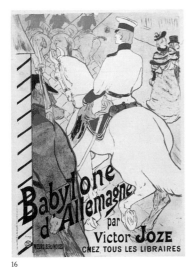

16

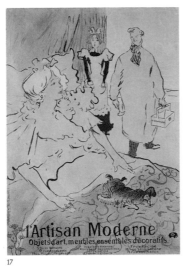

17

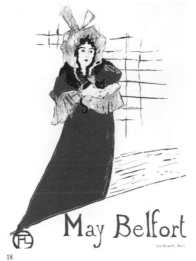

18

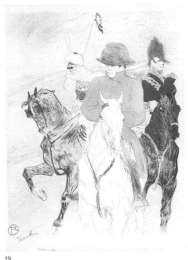

19

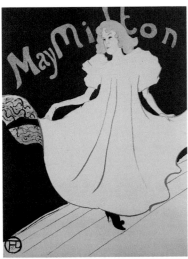

20

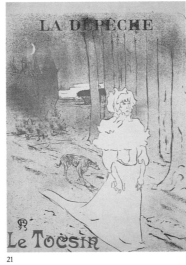

21

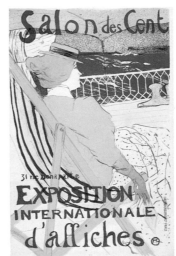

22

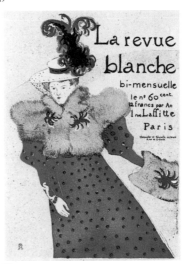

23

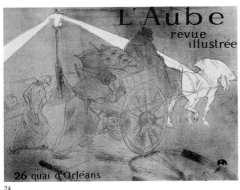

24

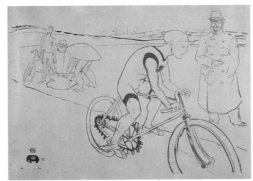

25

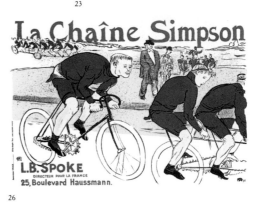

26

27

28

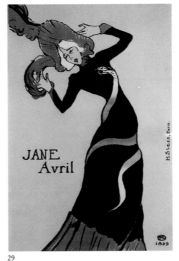

29

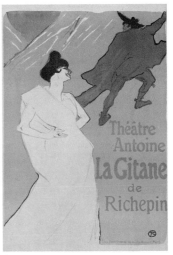

30

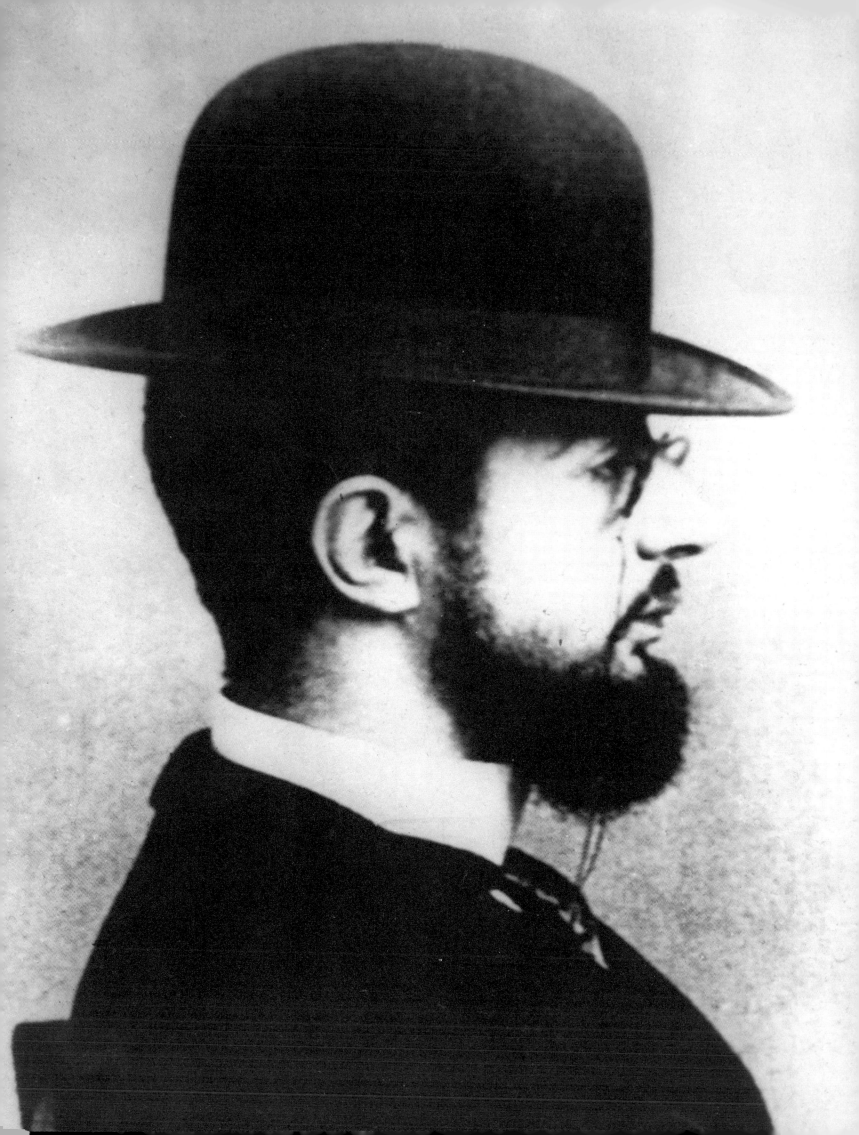

"Ah, ces Dames"

In every epoch painters have resorted to brothels in search of models, from Vittore Carpaccio (*c.* 1455–*c.* 1526) to Jan Vermeer (1632–1675), from Polidoro da Caravaggio (1490/95–1543) to Frans Hals (1581/85– 1666). In the prudish and hypocritical days of the Second Empire, the brothels were blessed by the mighty. They multiplied and became famous. Writers were not ashamed to describe them in great detail: in 1876 Joris-Karl Huysmans (1848–1907) published *Martha, the Tale of a Whore*; Edmond de Goncourt (1822–1896) followed suit in 1877 with *The Whore Elisa*; then came Zola with *Nana* in 1880; in 1881 Guy de Maupassant (1850–1893), a regular brothel-goer, drew on his experiences to write *La Maison Tellier;* and in Baudelaire's poetry they are a recurrent theme. Each year brought a new wave of beauties, and the painters too were at the ready, exploiting the atmosphere and seeking the subjects of their paintings there. Degas devoted seventy monotypes to brothel scenes, extraordinary works which his brother destroyed for the most part "out of sheer compassion". Lord protect us from our heirs!

Manet, Seurat, Bonnard, Vuillard, Rouault and Picasso sought in the brothel that privacy and intimacy which is one of the wellsprings of painting. Van Gogh, for all his mysticism, worked in sleazy dives and dosshouses, and lived for a time in The Hague with a prostitute whom he even wanted to marry. Japanese artists such as Kitagawa Utamaro (1753–1806), Suzuki Harunobu (1725–1770) and Hokusai, so greatly admired by Degas and Lautrec, depicted the life of Yoshiwara and the ceremonial of the "green houses" of Edo in great detail. These motifs re-surface in the work of the Berlin artists of the twenties; Christian Schad (1894–1982), Otto Dix (1891–1969) and George Grosz (1893– 1959) are among those who felt themselves driven to seek in brothels the natural simplicity which could be found nowhere else.

When Lautrec suddenly disappeared, and was not to be seen at the Moulin Rouge or at Bruant's place, and his studio in the Rue Tourlaque remained empty, then those in his immediate circle knew that he had found lodging in a brothel, that he had packed his bag, ordered a cab and cried: "Coachman, to the brothel!" usually accompanied by one of his faithful friends, Maurice Guibert, Maxime Dethomas or Romain Coolus. Only a few hundred metres separated Montmartre from the

Mireille, Lautrec's favourite from the brothel in the Rue d'Amboise.

Lautrec at the age of thirty, 1894.

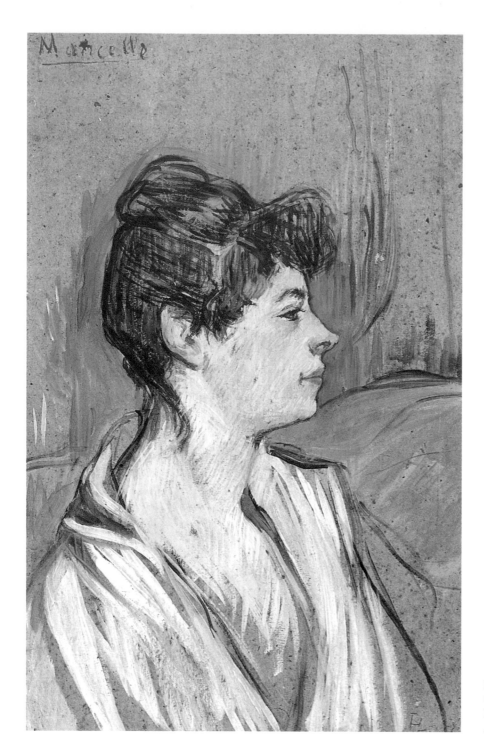

Marcelle, 1894
Oil on cardboard, 46.5 x 29.5 cm
Dortu P 542
Albi, Musée Toulouse-Lautrec

red-light district where Lautrec settled in as if he had come to take the spa waters, or to find refuge in a monastery. "Brothel! What brothel!" he would say. "Those are houses on the water. Do people need that much water? All a matter of washing technique!"

It would be too simplistic to explain these rather strange excursions solely in terms of his virility and its needs, or to believe that Lautrec surrounded himself with those who, like himself, were despised and rejected, or that he only went to them because anything could be obtained from them for money. "A model is always a stuffed doll," Lautrec explained, "but these women are alive. I wouldn't venture to pay them the hundred sous to sit for me, and God knows whether they would be worth it. They stretch out on the sofas like animals... They

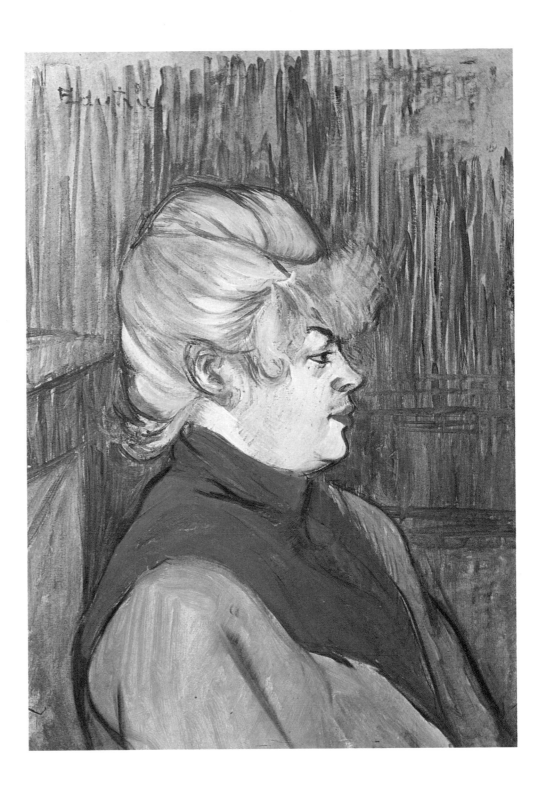

Brothel Woman, 1894
Femme de maison close
Oil on cardboard, 49 x 34 cm
Dortu P 540. New York, private collection

make no demands and they are not in the least bit conceited!" Degas said much the same when he went the rounds of the Opéra district, where his little monsters of dancers came from, and landed in the underworld of sex, peopled by women naked or in tattered clothing, at their rituals, caught in their most intimate acts: "That is the human animal turned in on itself, a cat licking itself."

Behind the closed shutters of these houses Lautrec was at ease: "I have found girls of my own size!… Nowhere else do I feel so much at home." There he could concentrate once more on the creation of masterpieces. The working girls went by bizarre, suggestive names, such as "Miss Botty"; they were his models and his accomplices. "On Sundays," he said, "we play board games." In these paintings, drawings

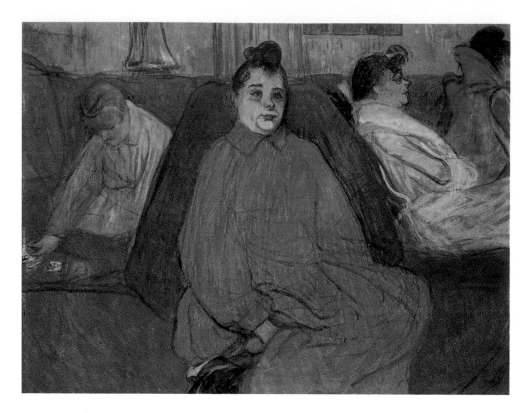

The Sofa, 1893
Le divan
Oil on cardboard, 60 x 80 cm
Dortu P 502
São Paulo, Museu de Arte de São Paulo
Assis Chateaubriand

and lithographs we see the girls getting dressed, getting undressed, having breakfast, looking at themselves in the mirror, not in the least embarrassed by the little man who drew them incessantly and who had become part of the furniture. They were not all beautiful, but in his eyes they had more important qualities: they were melancholy, human, moving. In the intimate scenes drawn on the spot there is nothing vulgar or offensive or ambiguous. In his pictures the girls are often expressing their love for one another, and that is nothing more than the natural expression of two people consoling themselves and each other, in their own way, for what they have to put up with day by day in their joyless existence (pp. 137–140, 147, 150, 151, 157).

"Their hearts are in the right place. Good upbringing comes from the heart. That's enough for me," said Lautrec. To them he was "Monsieur Henri", a strange little man but nevertheless more normal than most of the obsessive men who called on their services. They did not see him as the descendant of one of the oldest families in France, nor as the famous painter that he had become in the meantime. He felt that they accepted him, he could strut equably around with his little stick and sit with them at table, where Madame was quick to remind everyone of their manners.

The girls responded to his attentiveness, they were delighted by his gentility and delicacy and forethought. He listened to their confessions, read and corrected their letters, comforted them when they were tearful and made them laugh. He remembered their birthdays and special celebrations and brought them little presents. He lived their life, watched them getting dressed and washing, took them by surprise when they were asleep, saw them early in the morning without any make-up, and was an accessory in their lesbian affairs.

From 1891 to 1895 Lautrec was a regular at the brothel in the Rue des Moulins. It was during this time that he drew many subjects from brothel life, including anything from the laundresses to the most intimate scenes between the women who lived in the brothel. It was in the salon, the brothel's reception room, that the women awaited their customers. Here introductions were made, and the visitors took their pick. Of the objects that decorated such salons – the mirrors, columns, plants and knick-knacks – there is almost no hint here. Instead the voluminous red sofas dominate the picture. As long as there were no guests the atmosphere in the salon was one of boredom, and Lautrec has brilliantly caught the listless, joyless waiting, the prostitutes' apathy, making this the theme of his picture.

He was particularly fond of Mireille, who can be seen in his large painting *In the Salon of the Rue des Moulins* (p. 145), sitting in half-profile in the foreground, with her right hand round her drawn-up leg. "They are trying to get rid of me," he said to Gauzi. "They hide Mireille when I ask for her, so I pay for her to have a whole day off. I write to her, and then she meets me. Yesterday she was here." Lautrec pointed to a little bunch of violets in a vase: "That's Mireille," he said, "she bought them and gave them to me as a present in her charming way when she came here yesterday." A little later he admitted to Gauzi: "Mireille is leaving for the Argentine. The pimps have convinced her that she will make her fortune there. I've tried to persuade her not to go, but she believes absolutely in every fairy tale she's told. No girl who has set off like that has ever returned. They are finished after two years at the latest."

In the brothels Lautrec was looking for nothing other than the essence of life, the eternal, as expressed by Hector Berlioz (1803–1869) in his oratorio "The Damnation of Faust": "The bestial in all its naïvety." His pictures, always of women, were pleading a case. He loved the ambiguity of living on the borderland between one universe and another, between the "sordid" outside world and the "pure" inside. When Yvette Guilbert asked him for his address, he gave the notorious number of a brothel in the Rue d'Amboise. The singer's shocked face

The Kiss, 1892
Le baiser
Oil on cardboard, 60 x 80 cm
Dortu P 436. Paris, private collection

Towards the end of 1892 Lautrec was commissioned to produce decorations for the salon walls of the Rue d'Amboise brothel, and he decided to design 16 panels in the style of Louis XV, each one centring on an oval portrait of one of the girls. It was during this time that Lautrec had the opportunity to study their lifestyle at close quarters.
He was fascinated to discover that many of them were deeply in love with each other, and he frequently made these couples the subjects of his paintings (cf. pp. 138, 139, 147, 150, 151, 157). He thereby succeeded in portraying the genuine depth of these lesbian relationships without exposing the girls' tenderness and helplessness to voyeurism.

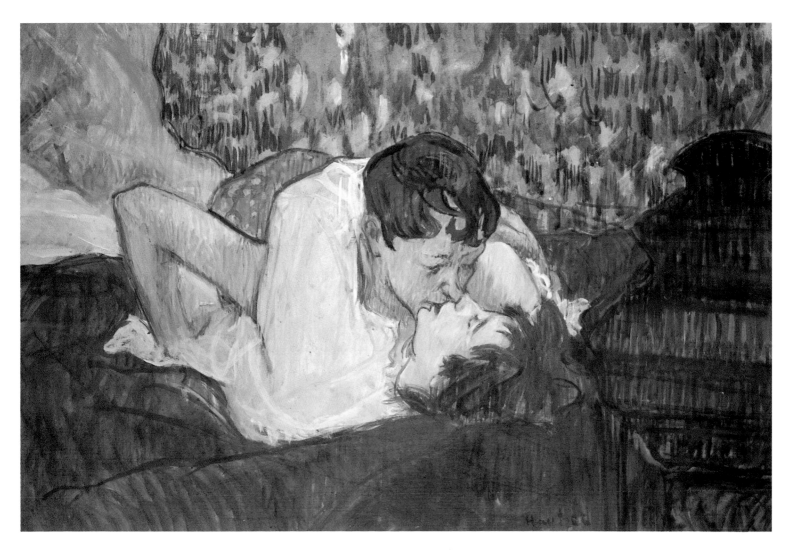

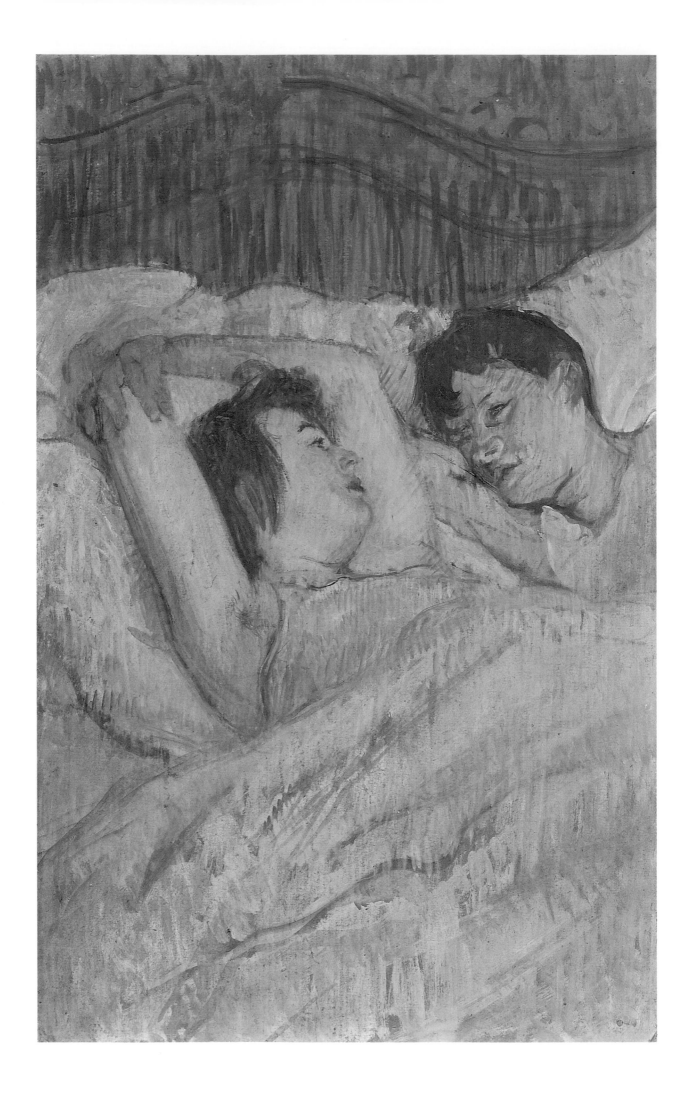

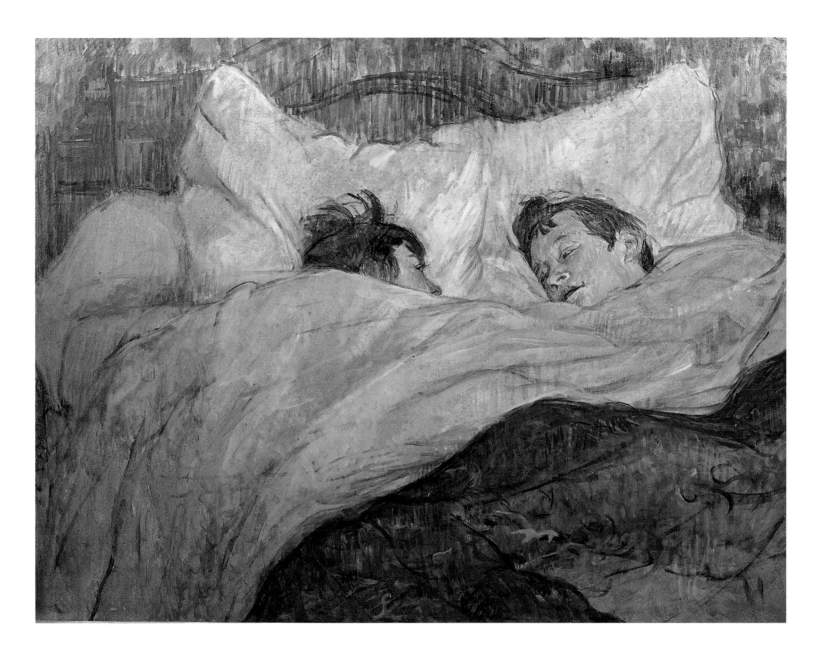

amused him very much. He exploited his sojourn in the brothel to expose the souls of his fellow citizens, in much the same way as he had made use of alcohol at the Natanson party. For instance, he received the art dealer Paul Durand-Ruel (1833–1922) in the brothel, having given him the address as if it was his studio address. The prudish bourgeois businessman never commented on Lautrec's reception of him amidst paintings and half-naked girls, in the salon captured for posterity in one of the masterpieces in the Musée d'Albi collection (p. 145), but one can imagine what his reaction must have been. Lautrec loved to put people to the test by taking them to the places where he felt at home; he was always interested to see how they would react when the mask fell from their faces. He enjoyed it most when the visitor was a member of the censorship board, or a journalist concerned with social justice.

The brothel owners and madames were not all uneducated. The Madame from the Rue d'Amboise, where Lautrec often held court, surrounded herself with works of art and collected pictures by Jean-Jacques Henner (1829–1905), Eugène Boudin (1824–1898) and Armand Guillaumin (1841–1927) – all clients of hers! Her *Maison* was one of

In Bed, 1893
Dans le lit
Oil on cardboard, 54 x 70.5 cm
Dortu P 439. Paris, Musée d'Orsay

In Bed, 1892
Dans le lit
Oil on cardboard, 53 x 34 cm. Dortu P 437
Zurich, E. G. Bührle Trust Collection

the establishments in which artists were wont to celebrate the success of a vernissage. She took it into her head to have Lautrec paint her salon. The setting was most suitable, since the house in the Rue d'Amboise dated from the 17th century and boasted wonderful Louis XV wood-carving. Lautrec set to work at once with great enthusiasm, with the help of a house-painter and a pupil of Puvis de Chavannes. He painted 16 large panels, almost two metres high, which filled the wall spaces between the pillars. He painted flowers and foliage in a rococo style on a pale yellow background, and adorned the portraits of the establishment's most famous girls with garlands: 16 oval medallions,

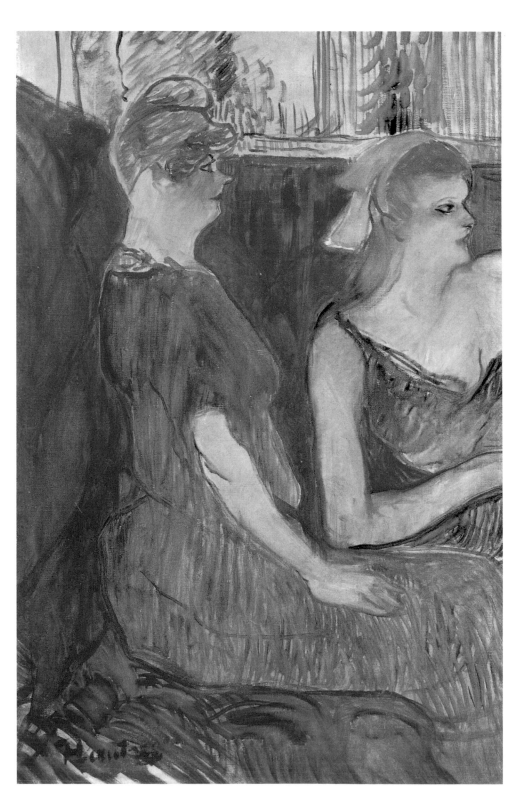

In the Salon of the Rue des Moulins, 1894
Au salon de la rue des Moulins
Oil on cardboard, 60.6 x 40 cm. Dortu P 558
Los Angeles (CA), Armand Hammer Collection

This painting is a study for the left background section of *In the Salon of the Rue des Moulins* (p. 145). The picture is dominated by the imperious pose of Rolande, one of the models Lautrec painted many times during his stays in the brothel, which often lasted weeks at a time. The final painting differs from this study in its harmonisation of colour, as well as in its more relaxed composition. Octave Maus, the Belgian art critic, journalist, and co-founder of the Impressionist group "Les XX" in Brussels, was so thrilled by the striking technique of the study that he bought it from Lautrec.

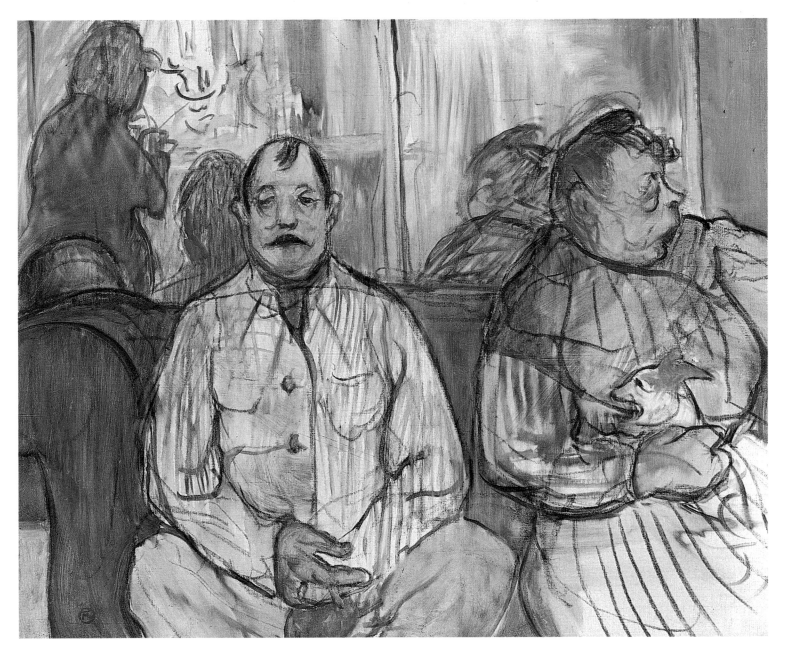

revealing one by one the members of the household – a blooming Carmen, a little Jewess, a red-haired Pompadour.

Following Lautrec's pattern of work is somewhat like compiling a documentary. One sees him paying his respects where respect is due, to *Monsieur, Madame and the Lapdog* (p. 141). The brothel-keepers are portrayed in paler shades, against contrasting red and green; they are thoroughly human types, drawn from the common people, portrayed with a freedom comparable to that found only in the work of Edvard Munch. There is something of the caricature in the picture too, and in this respect the influence of Daumier is evident.

A year later Lautrec turned to a more commonplace theme, the delivery by the *Brothel Laundryman* (p. 154). The picture shows a man bending forward to deliver the laundry, which Madame is checking off. A far cry from Venus arising from her ablutions!

His next picture is *Rue des Moulins: The Medical Inspection* (p. 152), depicting the most intimate moment in the girls' lives, namely the compulsory gynaecological check-up. The subject matter may seem

Monsieur, Madame and the Lapdog (Brothel-Keepers), 1893
Monsieur, Madame et le chien
Oil and black chalk on canvas,
48 x 60 cm. Dortu P 494
Albi, Musée Toulouse-Lautrec

ILLUSTRATION PAGES 142/143:
Lautrec in front of his painting *In the Salon of the Rue des Moulins* (p. 145), at his studio, 1894. To the left is his favourite, Mireille, holding a spear. She is also the main subject in the foreground of the painting, sitting on the salon sofa with her knee drawn up. The paintings *Monsieur, Madame and the Lapdog* (ill. above), *Woman Pulling up her Stocking* (p. 149) and *Alfred la Guigne* (p. 113) are standing on the floor.

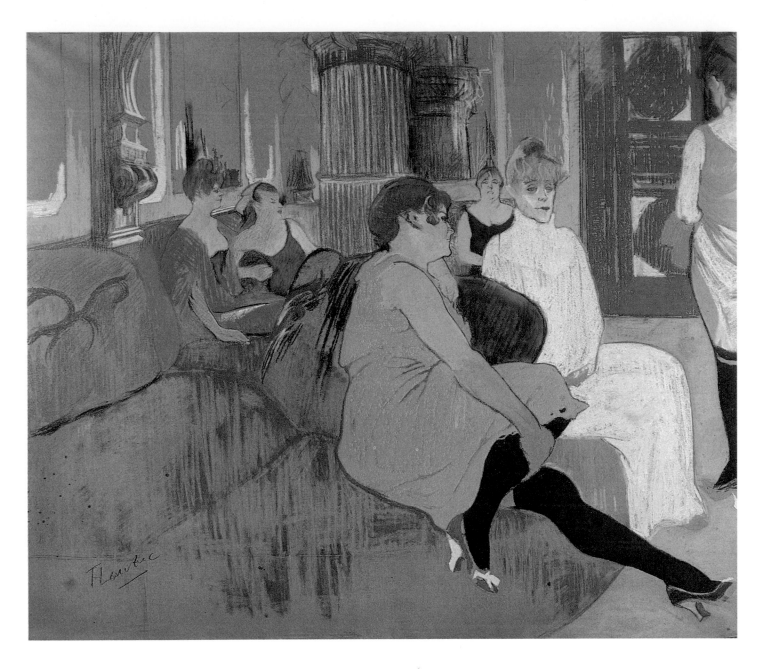

The brothel personnel. Seated on the
far left is Mireille, Lautrec's favourite.

unpleasant, and it would be easy to give it a pornographic or prurient
slant, but Lautrec's painting is naturalistic; it has no false shame, in fact
it is so unashamed that there is even a touch of humour in it. For the
girls the compulsory examination is part of their daily routine, and
Lautrec reproduces the event with an impartiality that is one of the
most remarkable characteristics of his artistic endeavours.

Rouault or Félicien Rops (1833–1898) would certainly have made
the most of the lewdness or sensuality of the motif. Degas would have
insisted more on "bestial humanity", viewing the naked women less in
terms of their beauty or ugliness than from the surprising perspective
allowed by foreshortened lines and divsion of pictorial space. Lautrec
proceeded in an entirely different manner. He never put the question
of whether "the great sadness came from the fact that they were no
saints". He did not see the girls as victims of bourgeois hypocrisy,
rather he drew them much as Charles Journet described them, "in all
their despair, yet with the purity of saints". It was not his purpose to
capture the girl in a humiliating pose.

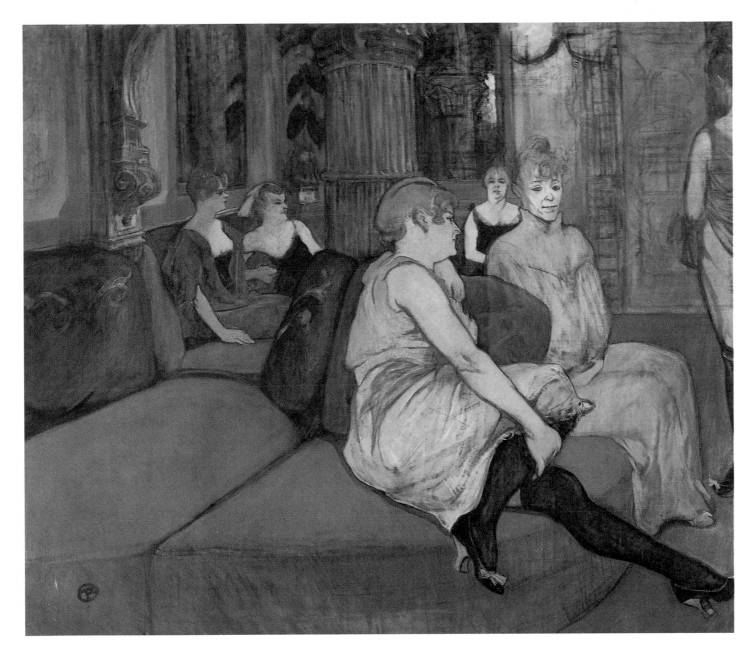

Looked at from this angle, the motif of the girl with the mirror, again in comparison with Degas and Rouault, is significant. Lautrec's version, called *Nude in front of a Mirror* (p. 160), does not show her fretting about her natural blemishes or those inflicted on her by society; nor is she portrayed in a degrading manner or with animal qualities, as is often the case with Degas. She is in her own way unblemished, at once whore of Pigalle and a prostitute of the Apocalypse. She may reflect sin, but she does not embody sin. She is simply human, though naturally with a touch of eroticism and an undertone of perversion. Lautrec was no saint, he would not paint figures of Christ as Rouault did, after dwelling first on the prostitutes down below. Lautrec's picture is a kind of final reckoning, a symbolic résumé of all other pictures of prostitutes. A harlot stands naked in front of a mirror that reveals her image. She wears nothing more than the obligatory black stockings; she is on the point of dropping the shift that she has just taken off. "Mirrors would do well to reflect [on what they see]…," said Jean Cocteau (1899–1963). The masks have

In the Salon of the Rue des Moulins, *c.* 1894
Au salon de la rue des Moulins
Oil on canvas, 111.5 x 132.5 cm
Dortu P 559. Albi, Musée Toulouse-Lautrec

The girls await their customers under the strict gaze of Madame. The title of the picture is not quite correct as the brothel shown here is not the one in the Rue des Moulins but the one in the Rue d'Amboise, in which Mireille, who is shown in the foreground, worked for a time. The artist only frequented the Rue des Moulins after Mireille had left for Argentina.

PAGE 144:
In the Salon of the Rue des Moulins, *c.* 1894
Au salon de la rue des Moulins
Pastel and chalk on paper on canvas,
111 x 132 cm. Dortu P 560
Albi, Musée Toulouse-Lautrec

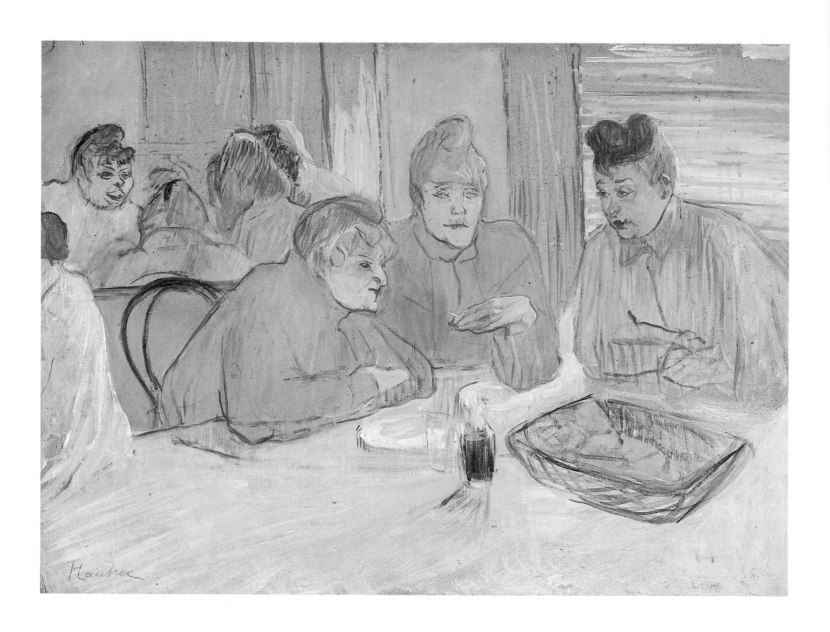

The Ladies in the Brothel Dining-Room, 1893
Ces dames au réfectoire
Oil on cardboard, 60.3 x 80.3 cm. Dortu P 499
Budapest, Szépmüvészeti Múzeum

As a regular and occasionally long-term guest of the brothels in the Rue des Moulins, Rue d'Amboise, Rue Joubert, Rue des Rosiers and Rue Richelieu, Lautrec was very familiar with the lifestyles of the women who lived there. They trusted him; being a dwarf and a cripple, he yearned for the unattainable social norms, just as they did, so they permitted him to portray the reality behind the illusory front of erotic pleasure. There is no hint of the way they earn their living as they sit over the communal meal. In buttoned-up dresses the tired women stare into space with blank listlessness, and only the loud colour combinations give any indication of their sorry existence.

fallen, the hour of truth has struck. A further observation by Cocteau reveals the true sense of Lautrec's picture: "Every day when I look at myself in the mirror I see death at work." This is also how Rembrandt sees himself from one self-portrait to the next: with growing frailty and hastening physical decline. This is seen, too, by the famous *Rokeby Venus* by Velázquez, whose back is turned to the beholder so that her beautiful and desirable posterior is in full view, but whose body merely serves as a pretext for studying a beauty that is already on the wane. The body of Lautrec's prostitute is still young and it is shown in all its ampleness, but it is evident that this woman is wondering – and we wonder too – how long will it last? Will people go on wanting her? And then, will she be able to continue in her profession? The untidiness of the bed in the background is an intimation of these questions. As with all masterpieces, whether in painting or in literature, different readings are available at different levels of interpretation. For some people it may suffice to see in her a provocative nude, painted by the hand of a master in the manner of Courbet, Renoir or Matisse (1869–1954). Since the time of Boucher (1703–

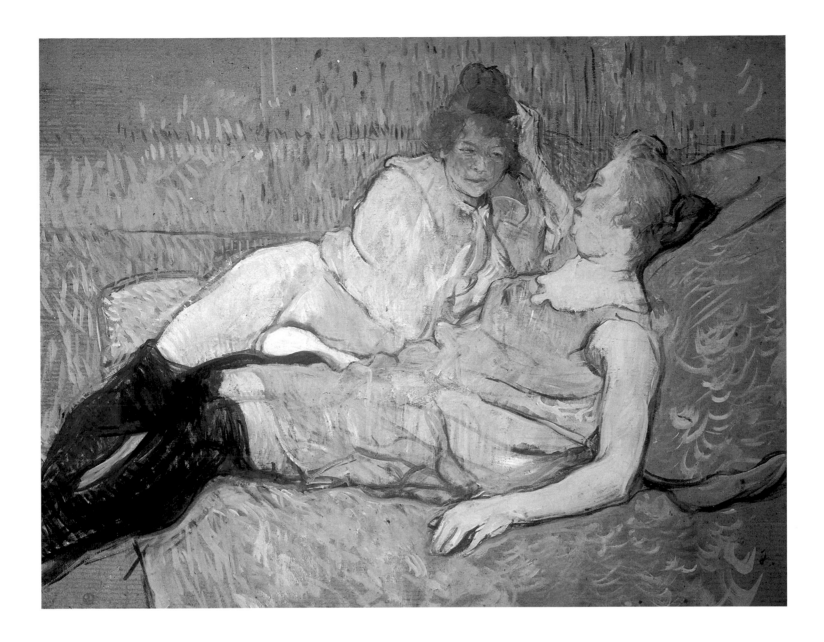

1770) this has been something of a French speciality. But Lautrec's work cannot be understood fully on this level, and the mirror which duplicates the figure has the function of reflecting a body in which an anxious and wounded spirit is enclosed, watchful and not blinded to decay.

Sometimes Lautrec took his friends with him to visit a woman with drunken features, of no certain age, who received her callers in indescribably wretched surroundings. He would take her chocolates. This miserable creature, who played the guitar for a dancing monkey on the café terraces of the Place Pigalle, was La Glu, Victorine Meurent (1844– c. 1895), a former model who had sat thirty years earlier for Manet's famous *Olympia* and *Le Déjeuner sur l'Herbe* (both in Paris, Musée d'Orsay).

One may speak of the vulgarity of Rouault, the malice of Degas, the shattering humility of van Gogh with regard to the theme of prostitution. In the case of Lautrec one is struck by the perspicacity and the psychological insight which he brings to the subject. In Natanson's words: "Small though he may be, Lautrec's vision is large. He gives

The Sofa, *c.* 1894/95
Le sofa
Oil on cardboard, 63 x 81 cm. Dortu P 601
New York, The Metropolitan Museum of Art

The woman half turning away in the foreground was known by the name of Gabrielle, and she modelled for Lautrec in a number of his paintings. It is not certain whether she was a prostitute or a model, or both, and it is therefore not clear whether the scene portrayed here was one observed by chance in a brothel, or a pose set up in the studio. It is possible that Lautrec was simply hinting at the current fashion in the brothels for guests of both sexes to pay to watch the lesbian love-play of the prostitutes.

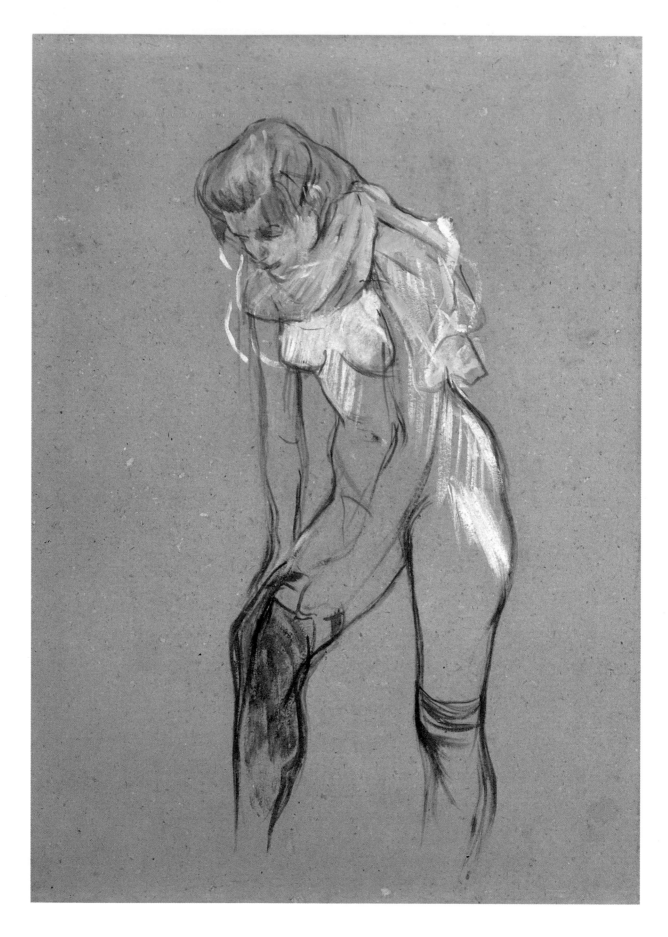

Woman Pulling up her Stocking (study), *c.* 1894
Femme tirant son bas
Oil on cardboard, 61.5 x 44.5 cm
Dortu P 553
Albi, Musée Toulouse-Lautrec

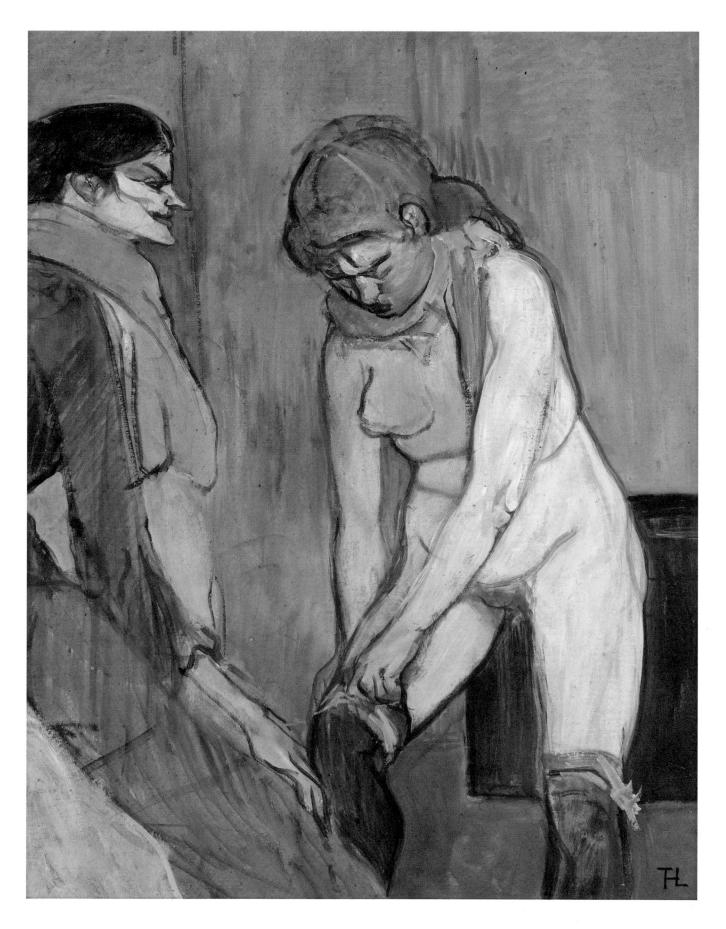

Woman Pulling up her Stocking, 1894
Femme tirant son bas
Oil on cardboard, 58 x 48 cm
Dortu P 552
Paris, Musée d'Orsay

space to everything. The voluptuous curves of a girl's body, the attraction of a bedroom scene or the charm of a pair of lovers sculpted like a bas-relief, the proportions of a washroom or a brothel salon... could have suggested to Jules Renard his formula of the 'majesty of sin'. It was a sight to be seen, how Lautrec could spend a whole hour playing with his little hand, opening and closing it, delicately stroking the palm, and his bearded cheeks, his large nose and his eyes, how he felt his moist breath without quite lowering his lips to his hand. With a woman he satisfied both his insatiable desire and his insatiable curiosity about her body and her heart. What he satisfied was the need to love, a need that keeps welling up anew in a heart that is true."

Between 1892 and 1895 he produced innumerable studies and no less than fifty paintings and over one hundred drawings from the brothels. The greatest achievement of these Herculean labours was the famous painting *In the Salon of the Rue des Moulins* (p. 145), one of the few compositions for which he relied on his memory and imagination, supported by jottings and sketches. For months he worked at it in his studio, creating individual studies for all the figures, and details

The Two Girlfriends, *c.* 1894/95
Les deux amies
Oil on cardboard, 64.5 x 84 cm. Dortu P 602
Zurich, E. G. Bührle Trust Collection

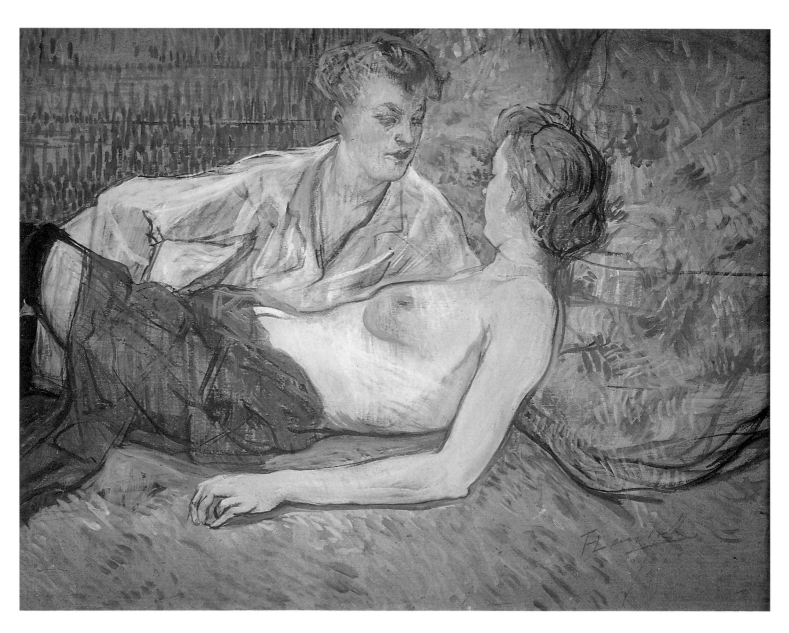

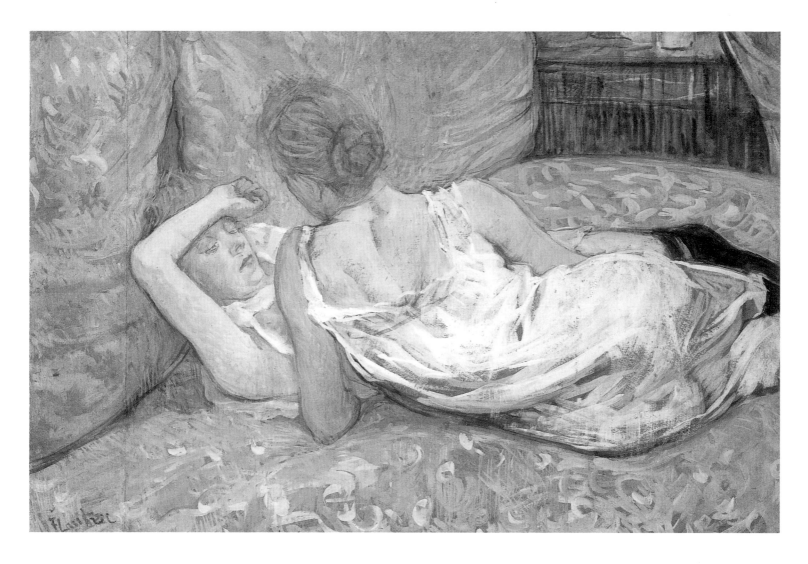

of architecture, decoration and furnishing. It marked the culmination of his artistic quest, and at the same time the end of his interest in the brothels. The harmonious interplay of pinks, mauves and reds with a few dots of green and black generates a kind of hothouse atmosphere, uniquely apt for the depiction of this particular place. Exotic décor was much sought after in these establishments; in this instance, the salon is oriental. In varying states of dress the girls await their clients, while Madame sits stiff as a poker on the right, upholding order and good behaviour. Problems of space are resolved, as might be the case with Gauguin or Seurat, by not according full volume to the figures; they are shown from the front or in profile, as in the Egyptian or Japanese style.

A recurrent, and continually surprising, feature of the works which originated in the brothels, and particularly of those in which women are portrayed dressing, undressing, or making up their faces, is the Japanese influence on the women's poses. There is also a link with Boucher and Fragonard (1732–1806); it is as if Lautrec had set out to establish the connection between his own inspiration and the French tradition of painting. In relation to Degas, a demarcation line is discernible. One may well ask: is the woman we see fixing her garter a countess or a brothel girl? To what class do these two embracing women belong? These questions cannot be answered: the women's gestures are

The Two Girlfriends (Abandon), 1895
Les deux amies (L'abandon)
Oil on cardboard, 45.5 x 67.5 cm
Dortu P 598. Switzerland, private collection

The figure with her back to us in the foreground acts as a barrier between the viewer and the intimate scene that is taking place between the two girlfriends, blocking the voyeur's view of titillating detail. The composition of this picture may have been inspired by a Japanese woodcut of two lovers, in which a reclining figure in the foreground is likewise turning her back on the viewer. Lautrec owned a collection of these erotic Japanese woodcuts, called *shunga*, and frequently took his inspiration for new compositions from them. Of the second woman in Lautrec's painting only the head is visible, yet the small, upturned nose easily allows us to recognise the characteristic face of Rolande, who was on several occasions his model for brothel scenes.

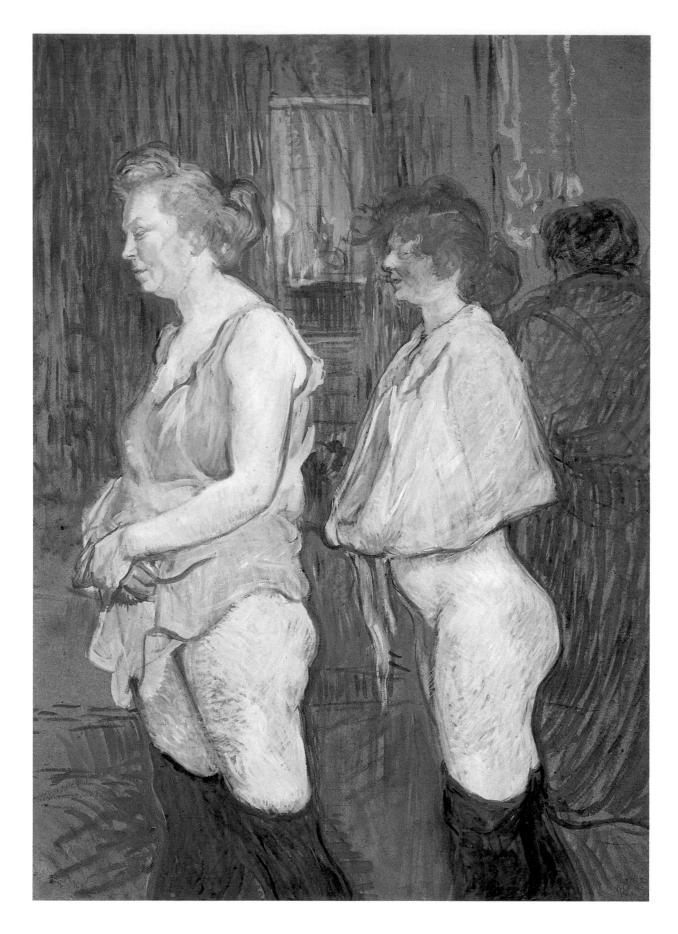

Rue des Moulins: The Medical Inspection, 1894
Rue des Moulins: La visite médicale
Oil on cardboard, 82 x 59.5 cm
Dortu P 557
Washington (DC), National Gallery of Art
Chester Dale Collection

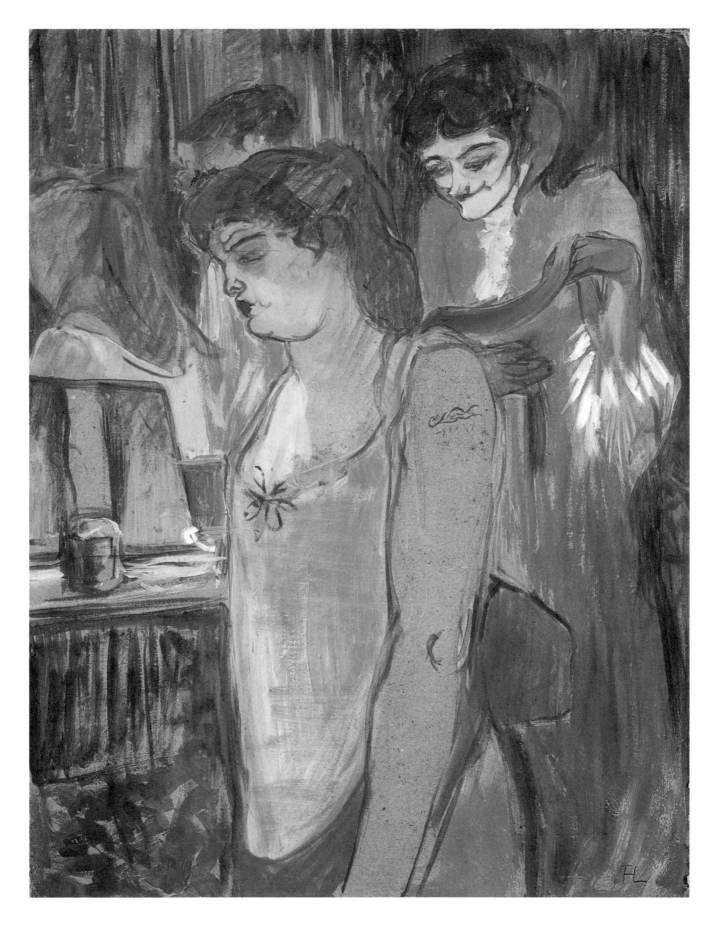

The Tattooed Woman or **The Toilette**, 1894
La femme tatouée ou *La toilette*
Oil on cardboard, 62.5 x 48 cm
Dortu P 551. Private collection

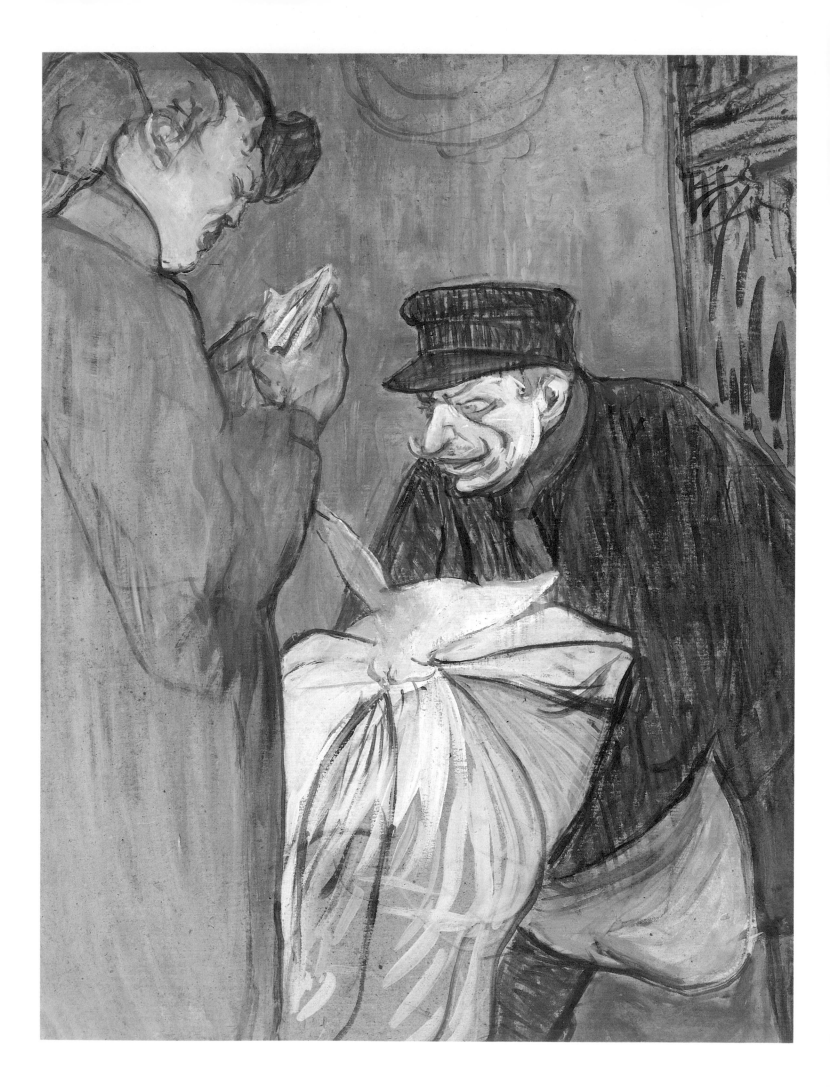

valid to eternity; one cannot say whether they are in a bedroom or a brothel. The figures have been spellbound in some unreal castle by the magician's wand, and lie outside time; the magician is the painter. On one grand society occasion in the Rue de la Faisanderie, the anxious host enquired whether Lautrec regretted having come, whether he was finding any entertainment; with a glance at the décolleté of the society ladies, with their bare shoulders and sparkling necklaces, Lautrec laid bare his deepest thoughts: "What entertainment! Absolutely divine, my friend! One could almost imagine oneself in the brothel!"

Finally Lautrec dedicated a studio album to the brothel girls. It comprised ten lithographic plates, first entitled *The Whores*, but then renamed with a better, more widely applicable title which embraced everything that the world of prostitution meant for him: *Elles* (plural form of 'she'). A poetic term worthy of Verlaine, it represented for him women in general, with no distinction drawn between prostitutes and others. He refused to recognise a distinction. Jean Adhémar has pointed out that Lautrec's friends shared this view, as is exemplified by Tristan Bernard's description of a brothel girl in his novel *Memoirs of a Well-Born Young Man*: "Daniel lay stretched out on a sofa and watched a plumpish person going in and out of the room; her simple clothing and her care and speed in carrying jug and basin could have led one to suppose her a charwoman." All the lithographs, with the exception of a portrait of the lesbian clowness Cha-U-Kao, show women recumbent or at their toilette, and were based on drawings which Lautrec had done in the brothel. Clothes and stage properties have been superseded by a much more effective spectacle, namely that of female anatomy. The strident contrasting colours of Lautrec's posters have given way to delicate half-tones in the most idiosyncratic combinations. In order to lend added weight and expressiveness to the bodies, he juggles with hatching, using tiny dots sprayed over the sheet to achieve a gradation of colour from light to dark. *Elles* represents a high peak of achievement in colour lithography. Unfortunately it did not achieve public acclaim, but for the Nabis, and above all for Munch, it became a point of reference; they learnt from it, and they took what they had learnt from Lautrec even further in their own colour lithographs.

It is astonishing that Lautrec never painted the prostitutes fulfilling their actual function, plying their trade. Of course his presence, however discreet, would not have been welcome at such moments, but he would have been in a position, had he wanted to, to gain access to live models for such pictures. For his own entertainment he had succeeded in poaching a lesbian from the La Souris bar in the Rue Bréda, in order to throw her into the arms of his friends from the brothels and watch their love-play as "enthusiastic observer", but there was no question of a paid act of copulation. Modesty prevented it, as did his refusal to paint pornographic pictures. Although Manet's *Le Déjeuner sur l'Herbe* had already ventured to show nude women and clothed men sitting side by side, at the time the brothel as subject was

PAGE 154:
The Brothel Laundryman, 1894
Le blanchisseur de la maison
Oil on cardboard, 57.8 x 46.2 cm
Dortu P 544. Albi, Musée Toulouse-Lautrec

Daily life in the brothels gave Lautrec a rich choice of motifs during the years 1892 to 1895. In this picture the laundryman's barely controlled lust is exposed in sharp caricature. Bending over the large bundle of washing, he holds it as if it were a monstrous penis rising from his groin, while the woman, entirely ignoring his offensive leer, concentrates on the bill. She appears not to notice his lecherous eyes on her body, though his face is contorted into a satyr's mask. His ironically exaggerated figure turns the laundryman into the very image of a voyeur. Lautrec hired this laundryman as a studio model in the Rue Caulaincourt for further studies on the theme of disfigurement caused by greed.

PAGE 156:
Two Half-Naked Women Seen from behind in the Rue des Moulins Brothel, 1894
Deux femmes demi-nues de dos, maison de la rue des Moulins
Oil on cardboard, 54 x 39cm. Dortu P 556
Albi, Musée Toulouse-Lautrec

PAGE 157:
The Two Girlfriends, 1894
Les deux amies
Oil on cardboard, 48 x 34.5 cm
Dortu P 550. Albi, Musée Toulouse-Lautrec

In spite of the fact that many of Lautrec's brothel pictures look like chance snapshots, likely to have a documentary rather than an artistic value, he did actually rearrange his figures and settings many times before he found the composition that satisfied him. This picture is a sketch for the central figures in the foreground of his painting *In the Salon of the Rue des Moulins* (p. 145). Mireille, the model with the dark hair, nestles close to her friend, but the sexual undertone is dropped for the final version of the painting, in which the two friends are separated by a red pillow.

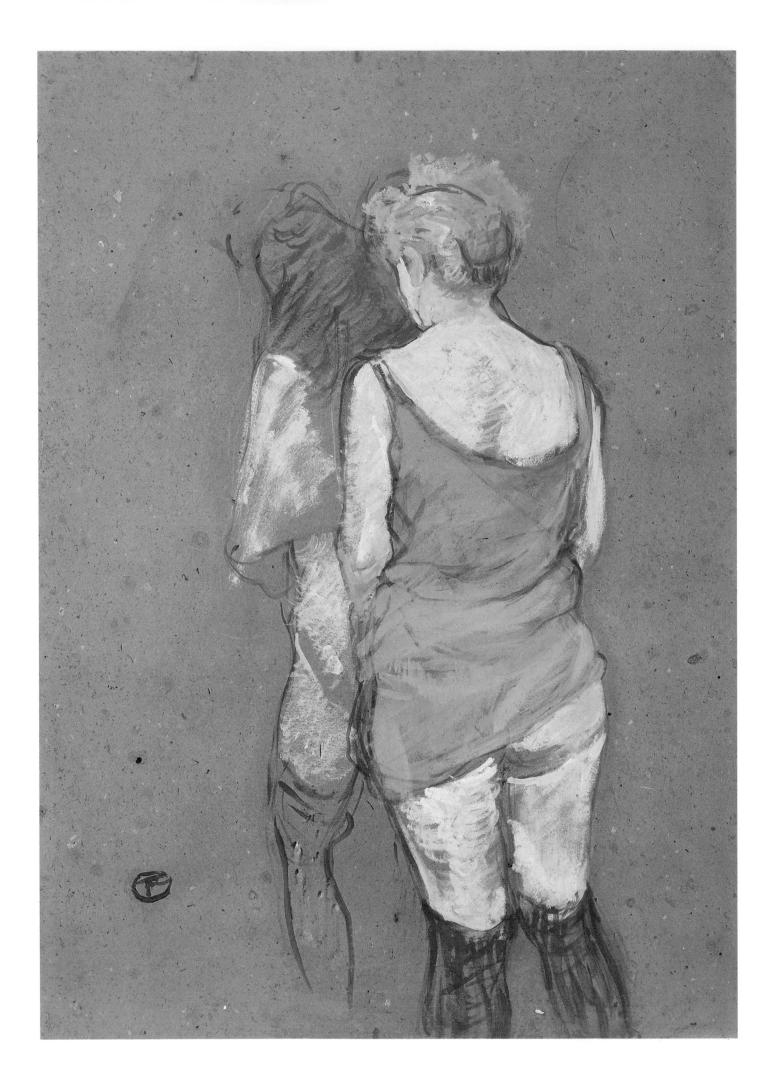

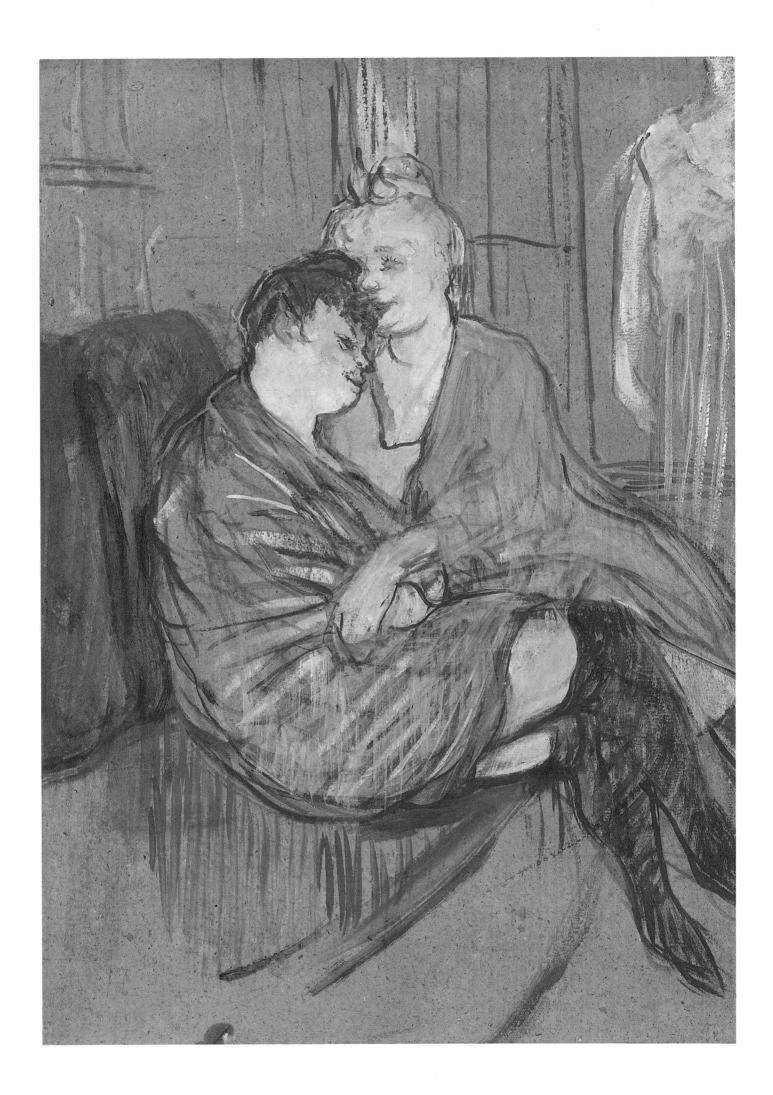

still scandalous. Lautrec was unambiguously aware that with his portraits and nude studies of prostitutes he was ahead of his time, although his portrayals were truthful rather than erotic. To his mind it was more important to sound the depths of a woman, to represent her daily state of mind and her emotions, than merely to display her charms and the desires she could arouse. If his works are erotic – and all are free to find in them the reflection of their own fantasies – such eroticism is an "extra", conveyed to us, as in the work of all great artists, but not as its prime aim.

Yet when Joyant exhibited the works on the the brothel theme in 1896 there was a great public outcry, accusing Lautrec of obscenity and cynicism. Today the works can be seen in the Musée Toulouse-Lautrec in Albi, without shock or horror. Gustave Geffroy (1855–1926) wrote in answer to the ugly contemporary criticism of Lautrec made in "Le Journal": "The visitor to the Rue Forest will not regret the trouble he has taken to get there, provided he has a love for direct observation, breadth of draughtsmanship, harmony of light over subdued nuance of colour... Cynicism? Obscenity? Not as far as I can see. The search for truth guides the artist's hand, it is stronger than the curiosity and purposes of those who come to look. Lautrec has painted terrifying pictures, with no space for fantasy or illusion; with an interdict on love and with the firm will to tell the whole truth, he has shed the grimmest light on vice, on one of the infernos behind the façade of civilisation. Never has there been so clear a representation, executed with such relentless calm, of wretched cunning, passive stupidity, brute unconsciousness, or, far more tragically, of the impossibility for so many simple women of leading a simple, happy and well-ordered life..."

Lautrec's studio at 7 Rue Tourlaque, on the corner of Rue Caulaincourt, into which he moved in 1886. In 1893 it also served as his flat.

Lautrec had taken certain precautions. The exhibition was not open to all comers; only those whom he deemed worthy were privileged to view his work. Word spread, but Lautrec would not budge. He sent the hawkish dealers packing: "Nothing is for sale." From that moment on, there was enormous demand for his paintings and drawings. Sure proof of his success were the forgeries that came into circulation, obliging Lautrec to take counter-measures in the following year. An important collector such as the banker Isaac de Camondo wondered whether or not he had to possess a Lautrec. He wavered, but finally he paid five hundred francs for a portrait of Cha-U-Kao (p. 119); it was given to the Louvre in 1914.

There were embroilments with the police. At an exhibition which included works by Bonnard, Vuillard, Maurice Denis (1870–1943) and Gauguin, Lautrec showed a drawing which portrayed a girl in bed with her hair cut significantly short. At the time, short hair on women was considered a "sure sign of depravity", as Francis Jourdain reports. The police officer responsible demanded that the picture be taken down, but the exhibition organiser laughed off the incident.

In 1893 Lautrec was finally blessed with the critical response that he had been hoping for. An exhibition organised by Joyant prompted a

Lautrec at his easel, at the time of the series of brothel paintings, c. 1895.

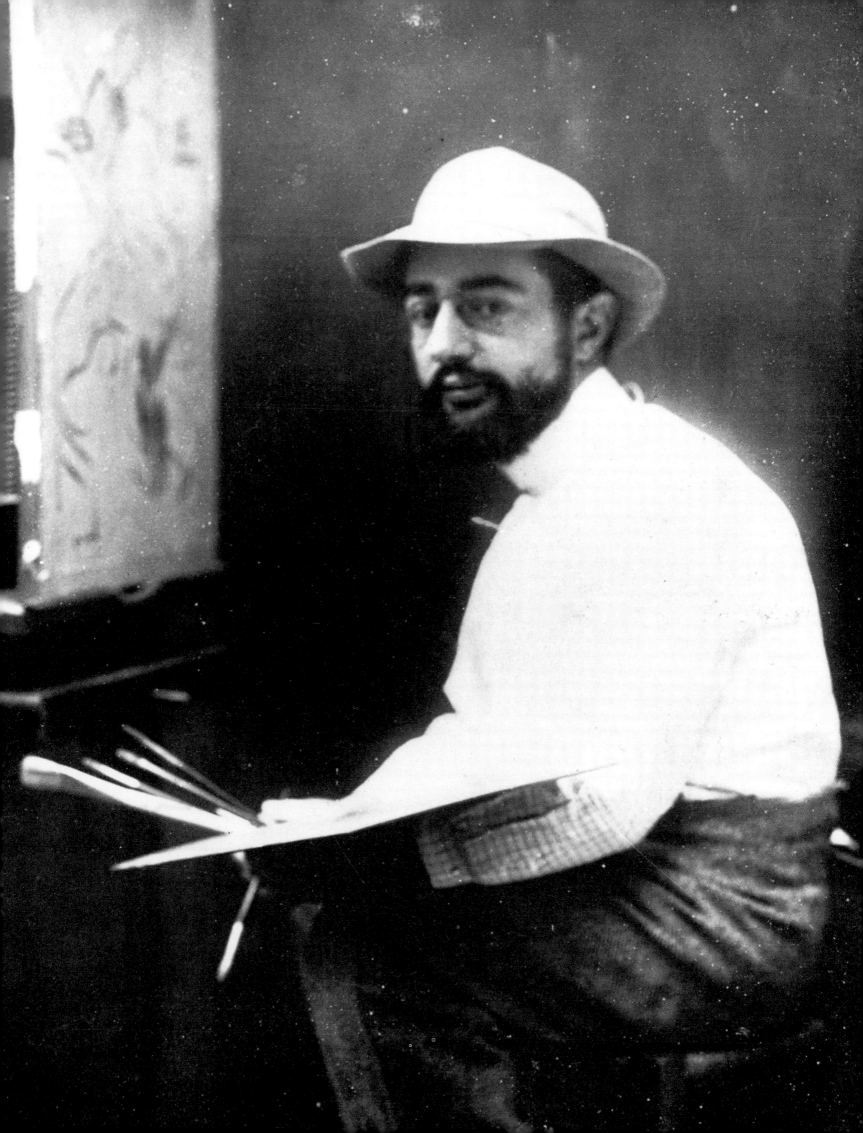

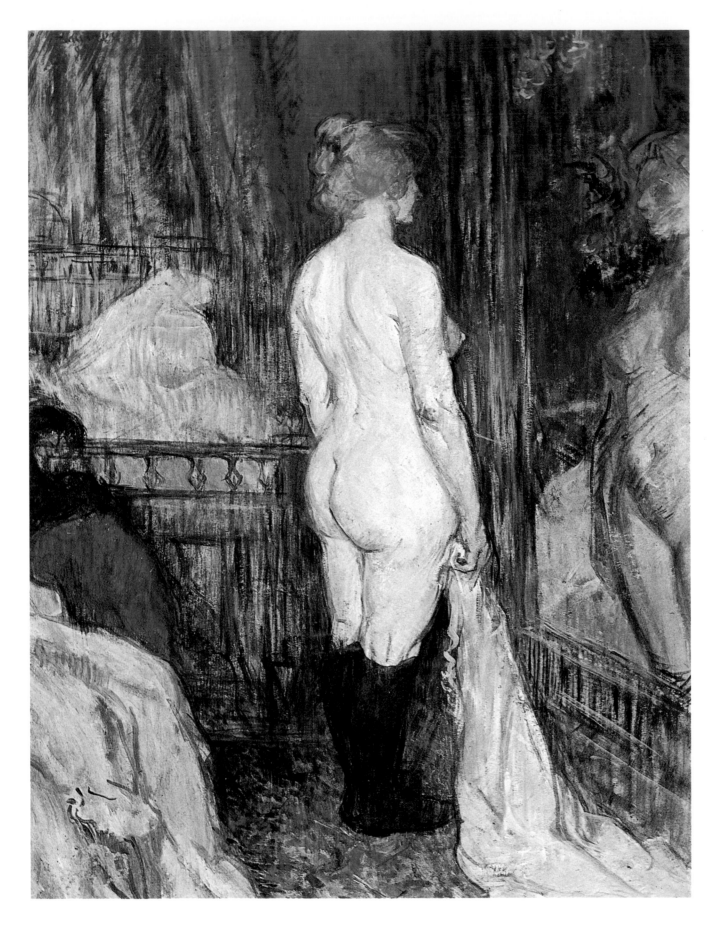

Nude in front of a Mirror, 1897
Femme nue devant une glace
Oil on cardboard, 62.2 x 47 cm. Dortu P 637
Rancho Mirage (CA), Walter Annenberg Collection

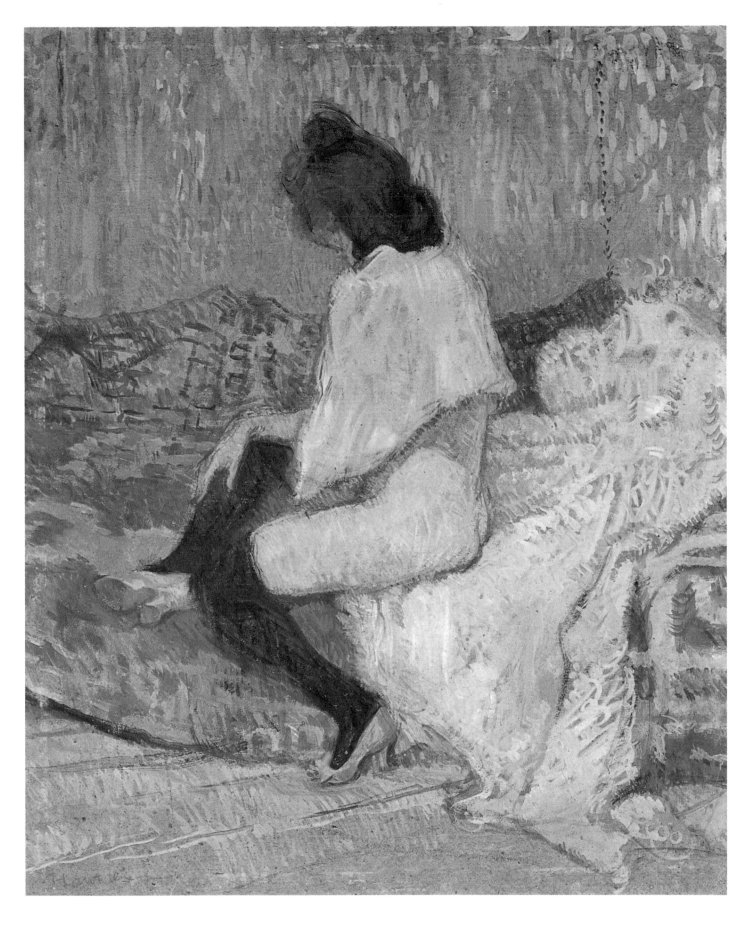

Red-Haired Woman on a Sofa, 1897
Femme rousse assise sur un divan
Tempera on cardboard, 58.5 x 48 cm
Dortu P 650
Switzerland, private collection

critic to write: "Toulouse-Lautrec, my friend, your treatment of our kind is harsh and critical… You sing a hymn of praise to the populace while offering life-size displays of its ulcers…"; but Lautrec was waiting above all for the promised appearance of Degas. "One evening about six o'clock," recounts Joyant, "there comes Degas, wrapped in his plaid, looks at everything with great care, humming to himself all the while, goes all round without saying a word, then makes for the exit. Only the upper half of his torso is visible when Monsieur Degas turns around on the spiral staircase and says shyly and rather nervously to Lautrec: 'One sees, Lautrec, that you are in the trade.' I can still see Lautrec in my mind's eye, radiant with joy and contentment over these throwaway words of recognition." It must be noted that Degas' judgement was really the only one that counted for Lautrec. He scorned compliments as well as criticisms. Yet success could not make up for what he fundamentally lacked. The sermonising clerics sent to him by his anxious family encountered declarations such as this: "Indeed I can do anything I like, since Mama has installed nuns in our old tower in Boussagues whose chief task is to pray for the salvation of my soul, and they climb up and down doing just that like frogs in a glass bowl!" One priest who remonstrated with him was met with: "Oh sir priest, never fear, I'm only digging my grave with my prick."

He noted the free days of all the girls in the establishments he frequented. He invited them to his studio, or took them out for a meal in a restaurant, or to the circus. And were they not just as well-mannered as society ladies? From time to time he visited his mother for breakfast or lunch, and enjoyed the brief tranquillity offered him by the respectable home, with its gleaming polished surfaces and cupboards fragrant with lavender. His only counter-move was to bring with him a garlic sausage, and to offer the guests a few slices. Mother and son still loved one another, although scarcely any mutual understanding remained. She worried because he was all too conscientious in adhering to the principle that he had more than once enounced: "One should drink little… but often." He was a faithful follower of Baudelaire: "One should be drunk. The only question is, what to choose. To escape the oppressive horror and back-breaking burden of the time, one needs constant intoxication. But of what sort? Wine, poetry, virtue, according to one's taste. In whatever way you like, get drunk. And when you wake on the steps of a palace, in the green grass of a roadside ditch, in the bleak solitude of your own room, and your intoxication has lessened or disappeared, then ask the wind, the wave, the star, the bird, the clock, everything that is fleeting and mournful, everything that passes and sings and speaks, ask what the time is; and the wind, the wave, the star, the bird, the clock will answer: 'It is time to get drunk!' If you want to escape the slavery and torture of the time, get drunk without pause! With wine, with poetry, with virtue, according to your taste…"

And if wine is not enough…, "then I'll pitch my tent in the brothel", said Lautrec.

Lautrec swimming in the Atlantic near Bordeaux, 1899.

Lautrec with his mother and her dogs on the steps of Malromé château, c. 1898.

The Curtain Falls

By 1898 Lautrec was completely exhausted by his work at the printers, the cocktails and his social life. "At the moment," he said to his friend Gauzi, "painting does not interest me one bit; my work at the printers keeps me away from my studio, which I rarely go to now; anyway I am often invited out…" For this reason he decided to allow himself one "day off". He added: "Every Friday I will receive guests in my studio; do come, it would give me great pleasure."

Lautrec, *paparazzo* to the stars, has now become a star himself. On Fridays a crowd of interested visitors regularly passed through his studio, but also a large number of unwelcome snoopers. Nevertheless Lautrec, in his friendly style, offered them all hospitality, and gave them his favourite cocktail, the "rainbow". People tried to buy his pictures from him at reduced prices. One stranger asked Gauzi to put in a good word for him: "Because he has increased his prices tremendously, so that they are quite beyond my reach; now he only wants to sell through dealers."

"I'm sorry," answered the loyal Gauzi, "but Lautrec sets the prices for his work according to his own estimates, with a precise knowledge of the subject. It is not for me to interfere in such a delicate matter."

Eventually Lautrec had had enough of the masses that meant nothing to him, and he gave up his "reception" days. He preferred instead to entertain people with apéritifs in the American bar on the Rue Royale. This became his new "throne", where he hunted for "types".

"Do you see that fat man at the bar, the one with the top hat, who carries a flower in his button hole with such elegance? He's the Rothschilds' coachman, unique, don't you think?" The artist made numerous sketches and lithographs of him.

For at this point in time, as he said to Gauzi, lithography interested him most. He had become the undisputed king of poster art because of the revolutionary style of his advertising designs. With his artistic "punches", which were to be seen on every wall in Paris, he had finally driven his predecessor and rival, Chéret, from the field; Chéret now preferred to restrict himself to the provocative little woman. In his graphic work Lautrec, the "Goya of prostitutes", was above all a precursor of the Expressionists. Again and again he lived up to his famous affirmation, "Oh yes, life!", attempting to express it in all its forms,

Lautrec's walking stick, cunningly fitted with a secret compartment for glass and flask in order to evade the dictates of the doctors who strictly forbade any alcohol consumption whatsoever.

Lautrec with his beloved mother Adèle in the garden of Malromé château, summer 1900.

however unconventional. To the prostitutes of Montmartre he boasted that he did not come as a researcher or adventurer, nor as a connoisseur, but as a "historian".

The poster *Mademoiselle Eglantine's Troupe* (p. 129, no. 14) marks a new development. The undisciplined and crazy era of La Goulue and the Moulin Rouge was over. The can-can had become respectable, and the girls enjoyed a different reputation. Lautrec's posters had gained more recognition than ever, they were noticed and remembered. A number of young artists used them as models. Picasso hung one in his studio in Montmartre, and Braque records that, as a young man, he could look out of his window and observe the bill-sticker covering the walls opposite with posters by Lautrec. Hardly had the man completed his task, than he would dash down and take the fresh poster from the wall to paper his own room.

One did not hesitate in those days to make a direct connection between the posters and the artist. Frantz Jourdain wrote in the year 1895: "Oh! Oh! There is someone who does not give a damn... Famous as an exotic animal, all Paris laughs about him, this regular of the Moulin Rouge, the Casino, the Folies Bergère, the bars of Montmartre, the way-out cafés, the hot spots... he never misses a party. And yet he is very intellectual, highly educated, a very talented artist, a man of the best pedigree... His works convey an impression of sorrow, of down-heartedness... With a few moves, with great delicacy and a gentle touch, he mixes his cocktails with a sense of perfection that the most famous barman of the Americas would envy... He is a great satirist, but he does not deform nature, he waits for it to show its grotesque side."

Goncourt is much more direct. He notes in his newspaper in 1896: "Exhibition at Joyant of lithographs by Lautrec, a homunculus whose absurd deformity is reflected in every one of his drawings." And from the mordant pen of Alexandre Hepp two years later: "By the way, the deformed, limping, apparently insignificant man was the creator of those works, which is strange. In most of his memorable figures he has drawn his own features and given life to his own appearance, as if in the grip of an obsession; the influence of his physical constitution is everywhere to be felt, and in the strangest way. The bone structure of the artist appears to impinge, bitter and human, on his personality, as if he had never had a soul to liberate him."

Much as Lautrec was discussed, he felt insecure, and worried... In particular he was beginning to feel the effects of the exhausting life he had led by his own choice, with full awareness, like a slow process of self-destruction. In addition to the weak physical constitution with which he was born, he had acquired syphilis, not yet curable in his day. It was something that had afflicted many of his contemporaries, even the most distinguished of them, including Franz Schubert (1797–1828), Baudelaire and Maupassant, Manet, Gauguin, van Gogh and Friedrich Nietzsche (1844–1900). On the recommendation of his doctor and friend, Henri Bourges, he tried to alleviate his affliction by

Lautrec at a picnic with friends, *c.* 1898.

The Motorist, 1898
L'automobiliste
Black-and-white lithograph, 37.5 x 26.8 cm
Adhémar 295, Wittrock 293, Adriani 290

Sitting at the wheel is Lautrec's cousin, Gabriel Tapié de Céleyran; he and Paul Guibert were among the first motorists in Paris. The little dog, well-known from many of Lautrec's prints, seems to be quite unruffled by the noisy motorcar.

means of travel and by taking cures. But instead of allowing himself to rest, he spent his nights in bars, drinking enormous amounts of alcohol, and his days working. He could resist everything except temptation, whether in the form of art or entertainment. He spent whole nights in bars and dance cafés, falling asleep in his carriage, and waking up to spend the next night at his printer's.

The commissions were coming thick and fast now: lithographs for one customer, portraits for another. Yet there appeared to be a crack in Lautrec's life. His friends often found his studio empty, his easel and palette covered in dust. "His work does not continue on the intended path, it turns out not to be a royal path. Perhaps in certain areas he has reached his ideal: he searches in various directions, but no longer finds his way to fully integrated synthesis, to complexity in simplification, and his colours become duller and duller. He returns to old themes, to painting outdoors, which he has ignored for ten years; he returns to paths that he had trodden with René Princeteau and his father. Lautrec has hardly passed the thirty mark, yet he is prematurely aged; even though he is still young, he has lived so much, so fast and with so little regard for his weak constitution, that he is physically and morally worn out." (P. Huisman and M.G. Dortu in *Lautrec par Lautrec*)

Tristan Bernard introduced him to the world of bicycle racing. Bernard was editorial director of the *Journal des Vélocipédistes*, a magazine for cyclists, and sports director of the *Buffalo* racing track at the Porte de Neuilly, which gave him the best credentials in the cycling sphere. Thanks to the invention of the rubber tyre by Dunlop, bicycles had become fashionable, and women were not slow to mount the wonderful machine in their culottes. One finds announcements such as: "Cycling lady, aged 45, seeks gentleman with bicycle." These new human "animals" attract Lautrec like a new breed of horse or fowl. The racers elicit the same kind of excitement in him as the dancers or acrobats. Lithographs and posters appear in rapid succession, especially for the Simpson "racing stable" (p. 131, no. 26). A pity that he cannot ride himself, but instead he buys himself a rowing machine for his flat! Without giving up drinking and without using his nights for rest, he nevertheless sometimes rows for hours on end, wearing a sailor's cap. A neighbour, who finds the unusual rhythmic noise incomprehensible, goes about the neighbourhood telling people that the painter has now taken on the strange habit of grinding flour for himself, to bake his own bread…

Things were not going well for Lautrec any more. He could no longer quench his thirst. From early morning he drank alternately white wine and spirits by the glass. He drank everything, regardless of what, regardless of where, but he failed to inebriate himself. The effects were noticeable not only in his temper but also in his work. His eccentric appearances were punctuated with scandalous scenes, somewhat like those instigated by his father, Count Alphonse. When the ex-king of Serbia came to Lautrec to buy a picture from him, he asked in a

Lautrec with his friend Maurice Guibert, in Guibert's garden, *c.* 1898.

In the Café: The Guest and the Anaemic Cashier, 1898
Au Café: Le consommateur et la caissière chlorotique
Oil on cardboard, 81.5 x 60 cm. Dortu P 657
Zurich, Kunsthaus Zurich

Lautrec has here taken up the subject of Degas' *Absinthe* (1876, Paris, Musée d'Orsay), and used it to express the hopeless loneliness and alienation of the two people portrayed. In both paintings a couple sit in front of a wall mirror, behind a table, and the bottle and glasses stand as a barrier between viewer and figures. Lautrec, however, directs the viewer's attention to the painful differences between the well-fed bourgeois and the pale, undernourished employee, who is pointedly turning away from her neighbour.

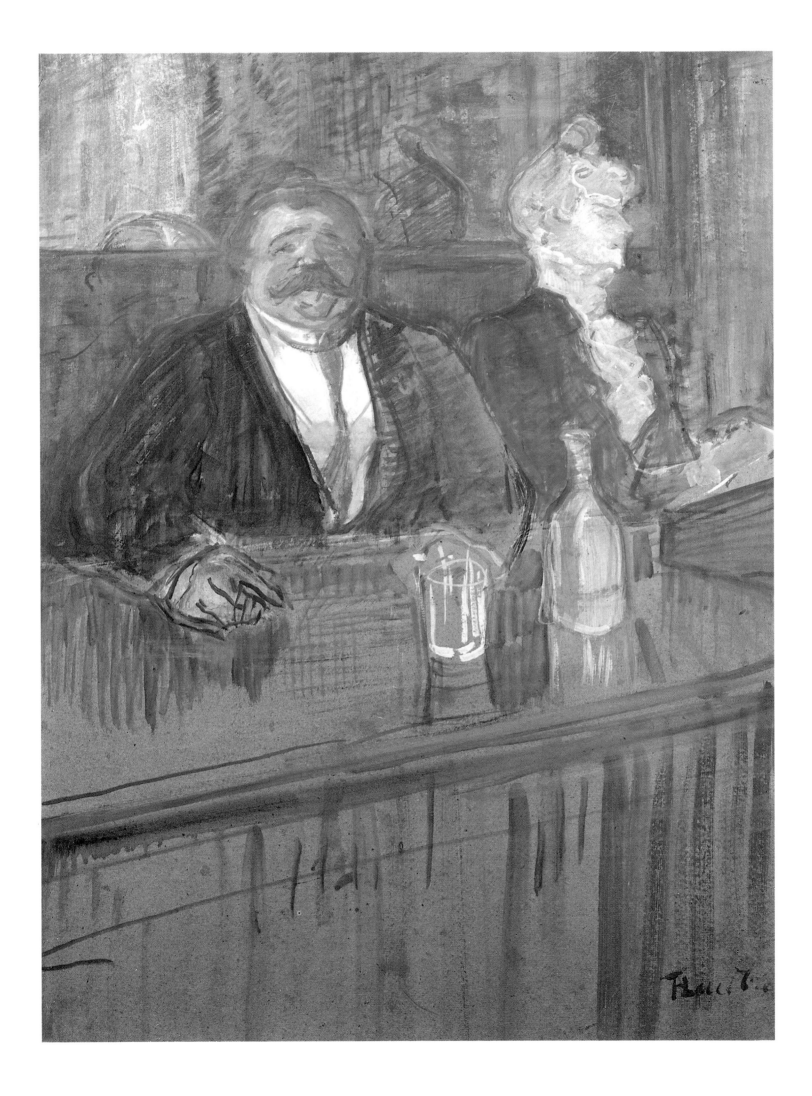

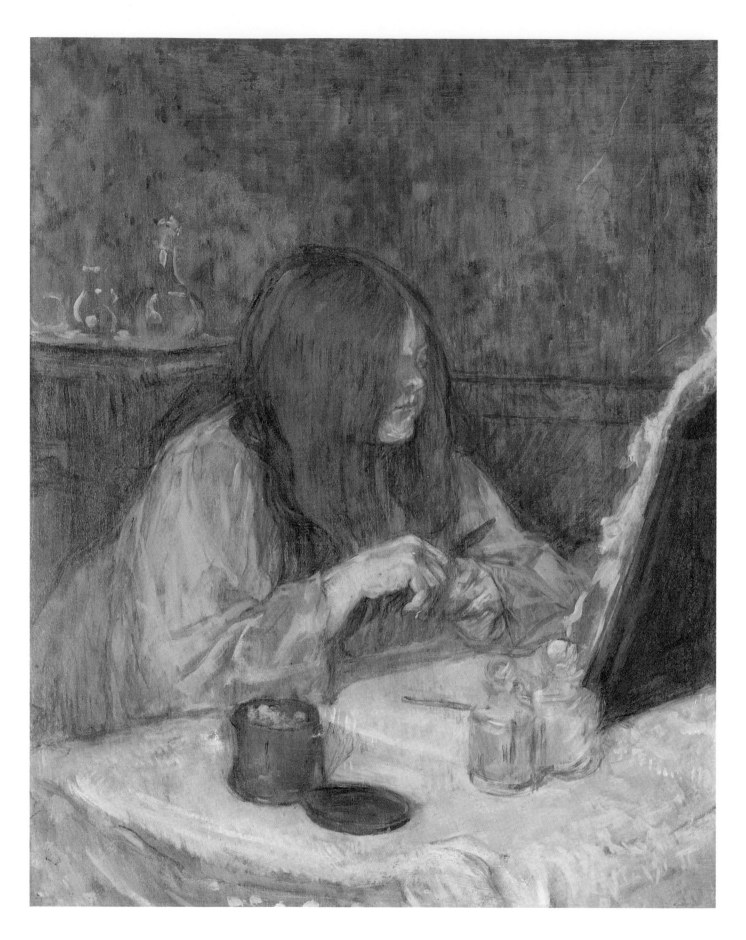

Madame Poupoule at her Toilette, 1898
Madame Poupoule à sa toilette
Oil on wood, 60.8 x 49.6 cm
Dortu P 668
Albi, Musée Toulouse-Lautrec

friendly manner: "Are you descended from the Count of Toulouse who achieved fame during the first crusade?"

"Remotely," replied Lautrec, "he was there when, in the year 1100, Jerusalem was taken, and also at Constantinople. You, at any rate, are only an Obrenovich!" And he mumbled under his breath: "Obrenovich, Karageorgevich, all pig-breeders!"

In his works a strange kind of imagination became more and more apparent. His drawing became enervated, his strokes uncontrolled. A fox terrier is shown wearing a lorgnon, with a pipe in his behind and spurs on his paws; he stands in front of a curled-up cat basking in sunlight and looking like Maurice Guibert. A train, which is racing by at full steam, is about to run over a poodle, while a man is trying to stop the train in vain. His friends, who did their best to stave off disaster, persuaded him to leave Paris and travel to the seaside, but his eccentric behaviour continued. He swam naked in the sea, and had Guibert take photographs of him acting the "lion". The good people of Arcachon were astounded by the sight of this dwarf promenading, limping along the beach with his pet cormorant, Tom, on a long thin lead, following him with just the same waddle. Lautrec took him with him wherever he went: fishing, to the cafés, he even ordered absinthe for him. "He's developed a taste for it," he said… In the evenings he dressed up as a muezzin and called his friends, the faithful, to prayer from his window.

He decided to go on a voyage with Guibert, to travel to Bordeaux on board the "Chili", which was bound for Dakar. Before the journey he organised some provisions, which consisted of boxes of brandy, port and olive oil. Rather unnecessarily, he also took along crustacea and fish, with which he proceeded to feast the crew, creating his own opulent dishes richly spiced with shallots, fine herbs, tomatoes, brandy and white wine. When they arrived in Bordeaux he suddenly noticed a fellow passenger, whom he had failed to spot previously because of his preoccupation with cooking, and she fascinated him. He thought she looked really charming with her wide-brimmed hat drawn down onto her forehead, her gaze lost in the distance. She was not a red-head but a blonde, who wore her hair in a large bun. She is portrayed in *The Passenger from Cabin 54* (p. 131, no. 22).

Lautrec had no illusions about his chances of seducing her, but no matter! He would follow her to the end of the world… Guibert was horrified to find himself suddenly on a voyage to Lisbon, while Lautrec was busy on the bridge, drawing like mad. But Guibert's pointless journey was not over yet. In Lisbon Lautrec began raving about elephant hunting, and assured him that "the fourteen-year-old negresses are quite delectable lovers, and the risk of being eaten by cannibals is an essential attraction for any expedition". Guibert, however, was of the opinion that he had better not travel to Dakar, and they managed to reach a compromise: the captain was persuaded to have a message sent to Paris under the ship's name, in which their happy arrival on African soil was announced. Lautrec, meanwhile, spent the rest of the

"Woman at her Toilette" was a popular theme in 18th and 19th-century French art, and Lautrec turned to it several times over a period of more than ten years. Unlike his predecessors, however, who usually concentrated on the charms of the women prettify themselves, Lautrec used the subject to express melancholy and loneliness (left). The girl's face is almost totally obscured by the lank mane of hair falling about her, and her gaze into the mirror suggests depression and bitterness. The contrast between the dispirited mood of Lautrec's picture and conventional treatments of the subject further highlights the impression of sorrow, of the girl's apparent regret for a wasted life.

summer with his mother in Malromé. There he rested a little, and continued to take his poison, absinth. He caught a frog in the garden, and amused himself by putting it in his mouth and letting it jump out from his lips.

Back in Paris, Lautrec inspected his winter quarters and picked up his usual life where he had left off: drinking sessions, girls and work. One after the other, he made lithographs of all his friends: Dethomas, his companion in tours of the brothels, he portrayed in a decidedly strange pose, and firmly entitled the picture *Corruption*. Tapié was shown as a bizarre representative of a new race who, dressed in cap, goggles and leather coat, sits at the wheel of an infernal machine and drones past as *The Motorist* (p. 166). In 1897 he published one of his best colour lithographs, *The Grand Box* (p. 125), through Gustave Pellet, whom he called the "undaunted publisher"; the lithograph was a preliminary to a painting (p. 124) and it shows two women and a man in a very respectable pose, watching a play. But the man in top hat, with his swollen face, was none other than Tom, the Rothschilds' coachman. The woman in the dark cape was the dancer and actress Emilienne d'Alençon, while the other was known as Madame Armande to her intimate clients, and was the manager of a lesbian bar called Le Hanneton in the Rue Pigalle. She was quite notorious, and Lautrec gave her the nickname "La Gambetta", while she nurtured motherly

Circus Rider, 1899
Ecuyer
Charcoal and coloured chalk on paper, 33 x 50 cm. Dortu D 4522
Cambridge (MA), The Fogg Art Museum, Harvard University

The Jockey, 1899
Le jockey
Lithograph, oil and water-colour, 51.5 x 36 cm
Adhémar 365, Wittrock 308, Adriani 345
Private collection

feelings towards him. He portrayed her as Juno as well as in "all her ugly nakedness". He called that "the technique of gentleness".

In his lithographs he continued to capture the reality of the moment: the exciting moment of a beheading, when the guillotine falls to the great thrill of the crowd. *Snobbery* describes a scene from the fashionable restaurant La Rue, on the Place de la Madeleine. *Royal Idyll* shows the scandalous and adulterous love affair between Princess Carman-Chimay and a gypsy. Lautrec sits them side by side; she is a "delicate bird, a marvel from the aristocracy", while he is pockmarked, "olive-skinned, almost a negro, fearful, the sad Rigo, who resembles a coachman from Theodora's circus". "With love it is like at the party in Neuilly," he laughs, "the dumbest can get lucky… why don't you try your luck… one can make some terrible mistakes, I can tell you…"

He returned to portrait painting, though these pictures were less and less destined to please their models: the engraver Henri Nocq; Monsieur de Lauradour, where Joyant saw scarcely anything but a top hat, a beard, and a water-pipe. "Who is this pipe-head?" asked Bruant, and Lautrec jumped for joy. The writer and journalist Paul Leclercq sat for the painter for five or six weeks, wearing a green felt hat over his eyes, "to concentrate the light and prevent shadows". But the sittings were frequently interrupted, because after Lautrec had set a few dabs of paint onto his cardboard, and sung a happy song, he would call out: "That's enough work done! It is so nice outside!" And off they went for a pub crawl.

His friends felt increasingly that "his heart was no longer in it". The lithographs and posters exhausted him, and he avoided painting altogether. At the sight of an interesting motif, which previously would have sent him off to get his brushes, it now sufficed to say: "Too nice! There is nothing more to be done!" However, he met Degas in the Rue de Douai, and the painter was unusually friendly: "Oh! How happy I am to see you. I have just come from Durand-Ruel, where I was shown your pictures. They are exceptional. They have expression, character, yes, character! My compliments. I am very happy to have seen that. It is terrific! Continue your work! You have an admirable talent…" and then he disappeared.

Lautrec was overwhelmed and, moved to tears, he asked his friend Anquetin, who was accompanying him: "Do you believe that he really meant what he said?" But Anquetin was undoubtedly jealous that Degas had not had a word to say about his own work, and he replied: "No, seriously, did you not notice that he was making fun of you!" That was like a cold shower, and from then on Lautrec remained sceptical towards all praise from Degas.

A few rather dangerous-looking bulldogs began to populate his paintings. They reminded him of his youthful enthusiasm for animals. It was as if the artist was returning to his own beginnings, and to his past. Carriages and horses interested him once more, just as they done in the early years.

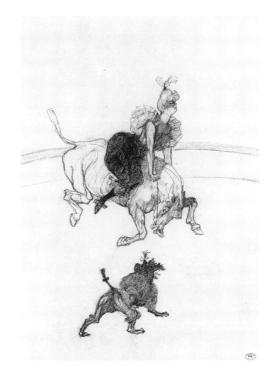

At the Circus: the Clownesse, 1899
Au cirque: Clownesse (Le salut)
Black chalk, colour crayons and pencil on paper, 35.6 x 25.4 cm. Dortu D 4528
Cambridge (MA), The Fogg Art Museum, Harvard University, Bequest of Frances L. Hofer

At the Circus: Horse and Monkey Dressage, 1899
Au cirque: Cheval et singe dressés
Black chalk, colour crayons and pencil on paper, 43.5 x 25.5 cm. Dortu D 4525
United States, private collection

The Natansons invited him to Villeneuve so that he could rest and drink less, but one morning they got a fright. Smoke was coming from Lautrec's room; horrified they rushed to the scene to find Lautrec lying spreadeagled on his bed, staring at a spider that was scuttling along the wall. When Count Alphonse heard that his son was drinking a dangerous amount, the laconic comment was: "Let him go to England; society won't notice it so much there." His friends stood guard over him, but at night he often evaded them and was brought home by night watchmen, sometimes with a black eye or bruised nose. Clearly he was more and more inclined to visit places which should have been avoided.

He called on Durand-Ruel with a woman in tow and held out his hat: "For the lady with whom I have just spent the night!" Durand-Ruel refused to give him any money, whereupon Lautrec proceeded to beg outside the gallery; he accused Durand-Ruel of all kinds of villainy and drew quite a crowd. He was afraid of the flies that buzzed around everywhere and never stopped bothering him. What on earth did they want from him? He slept with his boot-jack so that he would have some means of defence. His enemies were legion. Among them were the microbes that infested his studio. The place was crawling with them, and Lautrec sprinkled his floor with petroleum. Jane Avril, the truest of the true, commissioned him to do another poster for her, in gratitude for the fame that she owed to him. Lautrec came up with a twisted, perverse composition in which a cobra coils round the dancer (p. 127). The poster was not used. Nightmares, haullucinations, delirium tremens... "You see what awaits us," he had once prophesied. Alcohol and venereal disease had done their work. Alcohol and despair.

Early in 1899 Lautrec collapsed on the street and broke his collarbone, blind drunk yet again. He was taken to the hospital for psychiatric and nervous disorders in Neuilly, and his strength was restored by detoxication treatment. In order to save themselves the trouble of looking after him, those responsible had him veritably incarcerated in this mental asylum. The 35-year-old painter remembered the dedication that his father had written a quarter of a century earlier in his birthday present, the book on falconry, and he sent him an appeal for help: "Papa, you have the opportunity to act humanely. I am shut in, and everything that is deprived of freedom perishes!" But his father did not dare to respond, so he sent for Joyant. No one knew what to do. A discharge from hospital would be premature. A complete cure from addiction would take a long time. So Lautrec decided to prove that he was "normal" again. He asked Joyant to bring him materials so that he could begin to work: "When I have done enough drawings, they will not be able to detain me here. I want to get away from here, no one has any right to lock me up."

"I remember my first visit to Lautrec," writes Joyant, "the very first one, and how desperately sad it was. At the end of a narrow and very low passage, lit only by slits in the wall, with access through a single

The Englishwoman from Le Star at Le Havre (Miss Dolly), 1899
L'Anglaise du Star au Havre (Miss Dolly)
Water-colour over a lithograph on cardboard, 54 x 42cm. Dortu P 693
São Paulo, Museu de Arte de São Paulo Assis Chateaubriand

Le Star was an English sailors' inn in the harbour at Le Havre, in the Rue Général Faidherbe. Miss Dolly worked as a singer and barmaid there, and in July 1899 Lautrec was a frequent guest. The establishment survived until 1940. The print shown here is a lithograph which Lautrec painted over with watercolour and transferred to cardboard.

The Englishwoman from Le Star at Le Havre (Miss Dolly), 1899
L'Anglaise du Star au Havre (Miss Dolly)
Oil on wood, 41 x 32.8cm
Dortu P 684. Albi, Musée Toulouse-Lautrec

very low locked door, I reached two tiled and barred cells, one of which housed the warder, the other, Lautrec. Alert and calm, he had pencils and a few drawings spread out in front of him, and he greeted me as a liberator, as someone who would re-establish the link with the world outside, but at the same time I sensed that he was full of fear, afraid that he would be locked up here for ever, at the uncomprehending mercy of family and physicians…"

Joyant provided just the right stimulus for work by commissioning a series of circus illustrations. Using only his coloured pencils, without brush or oils, Lautrec produced in his asylum room a series of astonishing works, executed with the utmost precision. He had always had a liking for clowns and tumblers, his fellows, and for the acrobats whose accomplishments he could not match. Drawing from memory, he created a highly individual world of human beings, and he gave them life. With this demonstration of stylistic, artistic and technical expertise, Lautrec managed to impress and mollify the doctors, who were also the judges in his case, so that they agreed: "The physical and mental condition has stabilised… Symptoms of delirium are no longer present. There is scarcely any remaining sign of alcohol toxification, except in a light tremor… But his amnesia, his swings of character and the sporadic weakness of will make it absolutely essential for Monsieur Henri de Toulouse-Lautrec to be under constant supervision." He was granted conditional discharge.

Saved! Lautrec had been terrified, and he took care, to the day of his death, not to let a comparable situation arise. Of course he poured contempt on his medical judges: "Those are people," he said bitterly, "who think that sickness and the sick are made for them." But to his faithful friend Joyant he declared in all seriousness: "My drawings bought me my freedom." Without complaining he agreed to a disciplined way of life which was quite new to him, and which was a profound contradiction of his nature and his inclinations. Paul Viaud, a friend of the family, was with him night and day from that time on. He was charged above all to prevent Lautrec from drinking, but there were occasions when the tables were turned on him and Lautrec led his mentor home blind drunk. Lautrec also had a walking-stick specially made with a little flask in the knob, and he regularly took a sip when Viaud's back was turned (p. 165).

In the meantime the press had got wind of Lautrec's sojourn in the asylum. His loose talk, malicious remarks and independent spirit had created enemies as well as friends among critics and reporters. They had nothing better to do than to insult and humiliate him: Crazy? Right from the day of his birth. It had to come to this, Lautrec was destined for the madhouse from the start. Now there can be no doubt about it, this is lunacy unmasked, and all the while he was signing pictures and drawings and posters.

Lautrec was powerless to defend himself against such abuse, but so what, he was free! In July he and his "constant companion" went on holiday to Le Havre in Normandy, and he soon got to know all the

The painting *Séparée in the Rat Mort* (p. 179) was made after Lautrec spent some time in a sanatorium to cure a complete mental breakdown and alcohol poisoning. He subsequently recuperated in the provinces, where he recovered rapidly and even abstained for a while. But as soon as he returned to Paris and met his old drinking companions, he began to drink once more.
The woman represented is Lucy Jourdan, a well-known figure in the demi-monde, taking an intimate supper with a companion in the fashionable Rat Mort restaurant, Rue Pigalle. It is said that the painting was commissioned by her lover, the Baron de W., who is perhaps the person next to her.

Séparée in the Rat Mort, 1899
En cabinet particulier ou *AuRat mort*
Oil on canvas, 55 x 45 cm
Dortu P 677
London, Courtauld Institute Galleries

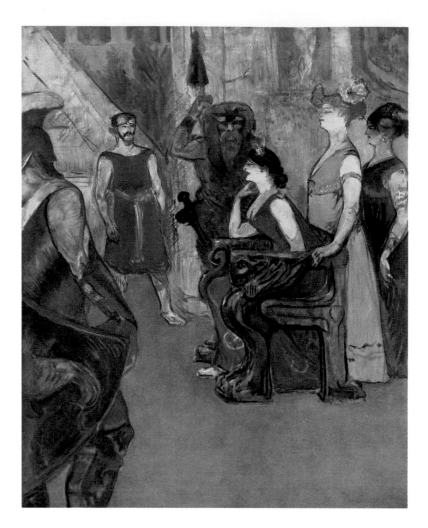

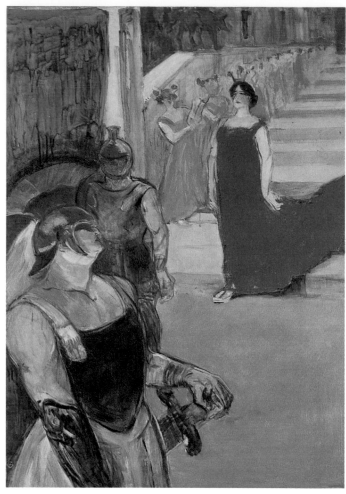

bars, international meeting-points for sailors and fishermen, where the nice serving-girls were singers and dancers as well, and ready to oblige any of their clients' fantasies. He took a particular liking to the young barwoman Miss Dolly, a sandy-haired Englishwoman who aroused in him once more the will to paint. He sent Joyant a telegram asking him to send painting material, and not long afterwards he wrote: "Dear Sir, yesterday I sent you by registered post a canvas with the head of the barwoman from 'Le Star'. Let it dry and take it to be framed. Thank you for the news of my finances. I hope that my guardian is satisfied with his ward." Lautrec called his friend Joyant by the ironic name of guardian, since, with Lautrec's consent, he managed the artist's finances.

From an artistic viewpoint Joyant had good reason to be satisfied. *The Englishwoman from Le Star at Le Havre* (p. 177) is a new masterpiece of portraiture. It reveals nothing of the tragedy that the artist had just experienced. The brush strokes are applied with more speed and precision than ever before. The palette is of rare subtlety. Delicate pinks mediate between the blue of the dress and the yellow-orange of the hair. Dabs and strokes of green give the contour of the blouse, and are taken up again in the geometrically constructed background, alternating with dots and strokes in blue. The thin oil-paint is applied in very fine transparent layers. The picture has the character of a mosaic composed of different motifs in the form of strokes and dots. This is

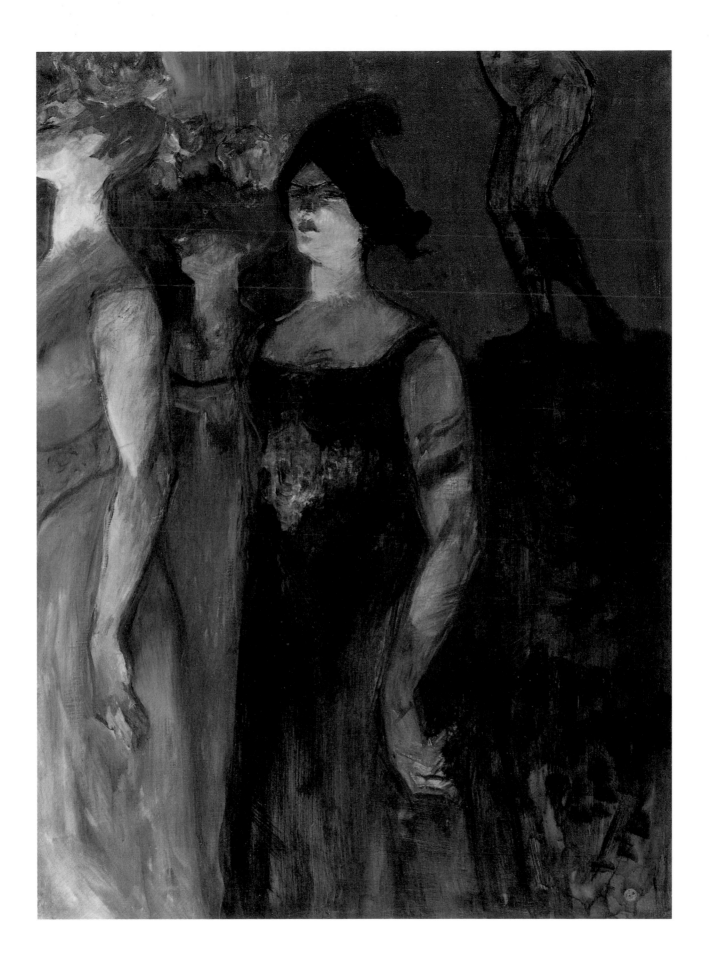

Messalina between Two Female Figures, *c.* 1900–1901
Messaline entre deux figurants
Oil on canvas, 92.5 x 68 cm
Dortu P 703
Zurich, E. G. Bührle Trust Collection

Lautrec at his greatest, and most modern – master of his own form of abstract art.

This masterpiece was followed by another, painted around the end of 1899 and beginning of 1900, the *Séparée in the Rat Mort* (p. 179), and the success of this work is even more remarkable. It marks a return to the demi-monde. The well-known cocotte Lucy Jourdan sits in all her finery beside a wooer who is represented schematically, with his body sliced off in the middle by the right edge of the picture, so that he is clearly not the central figure. The actual motif is the inflatable doll, whose face echoes the bowl of fruit on the table in front of her. The face and the fruit look equally delectable. As so often, Lautrec offers the viewer two interpretations, achieving the ambiguity in this case by giving the large pear in the middle of the bowl the same glowing red as the woman's heart-shaped mouth, and the yellow colour of the pear appears likewise in her face. Renoir, in comparable manner, uses the same colours in his palette for flowers and naked bodies. The difference lies in Lautrec's preference for edible objects. The glaring colours stand out against the background and project both figures and objects into the foreground.

Lautrec seemed to have overcome his most threatening difficulties, and was leading a healthy life: sea trips, excursions in the Bois de Boulogne. He had returned with new zest for work to palette and lithographic pen. Between autumn 1899 and summer 1900 he returned to his early themes, horses, jockeys, Amazons, and a range of equestrian scenes: *The Jockey* (p. 173), *Race Horses*, *Saddling*, *Jockey on the Way to the Start*, *The Amazon and the Dog*, *At the Races*. He seemed, in Joyant's words, "like an animal chased by dogs, returning to its preserve".

This last active year was exceptionally productive; it was one of the most fruitful and original phases of Lautrec's artistic career. But it was, unfortunately, the last. It frequently happens that critics and general public alike belittle the last works of a great painter. This is the case with Picasso, whose pink and blue periods, like his *Demoiselles d'Avignon* period, are generally preferred to the grandiose "wild" works of his late years, which are only slowly beginning to gain recognition. The same is true in the case of Matisse, whose late cut-outs using paper and scissors are often seen as an old man's idle play. But the last works of a great painter, even if he is old or ill, represent a culmination. Lautrec's technique had changed, and this may cause some confusion when late works are compared with early ones. He was applying paint more thickly, and his palette was growing darker. This inner development shows that he had gradually come to attach less importance to the line that had determined his early practice; nuances of colour had become more important to him. He became more of an Impressionist, but that did not mean turning his back on earlier stages, but rather that he was working towards a new development, one that was taken up again later on by the Fauves. His artistic intelligence was so finely strung, the sensibility of his eye so

Mademoiselle Cocyte in "La Belle Hélène", 1900
Mademoiselle Cocyte dans "La Belle Hélène"
Water-colour and pencil on paper, 62 x 48 cm
Dortu A 265. Albi, Musée Toulouse-Lautrec

The sick Lautrec spent the winter of 1900/1901 in Bordeaux, where he visited the Grand Théâtre and painted scenes from Isidore de Lara's opera "Messaline" (cf. pp. 180, 181) and Jacques Offenbach's operetta "La Belle Hélène". We know from a letter to his Parisian friend Joyant, however, that he was not enamoured of the actress playing the beautiful Hélène: "Hélène is being played by a fat sow called Cocyte."

acute, that he immediately achieved remarkable results with his new insight and pattern of work; he had a miraculous way of combining colour and light with the psychological truth of his models. The warmth of his colours reflects the subtlety of his message, the deeper meaning rings clear and true. This can be observed in his *Séparée in the Rat Mort*, and in the picture of a milliner, the first in a series of wonderful late portraits. Great artists know when the end of a period of their creative life has come, when it is time for them to make a new beginning. Lesser artists are content to stay with the "knack" they have found, and to exploit it.

The picture *The Milliner, Mlle Louise Blouet* (p. 188) shows once more the contrast between light and dark tones. Vermeer's young woman sitting at a window deep in thought comes to mind when one looks at Lautrec's young milliner with her sandy hair, shown in profile, wearing a shimmering green blouse that changes to yellow, looking down with narrowed eyes, entirely absorbed in her work, against a background of hats. Both pictures derive much charm from the artist's rich palette, and in both there is a special atmosphere of serenity and self-forgetfulness. Of Lautrec's picture one could go so far as to say that it is a consoling farewell. A few months later he was to say good-

One of the last photographs of Lautrec, taken while he was resting at Malromé château by Thadée Natanson, *c.* 1900/1901.

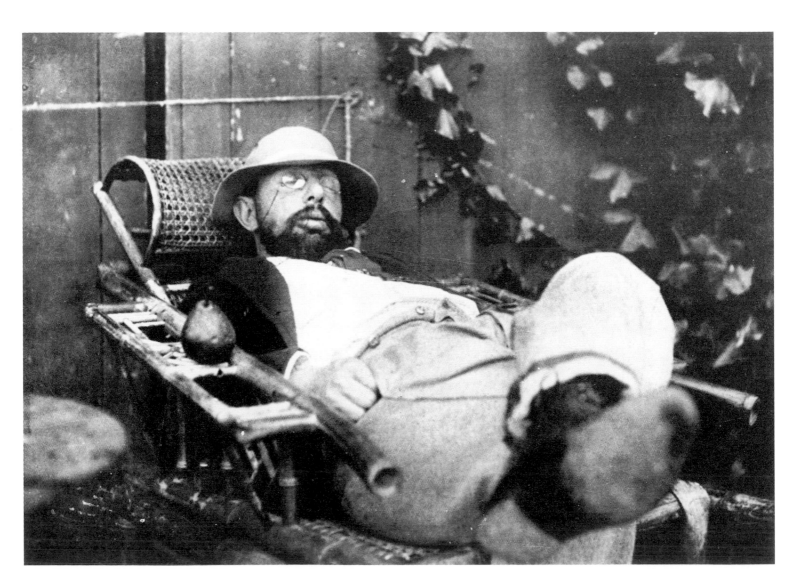

bye to the little milliner, and to embark on his last journey to the place where he was born, and the place where he was to be buried. The joyful grace and delicate beauty of this young woman sweetened Lautrec's last months, according to his friends. His parting words were calmly cheerful: "We can embrace, you will not see me again. When I am dead I shall have Cyrano's nose."

Some art historians give a lower estimate of Lautrec's achievements as an artist in his last years – their judgement is based above all on the decline of his physical health – and they consider the late works weak and flawed, but the fact is that Lautrec transformed his weakness into creative force. Indeed, when he felt his powers dwindling he painted even more rapidly, and speed was always an essential criterion in his work. At the given moment he had to transfer what he saw, and what

Admiral Viaud, 1901
L'amiral Viaud
Oil on canvas, 139 x 153 cm
Dortu P 722
São Paulo, Museu de Arte de São Paulo Assis Chateaubriand

The painting shows Lautrec's friend Viaud, who really was an admiral, and who allowed him to spend some time on his yacht in 1899, at Countess Adèle's request; Lautrec had just been released from hospital in Neuilly and his mother hoped that this ruse would prevent her son from succumbing to alcohol again.

he felt, to canvas, so that his perceptions, transmuted into pictures, would live on.

Shortly before his death he painted his friend Joyant at a duck shoot, standing on his yacht in yellow oilskins and souwester, his gun at the ready (p. 186). The background is only suggested; in some places the wood that Lautrec used as ground shows through – a technique that he developed to perfection. The figure of Joyant, by contrast, is painted with expressive brush strokes, entirely in yellows and russets. Only the yellowy-pink of the face and the reddish-violet of the hands interrupt the harmony of colour. The wild energy of the brush contrasts with the manner of his earlier paintings, in which more emphasis was given to design and shading, and the surface was only lightly coloured. Matthias writes of this unusual and particularly successful picture: "Such a sudden eruption of a picture, put down quickly and with no further correction, may have been prompted by 'Professor' Hals, from whom Lautrec had taken lessons from time to time in Holland."

It is clear that as a painter Lautrec, like most other important modern painters from Eugène Delacroix to Henri Matisse – and including Picasso – attached paramount importance to colour. Painting and colour come to mean much the same thing, and that seems quite natural. Lautrec designed a picture to go on the wall above the fire-place in the château dining-room: an ironic portrait of Viaud as admiral, in which his "constant companion" is represented in red costume on board ship, against a blue-green sea (p. 185). He is wearing a wig tied at the nape of the neck with a black bow, and his huge gauntleted hand stretches out to the railing. One sees only the red coat, the dominant expanse of colour. Progress on the portrait was slow, and when Lautrec left Malromé it remained behind, unfinished. But although he was working more and more slowly, the compulsion to paint was greater than ever.

He chose to spend the winter months in Bordeaux, and there his old interest in the theatre was re-kindled. He threw himself into Offenbach's "La Belle Hélène" which was being performed at the Grand Théâtre. He painted and drew feverishly. "I work as much as I can," he wrote to Joyant, "I'm getting there… the part of Hélène is being played by a fat sow called Cocyte." He also saw a performance of Isidore de Lara's opera "Messaline". He shouted his approval, crying "Beautiful!" to the annoyance of the rest of the audience. In the last days of 1900 he painted six pictures in rapid succession. *Messalina between Two Female Figures* (p. 181) is particularly representative of these last works, in which colour takes precedence over all other considerations. The picture is given life by the harmony of reds, blues and yellows. One sees again the expanse of red in the background, which seems to project the silhouettes, treated in cooler tones, into the foreground. The linear element that had dominated his earlier works becomes secondary, and is given attention only where it is structurally necessary. This is not to be ascribed to carelessness on the part of an

Maurice Joyant at the Duck Shoot, 1900
Portrait de Maurice Joyant en baie de Somme
Pencil on paper, 21 x 13 cm. Dortu D 4633
Albi, Musée Toulouse-Lautrec

Maurice Joyant at the Duck Shoot, 1900
Portrait de Maurice Joyant en baie de Somme
Oil on wood, 116.5 x 81 cm. Dortu P 702
Albi, Musée Toulouse-Lautrec

This portrait was inspired by a photograph of 1899 which showed Lautrec's friend Joyant on a boat at a duck shoot. The painting was preceded by a number of sketches, including the one above, and Joyant had to model for his friend no less than 65 times in all. The writer and art dealer Maurice Joyant (1864–1930) was one of Lautrec's most intimate friends, whom he had known since their schooldays together. In 1890 he succeeded Theo van Gogh as director of the Goupil Gallery in Montmartre, and later he opened his own gallery with Michel Manzi, in which he promoted young up-and-coming artists of the avant-garde. He also worked as an art critic and published the "Figaro illustré", for which Lautrec worked as an illustrator. It was Joyant who organised Lautrec's first exhibition, and he endeavored to gain recognition for him all his life. After Lautrec's death, Henri's father appointed Joyant as executor. He catalogued all of Lautrec's work and, in 1926/27, wrote the first extensive monograph about him, in two volumes. With Lautrec's cousin, Gabriel Tapié de Céleyran (p. 89), he built up the Musée Toulouse-Lautrec in Albi, which opened in 1922.

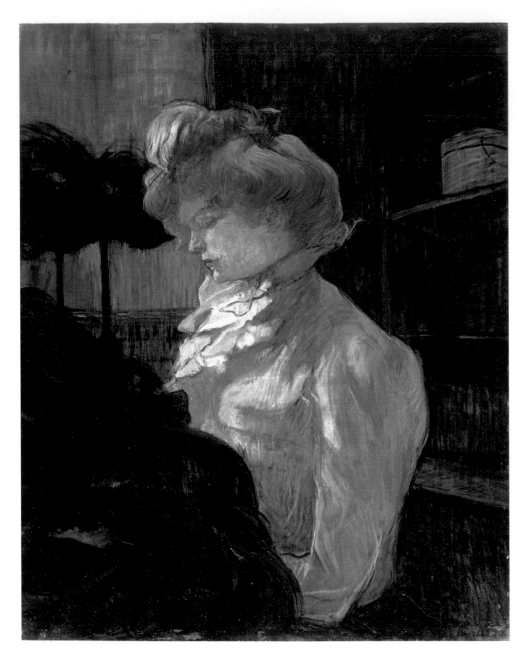

The Milliner, Mlle Louise Blouet, 1900
La modiste, Mlle Louise Blouet
Oil on wood, 61 x 49.3 cm. Dortu P 716
Albi, Musée Toulouse-Lautrec

The glittering world of fashion played a domi-
nant role in Paris in the late 19th century.
Through his friends, Lautrec was introduced
to the milliners of the Rue de la Paix. They
wanted to distract him from alcohol, but Lau-
trec was not drawn to the artificial world of
fashion and the affected grace of the manne-
quins. Through his friend Adolphe Albert he
was introduced to Renée Vert, who ran a hat
shop at 56 Faubourg Montmartre, and it was
only as a favour to her that he painted a few
pictures set in the millinery milieu. This por-
trait shows Louise Blouet, one of her em-
ployees.

exhausted artist but rather to an incipient development towards Ex-
pressionism, a newly liberated Fauvism.

Lautrec was almost 37 years old. He had reached the age at which
his friend van Gogh had died, as had Raphael and Watteau. He was
given the last rites: "Next time you come," he said to the priest, "You
will bring your little bell and candle…" To his father, who had been
summoned in haste, he said: "I knew you would be in at the kill, Papa."
And while he swotted flies with his bootjack he murmured affection-
ately: "The old idiot!" Count Alphonse was to draw attention to him-
self once more at the funeral. He took the place of the coachman and
drove the horses at such a pace that the mourners in the funeral pro-
cession had to run to keep up with him.

Lautrec left to posterity some 600 paintings, 330 lithographs, 30
posters and thousands of drawings and sketches, a quantity which
compares favourably with the output of his most famous contempo-
raries. Cézanne and van Gogh produced more, but he is on a par with

Gauguin and Seurat. His fame has grown steadily. Many have followed him and learnt from him. His influence on the young Picasso, who had a profound understanding of his work, should not be underestimated; it was particularly marked during Picasso's early years in Paris. The great Symbolist painter Gustave Moreau (1826–1898) advised his students, whether their names were Matisse or Rouault, to look at one of Lautrec's figures "painted entirely in absinthe". Without him the great successes of the later Fauve artists, whose paintings consist entirely of colour, would have been unthinkable. In his own time he was charged with frivolity, but today the same quality is seen as an essential element of his work, one and the same as his ability to recognise the essence of people and things and to convey this awareness to the viewer. Lautrec's art is, above all, an art of the emotions.

An Examination at the Faculty of Medicine in Paris, 1901
Un examen à la faculté de médicine de Paris
Oil on canvas, 65 x 81 cm. Dortu P 727
Albi, Musée Toulouse-Lautrec

This painting is Lautrec's last work. It was executed between the beginning of May and the end of July 1901, only a few months before his death on September 9th. It shows his cousin Gabriel Tapié de Céleyran taking his viva voce for his degree in medicine, although Tapié had in fact already qualified in 1899. The candidate is sitting on the far left, red-faced in front of his professors Fournier and Wurz (in academic dress), like a delinquent before a tribunal. The dark, barely illuminated scene seems out of keeping with Lautrec, and is more reminiscent of Dutch royal portraits in the 17th-century baroque style.

The Private World of Toulouse-Lautrec

ALBERT Joseph
C. 1865 Trefford – 1928 Paris. Landscape painter. Was a friend of Lautrec's from 1888, and accompanied him and Anquetin in 1894 on a journey to Brussels, Amsterdam and Haarlem. It was through him that Lautrec met Degas.

AMBASSADEURS, Les
Café-concert venue on the Champs-Elysées, run by Pierre Ducarre, who also ran the Alcazar d'Eté. When Aristide Bruant starred in the Ambassadeurs in 1892, he commissioned the now famous poster from Lautrec (p.99).

ANQUETIN Louis
1861 Etrepagny (Eure) – 1932 Paris. In 1882 he studied with Lautrec, Bernard and others at Cormon's studio, where he frequently protected his friend from the hurtful tricks others played on him. In 1886/87 he exhibited in the Parisian Café Tambourin, with Bernard and Lautrec. Accompanied Lautrec, along with Albert, on a journey to Belgium and Holland in 1894, and was often in touch with him.

AVRIL Jane
1868 Paris – 1943 Paris. Dancer, singer and actress. Avril's father was an Italian nobleman, her mother a demi-mondaine. She worked first as a cashier, then as a rider at the Hippodrome in the Avenue de l'Alma, and finally she was allowed to dance the quadrille at the Moulin Rouge with La Goulue, under the name "Mélinite". This

dance made her so famous that she then appeared only in the best venues of Paris. Trademark of her choreography was a particular pose, in which she held her left knee high and whipped it wildly from side to side (p.109). She enjoyed her greatest successes in the years 1890–1894 at the Jardin de Paris (p.105) and at the Folies Bergère. In 1897 she danced at the Casino de Paris and appeared in an ice revue at the Palais de Glace before going to the Palace Theatre in London. She still had great successes after 1900, in the French provinces and on an American tour. In 1895 she married the journalist and draughtsman Maurice Biais, who died in 1926, leaving her penniless. She spent the last ten years of her life in an almshouse. She had an especially close relationship with Lautrec, who often painted her (pp.106, 107). He gave her many of his works, but she passed them all on to her lovers over the years. The very last poster that he designed (p.127) was for her.

BELFORT May
Real name: May Egan, an Irish singer who first appeared in London. She was only in Paris for a short time, where she performed at the Eden Concert, the Jardin de Paris, the Olympia, the Parisiana the Décadents and the Petit Casino. She usually sang ambiguous children's songs in a reedy treble. She is said to have been a sadist, with a love of snakes and toads. A lesbian, she had relationships with her colleagues Jane Avril and, above all, May Milton, which gave Lautrec the idea of interchanging the posters he had designed for them (p.131, nos. 18 and 20). She was forced to retire from the stage early due to ill health.

BERNARD Tristan
1866 Besançon – 1946 Paris. At first he worked as a business adviser, then

as a lawyer and, from 1891 onwards, as a writer. In 1895 he became director of the Buffalo cycle racing track, in Neuilly near Paris, as well as editor of the *Journal des Vélocipédistes*. Lautrec made his acquaintance via the offices of Natanson's paper *La Revue Blanche*, and owed him his in-

troduction to the world of cycle racing, which fascinated him from this time onwards. He portrayed him once in a painting (privately owned), and two of Lautrec's posters take the sport of cycle racing as their theme (p.131, nos. 25 and 26).

BONNAT Léon
1833 Bayonne – 1922 Château de Mouchy-St-Eloi. Lautrec's teacher. Student of Madrazo in Madrid and, from 1855, of Cogniet in Paris. His work was particularly influenced by the Spanish School, as well as by a three-year visit to Italy. Director of the Ecole des Beaux-Arts in Paris, he was one of the most sought-after painters of his time. Lautrec was permitted to study at Bonnat's studio at 30 Avenue de Clichy, from April 1882, on the recommendation of Princeteau and Rachou. However, when Bonnat closed his studio that summer to become Professor at the Academy, he did not take Lautrec with him – he considered him a bad draughtsman.

BOUGLE Louis
Wholsesale bicycle dealer and general representative of the Simpson Company, which produced bicycles and bi-

cycle chains. In order to represent the English company, he called himself L.B. Spoke and took to wearing the clothes of an English gentleman (cf. p.131, no. 26)

BOURGES Henri
A childhood friend of Lautrec's, who lived with him at 19 Rue Fontaine from 1887 to 1893. After marrying and completing his medical studies in 1893, Bourges worked as a writer and translator of medical papers.

BRAZIER Armande
Well-known by her nickname, "Madame Armande". She ran Le Hanneton at 75 Rue Pigalle, which she had taken over from Madame Sallé. It was a popular meeting-place for lesbians and between 1897 and 1899 Lautrec was also a regular guest in this establishment.

BRUANT Aristide
1851 Courtenay – 1925 Paris. Singer, conférencier and poet. Bruant came to Paris from Sens, and worked first as an office boy for a solicitor. Afterwards he was an employee of the railways and, finally, conférencier in the cabarets. From the opening of Le Mirliton (p.129, no. 8), he performed as a singer of realist chansons with an occasional anarchist flavour. Bruant published the journal *Le Mirliton*, in which he always printed illustrations and paintings by his friend Lautrec. He also exhibited Lautrec's pictures on his premises. In 1889–1895 two volumes of his chansons appeared,

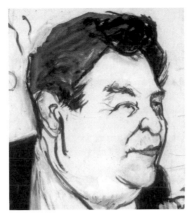

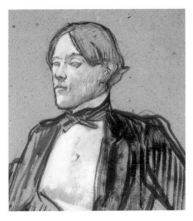

with illustrations by Steinlen. When he starred at the Ambassadeurs at the Champ-Elysées in 1892, he obliged the director, Ducarre, to hang the poster designed by Lautrec everywhere, and also to post it all over Paris. Bruant was married to Mathilde de Tarquini d'Or who sang at the Opéra Comique. In 1895 he retired from singing and moved back to Courtenay.

CAFE-CONCERT
These were cafés in Paris offering popular entertainment from around 1840, employing musicians, singers, dancers, artistes, and comedians. Some venues, like the Folies Bergère, are still famous today. However, the heyday of café-concerts was during the last two decades of the 19th century, when Lautrec was in Paris. They included Les Ambassadeurs, Les Décadents, Le Divan Japonais, Eldorado, Elysée-Montmartre, Folies Bergère, Jardin de Paris and Petit Casino. Lautrec regularly patronised all of them, as they offered him motifs for his work. His first album of lithographs, which appeared in 1893, bore the title "Le Café-Concert".

CAN-CAN
The word denotes "idle chatter" or "noise". The dance, an imitation of the Spanish fandango, was known in France from around 1830. Originally a decorous dance for polite society, the can-can later became the hit of Paris nightclubs. Women danced it at a wild tempo, leaping and flinging their legs high. A later development of the can-can was the "Quadrille Naturaliste".

CAUDIEUX
Caudieux was a comic singer at the Petit Casino as well as at the Eldorado and the Ambassadeurs. He reached the peak of his career around 1893 when Lautrec painted a portrait of him (p. 112). In the same year Lautrec also designed a poster for him (p. 129, no. 9) and portrayed him in his first album of lithographs, "Le Café-Concert".

CHA-U-KAO
Nude dancer, clown, contortionist and lesbian. Her artist's name evolved from the words "Chahut-Chaos", roughly meaning noise and chaos, and was also the name of a popular wild dance at the Moulin Rouge. Lautrec portrayed her in a number of paintings (pp. 75, 118, 119) and lithographs (pp. 74, 120).

CHOCOLAT
A Negro from Bilbao who performed as a clown, usually with his partner, the Englishman George Footit. They went on a European tour together, and had their greatest success in Paris in 1894. After his performances at the Nouveau Cirque he often danced and sang to please himself at the Irish and American Bar.

CONDER Charles
1868 London – 1909 Virginia Water. English painter and graphic artist who lived in Paris 1890–1897, and studied at the Académie Julien and at Cormon's studio, where he met Louis Anquetin and Lautrec. He became friendly with them, visiting the Moulin Rouge and Le Mirliton in their company. Lautrec stayed with Conder during his London visit in 1898, and probably met Oscar Wilde and James Abbott McNeill Whistler through him. He painted him as a distinguished guest at the Ambassadeurs in 1893 (detail above).

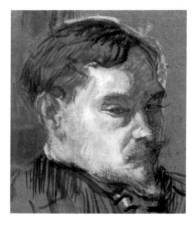

COOLUS Romain
1868–1952. Real name: Réne Weill. Writer and one of Lautrec's closest friends, who met him via the circle associated with Natanson's magazine *La Revue Blanche*. The two visited not only the theatres together, but also the brothels. Coolus claimed that he could write in peace there. Lautrec illustrated a number of Coolus' books: *Le Bon Jockey*, *La Belle et la Bête* and *Les Sœurs Légendaires*, and did several drawings of him.

CORMON Fernand
1845 Paris – 1924 Paris. Real name: Fernand-Anne Piestre. Cormon was professor at the Ecole des Beaux-Arts and also ran a very popular teaching studio (ill. above). In addition to Lautrec, his famous students included Anquetin, Emile Bernard, Laval and van Gogh. His teaching consisted mainly of copying paintings in the Louvre, which particularly annoyed van Gogh. He was nevertheless a popular teacher because he also gave his stu-

dents a certain freedom. His opinion of Lautrec, who was often the butt of his fellow students' heartless jokes, was very high, and he involved him in illustrating the works of Victor Hugo and even gave him a share of the fee earned.

DECADENTS, Les
Café-concert on the Rue Fontaine, opened in 1893 and run by Jouy and Louis Dufour. Because of a scandalous revue it was forced to close down the following year, but was reopened by Marguerite Duclerc in 1896 and run under the name of Café du Pendu.

DENNERY Gustave Lucien
1863–1953. Portrait and genre painter, and friend of Lautrec. Lautrec painted a picture of him during their time at Cormon's studio (p. 21).

DETHOMAS Maxime
1868–1928. Painter and graphic artist, friend of Lautrec and, from the beginning of the 1890s, a favoured companion for tours of the brothels. His painting was strongly influenced by Lautrec, with whom he travelled to Normandy and Holland (p. 95).

DIHAU Désiré
1835–1909. Lautrec was a good friend of the Dihau family, who came from Lille, and often visited them in their flat in the Rue Frochot where for a short time he also had his studio. He occasionally met Degas there as well. Dihau was a bassoonist in the Paris Opera Orchestra, in which role Degas portrayed him in *Orchestra at the Opera* (Paris, Musée d'Orsay). As a sideline he wrote poems for the ca-

baret Chat Noir. Lautrec portrayed him reading the paper in the Père Forest garden (p.67).

DIHAU Marie
Sister of Désiré Dihau. She was a successful singer at the Paris Opera in the 1870's, and later gave piano and singing lessons. Van Gogh's painting *Marguerite Gachet at the Piano* (Basle, Kunstmuseum) is highly reminiscent of Lautrec's portrait of her, which was painted the same year, but a little earlier (p.65). She donated Lautrec's paintings of herself and other members of her family to the town of Albi, who granted her a life pension in return. She died in 1935.

DIVAN JAPONAIS, Le
A small café-concert at 75 Rue des Martyrs, founded by Jehan Sarrazin, and run by Edouard Fournier from 1892. It was decorated in the then fashionable Japanese style, with lacquered cane and bamboo furniture, lanterns and silk screens. Its name was probably taken from a poem by Mallarmé. The singer Yvette Guilbert had her earliest success there, and it is she who is portrayed on Lautrec's famous poster *Divan Japonais* (p.115), even if only on the left upper part of the picture. In the foreground one sees the dancer Jane Avril and the critic Edouard Dujardin.

DUFOUR Louis
Orchestra conductor, who first worked at the Mabille. He succeeded best with the wild rhythms he conducted at the Elysée-Montmartre (pp.26, 27) and, even though he had tempting offers from the opera, Dufour chose to keep faith with popular music.

DUJARDIN Edouard
1861–1949. Music and literary critic, editor of the *Revue Indépendante* and the *Fin de Siècle*, founder of the *Revue Wagnérienne*. Lautrec portrayed him with his circle of friends in the painting *At the Moulin Rouge* (p.85) and on the poster *Le Divan Japonais* (p.115).

ELDORADO
Café-concert at 6 Boulevard de Strasbourg, opened in 1858. Very popular from 1865, when Thérésa (Emma Valadon) performed there. Lautrec met several actors there, whom he portrayed in lithographs. In 1892 he also designed a poster for Bruant's performance at the Eldorado (p.129, no.6).

ELYSEE-MONTMARTRE
The first café-concert in Paris, opened in 1840 on the Boulevard de Clichy, later moved to 80 Boulevard Rochechouart. Originally run by Serres father and son, it became very popular under the management of Madame Voisin. Dufour conducted the orchestra in Lautrec's day (pp.26, 27). In spite of electrification in 1889, it was unable to compete with the nearby Moulin Rouge and had to close in 1893.

FENEON Félix
1861 Turin – 1944 Châtenay-Malabry. Writer and art critic. Employed at the War Ministry from 1881. However, he was an anarchist and stood trial in 1894, charged with possession of explosives, and was forced to resign from his post. He was a critic and then editorial director for the *Revue Indépendante* and, until 1903, board secretary for Natanson's paper *La Revue Blanche*, for which he organised exhibitions. 1906–1925 director of the art dealers Bernheim-Jeune. A friend of Seurat's and Signac's, he was an energetic promoter of Neo-Impressionism. Lautrec portrayed him as a member of the audience in the decorative panel entitled *Moorish Dance* (p.91), which he designed for La Goulue's show booth.

FERNANDO, Circus
The circus had its pitch at 63 Boulevard Rochechouart, redesigned as a theatre in 1894. Among its regular visitors were Lautrec and Degas, Renoir and Seurat, who decorated the rooms with their paintings. *C. 1887/88* Lautrec painted *Bareback Rider at the Cirque Fernando* (p.37). Seurat's last and most famous painting, *The Circus* (1891; Paris, Musée d'Orsay), also shows a bareback rider from the Fernando Circus, and was probably inspired by Lautrec's picture.

FOLIES BERGERE
The Folies Bergère at 32 Rue Richer was a popular meeting-place for all strata of Parisian society. It was built as a circus in 1867, but soon had to shut down. It was re-opened as café-concert in 1881, and finally gained world fame as a revue theatre. Lautrec was a frequent visitor from 1894 to 1896.

FOOTIT George
1864–1921. English clown who appeared to great acclaim as an acrobat and rider at the Hippodrome on the Avenue de l'Alma. The story goes that he lost his horse in a poker game, and had to work as a clown from then on. In 1885 he was hired by Covent Garden theatre, later by the Nouveau Cirque in Paris. With Chocolat as partner he was successful in Paris in 1894; the two then toured Europe together.

FOREST "Père"
Photographer who owned a house with a large garden below the Montmartre cemetery, where the Rue Forest (whence his name) and the Rue Caulaincourt meet on the Boulevard Clichy. He installed a shooting range and small bar in his garden. Lautrec probably met Forest via the Dihau family. Since his studio was very close, he often went there to paint in the open (pp.43, 44, 60, 61, 67).

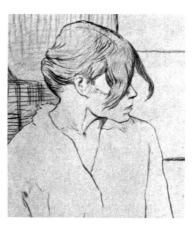

FULLER Loïe
1862 Fullersbury (Illinois) – 1928 Paris. Real name: Marie-Louise Fuller. Fuller was already on the stage by the age of five, when she worked as a singer, accompanying herself on the piano. She declaimed by the age of 13 and at 18 she recited Shakespeare. After seasons in New York and London she came to Paris in 1892, where she thrilled audiences at the Folies Bergère with her veil dance. In 1908 her memoirs appeared under the title *Fifteen Years of a Dancer's Life*. Although Lautrec portrayed her several times, Fuller did not particularly like the painter (pp.110, 111).

GAUDIN Carmen
Working-class woman who supplemented her income by modelling. Lautrec was especially fascinated by her red hair. He had espied her on the street through a restaurant window while dining with his friend, Henri Rachou, and was delighted by the girl's simple, unspoilt expression. She sat for a number of his portraits, one

of which was exhibited at the 1888 Brussels exhibition of "Les XX" (p.25, 33, 43, 45).

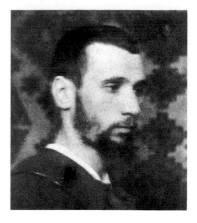

GAUZI François
1861 Toulouse – 1933. Fellow student of Lautrec at Cormon's studio, and his close friend for over a decade. Lautrec portrayed him a number of times, for example in 1888 as a father pushing a pram in the painting *The Day of First Communion* (p.34). His memoirs "Lautrec et son Temps" contain valuable biographical information.

GOGH Theo van
1857 Groot-Zundert – 1891 Utrecht. Art dealer and collector, and younger brother of Vincent. From 1878 he ran a gallery for Goupil-Boussod-Valadon on the Boulevard Montmartre, where he concentrated on selling Impressionist works. These efforts increased when his brother Vincent moved to Paris in 1886. Through mounting numerous exhibitions he helped many artists, including Degas, Gauguin, Monet and Pissarro, to sell their work. He also exhibited Lautrec but did not sell anything. In 1890 Maurice Joyant succeeded him at Goupil; he could no longer work after the tragic suicide of his brother Vincent.

GOGH Vincent van
1853 Groot-Zundert – 1890 Auvers-sur-Oise. A vicar's son who after failed attempts as an art dealer and lay preacher came to Paris in 1886, living with his brother Theo at 19 Rue Lépic in Montmartre. Met Lautrec shortly after arriving in Paris; regular contact and similar views on art history. Van Gogh even invited Lautrec – as he did Gauguin – to work with him in an artists' community, an idea, however, that Lautrec rejected. Van Gogh's search for light and colour in the south owed much to Lautrec's influence. Lautrec, Anquetin, Bernard and van Gogh exhibited in Paris together in November 1887. Lautrec did a beautiful pastel portrait of van Gogh (p.38).

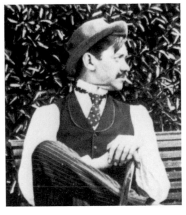

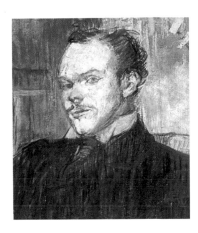

GOULUE, La

1870–1929. Real name: Louise Weber. She was from the Alsace and worked as a washerwoman until her talent was discovered. She received her nickname because of her uncontrolled appetite (goulue = greedy). She was discovered by M. Astruc, who gave her the chance to make her début at the Medrano. Afterwards she performed at the Moulin de Galette, the Alcazar, the Elysée-Montmartre and the Jardin de Paris. From the autumn of 1890 until 1895 she was employed by the Moulin Rouge where she was the most popular and attractive can-can dancer of her time. Particularly famous were her performances with Valentin the Contortionist, with whom she danced the quadrille (pp. 100–103). In 1895, when she became too fat, and the Moulin Rouge withdrew the quadrille, she opened her own show booth at the Foire du Trône with decorative panels by Lautrec (pp. 90, 91). After that she worked as a flower seller in the Casino, in 1896 as a wrestler at the Neuilly Fair, and as an animal tamer at the Juliano. Later she lived with a man who exhibited her as a fairground curiosity in 1925. She deteriorated ever more, survived for a time as a maid in a brothel, and died lonely and impoverished in the Hôpital Laribosière in Paris.

GRENIER Lily

1834–1917. Wife of René Grenier. Modelled for Degas and Lautrec, who adored her not only for her red hair, which he dearly loved, but also for her warm companionship (p. 35).

GRENIER René

1861–1917. Fellow student of Lautrec's at Cormon's studio. Lily Grenier's husband, member of a landed family from Toulouse, with a personal income of 12000 francs a year. Lautrec lived with the Greniers in 1885, in their apartment at 19 Rue Fontaine, which was famous for hospitality, especially for costume parties.

GUIBERT Maurice

1856–1913. Amateur painter and photographer who worked as a representative for the firm Moët et Chandon (p. 168). He was known as an expert on the brothel scene and often accompanied Lautrec on his adventures. Joined with Lautrec in the Brussels "Les XX" exhibition and, along with his brother Paul, accompanied the artist on his journey to Arcachon, and from Le Havre to Spain on the "Chili" in 1896. In 1900 he was in Bordeaux with Lautrec. Lautrec portrayed him in *After the Meal*, 1891, sitting beside a Montmartre model (p.66).

GUILBERT Yvette

1868 Paris – 1944 Aix-en-Provence. Singer and conférencière. Before her career she was a salesgirl and mannequin for Le Printemps. She appeared at the Eldorado in 1886 for the first time; in 1889 she appeared at the Jardin de Paris, and in 1890 at the Moulin Rouge. In 1891/92 she recited monologues by Maurice Donnay at the Divan Japonais and the Horologe to great acclaim. In 1895 she went on an American tour. Her success was based on her extravagant appearance as well as her suggestive songs. She wore long black gloves during her performances, as portrayed by Lautrec (pp. 88, 116). He dedicated two albums of lithographs to her. After her career on the stage she went on to write, and published a number of essays about the Belle Epoque.

IRISH AND AMERICAN BAR

A bar with a mahogany interior run by the Englishman Reynolds, at 33 Rue Royale. The owner was a Swiss called Achille, who was in the habit of addressing Lautrec as "Vicomte Marquis". A well-known barman here was Ralph (Randolph), of Amerindian-Chinese extraction, who served his guests with stoic calm, and mixed especially exotic hot cocktails. The customers included English jockeys and trainers, the clowns George Footit and Chocolat, who liked to dance here after his performances at the Nouveau Cirque, as well as the coachmen of the quarter. In 1895 Lautrec designed a poster that used the bar as motif; it shows Ralph standing behind the bar serving a drink to Tom, the corpulent coachman of the Rothschilds'. The poster advertised the American literary journal *The Chap Book* (p. 129, no. 13).

JARDIN DE PARIS

The club on the Champs-Elysées, originally called the Café Pavillon de l'Horologe, was opened in 1855 and was turned into a café-concert venue in 1889. Yvette Guilbert performed here in 1891/92. In 1893 it was sold to Joseph Oller, owner of the Moulin Rouge, who gave it the name Jardin de Paris. Lautrec designed a poster for the dancer Jane Avril's appearance at the Jardin de Paris (pp. 105 and 129, no. 4).

JOYANT Maurice

1864–1930. Writer and art dealer. One of Lautrec's most intimate friends, whom he had known since their schooldays together. In 1890 he succeeded Theo van Gogh as director of the Goupil Gallery on the Boulevard Montmartre. Later he opened a gallery with Michel Manzi. He was also active as a critic and published the *Figaro Illustré*, for which Lautrec worked as an illustrator. Joyant organised Lautrec's first exhibition, and endeavoured to gain recognition for him all his life. After Lautrec's death, Henri's father appointed Joyant as executor. Joyant catalogued Lautrec's work and wrote the first substantial monograph about him in two volumes, in 1926/27. With Lautrec's cousin, Gabriel Tapié de Céleyran (p. 89), he built up the Musée Toulouse-Lautrec in Albi, which opened in 1922. Lautrec portrayed his friend at a duck shoot in 1900 (p. 186).

JOZE Victor

Pseudonym of the Polish writer Victor Dobrski, friend and neighbour of Lautrec at 21 Rue Fontaine. Lautrec designed posters for his novels *Reine de Joie* (p. 83) and *Babylon d'Allemagne* (p. 131, no. 16).

LECLERCQ Paul

Writer and friend of Lautrec, born 1872. In 1889, with Auguste Jeunehomme, he founded the avant-garde art journal *La Revue Blanche*, for which Lautrec designed a poster (p. 131, no. 23). Lautrec painted Leclercq's portrait in 1897; it was given to the Louvre in 1920 (today in the Musée d'Orsay). His recollections of Lautrec appeared in 1921 (*Autour de Toulouse-Lautrec*).

LENDER Marcelle

1863–1927. Real name: Anne-Marie Marcelle Bastien. A variety actress who appeared for the first time aged 16 at the Théâtre Montmartre, and afterwards at the Gymnase. She celebrated her greatest successes with revues at the Théâtre des Variétés on the Boulevard Montmartre and, in February 1895, with the operetta revue "Chilpéric" by Florimond Hervé in which she danced and sang (p.93). Lautrec portrayed Lender in a painting (p. 123) and in numerous lithographs (p.92).

MACARONA, La

Spanish dancer, also called Georgette, who performed to great acclaim at the Moulin Rouge where Lautrec met her. He portrayed her in his painting *At the Moulin Rouge* (p. 85). She had a prince as a lover who gave her a villa in Bécon-les-Bruyères. She died of complications after an operation in 1895.

MANZI Michel

1849–1915. Art dealer of Italian extraction, copperplate engraver, printer and friend of Edgar Degas. From 1881 to

1893 he ran the print and photography department of the Goupil Gallery at 9 Rue Chaptal. He became director of the Boussod Gallery in 1890. Later he opened his own gallery with Maurice Joyant, where he promoted young avant-garde artists. He exhibited work by Lautrec in 1893 and 1896. His own collection, with works by Edouard Manet, Camille Pissarro, Degas and Paul Gauguin, was auctioned in 1911.

MARX Roger
1859 Nancy–1913 Paris. Art collector, journalist and critic for numerous papers and magazines. Inspector of fine art and general inspector of provincial museums. He was also a friend and promoter of Lautrec from 1892.

MELLOT Marthe
Singer, and wife of Alfred Natanson. She performed in "La Gitane" (The Gypsy) at the Théâtre Antoine in 1900, for which Lautrec designed a poster (p.131, no. 30). Presumably Alfred Natanson commissioned the poster from his friend Lautrec, though it was never used. Lautrec also portrayed Mellot in a cover design for the magazine *L'Image*.

METENIER Oscar
Born 1859. Secretary in the Paris Police Commission and friend of Lautrec. He wrote novels that were usually set in the Paris underworld. His novel *La Lutte pour l'Amour* (*The Battle for Love*) is said to have inspired Lautrec to his painting *Alfred la Guigne* (p. 113).

MILTON May
The English dancer and singer performed with a ballet troupe in Paris until she left it to accept a contract in the Rue Fontaine. She was a close friend of Jane Avril's without, however, gaining a fraction of her success, even though Lautrec designed a poster for her which was intended for her American tour (p. 117).

MIRLITON, Le
Cabaret at 84 Boulevard Rochechouart opened by Aristide Bruant in 1885. Lautrec was a frequent guest between 1888 and 1892 and designed a

poster for the Mirliton which Bruant also published in his magazine *Le Mirliton* on 15 November 1894 (p. 129, no. 8).

MOME FROMAGE
Nickname of a dancer who performed at the Moulin Rouge. The name roughly means "cheese girl" and is probably drawn from her love of cheese. She had been a dressmaker's assistant and was a close friend of La Goulue, which is why they were often referred to as sisters (pp. 76, 77).

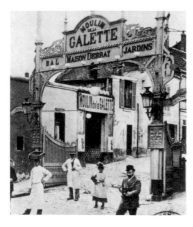

MOULIN DE LA GALETTE
This was a large barn on the hill of Montmartre, on the Rue Lépic, surrounded by a green wooden fence. In the grounds stood two windmills, one of which served as a dance hall, while the other ground lily bulbs for a perfume factory. The dance hall had been fitted by the millers Debray with a podium for the orchestra. They also baked the famous cookies that gave the venue its name (galette = flat, round pastry cake). From 3 p.m. to midnight every Sunday the families of Montmartre, the workers, students and artists met to dance either here or in the adjacent garden. The entrance fee was 25 centimes and the men were charged an extra 20 centimes for every dance. Lautrec was a frequent visitor and painted a number of pictures here. The evening dances were openly erotic and therefore offensive to polite society, often resulting in the guardians of public morals being summoned to the premises (p. 30, 48, 49, 79).

MOULIN ROUGE
This dance hall was opened by Charles Zidler on 5 October 1889 at 90 Boulevard de Clichy, formerly home to the "Reine Blanche", and at the turn of the century it was the meeting-place of Paris society, artists and the demi-monde. The red windmill at the entrance, installed by the designer Adolphe Willette, was just a mock-up; the back comprised various booths and a wooden elephant that could be turned into a stage. The venue was lit up as bright as day and decorated with mirrors, galleries and gas-lights. In the middle was a large dance floor surrounded by a promenade, tables and a garden. The entrance fee was 3.50 francs. Many singers, dancers and artists contributed to the programme; highlight was the "Quadrille Naturaliste" which had developed out of the can-can. The main stars were La Goulue and Valentin the Contortionist. Lautrec, who had a table reserved for him from the very first day, and his sketches and paintings constituted the house chronicle. His posters and paintings were exhibited from time to time in a small gallery in the foyer (pp. 58, 59, 68–71, 74–78, 84, 85, 101, 103, 106–109, 118–120).

NATANSON, Family
A family of Polish origin who as publishers, art patrons and generous hosts played a significant role in Paris cultural life. A unique personality was the knowledgeable Thadée Natanson, 1868 Warsaw – 1951 Paris, an important collector of Impressionist paintings, journalist and businessman. Also friend of the writers Stéphane Mallarmé and Anatole France, and publishing editor of the magazine *La Revue Blanche*. His memoirs *Un Henri de Toulouse-Lautrec* appeared in 1951. His wife Misia (1872–1950), was Lautrec's model for the poster *La*

Revue Blanche (p.131, no. 23) among others; but she later divorced Thadée. His second wife, Reine, bequeathed part of his collection to the Musée National d'Art Moderne in Paris. Alexandre Natanson and his brother Alfred were businessmen, but also sponsored art, especially by young artists. A memorable party took place at Alexandre's house in February 1895, at 60 Avenue du Bois de Boulogne, at which Lautrec was Maître de Plaisir and barman to the 300 invited guests. With Maxime Dethomas he mixed "American" cocktails, with which he plied the guests so insistently that the party ended in drunken chaos. Lautrec was a close friend of the entire Natanson family and, during summer, was often their guest in Villeneuve-sur-Yonne.

NOUVEAU CIRQUE
Circus at 251 Rue Saint Honoré, founded circa 1880, and run by Monsieur Loyal. Very popular with the audience because of its electric lighting. A technical trick enabled the middle section to be transformed into a swimming pool.

PALAIS DE GLACE
Ice palace founded by Jules Roques in 1894 at the Rond Pont on the Champs-Elysées, where, among others, Jane Avril performed in a skating revue in 1897.

PASCAL Louis
Son of the Prefect of the Gironde and Lautrec's second cousin, as well as his fellow pupil at the Lycée Fontane in Paris. Lautrec valued his company, as well as that of his mistress, Moute. Pascal later worked as an insurance broker and when he and his family got into financial difficulties in the summer of 1892 they were helped by the Lautrecs. Pascal accompanied Lautrec on his convalescence journey to Le Croytoy in June 1899. Lautrec portrayed him a number of times (pp. 72, 73).

PEAN Jules-Emile
1830–1898. Surgeon and professor at the medical faculty of the University of Paris who was hailed as a virtuoso of the knife. He operated at the Hôpital Saint-Louis in 1891, where Lautrec portrayed him during a tonsil operation (Sterling and Francine Clark Art

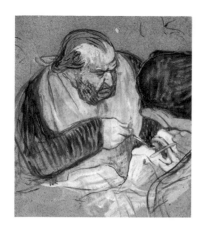

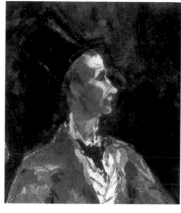

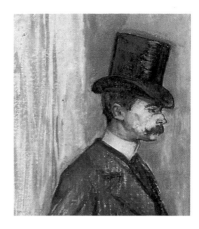

Institute, Williamstown, Massachusetts). Péan used to wear a black suit and a napkin around his neck during operations.

PELLET Gustave

1859–1919. The son of rich parents, he ran a shop for art literature, and later engravings as well, in the Rue de la Paix. He opened a printing shop near the Art Academy at 3 Quai Voltaire. He encouraged young artists, including Lautrec, and collected their paintings. In 1896 he published 100 copies of *Elles*, an album of ten lithographs by Lautrec which, however, did not sell well.

PETIT CASINO

Venue for café-concerts on the Boulevard Montmartre that was opened in 1893 and survived until 1948. Along with many others, the comic Caudieux and the dancer Jane Avril performed here.

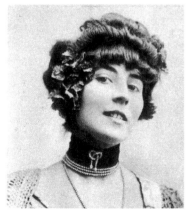

POUPOULE, Madame

Pet name for a working girl whom Lautrec portrayed twice (p. 170). The name is a prettified version of the colloquial word "poule" (chicken) meaning prostitute.

PRINCETEAU René Pierre Charles

C. 1839 Libourne – 1914 Libourne. Animal, history and landscape painter. The son of a wine merchant, he first studied sculpture in Bordeaux, and then painting at the Ecole des Beaux-Arts in Paris. He was a friend of the Lautrec family, particularly of Count Alphonse, and their frequent guest. Even though he was deaf and dumb he became Henri's

first teacher. Henri admired him very much and his early studies of animals were strongly influenced by him. For a time Lautrec lived in his Paris studio at 233 Faubourg Saint Honoré, where he met the painter Jean-Louis Forain (1852–1931). Lautrec painted a number of portraits of Princeteau (detail above), as well as showing a haggard depiction of him at the edge of his painting *Souvenir of Auteuil* (p. 10).

QUADRILLE NATURALISTE

This typical Parisian dance developed out of the can-can. It was most popular when danced by La Goulue and Valentin the Contortionist (pp. 59, 100, 101). It was also danced by women alone, e.g. La Goulue, Grille d'Egoût, Etoile Filante, Nini Pattes-en-l'Air, Môme Fromage and Sauterelle. At first the quadrille was danced at the Elysée-Montmartre, the Jardin de Paris, the Alcazar and the Frascati, but later it was mainly danced in the Moulin Rouge where it enjoyed a triumphant success. Grille d'Egoût taught the dance while Nini Pattes-en-l'Air even opened a dance school for it in the Rue Frochot. The most important sequences to be learnt were the guitar, presenting the weapon, the military salute, the foot behind the head and – the grand finale – the splits (p. 84).

RACHOU Henri

1855 Toulouse – 1944. Painter, copper engraver and comedy writer. Lautrec knew Rachou from childhood days in Toulouse. Later they both studied at Cormon's studio and, for a short time in 1884/85, Rachou invited Lautrec to work in his studio at 22 Rue Ganneron. They worked together on the illustrations for the "Vieilles Histoires". Later Rachou became curator at the Musée des Augustins in Toulouse where he argued for the purchase of a painting by Lautrec.

RENARD Jules

1864 Châlons – 1910 Paris. Realist writer whom Lautrec met through Tristan Bernard in 1894. In 1898 Lautrec provided illustrations for Renard's *Histoires Naturelles*, published in 1899; the illustrations did not quite match the expectations of the author.

REVUE BLANCHE, La

Founded by Paul Leclercq and Auguste Jeunehomme in 1889, this was a journal of avant-garde art and an important vehicle for Impressionist ideas. In 1891 the journal was taken over by the brothers Alexandre and Thadée Natanson who, from then on, organised exhibitions of modern art in their editorial offices in which Lautrec participated with Bonnard, Vuillard and Vallotton. The journal appeared for the last time in 1903. Lautrec designed a poster for the *Revue Blanche* in 1895 (p.131, no. 23).

RIVOIRE André

Writer and dramatist, as well as general secretary of the "Revue de Paris". Lautrec met him through his friend Leclercq. Rivoire wrote a number of appreciative reviews of Lautrec's work in 1901 in the *Revue de l'Art*.

ROCHE Coutelat du

He was better known by his nickname "Père la pudeur", (Father Prude). By day he worked as a photographer, by night for the police as a guardian of public morals. He had to make sure that during the exuberant erotic dances, especially the beloved "Quadrille Naturaliste", the dancers' skirts were not thrown too high, and that the ladies were wearing sufficient underwear. Lautrec repeatedly portrayed Coutelat, who took his responsibilities as moral guardian relatively lightly (pp.26, 27).

ROLANDE

A resident of the brothel on the Rue des Moulins and one of Lautrec's models. One can easily recognise her by her pointed nose, for example in the study for *In the Salon of the Rue des Moulins* (p. 140) and in the pastel and oil works of the same title, where she sits on the sofa in the left background (pp. 144, 145).

RUE DES MOULINS

The most luxurious brothel in Paris, at 24 Rue des Moulins (today no. 6), with a pompous interior of mirrors, panels and capacious red sofas. Between 1891 and 1895 Lautrec not only worked here but also sporadically lived here. This enabled him to make a whole series of intimate studies of the brothel and its residents (pp. 140, 144, 145, 146, 152, 156). Lautrec's favourite at the Rue des Moulins was Mireille (pp. 133, 142/143). In the painting of the brothel she sits in the foreground (p. 145).

SAMARY Henry

1864–1902. Actor at the Comédie-Française, where his famous sister, Jeanne Samary also appeared. Renoir painted her a number of times. Lautrec lightly caricatured Samary (p. 51) in the role of Raoul de Vaubert in the comedy "Mademoiselle de la Seiglière" by Jules Sandeau (1811–1883).

SESCAU Paul

Photographer who lived at 53 Rue Rodier in Montmartre, and had his studio at 9 Place Pigalle; the studio still existed in the 1960s. Lautrec met him through Maurice Guibert, who also took photographs, and became his close friend. Lautrec portrayed Sescau as a minor figure in two paintings (pp.85, 91) and was frequently photographed by him (p. 55). Lautrec designed a poster for Sescau in 1896 (p. 129, no. 15).

SOURIS, La

A popular gay bar at 29 Rue Henri Monnier (formerly Rue Bréda), run by the corpulent Madame Palmyre who was said to bear a strong resemblance to her bulldog. "Monsieur Henri" was a favourite guest from 1896 and, in the spring of 1897, he even lived here for a while.

STAR, Le

English sailors' bar in the port of Le Havre, Rue Général Faidherbe, where Miss Dolly worked as singer and barmaid (pp.176, 177). Lautrec frequented the place in July 1899 and it existed until 1940. The novel *Le Payse* (1930) by Charles le Goffic is partly set in Le Star.

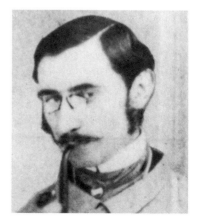

TAPIE DE CELEYRAN Gabriel

1869–1930. Cousin of Lautrec and probably his closest friend. He studied medicine with Jules-Emile Péan in Paris and qualified in 1899, an event chosen by Lautrec as the motif for what would be his last painting, executed in 1901 (p.189). After Lau-

trec's death, he campaigned for the town of Albi to rename the street Henri was born in after him. With Maurice Joyant he set up the Musée Toulouse-Lautrec in Albi, to which he bequeathed many of his paintings. Lautrec portrayed his friend numerous times, including in a theatre lobby (p. 89) and at the wheel of an automobile (p. 166); his spindly figure is easily recognisable.

vice of her circle (Lautrec, Degas, Renoir), began to draw. For a time Valadon had a close relationship with Lautrec and it is said that she wanted to marry him. When he discovered her intentions he quickly separated from her, to which she responded with a suicide attempt in 1888. Lautrec painted numerous portraits of Valadon (pp. 29, 40, 41); in some she is portrayed as an alcoholic.

world famous; he appeared alongside La Goulue on the 1891 *Moulin Rouge* poster, which was posted all over Paris (pp. 59, 100, 101).

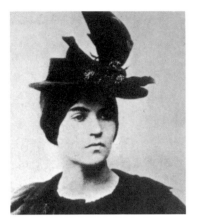

WARNER
1861 Lincoln – 1934. Real name: William Tom Warrener. An Englishman who studied at the Académie Julien in Paris from c. 1885. He later worked as an impresario and frequently visited the nightclubs where he tried to get the artistes of the café-concerts on his books. Lautrec portrayed him several times, including in the 1892 lithograph and painting *The Englishman at the Moulin Rouge* (p. 78).

VALADON Suzanne
1867 Bourg de Bessines (near Limoges) – 1938 Paris. Real name: Marie-Clémentine Valade. An illegitimate child, she grew up in Montmartre, neglected and deprived, and had an illegitimate son herself when she was 18, who later became a famous painter under the name of Maurice Utrillo (1883–1955). She first worked as a laundress, before joining the Molier travelling circus as a trapeze artist. When she fell from the trapeze at fifteen, she had to work as a model – for, among others, Puvis de Chavannes, her lover, Renoir, Lautrec and the Italian Impressionist, Federico Zandomeneghi (1841–1917), who was living in Paris at the time. She became something of a celebrity among the Montmartre bohemians and, with the encouragement and ad-

VALENTIN LE DESOSSE
1843–1907. Real name: Etienne Renaudin. A lawyer's son from Sceaux, he first worked as a wine salesman on the Rue Coquillère. After the business was repossessed he worked as a debt collector for his brother, who was a notary. After that he made a living by renting out apartments on the Rue La Motte Piquet. An enthusiastic dancer, he performed as Valentin the Contortionist at the Tivoli Vauxhall for his own pleasure, and also worked as master of ballet at the Valentino, Mabille, and Elysée-Montmartre. He also danced with La Goulue at the Moulin Rouge, where he enjoyed great success. Furthermore he was a passionate horse rider, whom Lautrec often met early in the morning in the Bois de Boulogne. Through Lautrec his tall, haggard figure in top hat became

VARY Hélène
Young Parisian and neighbour of Lautrec, who probably already knew her as a child. Lautrec admired her beauty and had her photographed. He portrayed her twice when she was 17 (Bremen, Kunsthalle; Albi, Musée Toulouse-Lautrec), working from the photographs.

VIAUD Paul
When Lautrec was released from a detoxication cure in a Neuilly hospital, his mother begged Viaud, including to look after her son in Bordeaux. She hoped to keep him away from alcohol in this way, but Henri outwitted Viaud by having a walking stick made that contained a secret compartment for alcohol (p. 165). Lautrec spent some time in the company of Viaud, part of it on his yacht and, for the winter of 1900, rented a flat for himself and Viaud in Bordeaux. Viaud had been an admiral, and it was as such that Lautrec portrayed him in one of his last paintings (p. 185).

WENZ Jeanne
Companion, not wife, of the painter Frédéric Wenz who studied with Lautrec at Cormon's studio in 1882.

Chronology of Life and Work

1864 Henri-Marie-Raymond de Toulouse-Lautrec-Monfa is born on 24 November at 6 a.m. in the Hôtel du Bosc, Albi, in southern France. He is the eldest son of Count Alphonse-Charles-Jean-Marie de Toulouse-Lautrec-Monfa (1838–1913), whose family can be traced back to the 12th century, and of his wife, Adèle-Zoë-Marie-Marquette Tapié de Céleyran (1841–1930). The parents are first cousins. Henri spends his early childhood well-protected on the family estate near Albi as well as in Céleyran near Narbonne.

1868 Henri's younger brother Richard-Constantine dies at the age of one. His parents separate in August and Henri is brought up by a governess.

1872 Eight-year-old Henri is taken by his mother to Paris, where he attends the Lycée Fontane from October. Among his fellow pupils are his cousin Louis Pascal and Maurice Joyant, later his friend and first biographer. Draws first sketches and caricatures in his exercise book. Receives first lessons from the deaf-mute animal painter, René Pierre Charles Princeteau, a friend of his father's.

1875 Returns to Albi for health reasons in January, where he now receives private instruction. To encourage his physical development, he takes thermal baths in Amélie-les-Bains. Over the following years his mother consults a variety of doctors in the hope of alleviating his condition.

Henri in 1868, aged three, affectionately called "Petit Bijou" (Little Jewel) by his family.

1878 Henri has hardly grown in the last ten years. In May the 13-year-old breaks his left upper thigh in a fall at Albi. He is put in plaster and bedridden for a long time. Afterwards he convalesces in Barèges, Amélie-les-Bains and Nice, where he reads a lot, draws and paints.

1879 He breaks his right upper thigh in a fall during a walk with his mother in Barèges. From then on, neither leg grows any more. The fractures are due to a congenital anomaly, namely insufficient in bone formation (*osteogenesis imperfecta*). Every medical treatment, including electric shock treatment, proves futile. He becomes a cripple, with a heavy torso resting on rigid, fragile legs, and only reaches a height of 1.52 metres.

1880 In Nice from January to March. Paints and draws a lot in Albi and Céleyran, encouraged by his Uncle Charles. Since 1871, Henri has executed almost 2400 drawings, using every technique.

1881 Fails to matriculate in Paris in July; passes at the second attempt in Toulouse in November. Decides to become an artist, encouraged particularly by his Uncle Charles and Princeteau. His mother yields to his insistent demand. Returns to Paris and visits Princeteau in his studio, at 233 Rue Faubourg Saint-Honoré.

1882 Spends the winter months in Albi and Céleyran. Begins his studies in Paris in March. Works in Princeteau's studio and meets the painter Jean-Louis Forain there. On the recommendation of Princeteau and Henri Rachou, he enrolls at the studio of the celebrated salon painter Léon Bonnat, 30 Avenue de Clichy, on 17 April. Bonnat, who becomes professor at the Paris Ecole des Beaux Arts in 1883, is a strict teacher and has no high regard for Henri. After the closure of Bonnat's studio, Lautrec and most of his fellow students continue their studies with Fernand Cormon,

Albi, Lautrec's birthplace, on the Tarn river. In the background the Gothic cathedral, left the Palais de la Berbie in which the Musée Toulouse-Lautrec has been housed since 1922.

10 Rue Constance. Among the students are: Rachou, René Grenier, Charles Laval, François Gauzi, Louis Anquetin. Later he also meets Emile Bernard and Vincent van Gogh there. *Young Routy in Céleyran* (p. 19).

1883 Has first affair with Marie Charlet, a 17-year-old "model". Through Bernard he meets the paint merchant "Père" Tanguy, who shows him paintings by Cézanne. His mother buys Malromé château near Bordeaux, where Henri often spends his summers.

1884 In July he rents accommodation in the apartment of Lily and René Grenier at 19 bis Rue Fontaine in Montmartre. From 1879 to 1891 the same building houses the studio of Edgar Degas, whom Lautrec meets and admires. Later he lives and works with his friend Rachou, 22 Rue Canneron, and afterwards with Gauzi, 7 Rue Tourlaque. First group exhibition in Pau. *Fat Maria* (p. 22).

1885 Frequents the Montmartre café-concerts: the Elysée-Montmartre, Moulin de la Galette, and by preference Aristide Bruant's Le Mirliton, where he also exhibits. Visits Anquetin in Etrepagny (Normandy) and the Greniers in Villiers-sur-Morin.

1886 Spends the summer in Villiers-sur-Morin, Malromé, Arcachon and Respide. Meets van Gogh in Cormon's studio and becomes his friend. Leaves Cormon's studio in the autumn and rents a studio at 7 Rue Tourlaque, on the corner with 27 Rue Caulain-

Ink drawing from an exercise book, which already shows Lautrec's extraordinary talent, c. 1876–1878.

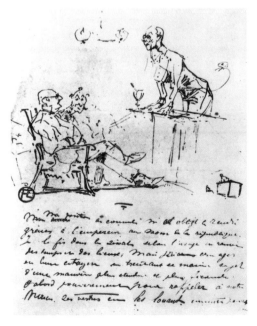

The 12-year-old Henri (middle), with his Uncle Charles (left) and his father Alphonse, who is holding a falcon on his arm. Château du Bosc, c. 1877.

Cormon's studio, where Lautrec studied from 1882 to 1886. At the left edge of the picture is Lautrec, in the middle with paintbrush is Anquetin, c. 1885.

Lautrec (far left) with his friends Anquetin and René Grenier (next to him) on a trip into the countryside, c. 1885.

court, which he keeps until 1897. Meets Suzanne Valadon there, who models for him (p. 29) and is his lover, until her suicide attempt in 1888. *The Laundress* (p. 33).

1887 Lives with the physician Henri Bourges at 19 Rue Fontaine until 1891. In May he takes part in a group exhibition in Toulouse, under the pseudonym "Tréclau" (anagram of Lautrec). Théo van Rysselberghe invites him to exhibit in Brussels. Exhibits in Paris with van Gogh and Anquetin. Studies Japanese woodcuts. Portrait of *Vincent van Gogh* (p. 38).

1888 At the invitation of the Belgian critic Octave Maus he takes part in the February exhibition of "Les XX" in Brussels, with eleven pictures. Theo van Gogh buys *Rice Powder* (p. 41) for 150 Francs, for the Goupil Gallery. Autumn in Villiers-sur-Morin. *Bareback Rider at the Cirque Fernando* (p. 37).

1889 From now until 1894 he takes regularly part in the Salon des Indépendants and the

With Anquetin in Aristide Bruant's Cabaret Le Mirliton, c. 1886.

Cercle Artistique et Littéraire Volnay. Paints a number of open-air paintings in the garden of "Père" Forest in Montmartre (pp. 43, 44). Summer in Arcachon. Wins a regatta at the helm of the yacht "Damrémont". From its opening on 5 October, he is a regular at the Moulin Rouge, 90 Boulevard de Clichy, where he has a permanent table reservation, and where his paintings are also exhibited. *Ball at the Moulin de la Galette* (p. 49).

1890 Travels to Brussels in January for opening of "Les XX" exhibition, with Paul Signac and Maurice Guibert. A furore is caused when Lautrec defends van Gogh and challenges his opponent H. de Groux to a duel. Van Gogh visits Lautrec in Paris on 6 July, shortly before his suicide. Joyant, Lautrec's friend from his schooldays, becomes Theo van Gogh's successor at the Goupil Gallery in Montmartre. Summer holiday in the spa town Taussat, with trips to Biarritz and San Sebastián. Meets Jane Avril. Paints *Ball at the Moulin Rouge* (p. 59), which the director, Joseph Oller, immediately buys and exhibits on the premises.

With Maurice Guibert and cousin Gabriel Tapié de Céleyran (right), at the Hôpital Saint-Louis, c. 1892.

1891 In April he moves with Bourges to 21 Rue Fontaine. August in Arcachon and Malromé. In the autumn his cousin and friend Gabriel Tapié de Céleyran comes to study medicine in Paris. First lithographs. *After the Meal* (p. 66) and the famous *Moulin Rouge* poster (p. 101) are executed, the latter making him famous overnight throughout Paris.

1892 Travels to an exhibition in Brussels in February, and to London at the end of May. Late summer in Taussat. Yvette Guilbert asks him to design a poster in December. Designs posters for the *Divan Japonais* (p. 115) and for Bruant (p. 99).

1893 First large one-man exhibition, with *c.* 30 works, organised by Joyant at the Boussod-Valadon Gallery. Visits Bruant in Saint-Jean-les-Deux-Jumeaux in April. Lives in the house where his studio is, Rue Tourlaque. His mother moves to the neighbouring Rue de Douai. Through Tristan Bernard, Romain Coolus and Félix Fénéon, he is introduced to the literary world, particularly the theatre;

Lautrec as Jane Avril, wearing her hat, furs and costume, c. 1894.

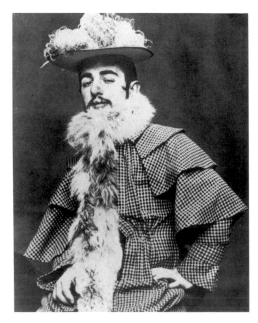

With Thadée and Misia Natanson at the seaside resort of Etretat, c. 1896.

hardly misses a première. Occasionally lives in the brothel on the Rue d'Amboise, a 17th-century palace, and paints 16 pictures there. Takes part in the "Peintres-Graveurs" exhibition with eleven lithographs. When Bourges marries, Lautrec temporarily moves in with his mother. Poster for Jane Avril's appearance at the Jardin de Paris (p.105).

1894 In January moves into the ground floor apartment at 27 Rue Caulaincourt, for 18 months. Travels to Brussels with Anquetin, where he attends the Salon de la Libre Esthétique, and on to Haarlem and Amsterdam to study Rembrandt and Hals. Exhibition in Toulouse in May. Travels to London in June and October to exhibit posters at the Royal Aquarium. In the summer he makes an extended journey to Spain, visiting Burgos, Madrid and Toledo; afterwards with his mother in Malromé. Album of lithographs dedicated to Yvette Guilbert. Moves in the circle of Natanson's journal *La Revue Blanche*, where he meets the Nabis Bonnard, Vuillard, and Vallotton. Sporadic brothel residences. *In the Salon of the Rue des Moulins* (p.145).

1895 Travels to Brussels for the Libre Esthétique and in May to London, with Joyant. Meets Oscar Wilde and Whistler, whom he portrays. Excursions to Normandy with Maurice Dethomas. Moves to an apartment at 30 Rue Fontaine, where he remains until 1898. In August he sails on board the "Chili" from Le Havre via Bordeaux to Lisbon accompanied by Maurice Guibert. Return via Madrid and Toledo, where they study Velázquez, Goya and El Greco. Takes part in a large exhibition of lithographs at the Ecole des Beaux-Arts in Paris. Decorates the show booth of La Goulue at the Foire du Trône, on the present-day Place de la Nation (pp.90, 91). Frequents the Irish and American Bar. Affair with the singer May Belfort. Poster for May Milton (p.117) and portraits of Cha-U-Kao (pp.118, 119).

1896 Second large one-man exhibition at Joyant's gallery at 9 Rue Forest, with many visitors and high prices. Refuses to sell a picture to the ex-king of Serbia, whom he regards as a "pig breeder". Travels to Le Havre, Bordeaux and Arcachon. In February in Brussels with Joyant. In August extended journey to Spain, to Burgos, Madrid and Toledo. Intensive study of erotic Japanese colour woodcuts, especially Utamaro. Visits the Loire châteaux in November. Takes part in a poster exhibition in Reims. Is introduced to the world of cycle racing by T. Bernard, and designs two posters on this theme (p.131, nos. 25, 26). Album of lithographs entitled *Elles*. *Marcelle Lender Dancing the Bolero* (p.93).

1897 Exhibits at the "Libre Esthétique" in Brussels in February. Moves into a studio at 15 Avenue Frochot, near Place Pigalle, in May (until 1898). Leaves 87 pictures in the old studio, some of which the new tenant uses to fill holes in the wallpaper, while the rest are squandered. In London with Joyant in June. Travels with Joyant to the Somme, and explores the Dutch canals on a houseboat with Dethomas. Does not draw much, but drinks all the more. Attack of delirium tremens in Villeneuve-sur-Yonne. *The Grand Box* (p.125).

1898 Rents an apartment at 9 Rue de Douai, where his mother lives. Exhibits 78 pictures with Goupil in London, in May; sells only one picture, but that one to the Prince of Wales. Second album of lithographs featuring Yvette Guilbert for the London publishers Sands. Is only rarely sober and produces less and less. Summer in Arromanches and Villeneuve-sur-Yonne. Suffers an attack of paranoia, feels threatened by the police, and flees to a friend. *Madame Poupoule at her Toilette* (p.170).

1899 Illustrates Jules Renard's "Histoires Naturelles". Increased depressions, hallucinations and panic attacks, added to which his mother leaves Paris for Albi in January to look after her own mother. Suffers methyl-alcohol poisoning in the brothel on the Rue des Moulins, and is committed to the psychiatric hospital in Neuilly, Avenue de Madrid, from

The last photograph of Lautrec, taken at Malromé château in August 1901, about two weeks before his death.

Lautrec in June 1899, bathing at Le Crotoy after his hospitalisation in Neuilly.

the end of February until 17 May. Malicious articles on his mental state appear in the press. In hospital he draws pictures of circus scenes from memory with coloured crayons (pp.172, 174, 175). After the scandal he becomes more famous and his prices rise. Convalesces in Albi, Le Crotoy, Le Havre and Bordeaux, accompanied by Paul Viaud. Together they sail to Taussat. Returns to Paris with Viaud in the autumn. *The English-woman from Le Star at Le Havre* (p.177) and *Séparée in the Rat Mort* (p.179).

1900 Financial conflict with the family, who wish to place him under guardianship. His will to live is broken and his alcohol problem increases. Is a member of the jury adjudicating for poster section of the Exposition Universelle in Paris, which he attends in a wheelchair. Spends the months May to September in Taussat, and October in Bordeaux. Rents an apartment and a studio there (until April 1901), for himself and Viaud, whose supervision of his alcohol consumption he cunningly evades. *Maurice Joyant at the Duck Shoot* (p.186); *The Milliner* (p.188).

1901 Visits the theatre in Bordeaux; six paintings on the theme *Messalina* (pp.180, 181). In March, renewed collapse, including brain haemorrhage, which paralyses both legs. Spends another three months in Paris from the end of April; makes a will and signs important works. Leaves Paris for the last time, with Viaud, on 15 July. Again travels to the sea, to Arcachon and Taussat. Suffers a stroke on 15 August in Taussat, which leaves one side of his body paralysed. On 20 August his mother takes him to Malromé, where he dies on 9 September at 2.15 a.m., aged 36, in the presence of his parents, his cousin Gabriel, and Viaud. Burial in Saint-André-du-Bois, remains subsequently transferred to Verdelais (Gironde). His last two pictures are *Admiral Viaud* (p.185) and *An Examination at the Faculty of Medicine in Paris* (p.189).

Acknowledgements and Bibliography

The editor and publishers thank the museums and public collections, the galleries and private collectors, the archives and photographers, and all others who helped them with the preparation of this monograph. Picture credits: Musée Toulouse-Lautrec, Albi: 30, 39, 52, 56/57, 62, 65, 73, 88, 89, 142/143, 156, 157, 170, 189. – Rijksmuseum Vincent van Gogh, Vincent van Gogh Foundation, Amsterdam: 41. – The Fogg Art Museum, Harvard University, Cambridge (MA): 40 below. – The Cleveland Museum of Art, Cleveland: 86. – André Held Archive, Ecublens: 13, 44, 45, 78, 106, 114, 123, 139, 148, 150, 169, 188. – Benedikt Taschen Verlag Archive, Cologne: 19, 33, 37, 59, 83, 99, 115, 127, 141, 146, 147, 177, 179. – Ny Carlsberg Glyptotek, Copenhagen: 29, 87. – Christie's Colour Library, London: front cover, 77, 92, 124, 125. – Courtauld Institute Galleries, London: 107. – Sotheby's, London: 27, 162. – Alexander Koch Archive, Munich: 6, 15, 154, 183, 186. – Réunion des Musées Nationaux, Paris: 21, 51, 60, 109, 119, 149. – Museu de Arte de São Paulo Assis Chateaubriand, São Paulo (Photo: Luiz Hassaka): 47, 110, 185. – National Gallery of Art, Washington: 95. – Von-der-Heydt-Museum, Wuppertal: 22. – E. G. Bührle Trust Collection, Zurich: 139. All other illustrations were provided by the author or from the publisher's archive, or from the archive of the former Walther & Walther Verlag.

CATALOGUES RAISONNÉS

Adhémar, Jean: T.-L. His Complete Lithographs and Drypoints. New York 1965 (cited as Adhémar)

Adriani, Götz: T.-L. Das gesamte graphische Werk. Sammlung Gerstenberg. Cologne 1986 (cited as Adriani)

Adriani, Götz: T.-L. Das gesamte graphische Werk. Cologne 1976

Delteil, Loys: H. de T.-L. In "Le peintre-graveur illustré", X–XI. Paris 1920

Dortu, M. G.: T.-L. et son œuvre. Catalogue des peintures, aquarelles, monotypes, reliure, vitrail, ceramique, dessins. 6 vols. New York 1971 (cited as Dortu)

Sugana, G. M. and Giorgio Caproni (eds.): The Complete Paintings of T.-L. London 1973

Wittrock, Wolfgang: T.-L. The Complete Prints. 2 vols. London 1985 (cited as Wittrock)

LAUTREC'S OWN WRITINGS

Goldschmidt, Lucien and Herbert Schimmel (eds.): Unpublished Correspondence of H. de T.-L. London 1969

Schimmel, Herbert (ed.): The Letters of H. de T.-L. Oxford 1991

DOCUMENTS, MEMOIRS, FIRST-HAND ACCOUNTS

Beauté, Georges (ed.): Il y a cent ans H. de T. L. Geneva 1964

Beauté, Georges (ed.): A T.-L. album. Salt Lake City 1982

Gauzi, François: L. et son temps. Paris 1954, Lausanne 1957

Gauzi, François: My Friend T.-L. London 1957

Guilbert, Yvette: La chanson de ma vie. 1927

Joyant, Maurice: H. de T.-L. 1864–1901. 2 vols. Paris 1926–1927

Leclercq, Paul: Autour de T.-L. Paris 1921, Geneva 1954

Natanson, Thadée: Un H. de T.-L. Geneva 1951

Tapié de Céleyran, Marie: Notre oncle L. Geneva 1953, 1963

FURTHER LITERATURE

Adriani, Götz: T.-L. und das Paris um 1900. Cologne 1978

Adriani, Götz: T.-L., Gemälde und Bildstudien. Cologne 1986

Arnold, Matthias: H. de T.-L. Reinbek 1982

Arnold, Mattias: T.-L. Cologne 1987

Bouret, Jean: T.-L. London 1964

Castleman, Riva and Wolfgang Wittrock (eds.): H. de T.-L.: Images of the 1890s (exh. cat.). The Museum of Modern Art, New York 1985

Catalogue Musée T.-L. Albi 1985 (Catalogue of Collection)

Chastel, André: T.-L. Paris 1966

Cogniat, Raymond:L. Paris 1966

Cooper, Douglas: H. de T.-L. London, 1955, 1988

Denvir, B.: T.-L. London 1991

Fermigier, André: T.-L. New York 1969

Frèches, Claire and José: T.-L. Les lumières de la nuit. Paris 1991

Huisman, Philippe and M. G. Dortu: L. by L. New York 1964, London 1973

Jedlicka, Gotthard: H. de T.-L. Erlenbach and Zurich 1943, Berlin and Munich 1960

Jourdain, Francis: T.-L. Paris 1951

Jourdain, Francis and Jean Adhémar: T.-L. New York 1952

Julien, Edouard: T.-L. Paris 1991

Keller, Horst: H. de T.-L. Cologne 1968, 1980

Lassaigne, Jacques: T.-L. Paris 1939, 1946

Lassaigne, Jacques: T.-L. Geneva 1953

Le Targat, F.: T.-L. Paris 1988

Lucie-Smith, Edward: T.-L. Oxford 1977, 1983

Mack, Gerstle: T.-L. New York 1938, 1953

Mac Orlan, Pierre: L., peintre de la lumière froide. Paris 1934

Néret, Gilles: T.-L. Paris 1991

Novotny, Fritz: T.-L. London 1969

Perruchot, Henri: T.-L. London 1960

Polasek, Jan (ed.): T.-L. Zeichnungen. Hanau (year not given, c. 1963)

Rodat, Charles de: T.-L., Album de famille. Fribourg 1985

Roger-Marx, Claude: T.-L. Paris 1957

Schaub-Koch, Emile: Psychoanalyse d'un peintre moderne: H. de T.-L. Paris 1935

Thompson, Richard: T.-L. London 1977

Thompson, Richard, Claire Frèches and Anne Roquebert (eds.): T.-L. Hayward Gallery, London; Grand Palais, Paris. London and Paris, 1991–1992 (exh. cat.)